The Lively Arts
General Editor: Robert Ottaway

# RENOIR,
# MY FATHER

*

## JEAN RENOIR

Translated by
Randolph and Dorothy Weaver

Mercury House, Incorporated
San Francisco

This edition published by arrangement with Columbus Books Limited, London. First published in English in 1962 by Little, Brown and Company, Boston. This trade paperback edition published in 1988.

Published in the United States by
Mercury House
San Francisco, California

Distributed to the trade by
Kampmann & Company, Inc.
New York, New York

Manufactured in the United States of America

*Library of Congress Cataloging-in-Publication Data*

Renoir, Jean, 1894–
   [Pierre–Auguste Renoir, mon père. English]
   Renoir, my father. / Jean Renoir : translated by Randolph and Dorothy Weaver.
      p.  cm. — (The Lively arts)
   Translation of : Pierre-Auguste Renoir, mon père.
Reprint. Originally published: Boston : Little, Brown, 1962.
   Includes index.
   ISBN 0–916515–39–7 : $9.95
   1. Renoir, Auguste, 1841–1919.  2. Painters — France — Biography.  3. Painting, French.  4. Painting, Modern — 19th century — France.  5. Painting, Modern — 20th century — France.  6. Impressionism (Art) — France.  I. Title.  II. Series.
ND553.R45R42813   1988
759.4 — dc19
[B]                                                              87–30164
                                                                      CIP

# Pierre Auguste Renoir

'The earth as the paradise of the gods, that is what I want to paint.'
Renoir's love of life and joy in painting shine out of his every work. He
was master of many techniques, not only impressionist, and for that
reason he is seen as one of the painting masters of all time. Renoir's
pictures are today reproduced worldwide, loved and familiar images
to people who may not even know the artist's name.

Renoir was born into a working-class family in Limoges, in 1841.
When he was about three, his father, a tailor, decided to move the
family to Paris in order to find work. Renoir showed a very early gift for
drawing and was apprenticed in an appropriate trade, to a porcelain
factory. At sixteen he painted his first portrait, of his grandmother, but
it was not until 1862 that he enrolled at the Ecole des Beaux-Arts, in
Gleyre's studio. He was at once drawn into a circle of friends that
included Monet, Sisley and Bazille, and came under the influence of
Manet and Courbet. Caillebotte, too, became a lifelong friend.

For ten years from 1873 Renoir had his studio in the Rue Saint-
Georges in Paris; Manet and Pissarro were constant visitors. Though
his paintings were frequently rejected by the Salons, he managed to
sell work regularly, usually portraits for the well-to-do circle of the
publisher Georges Charpentier and his wife, for Paul Gallimard, and
also for the dealer Paul Durand-Ruel and his clients. In 1881 Renoir
travelled abroad, to Algiers and Italy, and on returning to France spent
some time at L'Estaque, working with Cézanne. From then on he
travelled regularly within France: to Essoyes where he bought a house,
to Mézy, to Wargemont near Dieppe, to Cagnes-sur-Mer in Provence
where he bought another house.

In his sixties Renoir was stricken with rheumatoid arthritis. By 1912
both legs were paralyzed and his paintbrush had to be tied to his hand.
Renoir always felt that a painting should give pleasure, so neither his
own suffering nor that of the world at large was ever allowed a place in
his work. At seventy he began a new career as a sculptor with the help
of an assistant.

In 1890 Renoir had married Aline Charigot, his mistress of ten years,
when their first son, Pierre, was five years old. Their second son, Jean,
was born in 1894 and their third, Claude, in 1901. In 1915, when Jean
was seriously wounded in the First World War, Mme Renoir rushed to
see him in hospital; on her return home she died. Despite his loneliness
and difficulties, Renoir continued to paint – smiling, harmonious
pictures of children and beautiful, passive women – till the end of his
life. In 1900 he had been awarded the Légion d'Honneur and in
August 1919 he saw one of his portraits hung in the Louvre. In
December of that year, at Cagnes, he died.

| | |
|---|---|
| THE READER: | *It is not Renoir you are presenting to us, but your own conception of him.* |
| THE AUTHOR: | *Of course. History is essentially subjective, after all.* |

# ILLUSTRATIONS

Unless otherwise indicated photographs are reproduced courtesy of Photo Durand-Ruel.

# I

In April 1915 a Bavarian sniper did me the favour of putting a bullet through my leg. As a result of the wound I was eventually transferred to a hospital in Paris, where my father had been brought so as to be near me. The death of my mother had completely crushed him and his physical condition was worse than ever. The journey from Nice to Paris had tired him so much that he was unable to visit me in the hospital. But as soon as I was well enough to dispense with having my leg dressed, I easily got permission to spend most of my time at home.

It was one of his models, 'La Boulangère' as we called her, who opened the door. She let out a shriek when she saw my crutches. Then 'Grand' Louise', our cook, appeared from my father's studio, which was on the same floor as our apartment. They both kissed me, and told me that 'the master' was busy painting some roses La Boulangère had bought on the Boulevard Rochechouart. I had noticed the flower-woman leaning against the wheel of her little push-cart as I got out of the taxi. She was the very same one who had been there before the war. Outwardly nothing had changed, except that the rumble of cannon-fire could be heard when the wind was in the north.

My father was waiting for me in his wheel-chair. For several years he had not been able to walk. I found him much more shrunken than when I had first left for the Front. Yet the expression on his face was as lively as ever. He had heard me out on the landing, and he was beaming with happiness, in which, however, there was a touch of irony. His eyes seemed to be saying, 'They missed you this time, didn't they?' He handed his palette to Grand' Louise with an almost casual gesture, and warned me, 'Mind you don't slip. The concierge waxed the floor in your honour, and it's very dangerous!' He turned to the two women: 'Wash it off well

with plenty of water. Jean might slip and fall.' I kissed my father. His beard was wet with tears. He asked for a cigarette, which I lit for him. For a moment we found nothing to say to each other. I sat down in my mother's favourite chair, a little armchair in rose-coloured velvet. The silence was broken by Grand' Louise's sobbing. She sniffed a great deal when she cried, as women do in Essoyes, my mother's native village, where Grand' Louise had been born. It made us laugh, and she left the room in a huff. Her tears were often the subject of jokes in our family. We used to say they were the cause of too much salt in the soup. Renoir went back to the study of roses he was working on 'just to pass the time', and I made a tour of the apartment. It seemed almost deserted. There was no sound of models and servants laughing now. The pictures had been sent down to Cagnes,[1] the walls were bare, the shelves empty: and my mother's room smelt of moth-balls.

After a few days our life became more organized. I spent much of my time watching Renoir paint. When he paused we would talk of the stupidity of the war, which he hated. At meal-times he would be wheeled into the dining-room; he had no appetite, but he believed in the ritual of meals. My brother Pierre, who was married to the actress Véra Sergine, had had his arm shattered by a bullet, and had been invalided out of the army. He often came to lunch with his wife and their two-year-old boy, Claude. In spite of his wound he was trying to take up his career as an actor again.

Renoir would stop painting as soon as it grew dark. He did not like artificial light. We would wheel him into the apartment, and I would remain practically alone with him for several hours before and after dinner. The war had changed the habits of most Parisians, and few people made calls. For the first time I felt, in my father's presence, that my childhood was over and I had become a man. My wound gave me an added sense of being on an equal footing with him. I could not move about without my crutches. We were both cripples, more or less, confined to our chairs.

Renoir did not like playing draughts, and cards bored him. He was fond of chess, but I was poor at it, and he could beat me so easily that he soon lost interest. He read little, as he wanted to save his eyes for his work, though his sight was as good as it had been when he was twenty. Conversation was all that remained. He liked to hear my stories about the war, at least those which brought

[1] A village near Nice where Renoir owned a house.

out its absurd side. Here is one which particularly amused him :

During the retreat near Arras, I had been sent out on patrol with half a dozen other dragoons. From the top of a hill we caught sight of half a dozen or so Uhlans, also patrolling. We deployed in battle formation, each man taking his stand at twenty yards' distance from the next, and bracing his lance, while the Uhlans on the opposite hill did the same. We started off at a walk, well in line, then broke into a trot, and then into a gallop ; and when we were within a hundred yards of the enemy we charged, each of us determined to spear the horseman in front of him. We felt as though we were back in the time of François I, at the Battle of Marignan. The space between us narrowed. We could make out the expression on the drawn faces of our adversaries under their shapskas, just as they could ours under our helmets. In a few seconds the affair was over. In spite of our spurring them on, and jerking on the bridles, our horses showed little desire to be run through, and shied away, taking us out of range of the opposing lances. The two patrols rushed past each other at a furious pace, treating a few grazing sheep to a brilliant if harmless display of horsemanship. Somewhat crestfallen we returned to our lines, and the Germans went back to theirs.

As a fair exchange for my war stories, Renoir entertained me with recollections of his youth. He took this opportunity to get closer to his son, and the man I felt I had now become began to discover an unknown Renoir. I think he tried, at the time, to simplify things to enable me to understand him better. He succeeded very well, and in the course of our talks the child, the young man and the mature man he had been, all became clearer to me. So I had good reason to be grateful to that Bavarian soldier for bringing my father and me together again.

I have often reproached myself for not publishing immediately after Renoir's death a selection of the many conversations I had with him. But now I no longer regret it. The passing of the years and my personal experiences have given me a clearer view of him. And there is one aspect of him which I did not even glimpse at that period, and that is, his genius. I admired his painting intensely, but it was a blind sort of admiration. To be truthful, I was totally ignorant of what painting was. I was hardly aware of what art in general was all about. Of the world itself, all I could take in was its outward appearances. Youth is materialistic. Now I know that great

men have no other function in life except to help us to see beyond appearances : to relieve us of some of the burden of matter—to ' unburden ' ourselves, as the Hindus would say.

I wish to present to the reader this collection of reminiscences and personal impressions as a partial answer to the question I am often asked : ' What sort of man was your father ? '

# 2

My father had the pleasantest memories of his childhood, even though my grandparents were poor. I am convinced that Renoir never tried to ' make up ' anything, and that he had really been happy when he was young. He loathed the foolish embellishing of the past that old men especially like to indulge in. He had a deep respect for what was still left of the eighteenth-century way of life in France, even though he realized how fragile these remnants were. And he deplored the mad determination of his nineteenth-century compatriots to squander their heritage. Their behaviour seemed to him like that of a man who, though healthy and carefree, is slowly but surely heading towards suicide.

The bloodshed of 1914 was to him one of the concluding scenes in our country's history. Owing to the scarcity of actors, the performance would soon come to an end. And as he could not resist a paradox, he added that he had nothing against war, because it helped to reduce the population. ' We are too numerous not to be a crowd. In Athens there were several thousand individuals.' He winked as he pronounced the word ' individuals '. His chief grudge against war was that it *resulted in the survival of the wrong people* : that is, it killed off the ' nobility ' and allowed the ' dregs ' to live on.

The nobility have a passion for getting themselves killed—not out of patriotism or even courage, but simply because they don't care to owe their lives to some anonymous substitute. ' The result is that only the dregs make history. And what history ! '

To Renoir, nobility had nothing to do with birth. I shall come to that later when I go into the question of his origins. But I must add that, as regards his opinion of the toll taken by the First World War, he did not pretend to be a prophet. He always voiced his fears casually. They were part of his love for life. Any sort of

destruction, whether of men, animals, trees or things, shocked him. He never forgave Napoleon for the remark which according to certain historians he made after the holocaust of Eylau : 'One night in Paris will repair all that.'

Pierre Auguste Renoir was born in Limoges in 1841. His grandfather, François Renoir, who died in Limoges in 1845, claimed that he was of noble birth, and explained that he had been given the name Renoir by a shoemaker who had taken him in when he was a baby. It seems that when Louis XVIII returned in 1815, after the fall of Napoleon, François went to Paris to present his case to the Commission set up to study the claims of aristocrats who had been despoiled by the Revolution, but he had been sent packing. He had tried to make an appeal to the King, but the guards had gently shown him the door. This story was interpreted in different ways in the family. My grandfather Léonard's in-laws in the town of Saintes believed it. He himself cared little for titles of nobility : he was more concerned about whether there might be any hope of recovering valuable land. But he was convinced that the present owners would not be likely to give up anything without a struggle— and to put up a fight, you needed money. Later on, after I was born, when my parents used to go out to Louveciennes to see my grandparents, then living in retirement, the subject would sometimes come up for discussion. Charles Leray, my Aunt Lisa's husband, thought he would tease my father by calling him ' Monsieur le Marquis ', but Renoir did not even hear him. He was more interested in the light and the trees of the Ile de France than he was in family pleasantries. He had the precious gift of being deaf when convenient. Many people took this for absent-mindedness, but it was rather his faculty for concentrating on what suited him, and remaining impervious to what seemed inappropriate or useless. He was in no way a daydreamer : or at any rate his dreams were based on a sharp observation of life, for in order to grasp reality better he limited his perceptions to a few definite things.

A writer of Limoges, Henri Hugon, published in *La Vie Limousine* for 25th February 1935 (the anniversary of Renoir's birth) a very interesting account of the painter's connections with his native town, which were limited, however, to his having been born there. I have made several excerpts from M. Hugon's study, which

help to throw further light on the genealogy of my family. M. Hugon, who knows Limoges and the Limousins thoroughly, went to considerable trouble to investigate the subject. He writes:

> We come now to the last section of my researches, that is : the marriage whereby, on the 24th Frimaire of the year 4 (i.e., 1796), Citizen François Renoir, shoemaker by profession, residing in Limoges, in the Rue du Colombier, Section de l'Egalité, being of legal age, was united to Citizen Anne Regnier, a minor, and the legitimate daughter of the late Joseph Regnier, a carpenter. . . . The chief witness was a friend ; the other three witnesses were relatives of the bride.

M. Hugon had easily found Anne Regnier's baptismal certificate in the parish church of Saint-Michel-des-Lions, as well as other information about the family. He had more difficulty in ascertaining the origins of François Renoir. The marriage record made no mention of the bridegroom's parents. M. Hugon had consulted in vain all the records in all the parishes in Limoges and its environs, when his attention was caught by the name of a priest who before the Revolution had been attached to the general hospital. The name was Lenoir. I can well understand how the similarity between Lenoir and Renoir, which have the same sound, should have aroused the curiosity of M. Hugon, especially as he had already come across another Lenoir, a magistrate, who had officiated at the marriage of the Renoir couple in 1796. One is often inclined to ponder the many different methods of classifying the elements composing our universe, and to ask why certain classifications could not be based on sounds instead of ideas. My father, who mistrusted the intellect, would have approved of that procedure. M. Hugon was rewarded for his anti-Cartesian impulse, for in the Catholic register of the hospital where the Abbé Lenoir had officiated he discovered the following entry : ' In the year of Grace, 1773, on the 8th of January, a new-born child, a foundling boy, was baptized by me. He was given the name of François . . . etc.' And our author concludes : ' In accordance with custom, an abandoned child without identification papers received only a Christian name, to which a surname, often taken from a foster-father, was added.' There were people in Limoges who were called Renouard. How their name came to be applied to the foundling no one knows.

# Renoir, My Father

We do know that twenty-three years later, in 1796, François married Anne Regnier. The scribe of the marriage records wrote down the groom's name as it was given to him verbally, and spelled it Renoir. The young couple were unaware of the fact, as they were illiterate. And so it happened that, because of the scribe's phonetic spelling, our family acquired its legal name.

Here is what Ambroise Vollard said at the beginning of the second chapter of his book *Renoir: An Intimate Record* (it is Renoir who is supposed to be speaking) : ' My mother often told me how my grandfather, a man of noble birth whose family perished during the Terror, was picked up as a child and adopted by a shoemaker named Renoir.' I have the greatest admiration for Vollard's biography, but it would be a mistake to take his word as gospel truth— partly because Renoir sometimes liked to ' lead on ' picture-dealers, and especially because Vollard was a visionary as well as a business- man, who lived in a dream and ' heard only what he wanted to hear '. My father once said, in commenting on the work, ' Not bad, Vollard's book on Vollard.' Besides, he always thought any book about himself a sort of childish undertaking. ' If it amuses him, I can't see any harm in it '—and he added, ' especially as nobody will read it.' But in that he was mistaken.

I recall some of Renoir's remarks about heredity.

' It is the parents who " make " the children, but after their birth. Earlier, there are hundreds of influences which we cannot trace. Mozart's genius stems perhaps from a Greek shepherd who, long before the Christian era, was moved by the sound of wind in the reeds. I am thinking, of course, of important hereditary traits. As for rheumatism or cauliflower ears, you can always pin these on some grandfather.' Another remark : ' In a few generations you can breed a race-horse. The recipe for making a man like Delacroix is less well known.' And further : ' The parents' function is to bring together many mysterious forces, not only the life-force of human beings, but the forces inherent in the forests, in the sea, in all life.' And finally : ' A plum-stone cannot produce an apple.' This statement was immediately offset by the further remark : ' Most of a child's failings and qualities result from those who bring it up. A prince kidnapped by gipsies will steal chickens as other gipsies do . . . but perhaps he will steal them in princely fashion.'

If Renoir was little concerned about his grandfather's claims to

a title, he was certainly pleased that he had been adopted by a shoe-maker :

'When I think that I might have been born into a family of intellectuals ! It would have taken me years to get rid of all their ideas and see things as they are. And I might have been awkward with my hands.'

He talked constantly of 'hands'. He always judged people he saw for the first time by their hands.

'Did you see that fellow, and the way he tore open his packet of cigarettes ? He's a scoundrel. And that woman : did you notice the way she brushed back her hair with her forefinger ? . . . A good girl.' He would also say sometimes : 'stupid hands'; 'witty hands'; 'ordinary hands'; 'whore's hands' . . .

One usually looks people in the eyes to see if they are sincere. Renoir always looked at their hands. We shall see, gradually, how hard he found it to accept standard values. The idea that the intellect is superior to the senses was not an article of faith with him. If he had been asked to name the different parts of the human body according to their value, he would certainly have begun with the hands. In an old desk drawer at home I have a pair of gloves which belonged to him : pale-grey gloves made of very fine leather, whose size sets one musing. 'He had unbelievably small hands for a man,' Gabrielle[1] said. If any ancestor were responsible for Renoir's hands, then instead of thinking of his shoemaker grandfather's thick fist, I should be inclined to conjure up the tiny fingers of some great lady more accustomed to playing the harpsichord than to doing the washing. But let me return to M. Hugon's research.

After his marriage, François set up shop in Limoges, as a shoe-maker. The young couple had nine children. Léonard, the eldest, who was born on 18th Messidor of the Year 7 (1799), became a tailor and travelled about the country. On 17th November 1828 he married Marguerite Merlet, a seamstress, at Saintes. He came back and settled in Limoges, where he had seven children. The two first-born died young. Then came Henri, Lisa, Victor, Pierre-Auguste (my father), and Edmond, who was born in Paris.

Here is the record of Renoir's birth :

This day, 25th February 1841, at three o'clock in the after-noon, appeared before us, the Deputy of Monsieur the

[1] 1879-1959. A cousin of Mme Auguste Renoir, and one of the painter's models.

Mayor of Limoges, Léonard Renoir, Tailor, aged 41 years, residing in the Boulevard Sainte-Catherine, and presented to us an infant of the male sex, borne to him in his house, at six o'clock this morning, by his wife Marguerite Merlet, aged 33 years; to which child they gave the name of Pierre-Auguste.

# 3

My great-grandfather François died in 1845, after which my grand-father Léonard came and settled in Paris. My father was then four years old and it was in the capital that he grew up and his character was formed. The memories of his early childhood in Limoges quickly faded. Renoir considered himself a Parisian. At that period the Esplanade of the Louvre, instead of opening on the Tuileries Gardens, was shut off by the Tuileries Palace, which was destroyed by fire under the Commune. Today this space is planted with flowers which vary with the season, but in 1845 it was lined with houses, and the Rue d'Argenteuil extended through it as far as the Seine. These houses had been built in the sixteenth century by the Valois to shelter the families of the noblemen of the Palace Guard. The broken cornices, the cracked columns and the remains of coats-of-arms bore witness to their former elegance. The original owners had long ago been replaced by people of less affluence. It was in one of these houses that my grandfather found an apartment to let, and he moved in with his family.

One wonders how successive kings could have tolerated such a seedy neighbourhood under their very noses. The quarter was a perfect network of lanes and alleys which crossed each other in the most wayward fashion. The washing was hung out to dry from the windows, and the smells floating up from the kitchens indicated the different regions from which the inhabitants had come. This is easy to imagine, for the march of progress has not yet succeeded in standardizing the quality of French cooking. In Paris the steam from the casseroles still gives the passer-by a clue as to whether a Burgundian is stewing kidney beans with bacon or a Provençal is preparing a dish heavily flavoured with garlic.

In this indifference towards the noise and smells of the common people on the part of the royal family my father saw the survival of

customs prevalent 'before the rise of the middle class'. 'Democracy has done away with titles and replaced them by distinctions just as puerile.' He hated the division of modern cities into slums, middle-class quarters, workers' sections, and so on. 'They have ruined the best parts of town.' Then he added in a burst of fury, 'I'd rather die than live in Passy.' For him Passy was a sort of scapegoat on which he vented his scorn.

'In the first place, it isn't Paris. It's nothing but a big cemetery at the gates of Paris.' And when a lady came to ask him to paint her portrait and he had her shown out because she seemed pretentious, he remarked afterwards, 'She was probably from Passy.'

So Louis-Philippe, 'the Bourgeois King', was not bourgeois to the point of being disturbed by the proximity of the people living in the old houses. For their part the Renoirs found it quite natural to be neighbours of the descendants of King Henri. The young rapscallions in the quarter lost no time in adopting the youngster from Limoges and including him in their games, the most popular of which was 'cops and robbers'. The games they played in the courtyard of the Louvre were naturally accompanied by a vast amount of noise and scuffling. A swarm of urchins would gather to pester the Palace Guards, who thereupon went to the parents and requested them to keep their offspring under better control. The mothers of the culprits would appear on the scene and put an end to the row by administering a few slaps, thus provoking a fresh outburst of yells. A window in the Tuileries Palace would open, and a dignified lady would lean out and make a sign to the young scamps to calm down. Immediately they would gather under the window like greedy sparrows. Then another lady would appear and throw sweets down to them. The Queen of France was trying in vain to buy a moment's peace. After the bounty had been distributed, the lady-in-waiting would close the window. Queen Marie-Amélie would return to her domestic duties, and the young rascals to their games.

Léonard Renoir and his wife and children had of course come to Paris by stage-coach. The journey from Limoges took just over two weeks. My father had no recollection of it, but my Uncle Henri spoke of it to me several times. He remembered especially the unbearable heat inside that rolling box, ventilated only by a small window. Before starting out, the Renoirs had raised a few sous by selling everything they did not absolutely need. They wore their

best clothes, which their father had cut out of good material, heavy enough to serve as a protection against the severe winters of Limoges. One day when the sun was beating down unmercifully, little Lisa had fainted. The postilion had lifted her out and placed her on the seat beside him, and when they reached the next relay he made her drink a glass of neat brandy : my grandmother got out of the coach too late to save her daughter from such a drastic remedy.

Once inside the inn, everyone sat down at the main dining-table. Among the guests was a commercial traveller who every evening recounted the same anecdote about an attack on a diligence, at which he claimed to have been present. The bandits had forced the travellers to get out of the conveyance and then robbed them of their money, baggage and clothing. He himself had escaped the fate of the others because he was lying drunk on the floor of the coach and so remained unnoticed. He had awoken an hour later, after the stage-coach had resumed its journey, and had been quite surprised to see his fellow-passengers as naked as Adam in the Garden of Eden.

After supper, my grandmother and Lisa went to bed in a room in the inn. Léonard Renoir and the boys slept on the straw in the stable.

There are several of these inns still in existence in France. I know of a magnificent one a little to the north of the town of Saint-Étienne. It stands at the intersection of two main roads. It is a large structure, facing the corner, its walls covered with slates and pierced at regular intervals by rather small windows. A covered carriage-entrance opens like an enormous mouth at the angle of the building. Every time I go there I am struck by the beauty of the timber-work. The master beams seem to be taking flight as they soar towards the roof. The joists are interwoven like lace. I feel as if I had been transported into the overturned hull of a great ship. The coach-houses and stables take up considerable space, and face on to a large courtyard in the centre. It is like the waiting-room of a railway station, and gives access to all parts of the building. In the old days the horses stood in their stalls and the men gathered together in the common room to drink jugs of native wine.

The last time I stayed there the inn had lost none of its busy atmosphere, though the diligences had been replaced by lorries : the lorry drivers, those modern poets of the highway, have had the good

sense to adopt it as a stopping-place on their journeys. Like me, the drivers can probably picture the heavy coaches with their huge iron-rimmed wheels whirling up with a splendid clatter, their six percherons stamping on the cobblestones, their iron-shod hooves sending out a spray of sparks. The servant-girls come running out in their freshly-ironed aprons, the postilion tosses down a goblet of cool white wine offered him by the inn-keeper : a tribute, unbegrudged, to the hero of the moment, the man who brought to the sleepy villagers in their beds a fleeting impression of cities they would never see.

Nowadays the big lorries come roaring up in a cloud of fumes and dust. The servant-girl appears at the door of the inn, and through it the driver catches sight of a world of solid comfort. The cat gets up and stretches, showing its claws, and then curls up in a ball by the stove, while the man sits down, ears still ringing from the noise of his engine.

I cannot help marvelling at the destiny which caused Renoir's life to fall within two absolutely different phases of the world's history. True, there were railways in his youth, but they went only short distances, and a good many people were afraid to travel by rail. There was a great deal of talk about the terrible accident on the Paris–Versailles line, which claimed so many victims, among them the famous Dumont d'Urville. It was interpreted as a bad omen that that famous navigator had been able to sail distant seas, discover unknown lands and live among cannibals, all without harm, and then had made the blunder of getting into a train, only to be burned to a cinder. Some asserted that the smoke from locomotives harmed certain kinds of crops and even kept potatoes from growing.

Many of the great discoveries which were to transform the world had now been made : iron ore was smelted in blast-furnaces, coal was mined at greater depths, cloth was manufactured by machine. Yet, except in England, the industrial revolution had not entirely changed things. Apart from their dress and tools, peasants in the country around Limoges worked the land in almost the same way as their ancestors in the time of Vercingétorix. The Champs-Elysées was not yet built ; oil lamps were still used for lighting ; people still depended on water-carriers for water ; the poor went to the public fountain. The telegraph was still in the experimental stage. Houses were heated by open fires, and the chimneys were cleaned by little ' sweeps ' who climbed directly up the flues, wore old stovepipe hats,

and kept pet marmots. Sugar, which was sold in big blocks, was broken in pieces with a pointed tool and hammer. Fires were put out (sometimes) by men forming a chain and passing along buckets of water. There were no sewage systems, for the simple reason that there were no sewers : the chamber-pot was king. The rich were just beginning, regretfully, to abandon the night-commode. Vegetables were grown in one's own backyard, or else in the neighbouring market-gardens. Wine was served in jugs : for bottles were a luxury —they were blown straight on to the end of long tubes by young boys in the glassworks. Many of these young workers died of consumption and none of their bottles were alike. Butchers slaughtered their animals in the rear of the shop, or else in the court-yard. Housewives who came to buy a nice joint of meat were met by the 'executioner', apron and hands smeared with blood. It was impossible to ignore the fact that the pleasure and strength derived from meat-eating had to be paid for by suffering and death. Anaesthesia was unknown ; and so were microbes and anti-biotics. Women gave birth to children in pain, in accordance with the decree of the Creator. Poor women nursed their babies at the breast ; the rich hired a wet-nurse whose hair was tied up with little bows of different-coloured ribbons. It often happened that the wet-nurse would favour her own offspring at the expense of the rich woman's child, thus causing it to develop a pale complexion, which was thought to be very distinguished. Society women were tubercular, and coughed up blood : a healthy colour and a well-developed bust were considered to be in bad taste—only peasant women could afford to look so alluring. Sports in general were un-known. The poor played hand-ball and made free with the girls ; the rich went riding. Smokers rolled their own cigarettes. Locks, carriage-springs, tools and banister-railings were forged by hand. Artisans lived over their shops ; they did not yet have to make long trips underground in the Paris Métro, to get to factories. Mills run by machinery did not exist ; flour retained all the vitamins of the wheat ; bread was coarse and nourishing. Workmen worked twelve hours a day, and earned one franc fifty. A dozen eggs cost one sou and there were thirteen to the dozen. One sou was a large sum : it was worth two liards (equal to one English farthing in those days) and for one liard you could buy half a bun. On coming out of church after Mass a 'respectable' woman would hand a liard to her favourite among the poor. If she had given him a sou her

righteousness would have been questioned : she would have been suspected of wanting to appropriate another's property, a beggar being looked upon as an ornament—like a fan, a silk parasol or a pair of gloves.

There were no gramophones. The rich had to go to concerts for their music ; they could also learn to play the piano, if they chose. The poor played the penny flute, and sang patriotic songs by the popular composer Béranger. In summer they danced in little open-air cafés under the trees on the outskirts of Paris. They had to be satisfied with a flesh-and-blood band. The can-can was the favourite dance in the poorer quarters, while the better classes were just taking up the new waltz steps, which were frowned upon by the Church. The average expectation of life in France was thirty-five years. In spite of the massacres of the Napoleonic Wars, France had a larger population than the other countries of Western Europe. Algiers had been taken fifteen years before. The Duc d'Aumale was adored by the Arabs. Alexandre Dumas's play *Napoleon* was a triumph at the Porte Saint-Martin Theatre, which was larger then and could accommodate an audience of four thousand people. The play took three consecutive evenings to perform. Motion pictures had not yet been invented, nor radio nor television. There was no such thing as photography : the self-made man who wanted a portrait of himself had to apply to a painter, and so did a shopkeeper who wanted a picture of his shop to hang in his parlour.

Such was the condition of the world in 1845 when my father arrived in Paris by the diligence from Limoges.

He died in 1919. Four years earlier I had received my pilot's licence in the air force. We had long since become familiar with the ' Big Berthas ', air-raids and gas-attacks. People were leaving the country for the city. The suburbs of Paris had already begun to develop into the unsightly horrors they are today. The working classes were being lured to the factories. The vegetables sold in Paris now came from the south of France, and even from Algeria. Renoir had a motor-car, and he used it as a matter of course to drive from Nice to Paris in two days. He had a telephone in his house. He had been operated on, and had had the benefit of anaesthetics. Childbirth was now painless. French people had acquired a mania for soccer. The little cafés had turned into cheap dance-halls. The Communist Revolution had taken place. Anti-Semitism was spreading. We had a gramophone ; we had also bought a ciné projector

so that my young brother Claude could show films to my father. We had a crystal set. The newspapers were disturbed over the spread of drug-taking among the younger generation. Divorce was popular. There was talk, for the first time, of the right of peoples to self-government. The problem of oil preoccupied the world. Psychology had come into vogue. People were talking about a certain man named Freud. Homosexuality was becoming more common. Women had begun to bob their hair. Housewives were beginning to use tinned foods, and they insisted that tinned peas were ʰetter than fresh ones. Income tax had come to stay. Passports were compulsory, and so was military training. Elderly gentlemen gave lectures on the problem of youth. People smoked manufactured cigarettes. Boys and girls in their teens had begun to attack pedestrians late at night. The roads were now tarred. Our house was equipped with central heating, hot and cold running water, gas, electricity, and a bathroom.

It was a far cry from the days when the young Renoir munched the sweets tossed down by Queen Amélie in the courtyard of the Louvre to the days when his son sat at the wheel of a car, speeding along the roads of southern France. By the time my father died the industrial revolution was an established fact. Man had begun to believe that he could carry out this first serious attempt to escape from God's Curse. The children of Adam were going to force the gates of the Garden of Eden, and science would enable them to earn their bread without toiling by the sweat of their brows.

At times my father and I would try to guess the approximate moment, symbolically speaking, when civilization had evolved from the work of the hand to that of the brain. Renoir admitted that progress had come about through evolution, from the first flint implement to the discovery of Hertzian waves, but he insisted that the bewildering increase in the speed of progress during our lifetime had begun with the invention of the tube. Water, gas, all sorts of liquids, were now brought to us by means of pipes. Pipes have made it possible to construct stills, to distil wine and barley. Before the arrival of the tube we could only get drunk on naturally-fermented wine. Piping has brought us the locomotive and the bathroom. It has contributed to the building of Montmartre. When Renoir was a young man the pipe was just beginning its conquest of the world. Industry was not yet turning out tubing by the yard, like macaroni. Montmartre was only a village, and very delightful it was, hidden

away amidst a thick growth of wild roses. Montmartre could not be anything but a village, because it had only five wells, and that limited the number of water-drinkers. But by means of 'the tube', water was piped up to the top of the hill, with the result that Montmartre is now covered with huge grey Lousesˌ prisons for satisfied ants.

Having been born into the world too late to greet the advent of running water, gas-light and 'Three Star Brandy', I attributed the sweeping changes to the War of 1914, and in support of my argument I told my father of an incident connected with the wound which had restored me to him. He was much struck by the anecdote. I had just been wounded and I was being nursed in a field hospital in the combat zone. I had heard how life had changed at home, but in the big ward, which was for the moment my universe, I could see nothing of the world outside : nor did the fifty other wounded men know more about it than I. One day I was informed that my sister-in-law had come to see me. I knew that it must be for some very urgent reason, otherwise the authorities would not have permitted a civilian to enter the war zone. The fact that she was Véra Sergine, one of the great theatre stars of the time, caused considerable excitement. The commandant of the hospital was very much impressed, and he received her in his office while the orderlies and less seriously injured hastened to tidy our ward. It was the month of June and a kindly nun went to the trouble of bringing a little bouquet of wild flowers to brighten up the place, warning us, however, that afterwards she would take it to the chapel, where it properly belonged.

Véra Sergine finally made her entrance. Her hair was cut short and she wore a dress that stopped at the knees. Her attire seemed all the more strange to us as she was in mourning. She had come to break the news to me of my mother's death. I was so shocked by this new creature that it took me several seconds to grasp her terrible message. The girls my fellow-soldiers and I had left behind had had long hair. Our idea of feminine charm was associated with hair worn like that : and here we were, suddenly confronted with the new Eve. In the space of a few months she had cast off the outward signs of servitude. Our slave, our other half, had become our equal, our comrade. A new style, a few snips of the scissors, and above all the discovery that she could tackle work which had so far been the province of the lord and master, had destroyed for good the social structure maintained by males for thousands of years.

After Véra Sergine had gone, the remarks flew thick and fast.

' That kind of outfit suits her because she's an actress . . . you have to get used to it. . . . That's all right for Paris, but I'm sure that at home in Castelnaudary neither my mother nor my sister . . . '

The man in the next bed, a farmer from the Vendée, declared thoughtfully, ' If I find my wife rigged out like that when I get home, I'll give her a kick in the —— ! '

Incidentally, I used this episode in my film *La Grande Illusion*.

My father remembered perfectly the apartment in which he lived as a child—' a pocket handkerchief' he called it. He much preferred to be out in the street. ' In the streets of Paris I felt at home. There were no motor-cars then and you could stroll around as you pleased. . . .'

The birth of his younger brother, Edmond, and all that that entailed in the way of washing clothes and receiving visitors, left even less room for his other brothers, his sister and himself. Luckily Henri, the eldest, was taken on as an apprentice by a silversmith, a friend of his parents. After a few weeks, he became so adept that his salary was raised enough to enable him to rent a furnished room. My father was then given Henri's bed in the little room he had shared with his elder brother, Victor. Previously Renoir had been obliged to put up with a tailor's ' bench ', which his father had installed in the ' parlour ' where he received his customers. At that period all tailors sat cross-legged in the Oriental manner on a little wooden platform about a yard and a half long by two and a half feet wide, with legs fifteen inches high. Renoir could still recall how his father looked, his legs crossed Yogi-fashion and surrounded by rolls of cloth samples, scissors and little red velvet cushions, which he kept fastened on his forearm so that he could stick his needles and pins into them. He got up only to receive a customer, and for meals or some other need of nature. But his Buddha-like posture seemed so natural to his children that when he came to the family table they were almost surprised to see him walk like an ordinary human being. After work Léonard Renoir would carefully put away everything he had been using on ' the bench '. Then my father would bring in the mattress and bedclothes, which had been stored away on top of the wardrobe during the day, and make his bed. The mattress was not very thick and the wooden bench felt hard under

it, but he did not care : spring mattresses were luxuries reserved for
the great of this world. What bothered him were the pins scattered
on the floor, which stuck into his feet when he forgot to put on his
slippers in the morning. My grandfather Léonard, a grave and silent
man, considered that the only important thing in life was to give his
children an education and to bring them up in a manner worthy of
their legendary forebears. He worked all day long, but as he was a
simple man and his prices were reasonable, he made only a modest
income. Yet if Renoir's childhood impressions are correct, his father
was happy in his work.

The dining-room was tiny. The round table, with its extended
leaves, almost touched the walls, and once the family sat down for
supper no one was able to budge from his place. My grandmother,
Marguerite Merlet, took the chair nearest the kitchen. My father
hated the kitchen, especially when the season for fresh peas came
round. In spring, the peas were brought in from the country by the
cart-load and sold for next to nothing. As the two eldest children
were apprenticed and his sister Lisa was at school, it was Renoir who
had to shell the peas. Seventy years later he could still feel in his
fingers the boredom of opening all those pods.

His parents' room looked out on to the Rue d'Argenteuil. My
father recalled how, in contrast to all the neighbouring bedrooms, his
parents' room had no heavy curtains. My grandmother liked plenty
of light and air.

Their apartment was, I think, on the first floor. The stairs were
of stone and the banisters of wrought-iron. The front door of the
house was somewhat narrow, and had a spiral column on either
side. Over the lintel there was a niche for the statue of a saint,
doubtless destroyed during the Revolution. The other tenants paid
little attention to such bygone splendours, but Renoir was glad that
he had grown up amid these reminders of past elegance. For him
elegance, even luxury, did not consist in horses and carriages,
sumptuous banquets, or mistresses decked out in jewels. It was
essentially a matter of having an opportunity to look at objects of
intrinsic value. An object had value for him only if it expressed the
personality of its creator. It could be a sculpture, a picture, a plate
or a chair. It could be the humblest kitchen-utensil or King Charle-
magne's crown. What was vital was to be able to recognize in the
stone, wood or fabric the human being who had conceived and
executed the work. Renoir even went so far as to assert that the

defects of an object interested him as much as its virtues, and pettiness as much as grandeur of conception.

Later, when his business improved, my grandfather rented a shop in the Rue de la Bibliothèque, just a step from the Rue d'Argenteuil : and my grandmother was at last able to have her parlour back.

# 4

Before going on with my account of Renoir the Paris gamin, I should like to give you some idea of Renoir as I knew him towards the end of his life.

In the garden of my house in California there is an orange tree near the kitchen door. I gaze at it and I breathe in its perfume. It is covered with blossoms. I never see an orange tree in flower without thinking of Cagnes. And thinking of Cagnes immediately conjures up the figure of my father. For it was there that he spent the best of his last years, it was there that he died. At his home, ' Les Collettes ', the scent of orange blossoms is still the same and the olive trees have not changed. The grass in particular makes me feel close to him. Though thin, it is tall and wiry, grey, except in winter, composed of the most varied species and sprinkled with the prettiest wild flowers imaginable. Its perfume does not assault your nostrils violently as it does in the wild, stony stretches of land around Aix-en-Provence. It has a subtler unforgettable quality. If I were to be taken blindfold to Les Collettes, I am sure I should recognize it at once just from the scent.

The shadow cast by the olive trees is often mauve. It is in constant motion, luminous, full of gaiety and life. If you let yourself go, you get the feeling that Renoir is still there and that you are suddenly going to hear him humming as he studies his canvas. He is part of the landscape. It does not need much imagination to see him sitting there at his easel with his white linen hat half askew on top of his head. His emaciated face wears an expression of affectionate mockery. Except in the last few weeks, the sight of his pitifully thin and paralysed body did not worry us unduly; Gabrielle and my brother and I were not upset by it, nor was anyone close to him. We were accustomed to it, and so was he. Now, with the passage of time, I see him better. Easy comparisons come to mind. In Algiers,

Europeans will call an old Arab 'trunk of a fig tree'. In France literary men who like to affect the speech of the peasants refer to an old villager as a 'vine-stalk'. These expressions are based on entirely physical analogies. With Renoir, however, they might be carried further, to evoke the abundant and magnificent fruit which the fig tree and the vine produce from stony soil.

My father had something of an old Arab about him, and a great deal of the French countryman—apart from the fact that his skin had remained as fair as that of an adolescent because it was constantly protected from the rays of the sun; for he had to keep his canvas away from the reflections of light, which he declared 'play the devil' with one's work.

What struck strangers most at first meeting were his eyes and his hands. His eyes were light brown, bordering on amber, and they were sharp and penetrating. He would often point out a bird of prey on the horizon, flying over the valley, or a lady-bird climbing up a single blade in a tuft of grass. We with our young eyes had to look carefully, concentrate and examine everything closely, whereas he took in immediately everything that interested him, whether near or far. So much for the physical aspect of his eyes. As for their expression, they had a look of tenderness mixed with irony, of merriment and sensuousness. They always seemed to be laughing, perceiving the odd side of things. But it was a gentle and loving laughter. Perhaps it also served as a mask. For Renoir was extremely shy about his feelings and never liked to give any sign of the emotion that overpowered him when he looked at flowers, women or clouds, as other men touch a thing or caress it.

His hands were terribly deformed. His rheumatism had made the joints stiff, and caused the thumbs to turn inwards towards the palms and his fingers to bend towards the wrists. Visitors who were unprepared for this could not take their eyes off his deformity. Though they did not dare mention it, their reaction would be expressed by some such phrase as, 'It isn't possible! With hands like that, how can he possibly paint those pictures? There's some mystery somewhere.' The 'mystery' was Renoir himself: a fascinating mystery which I shall not try to explain, but only comment upon, in this memoir. I could write ten, a hundred books on the subject of the Renoir mystery and I should be no nearer to solving it.

Since I have begun on Renoir's physical characteristics, I may as well give a few more details. Before he became paralysed his height

was about five feet ten, but if he had been able to stand upright he might not have been as tall, for his spinal column had shortened slightly. His hair, which had once been light brown, had turned white, but was still quite thick at the back of his head. On top, however, he was completely bald, a feature which was not visible since he always wore a cap, even indoors. His nose was aquiline and gave him an air of authority. He had a beautiful white beard, and one of us always kept it trimmed to a point for him. Curiously enough, it curved slightly to the left, owing to the fact that he liked to sleep with the bedclothes tucked well up under his chin.

As a rule he dressed in a jacket with a buttoned-up collar and long, baggy trousers, both of striped grey cloth. His Lavallière cravat, royal blue with white polka-dots, was carefully knotted round the collar of his flannel shirt. My mother used to buy his cravats in an English shop, because French manufacturers had gradually let their blue turn to a slate colour : ' a sad colour ; and nobody has noticed it because people haven't got eyes. The shop-assistant tells them it is blue, and they believe it.' In the evening, except in summer, a little cape was put round his shoulders. He wore high grey-checked felt carpet-slippers, or else plain dark brown ones with metal clasps. Out of doors he was shielded from the sun by a white linen hat. In the house he preferred a cloth cap with ear-flaps of a type advertised by ' novelty stores ' at the beginning of the century as ' chauffeurs' caps '. He did not look much like a man of our times, but made us think of some monk of the Italian Renaissance.

Cézanne once happened to complain to my father about a well-to-do man in Aix-en-Provence. It seems that the fellow was not only guilty of adorning his parlour with a picture by Besnard[1]— ' that *pompier* who's always on fire '[1]—but he had the nerve to stand next to Cézanne at Vespers and sing off-key.

Very much amused, Renoir reminded his friend that all Christians are brothers, and added : ' Your "brother" has a right to like Besnard, and to sing off-key at Vespers too, if he chooses.'

' No,' retorted Cézanne, and continued, half seriously and half joking, ' Up in heaven they know very well I am Cézanne.' It was not that he thought himself superior to the man in Aix, he simply

[1] 1849-1934. French painter. Studied with Cabanel in Italy, and won the Prix de Rome.

[2] A play on '*pompier*', which means not only ' fireman ' but anything banal or academic in art. (Trans.)

knew that he was different—'as a hare is different from a rabbit!'
Then he said, contritely: 'I don't even know how to work out my
problem of volumes as I should. . . . I'm nothing at all. . . .'

This mixture of grandiose pride and no less grandiose humility
was perfectly understandable in Cézanne. He had never been asked
to exhibit in the Salon à la 'Monsieur Bouguereau'.[1] Although
Renoir had been criticized and vilified and often insulted in his day,
he had, towards the end of his life, succeeded in establishing a wide
reputation. The art-dealers were all competing furiously for his
work, the great museums everywhere had opened their doors to him,
the younger generation in every country had begun to make pilgrim-
ages to Cagnes in the hope of being allowed to see the master for a
few moments. He accepted all these tributes with a grain of salt.
Whenever people would start singing his praises, Renoir would
quickly bring them down to earth: 'Who? Me? A genius?
What rot! I don't take drugs, I've never had syphilis, and I'm not
a pederast. Well then . . . ?'

[1] 1825-1905. French painter. Prix de Rome. Member of the French
Institute. His most ambitious work is his large 'Apollo and the Muses'
in the foyer of the Opéra at Bordeaux. Highly popular in his day, he
has been stigmatized as trivial and academic by many modern critics.

# 5

In telling me about his youth Renoir would skip from one subject to another, going from an enthusiastic description of the architectural beauties of the quarter where he lived to an equally glowing eulogy of the game of marbles. In all instances what he admired was economy of means. A game which could be played with a few balls of coloured glass was in his opinion superior to fox-hunting, 'which requires horses, carriages, society-people, ridiculous clothes, and even a poor fox. All that trouble, and no more enjoyment than from a game of marbles.' More important, I think that for Renoir a game of marbles was a means of 'communicating'—that is, of joining with the other youngsters in the Louvre quarter: in other words, of satisfying one's insatiable need for the companionship of one's fellow beings. There is no doubt that in Renoir's eyes to be a mere observer of humanity was both pretentious and sterile. He believed that the unconscious desire of the artist to drink at the very springs of life should be entirely unconscious. For him the problem was not so much in understanding men as in mingling with them: in being a part of the crowd, as a tree is part of the forest. Every creative genius has a message to give the world. Yet the minute he is aware that he is uttering it, by a strange contradiction the message sounds hollow and loses its value. Prophets and saints have discovered eternal truths because they were convinced that such truths were not of their creating and that they were merely instruments for transmitting God's Word. To put it another way, Heaven grants its revelations only to the humble. Renoir went so far as to eliminate the word 'artist' from his vocabulary. He thought of himself as a 'workman-painter'. For the sake of convenience I shall in writing this narrative make use of the hated term 'artist'. I ask my father's pardon for so doing, but the word is now in such current use it is impossible to avoid it—in fact, he himself finally gave in to it. We

shall see later that he mistrusted imagination. ' We have to have a devilish amount of vanity to believe that what comes out of our brain is more valuable than what we see around us. Imagination doesn't take us very far, whereas the world is so immense. Even if we walked all our lives, we shouldn't see the end of it.'

I must confess that Renoir's stories, and the scenes they conjured up, were undoubtedly influenced by our mutual passion for the novels of Alexandre Dumas. From the moment I learned to read he insisted on my sharing his enthusiasm for them. One of his friends had pointed out to him that such books were not suitable for children, filled as they were with love-affairs, adulteries, abductions and so on. But it was Renoir's feeling that such distortions of morality were simply a proof of the admirable moral health of Dumas *père*. ' Whatever is healthy cannot make one ill.' In any event, it was impossible for me to hear him reminisce about the courtyard of the Louvre without visualizing d'Artagnan and the Musketeers, not to mention our favourites, the characters out of *La Dame de Monsoreau* and *Les Quarante-cinq*. From that it was only a step to suppose that the house the Renoirs inhabited had been built for one of the Gascon noblemen in the King's Guard. Chicot and Bussy d'Amboise had trodden with their own feet the black-and-white flagstones in the entrance-hall. In the kitchen where Renoir had shelled peas as a boy, men-servants had sharpened the swords with which the Duc de Guise was to be stabbed to death. In that very window where Queen Amélie used to sit with her knitting, Henri III would often stand, looking pale and thin, rouged and powdered like a woman, listlessly swinging a ball on a string with his right hand. Just behind him Chicot was playing with a little dog. Down in the courtyard the forty-five guardsmen, parading on horseback, felt their throats tighten. This pale ghost, heir of all the tragedies which were bringing the royal line to its close, was the King : the King of the land of France. A mysterious grandeur seemed to emanate from that degenerate man. The Gascons acclaimed him with a great burst of enthusiasm. Shouts of ' Long live the King ! ' echoed from the vaulted ceilings of the palace down the great entrance-hall where, two centuries later, the Swiss Guards were to be massacred in defence of another king. While they were falling under the blows of the mob, Louis XVI fled through the Tuileries Gardens, taking with him the last vestiges of the Divine Right of Kings on which the old Europe had built its foundations.

A dead leaf fluttered down from a tree and fell at the King's feet. He stopped for a moment to contemplate it, and with him halted the Queen, the royal children, and all their household. My father played marbles perhaps under this very tree, which was certainly still in existence when he first arrived in Paris. It was in this setting, so laden with history and legend, that Renoir grew up. But in my grandparents' house everyone had his feet firmly on the ground.

The first rule in their home was that the head of the family was not to be disturbed. The noise of the children made him nervous. If his attention was distracted from his work, it could result in a slip of the scissors and the ruin of a piece of Alençon cloth. You can imagine the drama that would cause. Then there were the customers to be considered. When people go to their tailor they like to find themselves in a dignified and calm atmosphere. In those days making clothes was a serious matter. A man's suit might cost as much as a hundred francs. As the normal salary of a working-man at that time was twenty francs a month, one realizes how expensive clothing was. Later on, when department stores made their appearance and offered ready-made clothes, one could get a complete outfit for twenty francs. Luckily for my grandfather, suits costing only a louis were not yet available. However, if clothes were dear, they lasted a lifetime ; they could even be remodelled and used for several generations.

Being accustomed to control his work, yardstick and chalk in hand, my grandfather had acquired a solemn manner which he never discarded even in private life. As an apprentice he had travelled all over France. Under the Restoration this custom was still common in all trades, but it was to be carried on for an even longer time among carpenters, cabinet-makers and coopers. The future journey-man apprentice set out on foot, dressed in the costume of his trade, with a knapsack containing a supply of fresh linen slung over his shoulder. The first thing he did on leaving Paris was to cut a hazel-stick, which he used for beating time as he went along, and which gave him a jaunty air. Whenever he halted for a drink at a public well, he would carve decorations on his stick with the point of his knife. On stopping for the night at the end of a day's march, preferably in a town, he would inquire if there was a 'mother' in the place, that is, the wife of a workman in the trade who had retired with small savings and the esteem of his fellows. The older man would find work for the young apprentice, while the 'mother',

for a modest sum, would furnish him with bed, board and a home atmosphere.

Until the end of the nineteenth century France was a country of incredible diversity. Though the railways had already come into existence they had not yet brought about the general hotch-potch which buses, wireless, films and television have contributed to our present civilization. At that time customs, opinions, accents and sometimes even speech varied from one village to another. Grandfather had a great deal to say about it all.

In the evening a few neighbours would gather after supper in my grandfather's workroom, which now reverted to its original function of parlour. One of the most frequent visitors had been the chief assistant of the celebrated executioner, Sanson, at the time of the Terror. The first time my father told me about this person I could hardly believe it. The difference in time made the thing seem improbable. Yet it was perfectly possible. Suppose that Sanson's assistant was thirty years old in 1793 ; then in 1845 he would have been eighty-two. As Renoir said, there are certain professions which tend to preserve people. The fact that my father actually met this survivor of another epoch still sets me musing. It makes one realize more than ever how inexorable is the march of time. This man had known France before the Revolution. He had belonged to the world of wigs and knee-breeches. The aristocrats he had executed still wore their swords at their sides. He had been well acquainted with sealed warrants of imprisonment, absolute monarchy, and beautiful ladies with their hair done *à la frégate*, like a ship in full sail. He may have passed Voltaire and Benjamin Franklin in the street, heard Mozart play the harpsichord, and attended performances of the plays of Monsieur de Beaumarchais. He had danced the gavotte, the minuet and the rigadoon. He had seen the astonished head of his King roll into the sawdust-filled basket ; he had seen Marie Antoinette, who looks so moving in the picture David drew of her a few minutes before her execution. During those talks my father and I had in our dining-room in the Boulevard Rochechouart, he tried to give me a picture of this man who had witnessed so many tragic upheavals, quietly sipping his cup of coffee. He was a tall old man with long, fairly thick white hair. He must have regretted the passing of powdered hair and periwigs. He was clean-shaven and he was as careful about his language as he was about his person. He got along very well with Léonard Renoir. After all, they were two

good workmen : one cut out cloth, the other cut off heads just as conscientiously. You did your job, and that was that. In order to cut a suit of clothes well you had to have sharp scissors. The same was true of the guillotine knife. Curiously enough, Sanson's assistant disapproved of Dr Guillotin's invention. It had ruined the profession by making it too easy. Facility always opens the doors to amateurs. In olden times, in order to cut off a head with the axe, one needed some training in the profession, not to mention a few natural gifts such as a sharp eye and a steady hand. But what merit is there in manipulating a machine which does the whole job for you ? So far as his own métier was concerned, my grandfather feared that the production of clothes wholesale might soon become the rule in France. The offensive had already begun in England. The opinions the two men expressed were certainly full of good sense. All sentimental considerations were excluded. Only bad workmen go in for sentiment : bad tailors, bad writers, bad painters, and—bad executioners. My father agreed with this view also.

At the time of these conversations with Renoir I was planning to put in an application for transfer to the air force. Because of my wound I could not serve in the infantry, cavalry or artillery. I ran the risk of being sent to some depot and made to do clerical work. Already at this period the very thought of boring routine work filled me with horror, a repugnance which has since led me to do many foolish things. My father did not approve of my idea of going into the air force. It was his belief that you should never tempt fate : ' One is merely a " cork ",' he said. ' You must let yourself go along in life like a cork in the current of a stream.'

But let us return to the past again.

In Renoir's mind, the most trifling recollections were as important as the revelation of his deepest feelings. This led to a certain disorder in his reminiscences, which I shall try to respect here. He even remembered the way my grandmother prepared her excellent coffee. She used a mill that ground the coffee very fine. Next she would boil the water in a little saucepan, pour the coffee in and then take it off the fire almost immediately. When serving it she would use a strainer. This method required a good deal of coffee, since the finished product was simply a sort of infusion. But all the bitterness and excess caffeine remained in the grounds. Renoir became very serious when he gave this recipe. He had no patience with those methods which attempted to extract more out of anything than it

could yield. To his way of thinking, the beauty of an athlete was at its best when the young man was lifting only a light weight. He did not like a *tour de force*. He maintained that harmony was in general the product of facility. His theories were for other people, of course: he did not realize how much effort he himself put into his incessant work.

The concept of having a 'purpose in life', of success or failure, of reward or punishment, was entirely foreign to Renoir. I am speaking, obviously, of 'material' purpose. His total acceptance of the human condition led him to consider life as a whole, the world as a single entity. '. . . It was all very well for that fool Galileo to assert that the earth is round and only one planet among countless others. Everyone accepts this but no one acts as though it were true. The old fellow living in retirement at Vésinet believes that his garden is a unique kingdom and that his roses bear no relation to those of his neighbour. Everyone believes that he has a destiny apart, that he is a bird alone in his own little world. As it happens, theories and discoveries change the world only by means of disasters. A man believes in the explosive power of gunpowder only when a bomb bursts near him. . . . Thinking that the world was flat did not keep the Egyptians from carving the statue of the " Seated Scribe "; or the Greeks the " Venus of Arles ", that buxom girl . . . you feel like patting her backside. The first awareness of Cleopatra's firm breasts can turn everything upside down just as surely as the knowledge that the earth is round.' For Renoir, there were no petty or great events, no minor or major artists, no small or great discoveries. There were animals, men, stones, and trees, which fulfilled their functions—and creatures that didn't. The chief function of a human being is to live : his first duty is to have a respect for life. These reflections were not intended to represent a philosophy : rather, they formed a part of the practical advice given by a father to his son. He used personal examples by way of illustration : ' I had to shell green peas and I loathed it. But I knew that it was part of my life. If I hadn't shelled the peas, my father would have had to, and he would not have been able to deliver on time the suit he was making for his customer and the earth would have stopped turning, much to the shame of Galileo. . . .'

Renoir's conception of life as a state of being rather than an undertaking seems to me an essential explanation of his character and, by extension, of his art. I should add that this attitude was a

joyous one, and that each stage of life was for him marked by amazing discoveries. He looked at the world with continual astonishment, a feeling of surprise which he made no effort to hide. I saw my father suffer absolute martyrdom, but I never saw him bored.

The reader may conclude that my father had taken a definite stand against science : but in fact it was more the stupid uses that science was put to that Renoir would rail against. His chief charge against 'progress' was that it had substituted assembly-line production for individual creation. I repeat: an object, even one intended for temporary use, was interesting to him only if it was the authentic expression of the workman who had made it. The moment the workman became part of a group, of which each member was a specialist in one stage of the making, the object in question in Renoir's eyes became 'anonymous'.

'It isn't natural,' he declared. 'A child can't have several fathers. Can't you just see a boy with ears inherited from one father, feet from another sperm, his mind coming from an intellectual and his muscles from a wrestler ? Even if each part were perfect he would not be a man but a limited company : you might say, a monster.'

He felt that science had failed in its mission by not fighting for the expression of the individual : instead, it had put itself at the service of mercenary interests and favoured mass production. The idea of turning out a perfectly finished product, which is the ideal of modern industry, never occurred to him. He was fond of quoting Pascal's phrase, 'There is only one thing that interests man, and that is man.'

One pleasant characteristic of my grandparents' home was that there were no knick-knacks in it. My grandmother detested all those little accessories and mementoes for which women generally have such a passion. Her clothes were plain and her furniture was uncluttered. A ribbon in her bodice she considered superfluous. She liked objects to have a function, and that function should not be disguised. The whole family laughed after a visit to a lady in whose house there was a pair of bellows decorated with a bow of pink ribbon.

Even in her younger years at Saintes, Marguerite Merlet had never used powder or face-cream, nor rouged her lips. She put her faith in kitchen-soap. A good stiff brush and plenty of suds washed the dirt off the hides of the Renoir family just as thoroughly as it did

off their floors. They had no bathroom, of course. They had to wash themselves with a sponge in a sort of wide tin basin. The dirty water was emptied into an aperture for that purpose out on the landing. This drainage system, which in those days represented the last word in hygiene, was called ' the leads ', doubtless because all the pipes, which were visible along the side of the staircase, were made of lead. The lavatories formed part of these same ' leads '. Tooth-brushes were still a luxury. The family washed out their mouths, night and morning, with salt water and cleaned their teeth with little wooden tooth-picks, which were then thrown away. When anyone really needed a bath, a tub had to be sent for. It was quite an undertaking. Two men had to carry up a copper bath-tub which they put in the middle of one of the rooms. A quarter of an hour later they reappeared with four large buckets of hot water, which they poured into the tub. Once the lucky candidate had bathed and the others had dipped their toes into the warm water, the two porters returned and emptied the tub in front of the neighbours, who disapproved of such ostentation.

Whenever one of the children fell ill, the entire household came to a standstill. My grandfather would then never hesitate to put aside the orders he was working on, and the normal course of life was not resumed until the crisis was over. But before such an emergency was declared my grandmother had to be convinced that the illness was serious.

I should like to say further, that my grandparents never incurred debts, and they purposely avoided mixing with people better off than themselves for fear of getting involved in expenses which they could not afford. They were moderately religious. My grandfather did not go to Mass but he insisted on his children doing so. His wife always fulfilled her Easter duties but she distrusted priests, who in her opinion were all schemers. Each Sunday she took her little family to a different church, preferably to High Mass because of the music. Sometimes she chose Saint-Roch. It was in front of this church that, sixty years before, Napoleon had cannonaded the Royalists, and so saved the Republic—only to devour it later. The Renoirs went also to the church of Saint-Germain l'Auxerrois. My grandmother certainly did not fail to point out to her children the window in the Louvre from which Charles IX, on Saint Bartholomew's Day, shot down with his harquebus a band of Protestants who were trying to take refuge in the house of God.

# Renoir, My Father

In the spring, when the trees along the quays began to come out, the little family group would venture as far as Notre Dame. The walk along the Seine was always delightful. Young Renoir breathed in Paris with all his soul : through all his pores : he was filled with it. The air was laden with the various smells of the city and its markets : the strong smell of leeks mingled with the faint but persistent scent of lilacs, all carried along by that pungent breeze which is truly the air of Paris. It is not the steaming atmosphere of Normandy when the sun beats down on the rich grass and the flies whirl madly : nor is it akin to the intoxicating smell of the sun-scorched earth in the Midi when it is swept by a blast of Mistral wind. Nor is it like the strong gales from the east of France, sharp as a razor and causing mental disorders and outbursts of collective madness. Before the carbon monoxide of motor-cars began to pollute it, the air of Paris was like everything that characterizes that city in its moderation and balance.

Anyone knowing the work of Renoir can easily recognize in his pictures the kind of gentle skies he must have looked at as a child. There is nothing harsh in the landscape of the Ile de France. Today men try to destroy its harmony by the lack of subtlety in their colours, which better suit the northern countries. The cold light of the north can absorb violent greens and dazzling yellows : but not Paris. Happily, its climate protects its beauty. Garish posters fade quickly from the effects of its misty autumn mornings ; unsightly walls crumble away under the action of the fine, persistent rain. The city which produced François Villon, Molière, Couperin and Renoir continues to produce artists from all over the world.

Léonard Renoir's children were completely ignorant of the use of the term ' Sunday best '. My grandmother saw to it that they were presentable no matter what the occasion. When he was helping in the kitchen or out playing in the street, my father was made to put on an old pair of trousers, but when not engaged in those two dangerous occupations he always wore the same clothes. Coming out of Mass on Sunday my grandmother would look pityingly at the chattering women bursting out of their corsets, trailing along youngsters bundled into their best clothes and limping painfully in tight shoes.

The time arrived for my father to go to school. They bought him the regulation black pinafore worn by school-children and a leather bag which he slung over his shoulders like a soldier's knapsack. The

school, located in an outbuilding of an old convent, was within a short distance of the house. It was run by the Christian Brothers. A decree of Robespierre's, published in 1793 during the Terror, had instituted a system of free schools, and all French children were expected to learn to read, write and count as well as acquire some elementary knowledge of vocal music. A child was not obliged to attend these schools if his parents could prove that he was being given an equivalent education privately or in some other way. The decree was still in force. The kings who came after the Revolution kept up this system, which they had inherited from their enemy. But in competition with the free schools, they had favoured and subsidized schools run by the clergy. At the Brothers' institution my father encountered some of the boys from his own neighbourhood. He set himself to learn to read, write and count, with the same seriousness he put into everything he did. Classes were held in very dark, vaulted rooms. My father recalled being punished several times just because, owing to the poor light, he had been unable to make out the words in his book. As punishment he was made to stand in the corner—a procedure still followed, I believe, in certain schools. Idle or foolish pupils were made to wear a dunce's cap cut out of paper in the form of a donkey's head, with two long ears, and they had to kneel down face to the wall. The schoolmaster always had his long wooden ruler ready, and he used it for a number of things. It served to point out the letters of the alphabet printed on a large placard hung on the wall, or to tap sharply on the desk to call for silence : and when a young pupil misbehaved and was caught in the act, he was made to hold the tips of his fingers out to the master, who rapped them mercilessly with the ruler. The very recollection of this practice filled Renoir with anger. Not that he was against corporal punishment, for he considered it was less painful and less degrading than being reasoned with : the teacher who succeeds in convincing a pupil that it is wrong not to study his lessons has a false conception of democracy, for he backs up his arguments with the authority given him by his official position—his victory can only mean a surrender on the part of the child. If Renoir disapproved of hitting children on their fingertips, it was only because such chastisement was likely to damage the nails. He had great belief in the importance of the five senses. The principle seat of the sense of touch is at the extremity of the fingers, and one of the functions of the nails is to protect this delicate nerve-centre. When I was a little boy I

liked to cut my nails very short, because I was less likely to hurt myself when climbing trees. My father told me I should not do it : 'You must protect the ends of your fingers : if you expose them, you may ruin your sense of touch, and deprive yourself of a great deal of pleasure in life.'

In winter it was deathly cold in the classroom despite the wood-burning stove roaring away there. The 'smarter' boys rushed for the seats nearest the fire and then they were too hot. My father would never outsmart anyone. For him, to be ' smart ' was the worst of misfortunes.

Several biographers have written that Renoir was continually drawing pictures in the margin of his exercise books. The statement seems plausible, yet Renoir never said anything about it to me. Apparently his greatest discovery as a child was singing. There was a great deal of singing in French schools at that period—a national custom which has unfortunately now disappeared. French people in the nineteenth century were still very fond of songs, and of course the vogue for Béranger is well known. Memories of the Napoleonic saga were revived by the return of the Emperor's remains to France and the event was celebrated in moving couplets.

Every once in a while during the season young Renoir, who was by now about ten years old, would go out with one of the neighbours on a hunting expedition. One Sunday he got up at midnight and, shoes in hand, crept out of the house on tiptoe for fear of waking the family. He was allowed to carry the game-bag and to stand by and watch. The neighbour's favourite hunting-ground was a wheat-field which lay between the Rue de Penthièvre and the 'village' of the Batignolles. The field is now the Gare Saint-Lazare and the quarter called 'Europe', but in those days the terrain was teeming with game, especially hares. When the hunt had been good the friendly neighbour would hand his young acolyte a choice bit or two, which was always a welcome addition to the family's customary fare.

After recounting these details of the chase, Renoir would invariably turn to the subject of the city planner, Baron Haussmann, who had transformed Paris in such an unfortunate way. It was not because of lack of space, however. For there was nothing to prevent him from extending the city out over the monotonous stretch of fields in the suburbs and leaving the trees and gardens within the city as they were. My father thought all other considerations had been

sacrificed to the desire for gain in order to make the price of land go up. He detested the world of manufacturers, bankers and speculators who had got control since the Second Empire.

'What they have done to my poor Paris! And worse, too, the houses they put up for their own use are ugly. Still, they are comfortable. There's no air in them but people don't mind that, because they have places in the country. But when it comes to the suburbs, how dare they house their workers in such places! It's a downright shame! And think of all those children who will become tubercular through breathing in smoke from the factories. A fine new generation that will produce!'

Next he would attack Garnier, who had built the Opera House. 'To think that the Germans missed it with their Big Berthas!' he exclaimed.

As for Viollet-le-Duc, I should like to give some idea of how my father felt about him.

In 1912 we had just moved into the apartment in the Boulevard Rochechouart where later on my father and I had our talks together. The lease had been signed and our furniture installed when Renoir suddenly became aware that the building, whose entrance was on the Boulevard, was situated at the corner of the Rue Viollet-le-Duc. Despite the advantage of having the apartment on the same level as his studio, my father wanted to move out immediately, as he could not bear seeing that name so near. Of course it was just a whim, nevertheless he meant it at heart. Of all architects Viollet-le-Duc was the one he hated most—and heaven knows he disliked architects! He never forgave him for spoiling the cathedral of Notre Dame in Paris, and the one in Rouen.

'I love theatre settings,' he said, '—but in the theatre.'

He asserted that Viollet-le-Duc had destroyed more French monuments than the German bombardments and all wars and revolutions put together.

# 6

On 22nd February 1848, just as Renoir was starting out on his way to school, he saw a company of Municipal Guards come along the street and take their stand in front of the Tuileries Palace. The men piled arms, broke up into little groups and began to roll themselves cigarettes. A neighbour of ours asked one of the soldiers what was happening.

'There's a revolution on,' the fellow answered facetiously.

Our neighbour repeated the news to my grandmother, who went back to her morning's work, while my father went on to school. At noon he ate his sandwich filled with bacon fat, and at four o'clock he returned home without noticing any change in the situation except that there were more soldiers around the Tuileries. At supper-time Henri and Lisa told how they had seen a group of workers in the Rue de Rivoli, one of them carrying a tricoloured flag. The Tricolour had been the national flag since Louis-Philippe and there was nothing subversive about it. The workers were singing the Girondins' song, which the elder Alexandre Dumas's play had made so popular. The next morning there was a still larger number of soldiers. Queen Amélie had not appeared at her window, but that was not surprising, as it was winter and the weather was cold. However, Renoir got the impression that Henri, Lisa and even his father were nervous, and he noticed that they were using such words as 'people', 'liberty', 'universal suffrage', etc., which had rarely been heard within the family circle. One and all seemed to want to vilify the name of Marshal Bugeaud. The man who had devised the military cap, the hero of the popular song, 'L'as-tu vu la casquette, la casquette?' was detested. My father wondered after-wards how the legend had grown around this character and shown him in such a sympathetic light. In fact by the time of our con-versations Bugeaud had become a sort of jolly Bayard in the mind

of the French people. I must have somewhere in my library a copy of the *Images d'Epinal*[1] which Gabrielle used to read to me when I was four or five to keep me quiet. It depicts Bugeaud in an aura of glory : charging at the head of his troops ; accepting the surrender of the Arab chiefs ; eating soup with his men ; acclaimed by cheering crowds throwing their caps in the air ; borne along in triumph ; and kissed by affable ladies. Renoir attributed the marshal's posthumous celebrity to the revival of the cockade spirit, which followed the French defeat in the War of 1870. In 1848, however, Napoleon's victories were still fresh in everyone's mind, and military glory was suspect.

The 'three glorious days', as the revolution of 1848 was called, began with songs. However, the shooting on the main boulevards, which caused so many casualties, turned what had started as a kind of friendly protest into a bloody affair. The King's soldiers had fired on the people ! The people retaliated by driving out the King, who, luckier than Louis XVI had been, succeeded in escaping to England. One fine morning the Renoirs discovered that their royal neighbours had thrown in their hand and that the palace was empty. They were sorry good Queen Amélie had gone, but they welcomed the arrival of the Republic joyfully. They had really seen nothing of this revolution which was to shake the world, though it had taken place only some fifty yards away from them. Gentlemen dressed in frock-coats replaced the royal family. The Louvre and Tuileries were baptized ' Palaces of the People '. The cost of living went up and my grandfather was obliged to raise the price of the suits he made. The Palace Guard stayed on. The coat-of-arms of the House of Orléans was replaced by the words ' Liberty, Equality, Fraternity '.

The newspapers reported that all Europe had followed the example of Paris. It was said that there had been fighting in the streets of German, Italian and Spanish cities. Word came that the uprising in the German states was being brutally repressed. Thousands of republicans fled, and many emigrated to America, where their knowledge and professional skills contributed greatly to the prosperity of the New World. But the movement had started in

[1] A book with coloured pictures printed from wood-blocks. They were done in Epinal, in the Department of the Vosges, which was a centre for this kind of illustration. A man named Pellerin established the industry there in 1790, and it soon became celebrated throughout France.

Paris, which had once again shown that it was the centre of the world. The Parisians were not a little proud of the fact and the Renoirs shared their pride.

One day their landlord paid them an unexpected visit. He informed them that the house was going to be pulled down, together with all the houses which encumbered the courtyard of the Louvre. The Republic wanted to fulfil an old dream of the French kings and also of Napoleon, namely, to unite the Louvre with the Tuileries. Countless plans had been proposed. The various régimes had always shrunk from the expense involved, not to mention the difficulty of expropriating so many small properties. Four days after the revolution a decree by the provisional government, inspired by General de Cavaignac, issued an order to carry out the work in accordance with a plan drawn up by the architect M. Visconti. The project was truly ambitious. As soon as the terrain was cleared, buildings much larger and more handsome than the old Louvre were to be constructed between the Rue de Rivoli and the Seine in such a way that they would be combined with the Tuileries and so enclose the whole in a quadrangle.

It had been three years since my grandfather had first settled in the quarter, and during that time he had worked up quite a good clientele for himself. He had made new friends and he felt that he could face the future with confidence. The thought of having to move out filled him with dismay. Henri, Lisa and Victor were no less disturbed at the prospect. They felt as if they had been threatened with exile. Renoir, on the other hand, rather hoped he would have a chance to take another trip in a diligence. My grandmother was not at all upset by the news of the catastrophe. She remarked that since the great Revolution of 1789 there had been at least twenty different projects for transforming the Louvre. The new plan would end up on some dusty shelf in some ministry, just as the others had done. Even if the decision went through, the administrative machinery would be slow in getting under way and that would give the Renoirs time to look around.

Marguerite Merlet was right, as usual. The coup d'état of 2nd December 1851 brought about the downfall of the Republic, and the Louvre was temporarily forgotten. The President, Prince Charles-Louis Bonaparte, became Napoleon III. Unfortunately he gave orders to start work on the project in 1854 and my grandparents were forced to move. They had had six years' delay, never-

theless. But if the December 2nd upheaval had angered them, the Emperor's decision to enlarge the Louvre struck them as being nothing less than an act of despotism. From then on, Lisa never referred to Napoleon III except as Badinguet, a house-painter whose name he had borrowed to conceal his identity when he was plotting his return to power and the King's police were searching for him.

The Renoir family established themselves in the Rue des Gravilliers, in the Marais quarter. Gabrielle talked to me several times about the house, with which she was familiar. She had gone there to take a present from my mother to my Aunt Lisa, who had stayed on in the family apartment with her husband, the engraver Leray, when my grandparents retired to Louveciennes to live. It was an old mansion which, like most of the residences in that district, had been fashionable in the days of Louis XIII. It had three floors. The façade was quite simple, and it had tall, small-paned windows. A carved door gave access to a covered entry, leading to an inner courtyard, which was dominated by a huge chestnut tree. Close by were the former stables. In 1854 the courtyard extended as far as a little kitchen-garden, which my Aunt Lisa tended with loving care. The stables were occupied by the horses of a furniture-remover. An arcade in the middle of the covered entry led to a magnificent stairway. Gabrielle remembered this stairway in particular because it had wide, shallow stone steps, so worn that they had become one continuous slope. It also had a balustrade of wrought iron intertwined with sculptured figures—' regular lace ', as Gabrielle described it. My grandparents' apartment was on the second floor. It was large enough to make it practicable for my grandfather to give up his shop in the Rue de la Bibliothèque, which was a little too far from the Rue des Gravilliers for his arthritic legs, and set up his bench in his own home. The handsome staircase went no higher than the first floor, unfortunately—to reach the next floor you had to go up some steep wooden stairs ; but my grandfather said that his customers would be so impressed by the first flight that they would hardly notice the rest. The children had a whole floor to themselves under the roof, with a beautiful view. The Renoirs had learned of the place through a friend who was a button-manufacturer, a godson of the owner, with a workshop on the first floor.

At the time they moved to the Rue des Gravilliers the different members of my grandfather's family were aged as follows : Léonard, 55 ; my grandmother, 44 ; Henri, 24 ; Lisa, 22 ; Victor, 18 ;

Edmond, 7; and Renoir, 13. It was time to apprentice him. The Renoirs earned their living honourably; but it was taken for granted that each should do his part. Henri worked for David, a silversmith, in the Rue des Petits Champs. M. and Mme David had grown fond of him because of his taste and skill, and my uncle was not indifferent to the charms of Mlle Blanche David. The question of marriage arose. Although the Davids were Jews there was no objection on the score of religion. In lower-middle-class Paris circles religious fanaticism had long since disappeared and racial prejudice had not yet shown itself.

Lisa had no regular occupation. She had learned dressmaking from her father, but her chief interest was the defence of oppressed humanity. She would get worked up over the most hopeless causes: she once brought home a foundling and could not rest until she had located its mother, who to her way of thinking was not culpable but simply a victim of a monstrous social system. When she could not find a baby to save, Lisa would pick up a stray dog or cat. Her room was full of animals, all more or less crippled or mangy. She was a great admirer of Saint-Simon,[1] Blanqui[2] and Fourier.[3] She never missed the meetings of the revolutionary group in the Gravilliers quarter. And when her employer behaved unjustly towards some poor defenceless working girl, Lisa did not hesitate to let him know what she thought about it. Her generous nature did not ingratiate her with her employer, but it won her many warm friends. One of her political acquaintances, Charles Leray, became a regular visitor to the house. His father had been a surgeon in Napoleon's armies and after the downfall of the Empire had continued to practise in the Paris hospitals. A statue had been put up to him in the square of his native town somewhere in the Vendée: and Lisa was certainly not indifferent to the distinction such a tribute conferred on his son.

Leray was an engraver by profession: he had done the illustrations for several books, and he worked for fashion magazines. My grandfather was very pleased about it. The young man was given a cordial welcome when he called. He often took Lisa dancing, and this was looked on favourably by all the family. But when he finally

---

[1] 1760-1825. French social philosopher. Fought in the army for American Independence.

[2] 1805-81. French revolutionist and radical thinker.

[3] 1772-1827. French social philosopher.

proposed to her she rebuffed him, saying, ' What ? Get married like any bourgeois ! ' It did not fit in with Fourier's teachings to the effect that ' privately-owned property is theft ', or those of Saint-Simon when he recommended that ' everything should be owned in common . . . there is no reason why a woman should belong to one man only.'

My grandfather let them talk. During the Terror his friend, the executioner's assistant, had seen the Goddess Reason crowned in Notre Dame. Once the cyclone had passed, the goddess in question, doubtless the daughter of some patriotic tradesman, forgot her moment of sacrilegious glory and married a well-to-do shopkeeper. Her children made their First Communion ; and her grandchildren knew how to recite the Catechism.

Marguerite Merlet coldly asked her daughter why she did not join her hero Saint-Simon in America, as he had founded a Fourier community on the banks of the Mississippi. In that earthly paradise, it was said, everything was shared : the harvest, the women and the children. The idler received as much as the worker.

In spite of his revolutionary ideas Charles Leray did not dare to flout the conventions. My father doubted if Lisa had even been his mistress. ' Her imagination runs away with her,' he commented.

One day Leray stopped coming to the house and began to appear in public with a cousin of Mlle David. Lisa announced that she was glad to be rid of him, then went to the Théâtre du Château d'Eau to wait for him to come out with her rival, whom he had taken to see *La Campagne d'Italie*. When he appeared she stepped up to him, and there, in front of several thousand spectators still stirred by the misfortunes of Joséphine de Beauharnais, gave the gentleman a good box on the ears. Leray had won the day. A month later he and Lisa were married by the parish priest.

As Lisa was putting on her white dress before the ceremony she declared : ' I am for Jesus. It is the priests who ruin everything.'

' He's lucky,' Léonard remarked.

' Who's lucky ? '

' Jesus Christ.'

Lisa evidently lacked what today we call a sense of humour.

My father's brother Victor worked for a tailor on one of the main boulevards, and was doing quite well. His stylish manner and smart way of dressing brought him many conquests. Lisa said of him scornfully: ' He runs after the girls. He's a born bourgeois ! '

Henri and Leray insisted that my father should learn engraving or fashion-designing. It was after he had made his First Communion that he began to draw constantly. As paper was scarce, he would draw on the floor with chalk. My grandfather got annoyed when his tailor's chalk disappeared. But he thought the figures his son sketched all over the apartment floor were 'not at all bad'. Marguerite Merlet was inclined to agree with him. She gave Renoir some exercise books and a supply of pencils.

'Auguste will do something some day,' she said. 'He's got the eye for it.'

She never called him by his first name, Pierre, as she thought that, coupled with ' Renoir ', it made too many ' r ' sounds.

Auguste liked drawing portraits especially. He did likenesses of his parents, his brothers and sister, the neighbours, dogs and cats, in short, everyone and everything, as he was to do for the rest of his life. He looked upon the world as a 'reservoir' of subjects created just for him.

Not one of the volunteer models who posed for him at the start of his career ever supposed that such a pastime would eventually become his profession—nor did Renoir think so. His 'likenesses' only gave him the hope that he might become an artisan like his brother Henri, or perhaps a fashion-designer, as Leray suggested, or a decorator of china and porcelain. It was the latter occupation which most appealed to my grandfather. For he was proud of the reputation of his native town of Limoges and would have been pleased to see his son carry on its great tradition. True to his ' cork ' theory, at that time only half formulated in his mind, Renoir left it to destiny to decide what he would do, and went on drawing in his exercise books.

He was very good at music, and he had a fine voice. His teachers, anxious that such a gift should not go to waste, wanted to have him taken into the celebrated choir of the church of Saint-Eustache. The choirmaster there was an unknown young composer by the name of Charles Gounod. The choir was composed entirely of boys, like the modern group known as Les Petits Chanteurs à la Croix de Bois. Many of the choristers were children of the women of the Halles Market, who did not lack for money and had, to use an expression of the time, lungs of brass. For these well-to-do trades-people it was considered a great honour to have a son who sang at Saint-Eustache. It was like putting a coat-of-arms on the flat-

bottomed baskets of cauliflowers and poultry. When the candidates failed to meet the musical requirements they were dismissed to the accompaniment of loud protests and strong language from the indignant mothers, whose real jewellery and bright silk dresses filled Gounod with terror. To aid him in his trials he had an old priest who, having always officiated in the Halles district, was well acquainted with its jargon and spoke it fluently.

Gounod took a great liking to my father. He gave him private lessons, taught him the elements of musical composition and trained him to sing solos. When Renoir described this to me, his imagination would carry him back into the vaulted interior of the church. His frail voice was the link which bound him to all the faithful hidden from him in the dim light. He was aware of their presence, transported by his high notes, pained if his voice became rasping. He discovered that communion between the artist and his public which is the essence of spiritual power, and he could achieve it without arousing his horror of personal exhibitionism.

' I was concealed behind the great organ,' he said. ' I was alone, yet at one with them.'

The rehearsals took place early in the morning. Before starting work the boys attended Mass while it was still dark. The church was lighted only by candles, which burned in great numbers in front of the statues of the Virgin and the saints. The little points of light flickered in the slightest draught.

' What riches ! To think how the priests have replaced that living light by the dead light of electricity,' said Renoir, and then added, ' It is bottled light—only fit for corpses.'

In that magic glow the faithful were dimly visible as they heard Mass : strapping porters from the Halles, holding their wide-brimmed hats in their hands ; butchers from the slaughter-houses, with their blood-stained aprons ; oyster-women wearing wooden clogs and short coloured petticoats ; dairy women dressed in white. Their faith and the beauty of the scene were tremendously moving.

' Faces of men whose job it is to kill; bodies accustomed to carrying loads ; men and women who know life and don't come to Mass to show off their Sunday clothes or for any sentimental reasons. It was then, on that cold winter morning, that I understood Rembrandt.'

Gounod gave my father seats for the opera : a box for the whole

family. It was not the clumsy Grand Opera House of Garnier's[1] day
—'that lump of overcooked brioche'—but a charming Italianate
building which you could get an idea of only by going to the
'Fenice'[2] in Venice—'entirely of wood and all boxes : a jewel-case
to show off the pretty women of Paris. Nowadays, the theatre is a
"cultural exercise". Architects have studied acoustics in order to
make their geometrical ceilings acceptable, but the Italians knew the
laws of sound without needing to formulate them. In their theatres
you could hear everything, so that a sigh from their prima donna
would wring your heart. And what reds and golds, what Venuses
and Cupids and Muses in painted wood ! You can still come across
quite pretty ones on the merry-go-rounds. . . . And the jewels on
the opulent bosoms ! I love jewels, but only when they are resting
on some woman's teat. I really prefer imitation jewellery. The
thought of what the other costs takes away half the pleasure. . . .'

One night they were giving *Lucia* at the Opéra. In those days
the singers knew nothing about the 'realistic style', and so kept their
faces towards the audience. Even when the tenor poured out his
passion to the soprano, he knelt with his back to her and stretched
out his arms to the orchestra. The Renoirs were delighted with the
performance, and my father was in the seventh heaven. But Lisa
said that it was not 'true to life'.

'In real life people don't sing, they talk.'

Her remarks set Renoir thinking, but did not convince him. His
own ideas on the theatre were revealed to me later when he
recounted the following incident:

'Madame Charpentier kept insisting that I see one of the plays
by the younger Alexandre Dumas. I resigned myself to it just to
please her. I didn't like the younger Dumas because of his attitude
to his father, who was currently despised. He was regarded as a
mere entertainer—as if it were always easy to entertain ! The bores
have it all their own way. The more they "stink", the more they are
admired. . . . Well, I went to see the Dumas play. The curtain rose
on a scene showing a real fireplace, a real fire and a real piano. I had
just married your mother, and as she liked music I had given her a
piano. Every evening when I came back from my studio the first

---

[1] 1825-98. French architect. He studied at the Beaux Arts and won
the Grand Prix de Rome in 1848.

[2] The Venetian theatre built in 1791 by Antonio Selva. It was
destroyed by fire in 1836 and rebuilt in 1837 after original plans. (Trans.)

thing I saw was that piano. Why waste an evening in an uncomfortable theatre looking at what I can see at home in my slippers and smoking a good pipe? I got up and left before the end of the performance.'

I should like to say here, in parenthesis, a word about Renoir's earthy expression which I quoted above in reference to bores. Ordinarily my father's speech was exceedingly correct and always grammatical. He did not like the 'burr' in the speech of people on the outskirts of Paris, as he considered it affected; nor did he care for snobbish speech which imitated the English, including their slight lisp. Errors in grammar irritated him. He himself had no noticeable accent. On the other hand he liked authentic local accents which derived from tradition, and peasant idioms in general. He avoided coarse words as much as possible, reserving them for a limited number of personal enemies, among whom were literary men and 'literary' painters in particular.

Gounod sent his old friend, the priest who had pacified the market-women of the Halles, to my parents' house with a proposal to give his pupil a complete musical education. Meanwhile, to enable him to earn his living he promised to obtain a place for him in the chorus of the Opéra. He never doubted that the young Renoir could become a great singer. The offer was tempting. Renoir loved singing but, as I have already mentioned, he had a horror of thrusting himself forward. It was not timidity but a feeling that he was 'not made for that sort of thing'. And he also sensed that behind the actor's appearance of ease lie hidden destructive forces, and that becoming Don Juan or Figaro entailed a kind of spiritual gymnastics for which he was not fitted. If Gounod's proposition had been the only one, he would have accepted it, in accordance with his policy of the 'cork'; and his parents would have given their approval. But a friend of the Davids, M. Lévy, the owner of a porcelain works in the Rue Vieille du Temple, offered to take him on as an apprentice. Porcelain: Limoges—Léonard's very dream! My father decided on porcelain. He bade his master a tearful goodbye.

Gounod said to him : ' Do you realize that the tenor you heard in *Lucia* earns ten thousand francs a year ? '

But even in those days money had little attraction for Renoir.

# 7

Renoir had an almost physical aversion to doing anything he did not like. He was never able, for instance, to teach. He was like a human sponge, absorbing everything that had to do with life. All that he saw, everything he was aware of, became part of himself. The thought that his every brush-stroke gave back these riches a hundredfold did not occur to him until late in his career. When he took up his brush to paint he always forgot that his work might be of the slightest importance. The role of professor, which implies a 'giving' of oneself, seemed unrealistic to him, who wanted only to take. Of his own unbelievable selflessness he had no conception.

It was the same in Renoir's personal life. Even as a child he had a tendency to be economical.

'I would walk on the soft earth along the side of the street in order to avoid wearing out the soles of my shoes on the hard pavement.'

Nevertheless, he did not hesitate to use his month's salary to buy a lace collar for Lisa, or a gold-headed cane for his father. He did not dare to buy presents for his mother. Marguerite Merlet did not care for frippery. She liked handsome furniture, rugs and bright-coloured hangings. Once my father gave her a Louis XIV commode: '. . . Not a Boulle,' he said. 'Much better, in my opinion. Boulle would sometimes go in for mannerisms. And if he had executed all the commodes attributed to him he would have had to live for three centuries! The Second Empire could have been a regular paradise for the collectors. Victor Hugo had turned people's heads, and they could no longer see anything with a discerning eye. They paid absurd prices for bad imitations—medieval armchairs with trashy sculptures that stuck into your back. . . . They built the imitation castles you've seen here and there ; the

Monceau plain is full of them : Gothic windows, coloured glass, no light, stairs you almost break your neck on. The machicolated turret usually hides the lavatory. And the bourgeois women who lived in these places thought they were Isabeau of Bavaria, and their ironmonger husbands François Villon. And all the while they were using the superb rustic and bourgeois furniture of the eighteenth century for firewood.'

Renoir began porcelain-painting with the sober enthusiasm he put into everything he did. Deep down he doubted whether his employer's wares would ever represent the ideal of plastic beauty. They were copies of Sèvres and Limoges : vases adorned with delicate garlands, plates set off by fine arabesques, and always with a subject in the centre such as shepherdesses, Imperial Eagles, or historical portraits.

'. . . It didn't set the world on fire, but it was good honest work. And there's a certain something about hand-decorated objects. Even the stupidest worker puts a little of himself into what he is doing. A clumsy brush-stroke can reveal his inner artistic dreams. I prefer a dull-witted artisan any day to a machine. . . .'

Renoir began by painting the borders round the plates, which were fairly easy. He was so proficient that he was soon promoted to the historical portraits in the centre. Lisa, who had continued to interest herself in the welfare of others, after her marriage, perceived that her brother was doing the work of a skilled decorator for an apprentice's pay. She went to see the owner of the porcelain-works, called him an exploiter, and threatened to get a job for 'Auguste' with a competitor across the street. The good man did not fancy losing his new recruit, who was, he said, 'a quiet, polite boy'. But he protested that he could not decently pay a youngster what he paid 'a man with a wife and children'. He constantly used the word 'proper', and no doubt out of timidity punctuated his remarks with discreet little sniffs. My father described him vividly as being a small man, very near-sighted, and with a large beard like that worn by Napoleon III, which gave him a false air of vitality. He finally consented to pay Renoir by the piece.

'I'll start him on dessert-plates at two sous the plate ; three sous for Marie Antoinette in profile.'

'Marie Antoinette in profile!' Renoir's voice was scornful. 'That nitwit who thought she was being so clever playing the shepherdess!'

My father painted her so many times that he could have done it with his eyes closed. And he worked so rapidly that his pocket was soon filled with sous. His employer sniffed and stroked his beard in disapproval.

'A mere boy ... earning so much money!' he exclaimed. 'It's not proper!'

He then proposed paying Renoir at the exorbitant salary of twenty francs a month. Believing that this would give him the financial security he might never otherwise attain, Renoir was ready to accept. But Lisa made him refuse the offer, so he continued working by the piece. He took advantage of his success with Marie Antoinette, however, to ask his employer to let him try other subjects. The good man was alarmed, but his wife, who sometimes liked to run her hand through the young artisan's light-brown hair, persuaded him to agree.

Renoir tried his hand by copying nudes from a book his mother had given him, *The Gods of Olympus by the Great Masters*, illustrated with engravings of works by Italian artists of the Renaissance. I had at home for many years a vase decorated with a Venus against a background of clouds. Already it was a real 'Renoir'. Despite the banality of the object and the evident intention of doing a purely 'commercial' piece, it revealed the hand of a great man. The vase unfortunately disappeared from my house during the Second World War. May its new owner enjoy it to the full!

Mme Lévy was a tall brunette. Renoir was terrified of her at first. He had never yet had his arms round a woman.

'As well as I can recall,' Renoir told me, 'she was quite attractive, but big-boned; and she had big legs, big arms and a shapely bosom....'

As the Lévys' apartment was on the first floor she would often come down to the workroom, watch my father as he worked, and sigh. 'I am alone so much,' she would say. 'I am bored.'

And Renoir added, by way of comment, 'She must have read *Madame Bovary*, the sentimental hussy. I was a bit wary. Besides, I had other things to do. But I must admit she was a good sort, and all she really wanted was to help me.'

The manufacturing side of the work fascinated Renoir. But M. Lévy continued to oppose his desire to know more about it, for he was interested only in increasing the supply of Marie Antoinettes, which were selling better than ever.

'We owe that to the guillotine,' said Renoir. 'The bourgeoisie love martyrs—especially after a good meal, with plenty of wine and liqueurs!'

Even so, Renoir learned to mould vases and shape them on the potter's wheel. The old workman who tended the kilns became his friend and taught him the secret of firing. In those days wood was still used for heating the ovens. Renoir soon became adept at regulating the degree of heat required and gauging the temperature inside by the colour of the enamel in the process of fusion. There was a small opening in the side-wall for keeping watch on the progress of the operation. As he sipped his cheap red wine the old man gave his pupil endless instructions.

'You must drink—but take wine with water in it. If you don't drink, the heat from the furnace will dry you up. I knew one fellow who got so dried up he had no flesh left on him. He was nothing but skin and bones. His heart and lungs wouldn't work any more ... too cramped by the ribs ... and he died. The colour of the vases mustn't go from dark red to bright cherry-red too quickly. And after that, you mustn't let the fire die down ; if you do, you'll have a lot of breakages.'

The firing usually lasted twelve hours. The owner's wife brought the kiln-tenders their meals.

'Here, my boy,' she would say to my father, ' I've brought you some nice boiled beef.'

But Renoir was too occupied watching the pieces of china turn from red to orange and her attempts to lure him failed.

The old workman was amused. 'You're too young, and I'm too old,' he remarked, with a chuckle, after she had gone. 'She's out of luck.'

My father would describe these incidents in a haphazard way. But I believe I have succeeded in sorting the facts and assigning them correctly to the period when he was at the porcelain-works. I think he was there about five years, from the age of thirteen to eighteen. During those five years Renoir was to learn the essentials of life : art and love. As regards the second item, I should perhaps have said more appropriately, 'women'. I must add that, with a few inevitable exceptions, for him women represented the materialization of his art. Renoir rightly refused to be an intellectual.

'What goes on inside my head doesn't interest me. I want to touch ... or at least to see!' he would say.

The term 'art', which he was finally obliged to accept—'you have to speak the language of your time'—changed from the abstract to reality for him when, strolling along one day, he happened to come upon the Fountain of the Innocents. It wasn't the first time he had seen it. It was much talked about in those days. The Government had at great expense decided to give the monument a setting more worthy than the one it had. Napoleon III had taken it into his head to beautify Paris and make it a healthier place, and in carrying out the Haussmann plan he did not hesitate to go to extremes. As a boy Renoir approved of such drastic changes. He was doubtless influenced by Lisa, who was all for progress. Yet in his later years the regret he felt over the disappearance of many of the old quarters would often come out in our talks.

'You can't imagine how beautiful and amusing Paris was,' he said. 'And whatever the opinion of Haussmann and other vandals may be, it was much more healthy than it is now. The streets were narrow and the central gutter stank a little, but behind every house there was a garden. There were plenty of people who still knew the pleasure of eating freshly-picked lettuce.'

The Fountain of the Innocents dated back to Charles IX. It had been erected in the middle of the Cemetery of the Innocents, once celebrated for its four charnel-houses, the common graves into which more or less anonymous corpses were thrown. Work on it had been started shortly before the Massacre of St Bartholomew. The artisans were working carefully on the delicate ornaments of the Fountain while the bodies of the Protestants were piled into open ditches. The Revolution did away with the cemetery, a relic of olden times, and replaced it with a market for fruit and vegetable growers from the villages of Charonne, Montreuil, and the districts farther out to the north-east. Senseless destruction was no longer in the wind: with the victories of its armies, the Republic had become more tolerant. This trend towards moderation is a phenomenon common to revolutions, 'including the Christian revolution', as Renoir observed. However that may be, the fountain was piously moved, stone by stone, to a corner of the cemetery, and so saved from the egalitarian pickaxe. Those who wished to admire its bas-reliefs could get to it by threading their way through a maze of wooden sheds, hand-carts and various animals with which the dealers had crammed the place. In 1855 this noisy collection of people was dispersed, classified and assigned places in the new central market, or 'Halles',

which had just been opened. The terrain of the former cemetery was then cleared and the fountain set up in the centre of the open space. And in place of the ramshackle market-stalls trees were planted above the piles of skeletons so as to form a public square. As might be expected, Renoir regretted the disappearance of the old market with all its colour and confusion.

' I don't like having a work of art presented to me on a platter,' he said. ' They did the same thing with Notre Dame, which for centuries managed very well surrounded by old hovels. Since there *is* such a thing as art, I say that there is no art without life. And if you kill life . . . But then, confound it, it's because of our modern mania for wanting to be "*distingué*". The bourgeois no longer want the smell of fish in their nostrils.'

Renoir, then, decided to stop and look at the Fountain of the Innocents. He thought the bas-reliefs might suggest some good subjects for his porcelain. The next day he returned and brough a sketch-pad and pencil. He quickly learned to distinguish the work of Jean Goujon from the other sculptures. He asked his brother-in-law Leray about it, and heard the story of the fountain from him. One question of prime importance arose in my father's mind :

' The women are all about the same : fine-looking girls with beautiful bodies—probably the sculptor's wife or girl-friend. But why are those by Jean Goujon more exciting than Lescot's ? Why do I want to stare for hours at Goujon's, while the others bore me after a minute or two ? ' Renoir concluded, ' If the answer were known it would be too easy.'

I may appear pretentious, but I think I know the answer. Renoir felt unconsciously that he was spiritually related to Jean Goujon. ' We be of one blood, thou and I,' said Mowgli in *The Jungle Book*, which my father read and reread many times. Communication is always easier between people of the same blood. What concerns us here is the whole question of knowledge of works of art. Only those who can rise to the level of the artist can communicate with him. Their number is, of necessity, limited. Then why are the museums thrown open to a largely ignorant public ? To this question Renoir replied that the best way to learn a foreign language is to go to the country where it is spoken and hear it. ' The only way to understand painting is to go and look at it. And if out of a

million visitors there is even one to whom art means something, that is enough to justify museums.'

At the time Renoir was telling me of the Fountain of the Innocents I did not really take in his remarks. It was growing dark in his studio. He went on with the story, glancing every now and then out of the corner of his eye at his unfinished flower painting. Not enough time had yet elapsed for him to be able to overcome the confusion in his mind caused by my mother's death. He did not yet feel equal to undertaking a picture of a figure, or going out to do a landscape. He was sunk into his chair and waiting for night to fall. I believe it did him good to talk to me about his childhood.

'You ought to take another look at the Fountain,' he said. 'But not me. It's such an effort for me to walk. . . . Give me a cigarette, will you? . . . To think I'm not even up to rolling a cigarette!' He looked at his hands deformed by rheumatism. 'Ready-made cigarettes . . . like kept women.' The comparison amused him and he made use of it often. I remember him saying, when my mother bought a motor-car for him a few years before, 'Here I am in a car, just like a high-class tart.' And he went right back to the Fountain, adding:

'Those women Jean Goujon carved have something of the cat about them. Cats are the only women who count, the most amusing to paint. But I remember a big nanny-goat: a superb girl! I've liked doing Pekinese, too. When they pout, they can be exquisite.' He liked comparing people to animals. 'Darwin didn't know a thing about it. Why just monkeys, I ask you? So-and-so '—and he mentioned a well-known art-dealer—' is certainly descended from a monkey. And Victor Hugo surely had a stallion among his ancestors. And how many women look like geese? They're none the less attractive for all that, a goose is a perfectly nice creature.'

Thinking it might please my father, I bought him some reduced-size casts of Jean Goujon's bas-reliefs at the Louvre. He hardly gave them a glance. However, a twelfth-century Virgin delighted him. I had picked it up by chance. The body was too long, the face clumsily modelled, and the Christ-child, much too small in proportion to the mother, was rigid, with a vacant stare like that of a cheap doll. Renoir's comment opened a whole new horizon before me:

'What grace that little French bourgeois woman has! And what modesty! They were lucky: I mean those stone-cutters who carved

the old cathedrals. To think of doing the same subjects all one's life : Virgin and Christ-child, the Apostles, the four Evangelists. I shouldn't be surprised if some of them did the same subject over and over again. What freedom ! Not to have to be preoccupied with a story, since it has been told hundreds of times. That's what is important : to escape from the subject-matter, to avoid being " literary " and so choose something that everybody knows—still better, no story at all.' As he talked, he looked at his picture again. ' It's too dark, now. I'm going to put aside those roses. Call Grand' Louise.'

My father was very meticulous about everything that had to do with his profession. He always kept his palette and brushes scrupulously clean. There were few people he would trust to take care of them. He had had perfect confidence, however, in my mother and Gabrielle, and now in Grand' Louise as well.

As soon as the inevitable cigarette was lit he resumed our discussion.

' Remember, this is only a plaster reproduction. There's nothing bad about plaster, but it lacks nobility. Goujon had plenty of talent, but to stand up in reproduction the work must have enormous strength.'

One day I heard my father tell a group of friends, which included Vollard the art-dealer and Gangnat the collector :

' Since the days of the cathedrals we have had but one sculptor. Sculpture is hard. You can still find a few painters and bucketfuls of writers and musicians, but to be a sculptor you have to be a saint, and have the strength to escape the snare of cleverness . . . and also not to fall into the trap of the would-be rustic.' And he went on, musingly, ' Since Chartres there has been only one sculptor, in my view, and that is Degas.'

This surprising statement did not startle his listeners greatly, for they were men who had stepped beyond some of the barriers which keep the masses within the bounds of accepted illusions.

' Those who worked on the cathedrals,' said my father in con- clusion, ' succeeded in giving us an idea of eternity. That was the great preoccupation of their time. Degas has found a way of expressing the malady of our contemporaries : I mean movement. Nowadays we all have the itch to move. Even Degas's jockeys and horses " move ". Before he came along, only the Chinese had dis-

covered the secret of movement. That is Degas's greatness : movement in a French style.'

To emphasize his point, he cited what he thought was the mistake Garnier had made in engaging Carpeaux to execute the group of dancing figures at the Opéra instead of commissioning Degas to do it. Renoir must have forgotten that, at the time, Degas was a very young man.

His praise of movement seemed to contradict certain opinions he had previously expressed. I reminded him of the comments he had made about the sculpture in the Luxembourg Museum.

'. . . Those men and women,' he had said, ' are so strained, it exhausts you to look at them. They stand on one foot, or else they brandish their swords with every muscle bulging. Such effort can't be sustained for all eternity. Being made of stone or bronze, of lasting material, sculpture should be as eternal as the material it is created out of. You almost want to say to those dying soldiers and screaming mothers : " Do be quiet ; get yourself a chair and sit down." '

Renoir was amused by my protest, and he replied :

' Movement can be as eternal as immobility so long as it is in harmony with nature : if it expresses a natural human function. The flight of a swallow is as eternal as the tranquillity of the " Seated Scribe " in the Louvre. The statues in the Luxembourg are over-active for intellectual reasons, for literary reasons. A swallow speeds through the air to catch a gnat and to satisfy its hunger : not to verify a principle.'

This negation of the value of non-physical subjects in art was characteristic of Renoir. It may not be out of place to recall that the man who held these principles would rather have starved than betray them.

Except for the Fountain of the Innocents, and a few other discoveries which I shall mention presently, Renoir rarely spoke of his development as a painter. It would seem that it came about as naturally as breathing and that he could not have done anything but paint. The different stages which were to bring it about were not the result of good or bad luck. They were the normal and inevitable steps along the road he was destined to travel. Even before he himself was conscious of it, his hand was formed for painting as our tongue is made for speech. It is no great discovery to learn that the primary function of our legs is to enable us to walk : a baby begins

to crawl, then one day he walks. Renoir went to school; he learned
to sing; he decorated porcelain; and one fine day he began to
paint. And that is all.

My father knew the Louvre Museum well. My grandfather and
especially my grandmother had taken him to visit it a number of
times. They were people of taste: ' You sometimes come across
them in France.' But Renoir's deep feeling for painting was not to
reveal itself until very much later.

' This notion of Rousseau's that men are born knowing every-
thing is a literary fancy. We know nothing when we are born. We
have all sorts of possibilities in us. But what work it takes to
discover them. It took me twenty years to discover painting:
twenty years looking at Nature, and above all, going to the Louvre.
But when I say discover——! I am still only just beginning, and I
still go on making mistakes. . . . Let us say you took a peasant
from Essoyes, for instance, to hear that masterpiece of all master-
pieces, Mozart's *Don Giovanni*, he'd be bored stiff. He'd much
prefer a café concert—despite that hypocrite, Jean-Jacques Rousseau.
It's simple enough: you begin with a café concert tune, but you
must choose a good one.'

Renoir himself began with something better than the café concert.
His first enthusiasms were for Watteau and Boucher.

' I longed to copy them on my porcelain. But my boss was afraid
that such complicated subjects would take too much time and lower
the output. I tried in vain to convince him that he would be losing
nothing since he was paying me by the piece. My work was very
much in demand, and that demand had to be met. I was quite
proud of myself.'

Renoir asserted that his success as a painter of porcelain had
given him greater satisfaction than all the compliments and honours
his admirers were to heap upon him in after-years.

' Think of it! A mere kid whose boss tells him how much he
needs him! It's enough to turn one's head. I would walk along in
the street imagining that the passers-by had recognized me : " That's
young Renoir: you know, the one who painted our Marie
Antoinette ! " Now, I know how little that means. The public is
equally indifferent to what is good and to what is bad. And after a
hundred years of slushy romanticism the French people have become
sentimental.'

He was alluding to a picture of his which had just been sold for a fortune at Sotheby's in London.

' Those picture-dealing scoundrels know perfectly well that the public is sentimental. They stuck a blasted title on my poor girl, who can do no more about it than I can. They called her " La Pensée ".' He frowned at the recollection of it. Then his eyes sparkled with malice, as he looked at his listeners. '*My* models don't think at all.'

# 8

Renoir got into the habit of going to the Louvre at noon instead of lunching with his mates in a little café round the corner.

' I had added Fragonard to my list of favourites, which included Watteau and Boucher, especially his portraits of women. Those bourgeois women of Fragonard's ! They are distinguished and at the same time good-natured. You hear them speaking the French of our fathers, a racy language but dignified. Barbers were not yet " hairdressers " and the word " *garce* " (hussy) was simply the feminine of "*garçon* ". People knew how to let a fart in polite society as well as to speak grammatically. Nowadays Frenchmen don't fart any more, but they talk like pretentious illiterates.'

As my Uncle Henri's employer and his wife, the Davids, had sold their business, my uncle went to work for Odiot, the well-known goldsmith in the Place de la Madeleine. His new position was to hasten his marriage with Mlle David, and also put him in touch with a more fashionable clientele. Odiot was purveyor to His Majesty the Emperor. There was a vogue for everything Chinese. The Imperial Government was planning to establish a French settlement on the coast of Indo-China and the entire Court suddenly discovered the Far East. Henri took my father to an exhibition of lacquered objects and china which had been brought to France by a partly diplomatic and partly commercial mission. Renoir politely admired the various vases, fashioned in complicated styles, and the many statuettes with their enigmatic smiles.

' I thought it all very pretty, very skilful, but somehow it didn't mean anything to me. It was too clever ! I was too young to realize that those idiots had chosen only things representing the decadence of a huge civilization. But suddenly over in one corner I discovered some marvellous pottery : the forms were so simple I was quite

moved by them. They had flecks of copper oxide on them—the kind of green that makes you think of waves : in short, porcelain that had been treated without too much care, like earthenware— good thick porcelain that you could handle without being afraid of breaking it. My brother, having already succumbed to the latest craze, couldn't understand my enthusiasm. And yet he was a marvellous engraver. But fashion spares no one. It keeps you from seeing what is eternal.'

The Chinese pottery Renoir saw aroused his doubts about the value of the articles manufactured by his employer at the porcelain-works. But the artist's profession seemed at that time to be beyond his reach : a vision of some distant Eden.

' After all, I was earning a good living decorating porcelain,' he said. ' I had been able to help my parents buy a house out at Louveciennes, to which they could retire some day. I could even have lived independently of them—and at fifteen, that isn't doing badly. But I liked talking with my mother at home in the evening. She was a very good woman and a wise one. She believed that I really could paint, but she advised me to save up my money for a year before launching out on any new experiment.'

The Fontainebleau School had made a name for itself. My father, following the public trend, was loud in his praises of this group, which had specialized in painting from Nature.

' Rousseau[1] amazed me, and Daubigny[2] also ; but I realized immediately that the really great painter was Corot. His work is for all time. Like Vermeer of Delft, he didn't paint just for his own day. I loathed Millet. His sentimental peasants made me think of actors dressed up to look like peasants. I loved Diaz.[3] He was someone I could grasp. I said to myself that if I were a painter, I would have liked to paint the way he did, and that perhaps I could have. I like a forest scene that makes you feel there is water some-where near. And in Diaz's paintings you can almost smell the mushrooms, dead leaves and moss. His pictures remind me of walks with my mother in the woods at Louveciennes and the Forest of Marly.'

Renoir was to make Diaz's acquaintance later on. When he told me about it, he still felt moved by the event. He became the eager

[1] 1812-67. French landscape-painter of the Fontainebleau School.
[2] 1817-78. Also of the Fontainebleau School.
[3] :808-76. Another painter of the Fontainebleau School.

young man once again, quite embarrassed on finding himself in the presence of the master. This is how they met.

Renoir was not quite twenty at the time. He had left the porcelain-works as I shall describe later, but he continued to earn his living as a decorator. When he was free, he would go out into the country and paint from Nature. One day when he was in the Forest of Fontainebleau and working on the ' motif ' he suddenly found himself surrounded by a band of Parisian rowdies—shop-clerks and working-girls out on a spree—who started making fun of the working-man's smock he wore.

' To the great despair of your grandfather, ready-made clothes were now the fashion and people began to look like tailors' dummies. You see, the trouble with ready-made clothing is that everybody can afford to look well-dressed—as well-dressed as a commercial traveller. You have the workman disguised as a gentleman, for the modest price of twenty-five francs fifty. When I was a youngster, workmen were proud of their profession. Carpenters wore baggy corduroy trousers and a blue or red flannel sash round their waist, even on Sunday ; house-painters wore a beret and a flowing tie. Now they've replaced pride in their profession by this idiotic vanity of trying to look like the bourgeoisie. In consequence, the streets of Paris seem to be filled with supers out of a play by the younger Dumas. And,' he concluded, ' it's all the fault of the English.'

To return to the episode in the Forest of Fontainebleau, Renoir pretended to ignore the remarks of the flippant young intruders and went on painting. Provoked by his deliberate silence, one of them kicked his palette out of his hand. You can imagine how the others laughed. . . . Renoir rushed at him, but was immediately jumped on by half a dozen or so husky lads. The girls attacked him with their parasols—' with the metal tips pointed at my face : they could have put my eye out ! '

All of a sudden the bushes parted and a man about fifty years old appeared. He was tall and strong, and he had a painter's outfit with him. He had a wooden leg, and he was carrying a heavy cane. He threw down his kit, hurried to the rescue of his young colleague, and, laying about him with the knob of his walking-stick, sent Renoir's assailants flying.

My father had meanwhile been able to get to his feet again and join the fray. The band of hoydens cackled like hens and, clinging to their gallants, beat a hasty retreat, leaving the two painters in

possession of the field. While the victim of the attack was expressing his thanks, his one-legged benefactor picked up his canvas and examined it carefully.

' You've got talent ; a great deal of talent. But why do you paint in such dark tones ? '

Renoir replied that a great many of the masters he admired used dark tones.

' But even the shadows of the leaves have light in them,' said the other. ' Look at the trunk of that beech tree there. Bitumen is just a convention. It won't last. . . . By the way, what is your name ? '

The two men sat down on the grass and Renoir talked freely about himself, telling his new friend of his modest ambitions. The newcomer introduced himself in turn. His name was Diaz.

' Come and see me in Paris some time, and we'll have a good talk.'

In spite of his admiration for Diaz, Renoir never followed up the invitation.

' We would have exchanged ideas and discussed theories,' my father explained. ' I was young, but I was already aware that a few pencil strokes are worth more than any number of theories, for me at any rate. I've never let a day go by without sketching something, even if it's only an apple on the page of a note-book. You lose the knack so quickly.'

I am not entirely convinced by Renoir's excuses. I am more inclined to think that he was unconsciously obeying his instinct which, in spite of his respect for Diaz, made him realize that he and the other man, in art at least, could never be ' blood brothers '.

It was industrial progress which forced my father to give up his profession of porcelain-painting. It happened in 1858. He was seventeen then. The process of stamping designs on faience and porcelain had just been perfected. Marie Antoinette's portrait could now be reproduced mechanically, thousands of times. It was the death-knell of a splendid craft. Renoir's employer stroked his beard for a long time while he mulled over the problem. To buy printing-machines of this kind required a considerable capital outlay. But he had a vague feeling that the days of small businesses like his were over. Pottery and porcelain would from now on be manufactured in factories with tall smoke stacks, whirling wheels, and offices filled

with white-collar workers. The worker-boss in his white apron, his workshop separated from his living quarters by a spiral staircase, would soon be a thing of the past, along with wigs and tallow candles. He decided to sell his place and retire to the country, where he could have a garden and raise melons. His tall brunette wife, however, did not at all care for this plan. She feared she might get bored in rustic surroundings. She loved the atmosphere of the shop. It rather amused her to try on a new dress and watch the effect on the more knowing workers, making it clear that she wore no corset because of the heat in the workroom. Young Renoir was not too timid to cast an appreciative glance down the opening of her low-cut bodice as Mme Lévy leaned over to inspect his work.

' My moustache was beginning to grow, and that made her laugh,' he said. Then, after a pause, he added, ' Don't trust anybody who doesn't get excited at the sight of a pretty breast.'

She sided with him when, by agreement with his fellow-workers, he made M. Lévy an extraordinary proposition. Although only seventeen, he had created an attitude towards himself which he was to inspire in everyone until the day of his death : he was looked upon as a master. With perfect confidence, his fellow-workers placed their fate in the hands of ' Monsieur Rubens ', as they had affectionately nicknamed him. He proposed to set up a co-operative. The rent of the premises would be paid to their employer out of the profits earned by the workers. What remained would be divided equally among themselves. His idea was to wage a ' battle of speed ' against the machine which was about to take the bread out of their mouths. Mme Lévy pleaded with her husband to accept the proposition ; he let himself be persuaded and put off raising melons till later. He would be needed to help the new co-operative with its commercial problems. They all set to work feverishly. With incredible rapidity Renoir began painting firm-breasted Venuses on hundreds of vases and plates. He was determined to beat 'progress' at its own game and prove that the ' hand ' of a Parisian artisan was as good as shining wheels and well-greased piston-rods. Seconded by M. Lévy, he approached the wholesale dealers in the Rue du Paradis to discuss the possibility of their buying his wares. The cost-price he proposed was lower than that asked for machine-decorated articles. The dealers, alas, showed little interest in his offer. What they liked about mass-produced dishes was that each one was an exact replica of the next.

# Renoir, My Father

'I was beaten from the start because of the public love for fashionable monotony. I had to give up.'

The closing down of the porcelain-works annoyed him more than it upset him.

'One can always earn a living. But I have an aversion to making decisions : the "cork", you remember . . .' he said, alluding once more to his favourite theory. 'You go along with the current. . . . Those who want to go against it are either lunatics or conceited ; or, what is worse, "destroyers". You swing the tiller over to the right or left from time to time, but always in the direction of the current.'

I was not convinced by this statement ; I reminded my father that his name was associated with the Impressionist revolution, and that he was credited with having changed the whole course of modern art. He gazed at me with an ironic smile.

I ought to describe how his face looked when anything amused him—which happened often. You would have said that he exuded gaiety from every pore. His very beard seemed to quiver with hidden laughter. His brown eyes, always lively, literally sparkled. The description has been over-used, but in the case of Renoir it is justifiable. His eyes flashed with fire as he spoke.

'Since Victor Hugo's day the French don't know how to express themselves in simple terms. They say I'm revolutionary ! Just what does that mean ?'

His theory—which I understand now—was that all men who have created something of value did so not as inventors, but as catalysts of existing forces as yet unknown to the common run of mortals. Great men are simply those who know how to look and how to comprehend. He cited Saint-Just, whose proposal of the metric system was far from revolutionary. Saint-Just merely perceived that the modern world was becoming a world of technicians and so must develop a form of universality : the universality of physics, chemistry and the natural sciences. And that would lead to the need for a simplified system of weights and measures, which could be accessible to all. The 'destroyers' are those who do not recognize the march of time and want to apply outworn solutions to new problems.

'I, for instance, believe that it would be better for a painter to grind his own pigments or else to have them ground by an apprentice. But there are no apprentices any more, and as I prefer

to paint rather than prepare my own pigments I buy them from my old friend Mullard, the dealer in artists' supplies at the foot of the Rue Pigalle, because he grinds them for me. If I wasted my time preparing my own pigments I would be as much of an idiot as if when I wanted to paint I dressed myself up as Andrea del Sarto. I should be forgetting the important thing, that del Sarto lived in the days when people had plenty of time and that he had apprentices who worked without pay, so grinding pigments was economical. That is why I am willing to get my paints in tubes. It is the business of the cork again. This passive attitude brought its reward. Paints in tubes, being easy to carry, allowed us to work from Nature, and Nature alone. Without paints in tubes, there would have been no Cézanne, no Monet, no Sisley or Pissarro, nothing of what the journalists were later to call Impressionism. Nevertheless, I am sorry there are no apprentices any longer. I hate the metric system, which is a creation of the mind, because it has replaced measurements based on the human body—the thumb, the foot, an arm's length and the league (a Gallic invention), which represents so effectively the distance an ordinary man can walk in one hour without getting tired.

' If I have painted in light tones it is because it is necessary to paint that way. It wasn't the result of a theory, it was a need which was in the air, in everybody's mind, unconsciously, not just in my mind only. When I painted in light tones I was not being revolutionary, I was being the " cork ". And the " official " painters, with their bitumen, were fools. You've got to be a fool to want to stop the march of time. It is the people who pretend to respect traditions who destroy them. So don't try to tell me that Monsieur Bouguereau is the successor of Chardin ! '

However that may be, the ' cork ' was inevitably obliged to decide on a new profession, since he could no longer be a porcelain-painter.

At this period the family was fairly prosperous. Grandfather Léonard had given up most of his work but kept on a few old customers. The children were all doing well. Henri and his wife, Blanche David, were happy now that they were well established. Henri had never been very venturesome. He knew that with the Odiot company he would be assured of an honourable living to the end of his days, and he aspired to nothing more. The Henri Renoirs never had any children and all their married life were able to indulge two passions : one for animals, the other for café-concerts. I

73

remember a fox-terrier they had when I was young. Its name was King, and it was certainly the king of the castle. They also owned a canary, which they called Mayol after the music-hall singer. My Aunt Blanche had a mania for auction sales and bargains. One day she came home with fifty umbrellas, which she had hired a porter to carry for her. At two sous each, she had not been able to resist such a bargain.

Victor was making a success as a cutter for a tailor on the Grand Boulevards. He himself dressed in the best of taste, and he could be very amusing. The girls found his wit irresistible and it led to a great many love-affairs. My grandfather disapproved. For him life had not been an adventure but a long and toilsome road, though often quite pleasant, and he had made his way along it confidently, accompanied by a companion who had never failed him. He insisted on mutual confidence between men and women. But perfect trust can only be had with a single person, because it must be reciprocal. Without it, life becomes a battle, which generally results in defeat for the man, because women are 'awfully strong'. My grandmother Marguerite was secretly proud of Victor's conquests ; but of all her children, my father remained her favourite.

Lisa and her husband lived with my grandparents. They often brought friends home to dinner. My grandmother had established a tradition which my father and mother were to carry on. Every Saturday she prepared a huge pot-au-feu, which did for all the guests. They did not need to let her know in advance whether they were coming. If no one turned up, then the family had to eat cold boiled beef for the rest of the week. My father did not mind, because he was fond of the pickles which went with it. When the season for pickling came round my grandmother mobilized all the children, and their friends if necessary, for the preparation of this condiment.

Among the people who came to those Saturday-night dinners there was one guest whose identity I learned from Gabrielle. He was an artist by the name of Oullevé. As Gabrielle related it to me, the incident runs something like this :

' You were little then, and posing in the studio. I was trying to make you keep still. All at once, the boss stopped the sitting and said to me, " Get some money out of my pocket." He always had a few notes in his pockets in case of need. For himself, he would make an awful fuss over buying a box of matches, but for other

people he would hand out a thousand francs without batting an eye-lid. Your mother knew he was like that but she never let on. Yet your family wasn't rich. They had everything they needed and all of the best, but they were not rich.

'I took the money over to Monsieur Oullevé in the Rue Blomet. The master had told me : " I hope he'll take it. He's a fine man, and a good artist. He gave me a lot of good advice when I was a boy. He encouraged me with my work, and told me I ought to copy the old masters."

'I went to the Rue Blomet and met an old gentleman, who couldn't understand how Renoir had found out that he was almost blind and so hard up he couldn't pay his rent. He began to cry, thinking of the master as a young man, " I knew he would be a great painter ; and so alive, like quicksilver." He gave me an antique soup-tureen to take to the master : a white soup-tureen of old Paris earthenware.'

I had that soup-tureen until the War of 1939. When I came back to my apartment it had disappeared. And that is all I have to tell about Oullevé, who used to be one of my grandmother's regular guests.

Another of the devotees of the famous pot-au-feu was the painter Laporte. I do not know how he became one of my grandparents' friends. He too thought young Auguste was very talented, although rather inclined to be careless in interpreting his subject's expression. His temperament and his way of painting were just the opposite of Renoir's, yet he was always generous in his praise of Renoir's work. His attitude had a great influence on my grandparents, when they had to admit their son was ready to 'cross the Rubicon'. It is very likely that Laporte was the first person to whom my father showed his first large canvas : Eve tempted by the serpent, which was coiled around the branch of the tree. The whole family awaited the master's verdict while he stood for a long time contemplating the picture. Finally he declared that young Auguste was a real artist, and that he should not turn a deaf ear to his vocation. Some years later Laporte met him again, after Renoir had become celebrated, and said to him :

' Young man, if you had remained faithful to bitumen, you would have become another Rembrandt.'

My father was very moved by his sincere compliment, but not enough to be converted to the use of bitumen.

But let us return now to the Rue des Gravilliers.

# Renoir, My Father

Lisa continued to wait for the 'Great Night', which for all liberals meant the expected revolt of the workers against their oppressors. My grandparents and Renoir teased her a little about it. Her husband, who was well paid by his magazines, had begun to settle down. Edmond was in the midst of his studies. He had a flair for everything related to history and literature. He and Lisa got along very well on the subject of politics. He wrote short, realistic stories, and everyone in the family and among his friends admired his style. He had even had a few poems published in a school paper. He had much more wit than Victor. Victor was satisfied with cracking jokes to amuse the girls, whereas Edmond could see the ridiculous side of things and point it up with a cutting comment. My father said that he was 'caustic'. He himself had little liking for wit.

'You can ruin a friendship by a witty remark. Words can be very dangerous. They can start you off in the wrong direction; worst of all, they can hide your real thoughts.'

The months went by and the money Renoir had saved while working at the porcelain-factory had begun to melt away at an alarming rate. Renoir would have starved rather than borrow from his parents. He once told me with great pride that he had never owed anyone so much as a sou. ' And I never died of hunger.'

One day he caught sight of a little notice tacked up outside a shop asking for a painter who specialized in decorating waterproof blinds. He introduced himself to the proprietor, who curiously enough bore a close resemblance to the porcelain-manufacturer. True he was taller and wore side-whiskers in the Louis-Philippe style instead of a pointed beard, but he wore the same kind of white smock and spoke the same precise language the Paris artisans use to set themselves apart from the ordinary run of working-people. Renoir assured him that he knew everything there was to know about painting blinds, and he was hired on the spot. The proprietor told him to start the next morning, and went back to the workroom in the rear of his shop. My father then invited one of the workers to have a drink with him in the ' *troquet*', or little café, next door (the term ' *bistrot*' had not yet come into use)—and there he confessed that he was completely ignorant of the craft. The young man, who had a frank and open face, informed him that he was the brother-in-law of the owner of the shop, a piece of news which made Renoir uneasy about his future in the awning industry. However, the fellow was

a good sort. ' Come and see me after work,' he said. ' I'll show you how it's done. It's as easy as anything.'

As he told me the story, my father yielded to a pardonable show of naive vanity. For anyone who had allowed himself to be taken in so often in life, this little white lie was almost Machiavellian. He told me the name of the brother-in-law, but I have forgotten it. The two became great friends. The young fellow's wife was a pale blonde who could think of nothing but her housework. Their apartment always smelled of washing, and everywhere you ran into things hanging up to dry. They had a little girl, of whom Renoir did several portraits, since lost. They admired my father and urged him to become a ' real artist'. But he kept on at his new work, as he was frightened at the thought of all he had yet to learn, and he hesitated to give up the security of a métier with so few problems. The shop's best customers were missionaries to the Far East. Subjects were taken from Bible stories and painted on translucent paper. These blinds were to serve as stained-glass windows in the rudimentary chapels which the good Fathers were putting up in Indo-China. The owner realized quickly enough that it would be to his advantage to allow his new employee a free hand in following his own inspiration, ' provided that what I portrayed was edifying '. My father had a very good time at it.

' I had hit on a trick,' he told me, with a wink. ' I did lots of clouds. You see, a cloud can be daubed on with a few brush-strokes.'

The blind-maker with the Louis-Philippe side-whiskers was worried. He had the same misgivings as the porcelain-manufacturer.

' Such skill isn't natural,' he declared. ' Earning so much with so little effort won't do you any good in the long run.'

# 9

My father was extremely prudish. I myself could not tell him of my adventures with women without feeling embarrassed. But we succeeded sometimes in overcoming this reticence, especially when I felt I was amusing him. We even got to the point of exchanging dirty stories, and without mincing words. In general, they were about people we did not know. We related them merely as a means of amusing each other, not as true stories. However, one day after a good meal with a few glasses of Essoyes wine he felt in the mood to tell me about some of his early love-affairs. If I add to these partial confidences the advice he would slip in, in the form of some anecdote or recollection ('How dare anybody advise others when he has done the same thing himself?'), I can get some idea of his experiences with girls.

On one occasion when he had dinner with the brother-in-law of the blind-manufacturer, Renoir met a certain Berthe, a superbly healthy blonde, one of those girls with unruly hair who spend their time putting their chignon in order. She had come to Paris from her native Picardy to help a relative with the housework. She had soon deserted her relative for an old gentleman, who set her up in a furnished apartment. While not envying her, the brother-in-law and his wife admired her for being so enterprising.

'She's in luck, all right,' the wife said, 'but she deserves it. There's not a speck of dust anywhere in her house.'

Her friend, who suffered from dyspepsia, allowed her plenty of liberty and she made full use of it. She took Renoir to a ball. He took her into the woods at Meudon. I am not sure whether she was his first mistress or not. My father spoke of her several times without going into details, and I did not press the point. I know that he mentioned Berthe's name during a talk with his friend Lestringuez on the subject of jealousy. Was he alluding to his own experience

when he made fun of young men who do not know the delight of being shut up in a wardrobe during the visit of the titular lover?

For several months Renoir spent a good deal of time with Berthe which he would otherwise have devoted to his experiments with painting. But his blind-painting brought him in good money, and he could afford to indulge in this little idyll.

At the gatherings in the Boulevard Rochechouart and later on at Les Collettes, in Cagnes, his views on the upbringing of young men often surprised his visitors.

' You do a lot of foolish things when you are young—it doesn't matter then, because you haven't yet taken on any responsibilities. But afterwards you'd be a fool to play around with cheap tarts instead of amusing yourself with painting. Of course, there's syphilis, but with " 606 "——'

His advice to 'behave badly' before marriage applied to girls as well.

' Before marriage you do whatever you please. You owe nothing to anybody and you harm nobody but yourself. But afterwards, when you've given your word to a life-companion, that sort of behaviour is treason. And it always ends badly.'

He was convinced that the remedy ' 606 ' was going to ' knock all the fun out of leading a fast life'. What would he have thought of penicillin, I wonder.

' It's not much fun to spend the night with a whore. The best part is what leads up to it. Later, it's ghastly. But there's always the risk. It's the risk that adds spice to the affair.'

It is very probable that Berthe got interested in another lover and let my father go. I have assumed as much because he several times advised me never to break off with anyone.

' How can you know that you aren't in the wrong? You lose your head; you don't know what you're doing. Afterwards you regret it. You feel guilty. All women are unbearable at times. . . . We are, too.'

Another of his admonitions was:

' Get away from your wife often, but not for long at a time. After you've been away you'll be glad to get back to her. If you stay away too long you may think she's ugly when you return, and she'll think the same about you. When you grow old together, neither of you notices how the other looks. You don't see the surplus fat or the wrinkles. Love is made up of a great many things

and I'm not clever enough to explain them. But I know it is also habit.'

I think it was after Berthe disappeared from the scene that a very important event in Renoir's life took place. He 'treated himself' to his first box of paints, along with a palette, palette-knives, saucers and an easel—a small folding-easel. It was Charles Leray who helped him make his purchases. Until then Renoir had used an old dish for a palette, and mixed linseed oil and turpentine in a little cup. Several canvases which are still in existence date back to that period : a portrait of my grandmother, one of my grandfather, and several heads of young girls.

'I loved women even before I learned to walk,' he said. And he began to talk to me for the hundredth time about his mother.

It was certainly no 'Oedipus complex'. Renoir had been the most normal of children, just as he was to be the most normal of men. And we must realize that in his vocabulary, words retained their proper meaning. 'I did not trust Victor Hugo's way of expressing things.'

When Renoir said, 'I love women,' he did not mean to give the phrase the roguish undertone which men of the nineteenth century implied when using the word 'love'.

'Women don't question anything. With them the world becomes something quite simple. They put the right value on things and they know that their washing is just as important as the constitution of the German Empire. You feel reassured when you're with them.'

He had no difficulty in conveying to me the atmosphere created by women. Our house was a house full of women. My mother, and Gabrielle, and all the young girls, servants and models who moved about the house, gave it a distinctly anti-masculine tone. The tables were strewn with odds and ends for sewing and dressmaking. 'Young Germain once told me I ought to have a valet. Fancy having a man to make my bed and leave his cigarette-ends on the mantelpiece!'

The young man he was referring to was the son of a prominent financier. He was a good friend of my father at the beginning of the century. The least that can be said of their friendship is that it was surprising ; this was often the way with Renoir, who was the living contradiction of the proverb that ' birds of a feather flock together '. Germain was affected and coquettish, and he used perfume. He spoke affectedly and was so effeminate that it seemed a pose. My

father praised his way of sizing people up and making unexpected comments on everyone and everything. For instance, in speaking of St Peter's in Rome he said that it was 'a complete success, from an industrial point of view: a regular factory for mass-production religion'.

I recall hearing a snatch of conversation he had with my father, who painted a fine portrait of him, after the sitting was over.

'Monsieur Renoir, what was your favourite game when you were a little boy?'

'I liked playing marbles.'

'Oh? I liked flowers.'

And when he brought up the suggestion of a valet again Renoir replied evasively, because he did not want to offend Germain. Once he was alone again, Renoir repeated, 'I can't stand having anybody around me but women.'

And women returned his affection for them.

When I was in school, I had a friend whose grandmother had known my father well. She stopped me one day just as I was coming out of school and looked at me closely.

'You don't look like him. You must take after your mother.'

She had first known Renoir just after the War of 1870.

'If you only knew how much everybody liked him!' she exclaimed. And she lowered her eyelids and smiled.

I was about ten at the time. I had never seen so many wrinkles on a human face before. I could hardly believe that the old lady had once been a young girl with rosy cheeks.

'We liked him because he didn't think he was important enough for us even to notice him.' She added that she did not want to see my father again because 'it is no use; it is better to keep one's memories.'

But my father was not one to live on memories. He was much too busy taking advantage of the present and endowing it with eternal values. Nor can it be denied that the present which most interested him was a present wearing petticoats. Renoir had many fine friendships with men, but he had even more with women, with whom his relations however tentative and delicate were always on the point of turning into something more romantic.

It should not be thought, however, that his admiration was blind. It could not be called admiration. As a matter of fact it was rather an appreciation of the favourable atmosphere they created. Some

people like hot countries, others prefer social life. Renoir bloomed both physically and spiritually when in the company of women. Men's voices tired him, women's voices soothed him. He wanted all the female servants to sing, laugh and feel at ease when working around him. The more naive and even stupid their songs were, the more pleased he was. How often I used to hear him ask, ' Why isn't La Boulangère singing today ? She must be ill. Or else the idiot has had a row with her lover.'

By one of those strange contradictions which made his reasoning difficult to understand, he would punctuate his statements about the superiority of women by a few jibes at their newly-acquired desire for independence and education. When someone mentioned a woman lawyer, he shook his head and remarked, ' I can't see myself getting into bed with a lawyer.' And he added sharply : ' I like women best when they don't know how to read ; and when they wipe their baby's behind themselves.'

With him it was not an echo of the bourgeois common sense so clearly expressed in Molière's *Les Précieuses Ridicules* or *Les Femmes Savantes*. It was simply another example of his revolt against accepted values. The nineteenth century believed in an élite and based its belief on the learning of such an élite. Renoir believed in the constantly renewed discovery of the world through direct contact with its physical elements, and the more accessible these elements are to us the more important the discovery.

' Newton's discovery of the law of falling bodies is all very fine, but that doesn't mean that a mother's discovery of how to hold her baby isn't important too.'

When he was reminded that Newton was endowed with genius, he retorted that a farmer's wife who knew how to make good cheese had just as much.

' Why teach women such boring occupations as law, medicine, science and journalism, which men excel in, when women are so fitted for a task which men can never dream of attempting, and that is to make life bearable.' As he told his friend Lestringuez :

' What you gain on the one hand you lose on the other. We're not universal geniuses. So what women may gain by education they lose in other fields. I am afraid that the generations to come won't know how to make love well, and that would be most unfortunate for those who haven't painting.'

His misgivings, though casually voiced, were very real to him.

He contended that the lack of physical exercise—'and the best exercise for a woman is to kneel down and scrub the floor, light fires or do the washing : their bellies need movement of that sort '—was going to produce girls incapable of enjoying sexual intercourse to the full.

' You'll find fewer and fewer of those pretty tarts who lose their heads when they give themselves completely. There's a risk that love-making, even the most normal, may become a kind of masturbation.'

Talking of such things was rare with Renoir, who disliked the physical aspect of the question, although he had an equal aversion to the romantic or intellectual approach. ' Things are as they are. Does blood analysis help me to give an idea of the blood circulating with my brushes ? ' It is possible that he was afraid of physiological details because of his belief in the need to get away from them, ' to take to the woods ' in order to seize the very essence of a subject he wished to depict.

He was firmly convinced that the triumph of principle was apparent rather than real, and likely to produce an immediate reaction :

' When women were slaves, they were really mistresses. Now that they have begun to have rights, they are losing their importance. When they become men's equals, they will be really slaves.' He believed in the strength of the weak, and that the seeds of destruction lay in success. ' The middle classes think they are clever, and they point to the Boulevard Haussmann, the Opera House and the World's Fair as examples of their achievements. They don't know they're digging their own graves. And it's the workers who will gain by it, for the simple reason that they live in slums and work underground.' The condition of miners seemed to him atrocious. ' We'll pay for it some day,' he warned.

To return to the subject of women, Renoir was fully aware of their faults. One thing that annoyed him was their slavish devotion to fashion. The vogue for the slender figure had just begun at the time he was starting out in life. Berthe undoubtedly asked him on occasion to help her lace up her corset. In order to perform the operation properly it was necessary for the husband or lover to place his knee against the victim's backside so that she could brace herself while he pulled the laces with all his might. Renoir protested against this brand of torture.

' Their ribs are squeezed together and gradually get deformed,'
he said. ' And when they become pregnant . . . I pity the poor brat
inside! . . . But when it comes to fashion, they go completely out of
their minds. And it's all to fill the pockets of the corset-makers, who
ought to be put in prison ! '

Narrow shoes and high heels also displeased him. On the other
hand lace pantalettes and a plethora of petticoats amused him, and
he sometimes compared a woman undressing to one of those circus
numbers in which the clown takes off half a dozen vests.

' They cover up their behinds as if they were at the North Pole,
but up above they strip down to the navel.'

The feminine frailty which irritated him most was their way of
doing their hair. ' Instead of leaving their hair alone, they twist
it around, burn it, tug at it unmercifully, fluff it up like sheep's wool
or make it look like a weeping-willow.'

He lost interest in seeing a young girl he knew because she spent
hours on end arranging the curls on her forehead. She would
succeed in achieving a hair's-breadth's difference, but the minute she
moved, the hair's-breadth vanished and she started fiddling with it
again.

' I could have killed her ! ' he declared, and concluded, ' But that's
the other side of the medal ; and why should we ask logic of women,
when it makes men so odious ? '

Sometimes we got on the subject of whores. Renoir could not
abide the romantic enthusiasm of the literary dilettantes for these
so-called ' accursed women '. In the first place, so far as he was
concerned no one was either damned or blessed. Everyone had a
role to play in life, and that was all. The part played by prostitutes
in a social system based on inheritance was perfectly obvious to him.

' It's all a question of money. The lord of the manor didn't want
his wife to deceive him because his domain might go to a bastard
if she did. And so chastity-belts came in. . . . And whores were
necessary in consequence, because if you amuse yourself by begetting
a few bastards on your neighbour's wife there's no reason why your
neighbour shouldn't come and do the same for you.'

He would make fun of men's paternal vanity and jeer at a father
who, bursting with pride over the birth of a male heir, shouts, ' He
looks like me ! '

' And you should see the airs he puts on. For a minute or two
the idiot acts as if he thought he was the Duke of Burgundy and had

just begotten an heir for the Duchy.' Renoir gave a sly smile and
added : 'But one never knows. Women with the strongest
characters are sometimes subject to fits of inexplicable weakness. All
they need then is for a good-looking pimp to come along——' He
seriously recommended having the family name passed on through
the female side : 'It would be a surer way.'

A friend of his who had travelled a good deal told him about the
matriarchal system in South India. He thought it an excellent
idea.

'Inheritance taxes are going to settle it all. Soon there will be
no inheritance left to pass on ; lawful wives will sleep with men
right and left and the "oldest profession" will die out because of
competition. It's a great pity.'

During the period when he was working for the blind-maker a
prostitute from the Halles quarter made open advances to him.

'Those girls from the Halles were really superb creatures. They
were prosperous-looking and covered with jewels. Under Hauss-
mann supplying food paid well, and the costers in the Halles earned as
much as ten francs a day.'

The girls from the Halles were somewhat out of fashion,
however. Many of them dressed like Queen Amélie but with a
lower neck-line. They had not yet been affected by the wave of
prudery which was spreading over England, and they had kept up
the charming eighteenth-century custom of letting their breasts
show over the top of their bodice.

'Those I saw in the Rue Montmartre and the Rue de la Réale,
on my way to work every day, were very young. As they got along
in years the girls from the Halles found they could still do business
in the Rue Saint-Denis. The real veterans took refuge in the streets
running down to the quays and often ended up under the bridges.
They were part of the landscape. Their gaily-coloured silk dresses
blended very well with the butchers' stalls and the mounds of big
orange pumpkins. They would have felt out of place in a drawing-
room in the Faubourg Saint-Germain. There's nothing like having a
sense of values. I had a good time roaming about in the clutter and
confusion of the Halles, but I would probably have been bored stiff
in the Faubourg Saint-Germain.'

The girl who was interested in Renoir was a handsome hussy of
the Spanish type. She kept her competitors in a constant state of
terror, pushing them aside to seize the most strategic place for herself

near the chestnut-vendor's brazier. The other ladies' pimps had the greatest respect for her. Her own ' mackerel ' had been killed in a brawl in which he had ' fallen on the field of honour '. One day she accosted Renoir and he followed her.

' She had a certain allure—and then I didn't want her to start making trouble.'

As soon as he left her he went to see a doctor who was a friend of Lisa's. The doctor explained to him that the only really dangerous venereal disease was syphilis.

' Your sister considers you a great painter,' he said. 'A great many geniuses have been syphilitic. Perhaps I ought to wish you had caught that disease.'

My father thanked him, but he was still uneasy. Even so, he went back to see his conquest. ' I was afraid she would be annoyed if I missed an appointment with her.' But she was so impressed by his modesty and well-bred manners, quite different from those of her usual customers, that she offered to support him as her pimp. ' Instead of doing those blinds you could do a portrait of me,' she suggested. Renoir was in a quandary. ' Not that I look down on a pimp's profession,' he explained. ' On the contrary, I envy them. But it takes up too much time ; and besides, you have to have the gift.'

Renoir must have thought up this anecdote on some rainy night when La Boulangère had forgotten to light the lamps in the apartment in the Boulevard Rochechouart. In any case he must have embellished it considerably. As regards women in general, I remember one of his remarks :

' I feel sorry for men who are always running after women. What a job ! On duty day and night : not a minute's respite. I've known painters who never did any good work because instead of painting their models they seduced them.'

My father often spoke of people's ' short-sightedness ': ' Their sentimentality keeps them from seeing women as they really are ! ' A cousin of Blanche David, Henri's wife, was so beautiful that everyone commented upon it. The lady in question was always draped in black veils and she powdered her face until it looked like a Pierrot's. Her dark hair and enormous eyes completed the effect. ' Spanish eyes ', Charles Leray called them. Spanish things were all the rage just then. ' Calf's eyes ' was Renoir's version. She was very much taken with the young artist ; she wanted him to do a painting

of her in the nude, seated in the moonlight on a high rock gazing out over the ocean.

'I could see her fallen breasts through her veils, so I got out of it by saying we didn't have the rock or the ocean.'

She brought him books to read. He had never read much except the French classics. He knew Ronsard by heart but had little knowledge of Victor Hugo. His great passions were Rabelais and François Villon. The lady with the veils introduced him to the Romantics. Out of all the rubbish he devoured ('Luckily I read rapidly, otherwise I would have lost too much time') he remembered two authors who were worth while : Théophile Gautier and Alfred de Musset. 'They are good company and they speak a language I can understand.'

His would-be Egeria was instrumental in helping him to form a few opinions on the subject of reading in general :

'It can become a vice worse than alcohol or morphine. You shouldn't gorge on books ; but if you do, then you should read only masterpieces. The great writers bring us nearer to Nature ; the Romantics drive us away. The ideal would be to read only one book during one's whole life. The Jews do it by sticking to the Bible, and the Arabs to the Koran. For myself, give me Rabelais any day ! '

It was this same lady who induced my father to go to the theatre occasionally.

'I had to go out sometimes, after all ; and my young brother, Edmond, got me tickets—just how, I never knew.'

Almost all the theatres were concentrated along the Boulevards, in that section between the present Cirque d'Hiver and the Variétés, which in those days was considered the advance guard of a general movement westwards. The Place de la République had not yet come into existence. The Boulevard Beaumarchais extended as far as the Ambigu, which at that time was one of the most modern and luxurious theatres in Paris. The building of the Opéra and the creation of the avenue of that name several years later caused the former entertainment-centre to move elsewhere. The Boulevards, where the theatre, the circus and music reigned supreme, were nicknamed 'Crime Boulevard', according to some people because of the bloody melodramas which were shown there every night, according to others because of Fieschi's attempt on Louis-Philippe's life.

In spite of what my old friend Georges Rivière says, Renoir did

not like melodrama. ' The bourgeois of the quarter love to weep over the misfortunes of the poor little orphan girl. They go home sobbing their hearts out, and then discharge the maid because she's pregnant.'

He could not abide anything of that sort except the works of the elder Dumas, ' that real poet, who invented the History of France '. He asserted in all seriousness that ' that old bore Michelet ' had done nothing but write tiresome imitations of Dumas. ' It's only when you make people yawn that they take you seriously.'

The feature Renoir liked most on ' Crime Boulevard ' was the knockabout shows outside the theatres. Those put on by the circus, which preceded the Cirque d'Hiver, were famous. As well as side-show barkers there were vendors of hair-tonic and hawkers of corn-remedies. The dentists who pulled teeth in public, however, and the doctors who sold their universal panaceas had long since disappeared.

The gas-lights, which flickered in the slightest draught, sent a dappled glow over the female equestrian performers and the dancers in tutus. The acrobats, ' stocky girls, planted on sturdy legs, proudly arched their backs, made supple by double somersaults, and rested on their hip a little hand which was trained not to miss the trapeze bar—and to scrape carrots for their evening soup.'

One wonders if Renoir knew that he would one day put these fleeting impressions of the circus on canvas. For the moment, he was absorbing them through his senses and storing them up for the future. The well-behaved young man whose clothes differed very little from other Paris artisans had already started out on the course which was to lead him to paint his ' Les Grandes Baigneuses ' (in the Louvre) and the last ' Anemones '. Renoir's life makes me think of the flight of migrating birds, that incomprehensible achievement which far exceeds any human invention. There exists no compass, radar or teleguided apparatus to surpass a wild duck's instinct and fixity of purpose. Every spring my garden is full of little grey birds related to the sparrow. My wife and I call them ' cricketers ', because of their black-and-white-striped caps. At a fixed date they come from other latitudes and alight under my olive tree. Without a moment's hesitation they fly up to a branch, which was the goal they were aiming for when they first started out on their journey thousands of miles away. This precision, which never wavered during the immense distance covered and which brought them, as if drawn by a magnet, to the spot Nature had assigned them, might

serve as a symbol to help us understand Renoir's pattern of behaviour. It would be incorrect to say that his will did not play a part in the matter. In spite of seeming to give up, the ' cork ' was struggling doggedly to keep on its way. The truth is that while his instinct was stronger than his intellect, he allowed the latter to assume control when it seemed appropriate to his destiny. He might make a detour here and there, even halt sometimes, even in spite of his theory go for a while against the current, but he always resumed the direction which led to his discovery of the world. I am quite certain that the direction Renoir took was as unpremeditated as that chosen by the birds to reach my garden. I believe, moreover, that if Renoir had not been able to paint, if for instance he had lost an arm or been blind, he would have followed the same route. He would have expressed what he had to say in another way. Instead of colours and forms, he would have used words, or just sounds. The ' literary set ', as my father designated writers who allow their imagination to isolate them from life, have thought up a great many reasons to explain talent. Some of them try to make out that Toulouse-Lautrec took up painting in order to escape from the anguish his physical deformity caused him. The fall from his horse, which happened to him when young, had stunted his growth so that his dwarfed appearance made society-women turn away from him as they would from a monster. Because of all this, he consoled himself with whores and painting. There is some truth in the theory that obstacles in one's path do help, but they are not sufficient : or perhaps they suffice in the case of inferior activities such as business or politics. Rockefeller's character was probably influenced by his weak stomach, Franklin Roosevelt's by his infantile paralysis. Even so, I am not convinced. Rockefeller was probably born with a genius for making money, and Roosevelt with a vision of history. Favourable soil and careful tending can make a magnificent oak out of a stunted sapling. But there was the acorn to start with. You can't grow roses by planting cabbages. As far as Toulouse-Lautrec is concerned, I have seen drawings that he did as a child, before his accident, and Toulouse-Lautrec is already evident in them.

Gabrielle knew him well. While I was still little, she used to carry me on her arm when she went out to do errands in the shops near our house in Montmartre. Toulouse-Lautrec was often to be seen sitting enthroned in the window of a café on the corner of the Rue Tholozé and the Rue Lepic. I was too young to remember

anything ; but in later years I was able to form some idea of what he was like through Gabrielle's stories about him. He called to us and made us sit down with him between two female friends of the moment : two Montmartre women in Algerian dress with exotic names. They did the belly-dance at the Moulin Rouge. When she gave me this description of him, I often asked Gabrielle : ' Do you think he was self-conscious about his deformity ? '

' Not at all,' she replied. ' He joked all the time. He was always asking after the master, and his eyes shone with real tenderness. He was very fond of the master.'

But let us return to the young Renoir, who did not yet dare to call himself a painter. One day as he was eating a croissant in a café near the Halles he happened to overhear an argument between the proprietor and a contractor about redecorating the place. They were discussing the cost of the work, but the price evidently seemed too high to the owner. As soon as the contractor had gone Renoir went up to the café-proprietor and offered to take on the commission. The latter refused to believe that a mere lad was capable of handling the job.

' And what if you ruin the walls ? ' he asked.

Renoir was able to persuade him by saying that he would not expect to be paid until the work was finished.

' You can hardly believe how exciting it is to cover a large surface. It's intoxicating.' He very soon realized that the great difficulty about mural decoration is in being able to judge the perspective. ' You've got your nose right up against your subject ; in easel-painting you can stand back to look at what you're doing. But with this sort of thing you're stuck there, on the ladder.'

He climbed up and down the scaffolding, running continually from one side of the café to the other so as to gauge the proportions of the mural he was painting. The café-owner's entire family gathered to watch his acrobatics.

' A regular squirrel, he is,' said the proprietor, whose plump figure lent him a certain slow dignity. He was highly pleased with the results. And well he might have been, for Renoir had completed in two days what a professional would have required a week to do.

' I had taken Venus rising from the waves for my subject. And I can assure you that I didn't spare either the Veronese green or the cobalt.'

The customers came in great numbers to admire the Venus and

drink a beer or two, and in this way Renoir got other commissions.

' I painted at least twenty cafés in Paris,' Renoir asserted cockily. ' How I would like to do decoration again, like Boucher, and transform entire walls into Olympuses. What a dream ! Or rather, what twaddle. Here I am, not even able to get up from this chair.'

Of all the murals Renoir painted in those days not one is left. I have no idea whether it was at this period that the architect in charge of building the Folies Bergère Theatre asked my father to do the decoration for it. In any event Renoir could not have accepted the commission because he would not have had the money necessary to rent the scaffolding, pay assistants, or meet the enormous expense entailed in such an undertaking.

' I don't regret it. I would have had to have the backgrounds done by others, and I had already developed a mania for doing everything myself.'

Even so, the Folies Bergère decorated by Renoir might have been quite an attraction in Paris !

Though I cannot recall these talks with my father word for word, I have tried to give a fairly accurate version of them, even if some of the incidents sound naive. In any great man there is a certain innocence. My main purpose is of course to enable the reader to form a clear idea of a man he already admires for his achievements. The essence of Bach is in his music, that of Socrates in his discourses as recorded by Plato in his *Dialogues*—and the essence of Renoir, the deepest and most vital part of him, is obviously in his painting. Nevertheless if, besides Plato's record, someone else had described how Socrates behaved when suffering from toothache, we should be very interested.

All the while that he was painting divinities and symbols on the walls of Paris cafés, Renoir was making plans. The idea grew, took shape and became more definite with every commission which added to his savings. He decided to study painting in one of the recognized art-schools. In other words, Renoir crossed his Rubicon and resolved to become a professional artist. He was a little under twenty at the time.

# IO

By the time he was twenty my father was mature. He had had to earn his own living, he had made many friends, and he had perhaps had a few love-affairs. He had not yet known poverty, thanks to the tender care of his parents and also to his own astonishing ability. His different occupations, his painting, which he fitted in on the side, his relationships with girls and men friends, his attachment to his family, had all enabled him to live through a troubled period in France's history without becoming too involved in it.

The establishment of the Republic in 1848 had been followed by frightful disturbances. There had been street fighting and barricades. The Royal Guards, though changed to Republican Guards, had continued to fire on the people as they had done in the past. France had known the immense hope of the Government Workshops— 'bread for all'—and the despair of a bloody setback. The Prince-President, in the name of liberty and democracy, had re-established the Empire ; as Napoleon III, he had revived the Court and made the troops dress in colourful uniforms before sending them out to be killed on distant battlefields. After several years of sacrifice in the cause of universal brotherhood, the French had become wildly patriotic, and the cockade had returned to favour. The social order was assured. Having liquidated the aristocrats, the middle classes had installed themselves in their châteaux and had no intention of being turned out of them. They had discovered how pleasant life could be. They were ready for the music of Offenbach. A few of them were to prove that they were ready for the art of Renoir. Those few were exceptions, naturally ; for it would mean a little sacrifice on their part to invest in something that might become the great art of tomorrow—though even if triumphant, of course, art

could not be compared with the stunning success of the courtesans then in fashion, the great dressmaking establishments, or the race-course. Unlike his friends, Renoir approved of these worldly pleasures which drew the new rulers into the round of fashionable life

'It is excellent training. They begin by getting to know a harlot; before long she becomes ambitious and wants to be set up in a mansion with a Watteau on the wall. For that, all she needs is a pimp who has a bit of artistic taste. And after the Watteau—who knows, she might be wanting a Manet!'

He was sure that the values of the eighteenth century he loved so much were in the process of being destroyed. ' Those who were replacing the older generation had to get rich, of course. One good way was to put up factories instead of laying out gardens. Before the factories appeared, the Ile de France was a rose-garden. All those factories! But at least they have no architectural pretensions. Alas, there's also the Opera House; and the Place de la République, and the Boulevard Raspail; and the Grand Palais! . . .'

Renoir believed that although bad taste was bound to spread, something good would surely come out of it.

' At any rate we certainly couldn't count on the descendants of the Crusaders to buy our pictures. They had eyes only for their racehorses. We were only too glad to have the rich bourgeoisie to fall back on. It was our only chance.'

The 'cork' was right once again. He was to find ample material for painting in the current which was carrying the new society along —and also, in spite of periods of financial difficulties, a way to avoid dying of hunger.

' Moreover, the taste so clearly visible in works of the eighteenth century was probably unconscious. Genuine human achievements are always unconscious.' And he cited a story that made him shudder: how Mme du Barry, for once in accord with Queen Marie Leczinska and the entire Court, had planned to have the ' Venus of Arles,' whom she thought too fat, ' remodelled '.

' Imagine daring to touch the " Venus of Arles " ! The Jacobins did well to guillotine that idiot du Barry. She deserved it a hundred times over!'

Regarding the ostentatious luxury which Parisian society indulged in after the Commune, Renoir said: ' I like beautiful materials, rich brocades, diamonds flashing in the light, but I would

have had a horror of wearing such things myself. I am grateful to those who do wear them, provided they allow me to paint them.' Then, as he so often did, he took the opposite view : ' On the other hand, I would just as soon paint glass trinkets and cotton goods costing two sous a yard. It is the artist who makes the model.' He reflected a moment. '—Yes and no. I need to feel all the excitement of life stirring around me, and I'll always need it.'

As Renoir had announced his intention of taking some courses in an art-school, his ' artist ' friends, Oullevé and Laporte, and his brother-in-law Leray, advised him to go to the Atelier Gleyre, one of the most talked-of in the capital.

What Renoir wanted to learn especially was to draw figures well : ' My drawing was accurate but a little harsh.'

I asked him if he thought he had learned anything in the school.

' A great deal,' he said. ' In spite of the teachers. The discipline of having to copy the same anatomical model ten times is excellent. It's boring, and if you weren't paying for it you wouldn't bother to do it. But the Louvre is the only place to learn, really. And while I was at Gleyre's, the Louvre for me meant Delacroix.'

From Renoir's allusions to this phase of his life, two important things stand out : his drawing a lucky army number, and his meeting with Bazille.

Without the first, Renoir would have had to serve seven years in the French Army. The system of military recruiting was based on ' drawing lots '. Those who ' won ' in the lottery were exempt from service : the ' losers ' had to do their seven years. When I congratulated my father on having been spared the ordeal, he replied : 'One never knows. Perhaps I might have become a military painter. It must be fascinating to paint scenes of besieged towns surrounded by different-coloured tents and little clouds of smoke.'

His meeting with Bazille[1] marked Renoir's entry into a new world, and the change from the provincialism of his early years to the more sophisticated life of the city.

' How many Parisians are really provincial and don't know it! '

I asked if he meant people in the district where he had lived at that time.

[1] 1841-70. French Impressionist painter, and one of Renoir's intimate friends.

'Not at all. In your own district you can get to the bottom of things. Being provincial is an inability to discern. In Paris you can choose, use your discernment. You don't bother about "getting on"; you gather in groups because you believe in the same things and you would rather die of hunger than retract.'

'How I wish you had known Bazille!' Renoir smiled pensively as he recalled the friend he had been so fond of, and his mind went back to the day when at twenty he first entered the Atelier Gleyre and saw that big room crowded with young art students working away at their easels. A large bay window on the north side shed a greyish light on a nude male model. 'Old Gleyre had made the model wear a pair of short drawers so as not to offend the female students.' There were three women in the class, one of them a young English girl, who was chubby and covered with freckles. Every time she came to the school she asked if the model could be allowed to take off his 'little panties'. Gleyre, a sturdy Swiss, who wore a beard and was near-sighted, refused flatly. The English girl asked if she might speak to him in private about it. The rest of the students swore they knew just what she had said :

'But Mr Gleyre, I know what it looks like, because I have a lover.'

And Gleyre is supposed to have answered, 'Put I don'd wand do lose my sdudenz from the Vaubourg Saint-Germain.'

As we know, Renoir wore his artisan's smock to work in. It was the same one which later on was to cause the incident of Diaz and the shop-girls in the Forest of Fontainebleau. This costume now caused his fellow-students to make fun of him, especially those young men who came from well-to-do families and wanted to dabble in art. Several of them gave themselves airs to the point of sporting a black velvet coat and a beret. Renoir did not feel at ease in a milieu so different from that of the Parisian artisans to which he was accustomed. But the jokes they made about him did not bother him much. He had come there to learn how to draw the human figure. The sheet of paper on his drawing-board was soon covered with charcoal lines, for he was too busy delineating the modelling of a leg or the curve of a hand to pay much attention to anything else.

One evening when he had been at the school for about a week one of the students came up to him as he was leaving and said : 'Are

you going down towards the Observatory? I live in the Rue Campagne Première.'

As the Atelier Gleyre was on the Left Bank, my father had rented a furnished room in that part of town. He had already noticed his fellow-student, a handsome, well-groomed young man—' the sort who gives the impression of having his valet break in his new shoes for him'.

They walked along together and entered the Luxembourg Gardens. A ray of autumn sun lit up the landscape. There were children with their mothers, young girls, soldiers: a medley of colours standing out against the grey stones of the flower-beds and the gold of the turning leaves. Bazille told his companion that that was the kind of thing he would like to interpret.

'The big classic compositions are finished,' he said. 'The spectacle of daily life is much more interesting.'

Renoir did not answer. His attention had been attracted by a baby crying in its pram. Its nurse had left it for a moment to flirt with a trumpeter in the hussars who was loitering near by.

'That infant is going to choke to death.'

He walked over and timidly rocked the pram. The child stopped crying, and the sudden silence made the nurse turn round. Seeing a stranger leaning over the baby, she uttered a cry of alarm.

The hussar approached Renoir and began to manhandle him. Several mothers came running up threateningly. There were shouts of 'Kidnapper!'

A park guard intervened just in time. Renoir's new friend explained what had happened, and with an air of authority, presented his card. The man, impressed by his well-bred look, became very respectful; but he said to my father: 'Don't let me catch you at it again.'

The two friends could not help bursting out laughing.

'Let's go and have a glass of beer,' Bazille suggested.

They went to the Closerie des Lilas and sat down at one of the tables.

'What gave you the idea of speaking to me in the first place?' Renoir asked.

'From the way you draw,' answered Bazille, 'I feel that you really are somebody.'

I must digress here to give the reader some explanation of the incident in the Luxembourg Gardens. My father often told me how

frightened he was of crowds, and how hostile they were to him. He cited a number of instances. I have already recounted the one relating to Diaz and the rowdies. It is difficult to account for the enmity of strangers towards one who inspired the most devoted affection in those who really knew him. Once more I must touch on the quality of 'strangeness' which emanated from Renoir. His self-effacing manner did not succeed in concealing the anomaly which so antagonized those not accustomed to it—which was, simply, genius. One gets used to everything. Most people got used to Renoir fairly quickly. But the first contact was usually startling. His personality was as unconventional as was his painting. It is the old story of the ugly duckling.

Here is another example of Renoir's relations with a crowd. At about this same period Renoir was going along a street where some buildings were under construction, when he felt a call of nature. He looked around, and as there seemed to be no one in sight, he went up to a long wooden fence which had been put up to keep out intruders, found an opening between two boards, and relieved himself. Suddenly he became aware of someone standing behind him. He turned round and saw a stranger staring at him indignantly. The stranger began to shout, ' Satyr ! Satyr ! Arrest him ! '—and climbed up on the fence and began to address a number of mothers with their children, who unknown to Renoir were on the other side. The newcomer had no trouble in persuading his audience that ' this disgusting individual was guilty of flagrant exhibitionism.' A furious crowd gathered in an instant—' they almost seemed to spring out of the earth '—and advanced towards him. Seeing that there was nothing else for it, Renoir took to his heels. The crowd followed in hot pursuit. Luckily Renoir was a fast runner. Nevertheless, though he ran like mad for half a mile, his tormentors were still close behind him. Suddenly he sighted a police station and in desperation dashed in, breathlessly told the officer in charge what was going on, and asked for protection. The officer lectured him severely, but kept him safe until the mob outside decided to forget about lynching him and gradually disappeared.

To return to Bazille, my father's new acquaintance came from a wealthy family of the old Parisian bourgeoisie. His parents were acquainted with Edouard Manet, and he had been invited several times to visit the master in his studio.

' Manet is as important to us,' he said, ' as Cimabue or Giotto

were to the Italians of the Quattrocento; and as the Renaissance is beginning again, we must be part of it. . . . Do you know Courbet ? '

Bazille and Renoir began to plan to get together a 'group' of artists who would carry on still further the researches of these two masters. They half sensed they were on their way to Impressionism. Their conversion to the cult of Nature had already started. They did not hesitate to steal the time they usually spent in the museums to study the dazzling spectacle of autumn foliage. Whenever they heard of some young painter who was ' following the new ideas', they would hasten to find out all they could about him. And each time they were disappointed, because he turned out to be the ' literary ' type of artist who imagined that the purpose of painting is to tell a story.

' If you want to tell a story, you take a pen and write it. Or you can even plant yourself in front of a fireplace in a drawing-room and tell it there.'

I had some trouble in persuading my father to give me a few more details about his friendship with Bazille, and the dreams and ambitions they shared.

' Why talk about the dreams of two young hot-heads ? The only thing that counts is what a painter puts on his canvas, and that has nothing to do with dreams. What he is dealing with is good paint, mixed with good linseed oil and a drop or two of turpentine.'

Yet at other times he would say to me :

' You should wander about and day-dream a bit. It's when you are not doing much of anything that you are accomplishing most. Before you can have a roaring fire, you've got to gather a good supply of wood. Think that one over. The important fact is,' he added, ' that Bazille had a great deal of talent—and courage, too. You need plenty of it when you have money, if you want to avoid becoming a mere society-man. Our discovery of Nature turned our heads.'

He often liked to enlarge on anecdotes which to me seemed rather trifling. One of them concerned the Dutch Ambassador's visit to the Atelier Gleyre. The Ambassador had a daughter who wanted to learn to paint. Gleyre was very impressed. His powerful figure shifted from one foot to the other, as he made little bows and friendly gestures of welcome. In his thick accent he exclaimed rapturously :

' A bubil from Remprant's and Rupens's native gountry. Vot an honour for de School ! '

His pupils, as though quite by chance, had left in full view the pictures of the male model, whom they had deliberately portrayed without his drawers. They had even equipped the gentleman with attributes of a size to make Karagueuze sick with envy. Gleyre flushed and hastened to turn the canvases face to the wall, edging his visitors to the safety of his private office. This office was at the far end of a little garden, and had three stone steps in front of it. One of the students, a bit of a wag, would occasionally place a bit of glazed faience in the shape of human excrement on one of the steps. Gleyre never paid much attention to it but usually pushed it aside with his foot when he went in. The Ambassador and his wife and daughter were dumbfounded when they beheld the unsavoury object blocking their way.

' Don't bay it any nodice,' Gleyre begged them, apologetically. ' It's only a choke.' And he picked up the offending piece with his hand to show the Ambassadress that it was only an imitation. However, by some mystery which was never explained, that day it turned out to be the real thing !

Renoir confirmed the well-known story about Gleyre stopping one day to examine the rough sketch my father was working on. After contemplating it for a moment, he said : ' Young man, you are fery skilful, fery gifted, but no doubd you dook up bainding chust to amuse yourzelf.' To which Renoir replied, ' Certainly. If it didn't amuse me I wouldn't be doing it.' His retort has rightly been considered by several authors of other works on Renoir as being a declaration of his artistic principles.

The sheer delight Renoir took in painting did not prevent him from being an excellent student. He passed brilliantly the competitive tests in anatomy-drawing, as well as those in perspective and ' likeness '. He was also among the first in the final examination. Fantin-Latour, then at the height of his glory, made no secret of his admiration for Renoir when he visited the Atelier Gleyre and singled out this pupil ' whose virtuosity harks back to the Italian Renaissance '. He invited my father to come and see him, and joined with Gleyre in cautioning him against ' the cult of the immoderate use of colour '. Renoir, who was always polite, acquiesced. And to please Gleyre—' a second-rate schoolmaster but a good man '—he painted a nude for him which conformed to all the rules : ' caramel-

coloured flesh set off by bitumen as black as night, back lighting on the shoulder, and a tortured expression on the subject's face, apparently due to a pain in the stomach'. At first Gleyre was thrilled, then he was shocked. His pupil had shown that he could paint 'dramatically', and yet he persisted in representing human beings 'just as they are in everyday life '.

' You are making game of beoble,' said Gleyre.

One day Bazille brought a young painter to Gleyre's studio, who was just as determined as he was to 'set fire to the *pompiers*'. His name was Sisley. His father was an English businessman who had married a French woman and settled in Paris. After each sitting, Renoir and his two companions would go and have a beer at the Closerie des Lilas, where they would carry on lively discussions together. Eventually Monet came to reinforce the group. He had so much self-assurance that he soon became their leader. Then Frank Lamy,[1] as well as several others whose names escape me, became members of the little band of young ' intransigents'.

Pissarro never attended the Atelier Gleyre. Bazille met him through Manet, and brought him to the gatherings at the Closerie. Old Gleyre sensed that the wind of revolt was rising in his school. He caught the freckled English girl putting a touch of vermilion on the nipples of the figure she was painting. Gleyre's face turned a bright red.

' Id's intecend.'

' I am for free love and Courbet,' retorted the young lady.

Pissarro and Monet were the most fanatical of the whole crowd. They were the first to condemn the study of the great masters and to advocate learning direct from Nature and from Nature only. Corot, Manet, Courbet and the Fontainebleau School were already working from Nature. But in interpreting it they followed the teachings of the old masters. The Intransigents' object was to transcribe their immediate perceptions on to their canvas without any interpretation. They considered any pictorial explanation as a capitulation. Renoir agreed, but with a few reservations. He could not forget Fragonard's enticing bourgeois women. The question he posed himself was whether Fragonard had painted in his portraits ' what he saw ', or had made use of the formulae handed down by his

[1] A painter who saw a good deal of Renoir during the ' Moulin de la Galette ' period.

predecessors. Yet the current was irresistible. And after hesitating for a short time, the ' cork ' plunged enthusiastically into this pool of impressions of Nature, which constituted the ' credo ' of the new painting.

Even before he had left the art school, Renoir was faced with the dilemma of his whole existence. Two contrary propositions which were to evolve later already troubled him and kept him awake at night.

The choice was between the excitement of direct perception and the austere ecstasy found in the study of the old masters. This choice was presently to assume a more definite technical character. One would be forced either to work from Nature, with all the uncertainties that that implied, including the tricks played by the sunlight : or else to work in the studio under the cold precision of controlled light. The real dilemma, which can be considered the central theme of his life—the contest between subjectivism and objectivism—Renoir always refused to put to himself in the form of a direct question. I hope that the reflections and recollections recorded in this book will aid the reader to solve it for him.

Everything conspired to influence him to follow the Intransigents: his love of life, his need to enjoy all the perceptions registered by his senses, as well as the talent of his comrades. The ' official school ', only imitations of imitations of the old masters, was dead. Renoir and his friends were very much alive, and it was to them that the duty of revitalizing French painting fell.

The meetings of the Intransigents were lively in the extreme. They were fired by the desire to share with the world their knowledge of reality. Ideas were tossed about, controversies broke out, declarations poured forth. Someone very seriously proposed burning down the Louvre. My father suggested that the Museum should be kept as a shelter for children on rainy days. Their convictions did not hinder Monet, Sisley, Bazille and Renoir from regular attendance at the school run by old Gleyre. After all, the cult of Nature was not incompatible with the study of drawing.

Monet amazed old Gleyre. Everyone, in fact, was impressed, not only by his virtuosity but also by his worldly manner. When he first came to the school the other students were jealous of his well-dressed appearance and nicknamed him ' the dandy '. My father, who was always so modest in his choice of clothes, was delighted with the

spectacular elegance of his new friend. 'He was penniless, and he wore shirts with lace at the cuffs !'

Monet began by refusing to use the stool which was assigned to him when he first entered the classroom. 'Only fit for milking cows.' As a rule the students painted standing up, but they had the right to a stool if they wanted it. Until then it had never occurred to anyone to bother about these stools one way or the other.

Good old Gleyre had the habit of getting up on the little platform on which the model posed, and giving advice from that vantage-point to this or that novice. One day he found Monet installed in his place. Monet's explanation was that he needed to get nearer the model in order to examine the texture of the skin.

Except for his friends in their 'group', he looked upon the rest of his fellow-students as a sort of anonymous crowd—'just a lot of grocers' assistants', he called them. To a rather pretty if somewhat vulgar girl who started to make advances to him he said : 'You must pardon me, but I only sleep with duchesses—or servant-girls. Those in between nauseate me. My ideal would be a duchess's servant.'

Pissarro was a totally different type. He was ten years older than Renoir. Born in the West Indies, he had a way of expressing himself slowly, in a soft, musical voice. He was careless in his dress, but not in words. He was to be the theorist of the new School.

Renoir had to leave the Atelier Gleyre and go back to his decorating work, for his money had run out. Even so, he did not give up 'real painting', and he remained a loyal and active member of the group. His family were alarmed to see him following such a risky course.

'He is an artist, but he'll die of starvation,' my grandfather said, shaking his head.

Even Lisa advised my father to be sensible and to try his hand at doing portraits.

'And that is just what I was doing. The only trouble was that my models were my friends, and I was doing their portraits for nothing.'

But within the family an unexpected champion appeared : Edmond, Renoir's younger brother. Edmond had not given up his ambition to become a writer. In fact, he was one already. At

eighteen he was contributing regularly to several newspapers. He
is the author of the first article on Renoir, in which he announced the
birth of a new movement.

Before concluding this chapter of Renoir's life, I should like to
digress a little and give a few examples of the kind of songs Gleyre's
students used to sing in the streets to proclaim that they were
qualified artists. Here is one :

> La peinture à l'huile,
> C'est plus difficile ;
> Mais c'est bien plus beau
> Que la peinture à l'eau.

Another ditty, sung to the air of ' Prends ton fusil, Grégoire '
went as follows :

> Prends ton pinceau, Gérome,
> N'rate pas le train pour Rome,
> N'oublie pas l'jaune de chrome.
> Ces messieurs sont partis
> A la chasse au grand prix.

Gérome was forty years old, and he was following nobly in the
steps of the *pompiers* and had just won the Grand Prix de Rome.
When Georges Rivière reminded Renoir, in my presence, of these
nonsensical pranks, my father shrugged his shoulders.

' They wouldn't have hurt a fly,' he said.

After Renoir had given up his decorating work entirely, he and
Monet shared lodgings. They managed to eke out a living by doing
portraits of small tradespeople. Monet had a knack for arranging the
commissions. They were paid fifty francs for each portrait. Some-
times months would go by before they were able to get another
commission, nevertheless Monet continued to wear shirts trimmed
with lace and to patronize the best tailor in Paris. He never paid the
poor man, and when presented with a bill, treated him with
the haughty condescension of Don Juan receiving Monsieur
Dimanche.

' Monsieur, if you keep insisting like this, I shall have to with-
draw my custom.'

And the tailor did not insist, for he was overcome with pride in
having a gentleman with such elegant manners as his customer.

' He was born a lord,' said Renoir.

All the money the two friends could scrape together went to pay for their studio, a model, and coal for the stove. For the problem of food they had worked out the following scheme :

Since they had to have the stove for the girl who posed for them in the nude, they used it at the same time for cooking their meals. Their diet was strictly spartan. One of their sitters happened to be a grocer, and he paid them in food supplies. A sack of beans usually lasted about a month. Once the beans were eaten up, the two switched to lentils for a change. And so they went on confining themselves to starchy dishes which required little attention while cooking.

I asked my father if eating beans at every meal had not been hard on their digestion. ' I've never been happier in my life. I must admit that Monet was able to wangle a dinner from time to time, and we gorged ourselves on turkey with truffles, washed down with Chambertin ! '

A few canvases remain from this period, for they were miraculously saved in spite of being moved from one house to another, or left in an attic, or destroyed by the artist himself, or going through countless other hazards. Renoir painted so many pictures that his work has escaped wholesale destruction from one cause or another. When one reflects on early paintings which have survived, such as the portraits of my grandmother, my grandfather, and Mlle Lacaux, as well as ' The Sleeping Woman ' and ' Diana the Huntress ', one can understand why the French public of nearly a hundred years ago left it for a later generation to pour out a stream of insulting criticism. It is good painting in the best French tradition. I am surprised, however, that this public did not discern in those pictures that little something which is, properly speaking, the sign of genius. How could they not have been struck by the serenity of the models, which relates them to those of Corot or Raphael ? One critic, my father told me, thought he detected in the ' Diana ' a trace of that ' discovery of Nature ' which was to make all Paris howl with rage ten years later. He spoke of the ' purity of the tones ' and he even used the expression ' love of flesh '. Young Renoir felt very flattered by the critic's appraisal : ' I began to think I was Courbet himself.' But as an older man, Renoir took quite a different view.

' I have a horror of the word " flesh ", which has become so shopworn. Why not " meat ", while they're about it ? What I like

is skin, a young girl's skin that is pink and shows that she has a good circulation. But what I like above all is serenity.'

He would mention time and again ' that gift women have of living for the moment. I am speaking, of course, of women who do housework or other kinds of work. The lazy ones get too many notions into their heads. They become intellectuals, lose their sense of eternity, and are no good to paint any more. And,' he pursued, ' their hands become as stupid and useless as this famous appendix modern surgeons are so fond of taking out.'

In 1863 Renoir submitted his 'Dancing Esmeralda' to the Salon. The picture was accepted, an event which was interpreted by the entire family as a triumph. Edmond Renoir wrote a long article about it. But Renoir was not too confident himself.

' It's all very well to be accepted by the Salon, but it only happened by a fluke. I already felt that the officials were going to turn against us sooner or later. Just at that time the issue was still in doubt.'

The first visits to the Charpentier family took place before the War of 1870, as is testified by the portrait of the elder Mme Charpentier, painted in 1869. At the same time my father met Arsène Haussage and Théophile Gautier, who helped him to place some of his landscapes. As a matter of fact, it was Gautier who introduced Renoir to the eminent publisher.

And then he met Cézanne.

' From the very start, even before I had seen his painting, I felt he was a genius.'

The friendship between the two men was to last all their lives, and it has been carried on by their descendants. And yet what a difference there was between the two artists. Cézanne was only two years older than Renoir, but he seemed much older. ' He looked like a porcupine.' His movements seemed restricted, as though encased in some invisible shell—and his voice too. He articulated his words carefully in his strange Aixois accent—an accent, I may say, which contrasted with the reserved but exaggeratedly polite manners of the young provincial. Yet his restraint would give way at times, and he would then come out with his two favourite insults, ' Eunuch ' and ' Blockhead '. Cézanne's constant fear was that someone might ' get his hooks on him '. He was very suspicious. Renoir was just the opposite. Not that my father was a simpleton : but in his opinion, being always on your guard wasted too much time and

energy. 'The game's not worth the candle! Besides, I had no possessions or money to lose.' He went so far as to assure me that you should let people get the better of you. 'If you don't fight, you disarm them,' he said. 'Then they become nice. People love to be nice; but you must give them the chance.'

Cézanne was never a very active member of the group of friends who more and more gathered around Monet and Pissarro. 'He was a lone wolf.' But he shared their ideas and their hopes. He had faith in 'the judgment of the people'. The whole problem was to find a way of getting one's work shown, of forcing the doors of Monsieur Bouguereau's Salon, and then the value of the New Painting would be obvious to everyone. Napoleon III, who after all 'was not such a bad bugger', as Cézanne put it, decided to organize a 'Salon des Refusés', open to those who had been rejected by the official Salon. This exhibition did not fulfil the hopes of the young innovators. The public took no interest in it, and the newspapers spoke of it as something His Majesty the Emperor had thought up for his own amusement.

When Cézanne first arrived in Paris, he had counted a great deal on Zola to help him to 'break in'. The two men from Aix had been schoolmates. Lying under the big pines at Le Tholonet, they had dreamed of Paris together, and together they had sketched their first landscapes and written their first verses. Zola had been received at the Charpentiers'. Cézanne was cantankerous by nature, and did not care to go out into society. He preferred the company of the painters he knew, and above all the solitude of his own studio.

'I paint still-lifes. Women models frighten me. The sluts are always watching to catch you off your guard. You've got to be on the defensive all the time, and the motif vanishes.' He kept hoping that his boyhood friend would 'put in a good word for him'. But Zola felt that his would-be protégé was not quite 'ripe' yet. He was all for official painting: 'That means something.' When Cézanne told him of his difficulties in solving 'the problem of volumes', his friend tried to convince him how vain such researches were.

'You are gifted. If only you would work harder on the expression. Your characters express nothing.'

One day Cézanne got angry.

'And what about my backside?' he demanded. 'Does that express anything?'

This retort did not provoke a quarrel, but it created a certain coolness between them. Zola was only too pleased, because he was somewhat ashamed of his friend. Cézanne's painting was that of a madman, and his peculiar accent made it awkward to take him anywhere socially. As Zola lost interest in him, Cézanne had gradually given up hope of being able to find buyers for his work. He went on painting, nevertheless, and consoled himself with the thought that he could, perhaps, count on 'posterity, which is never mistaken'.

One day he came, all radiant, into the studio Renoir shared with Monet, and announced in high spirits that he had a buyer. He had unearthed him in the Rue La Rochefoucauld. Cézanne was returning from the Gare Saint-Lazare on foot, as he had been out at Saint-Nom-la-Bretèche working on a 'motif', and he had his landscape under his arm. A young man in the street stopped him and asked to see the picture. Cézanne put it down against the wall of a house, making sure that it was well in the shade so as to avoid any reflections of light. The stranger was delighted with it, and especially with the green of the trees.

'You can almost smell the freshness,' he said.

'If you like my trees, you can have them,' replied Cézanne.

'But I can't afford to buy them.'

Cézanne insisted, and the art-lover went off with the canvas under his arm, leaving Cézanne as pleased as himself.

He turned out to be a musician named Cabaner, who played the piano in cafés and was practically penniless. His insistence on playing his own compositions caused him to lose every job he got. My father thought he had a good deal of talent. 'The trouble with him was that he was born fifty years too soon.'

Rivière also praised him, and declared that he was exceedingly gifted, 'though prematurely abstract'.

At a period when people were swooning over Meyerbeer, Cabaner claimed that there were only two composers: Bach and himself. My father told me 'he looked like a provincial lawyer.' Rivière, on the other hand, described him as a wild bohemian, as eccentric in his habits as in his dress. I might add that Rivière himself was the very prototype of the provincial lawyer. If I dwell for a moment on Cabaner, it is because his name often came up in Renoir's stories.

He became a member of the young painters' group. One day

the poet Charles Cros asked him if it was possible to express silence by music. Cabaner answered:

'To me it would be easy . . . with the help of three military bands.'

And again:

'My father was a type something like Napoleon, but less of an ass.'

Later on, during the siege of Paris, he chanced one day to be walking with Goeneutte[1] along the fortifications. Several shells exploded a hundred yards away from the two men.

'What's that?'

'Shells,' replied Goeneutte.

'Who's firing them?'

'The Prussians. Who do you suppose?'

Then Cabaner remarked with a vague gesture:

'How should I know? Perhaps the Turks?'

As Bazille had not entirely given up his social life, he brought one of his friends from time to time to the gatherings of his fellow-painters at their favourite café. The newcomer was the young Prince Bibesco, whose parents were intimate friends of the Emperor and Empress. He conceived a great liking for Renoir, bought some of his canvases, helped him to sell a few, and above all—'he took me out occasionally. There are times when one should spruce up a bit.' My father did not believe in the society-painter who when six o'clock came round threw off his velvet coat, donned his evening-clothes, and went to call on dancing-girls in their dressing-rooms, or courted duchesses, or else spent his mornings riding in the Bois de Boulogne, or practised fencing at Gastyne Reynette's establishment.

'He does his painting between two duels—when he can spare the time.'

He had no liking, either, for the gruff type of artist, who as a reproach to those dressed in silks and satins wears heavy corduroy and like Millet affects a thick peasant accent to show his attachment to 'the soil'. The jibe against artists 'surly as bears' should not be interpreted as applying to Cézanne. My father approved entirely of his ruggedness, justifying it by remarking that 'he is a real

---

[1] 1854-94. French painter and engraver; one of Renoir's friends and models.

person, at least; and his manners express all the finesse of the people of the Midi.'

Each of Renoir's friends brought him a gift for which he was grateful. Bibesco gave Renoir his first opportunity to see the bare shoulders of women in their beautiful evening-gowns; Cézanne revealed to him the precision of Mediterranean thought; Monet opened his eyes to the wild imagination of the art of the northern European countries; and Pissarro formulated in theoretical terms his own and his friends' researches. Each of his friends contributed to the store of aesthetic wealth which they shared in common: and certainly Renoir, more receptive than the rest, took advantage of it. He had already learned how to let himself be influenced by others and yet remain fundamentally himself.

Sisley's gift was gentleness. ' He was a delightful human being.' Women were particularly responsive to Sisley's sincere interest in them. But the road Sisley travelled ended in a calvary. He was the victim of his gentleness. He would be overcome by emotion by the pressure of a hand or even at a grateful look.

' He could never resist a petticoat. We would be walking along the street, talking about the weather or something equally trivial, and suddenly Sisley would disappear. Then I would discover him at his old game of flirting.'

It must be said that in these matters he showed very good taste. My father recalled one of his conquests, the servant-girl of an inn on the edge of a wood, in one of the Paris suburbs.

' She was a superb girl. I painted her, and she posed like an angel. But Sisley wasn't satisfied with just painting her. She was wild about him. I don't know how it all ended. I went back to Paris before he did, for I was going through a crisis just then.'

We know now what the crisis was that Renoir was referring to. It was going to lead him to the famous exhibition[1] of 1874, which prompted the critics, as well as the public, to pour out a flood of insults and thereby confirm his genius.

In the Art Museum at Cologne there is a portrait by Renoir of M. and Mme Sisley, which conveys some idea of Sisley's charming attitude not only towards his wife but towards all women. The expression of Mme Sisley's face, and even that of her whole body,

[1] The first of eight exhibitions at the photographer Nadar's, where Impressionism was born. (Trans.)

indicates better than any explanation I could give, her happiness and confidence in that gallant man. She was a model who had posed for my father ; and for her future husband also. Renoir had the greatest respect for her.

' She had a very sensitive nature and was exceedingly well bred. She had taken up posing because her family had been ruined in some financial venture.' She fell ill of a pitiless disease. Sisley was the soul of devotion, looking after her tirelessly, watching over her as she lay in her chair trying to rest. ' And how the money went ! ' She died in agony of cancer of the tongue. ' Her lovely little face was all twisted with pain. How little it takes . . .'

Some of my father's reflections, coloured by admiration and melancholy, lead me to suppose that he may have had some sort of affair with Judith Gautier, the writer's daughter. He gave me an enthusiastic description of that ' Amazon ', including her general appearance, her voice, her way of dressing, and her taste in furniture :

' She received me in a room decorated in the Moorish style, with a lion-skin on the floor. She didn't seem at all ridiculous in such a setting. She was the Queen of Sheba ! ' With a touch of wistfulness, he confessed that too brilliant a woman does not make a suitable companion for a painter. ' Our profession is made up of patience and regularity ; and that does not lend itself to passionate outbursts of romanticism.'

From what I know of Renoir, I can guess the nature of the misunderstanding. He had an immense admiration for the genuineness of this woman, who was truly her father's daughter. Judith, for her part, had discovered a genius, all the more alluring because of his modest appearance. But Renoir, the wise one, knew that such a woman was born to be a leader, to dominate. He himself had no desire to dominate : he disliked that intensely. But he knew perfectly well that his only chance of attaining the goal to which he aspired with his whole being was not to be dominated.

In 1866 Renoir painted ' Le Cabaret de la Mère Anthony ', which was probably in Marlotte, on the south side of the Forest of Fontainebleau. He had talked to me so much about the place, and the visits he had made to that village with Sisley, Bazille, Monet, Frank Lamy, and sometimes with Pissarro, that after his death I bought a house there. Cézanne's son followed my example and in-

stalled himself in a property which had once belonged to Jean Nicot, the man who had introduced tobacco into France at the end of the sixteenth century. The walks we took through the woods and clearings where the Intransigents had trained for their early campaigns made it possible for me to identify exactly one of the most important sites where Impressionism first came into being.

# II

Théodore Rousseau, Millet, Diaz, Daubigny and Corot had all worked a great deal in the environs of Fontainebleau. Millet lived all the year round at Barbizon, on the northern side of the Forest. It was in that setting, with its flat stretches of cultivated land, that he painted his sentimental peasants who so irritated Renoir. ' " The Angelus " has done more to set people against religion than all the speeches of the Commune put together.' And then he contradicted himself by saying, ' How stupid I am : I was forgetting how much people like picture-postcards. *The Golden Legend* would scare them to death.'

Diaz had also painted at Barbizon, probably in the neighbourhood where the incident which I mentioned earlier had occurred. Monet and my father explored that part of the countryside in search of ' motifs'; and they had been asked by their other companions to try and find a pleasant little inn where rooms could be had. Sisley had told them : ' Don't forget to take a look at the maid.' The two friends decided to leave Barbizon, because ' you run into " Millets " on every street-corner.' The villagers were so proud of their ' great man ' that they took on the look of the characters in his paintings, ' just as Parisian women, on holiday in Brittany, think they have to put on a lace cap for the sake of local colour.' This famous local colour—' always an invention of tourists'—was another of my father's pet dislikes. He hated disguises, and was equally critical of the girl from Brittany who as soon as she landed in Paris dressed as a Parisian. But he was delighted by country weddings, in which, before the War of 1870, people often wore local costume. The scraping of village fiddlers moved him to tears.

His dislike of the artificial in any form extended even to architecture. The pseudo-Norman manors and Italian villas around Paris infuriated him. I asked, therefore, how he felt about Versailles,

which he had to admit was an imitation of an Italian palace. Without hesitation he gave a reason for this distortion of local tradition and all distortions of the same kind from the Louvre to the Potsdam Palace. For centuries all improvements and innovations had come from Italy. The Italians invented ceilings, parquet floors, locks, glass windows, chairs, forks, chimneys that draw properly, silks as fine as those from China, muslins like those of Mosul, music, the theatre, opera—in short, almost every manifestation of social life. It was natural for Louis XIV to build a château in the style of the country which was technically the most advanced. Trouble begins when an architect takes advantage of his country's advanced technique to copy the exterior appearances of buildings of an earlier period. Then he finds himself a slave to accessories grown ugly because they no longer serve a useful purpose.

Although Renoir admired Versailles, he had his reservations: ' After all, it is not the Parthenon.' In his eyes, the greatest French architecture was embodied in Chartres Cathedral, the basilica at Vézelay, and especially the Abbaye-aux-Hommes at Caen, and the church at Tournus. ' Those buildings are not only French,' he said, ' they are universal.' I need hardly add that these digressions on the subject of architecture gave him another opportunity to pillory Viollet-le-Duc, who according to him was more ' dangerous' than Victor Hugo : ' The gargoyles he reconstructed fairly drivel with sentimentality.'

The end of Renoir's life coincided with the flowering of the ' *hostellerie* ', or deliberately ' quaint' type of inn. He would not believe me when I told him of the success of this ludicrous trend. Albert André,[1] my brother Claude and I therefore took him to see one of these picturesque temples of gastronomy—'another term I dislike intensely'. He laughed ironically at the preposterous décor : the ceiling reinforced with hollow beams made of thin plywood boards, the walls ornamented with sham joists of rough plaster, with imitation cracks showing imitation bricks behind it. But it was the wine-steward who came as the climax. The blue smock of a bona-fide vineyard-worker and the cotton cap he wore were a veritable masterpiece. And he insisted on our taking a bottle of Vosne-Romanée, which cost a fortune. Renoir would have preferred a glass of local wine. But although he had abandoned the black tail-coat, the

[1] 1869-1954. French painter. The most fervent of Renoir's young admirers.

steward's authority had not diminished and we were glad to get off as lightly as we did.

This feast reminds me of a meal Monet told me that he and Renoir had once had in Barbizon. The place they went to was modest enough in aspect, but a flaming red sign in front of it proclaimed the kind of customers the owner hoped to attract: 'Restaurant des Artistes'. 'We ought to have known better. The word "artist" so often hides something fishy.'

An old woman welcomed them in, saying, 'I'm all alone. My children have gone to Melun.' The little railway line between Melun and Barbizon had been built by then, and brought a great many tourists to this part of the Fontainebleau Forest. 'Can you make us an omelette?' Monet asked. The old woman started by rummaging in the kitchen. She was slightly lame and walked painfully; so we waited patiently while her preparations dragged on. She finally succeeded in ferreting out several eggs. 'I'm not sure these are the proper ones; the children keep some for hatching.' She opened a dirty cupboard, piled high with empty jam jars and soiled table-cloths, and took out a remnant of bacon. After glancing at this titbit, which was slightly discoloured, the two painters helped her to light the fire in the stove. Feeling that she had established a certain degree of intimacy with them, she began to unburden herself of all her personal misfortunes. She droned on about the many mis-carriages and still-born children she had had. Her daughter specialized in the same infirmity, and was in fact over at the hospital in Melun consulting a doctor about it. Monet and Renoir began to grow more and more depressed. The old woman finally had to sit down; and the two friends finished cooking the omelette themselves. Meanwhile she went on adding catastrophe to catastrophe, death to death. Once they started eating, she switched to the living; a deaf-mute grandchild, a niece who was an idiot, and finally a boy who had been terribly maimed in a railway accident. The two visitors found their eggs were stale and the bacon as tough as a piece of old harness. They were just about to get up from the table in disgust, when the old woman began a new set of horrors; so, deciding they could not add to her woes, they heroically choked down the repulsive food to the last morsel, paid their bill and set out for Marlotte as fast as possible.

Luckily for them, painters in those days had good legs as well as good stomachs. The kilometres Renoir and his friends used to

walk are really incredible. My father, for instance, would walk all the way from Paris to Fontainebleau—thirty-eight-odd miles. It would take him two days, stopping overnight at Essonnes.

At Mme Mallet's inn at Marlotte, Monet and Renoir were able to find the kind of cooking which was to make them forget the nasty meal in Barbizon. They found excellent beds, too ; dozens of subjects to paint within easy reach ; and a servant-girl whose charms they were sure would appeal to their friend Sisley. It was not long before Sisley joined them ; and he brought Pissarro with him. Bazille followed shortly after. Even the grumpy Cézanne turned up, as he was equally anxious to paint 'those sylvan paths where only nymphs were lacking'.

He was very much interested in the story of 'Sylvain Collinet', a veteran of Napoleon's Grande Armée who, inconsolable at the Emperor's defeat, retired to Fontainebleau during the Restoration. Little by little he made a cult of the Forest to take the place of his cult of Napoleon, and switched from reveries in the 'Cour des Adieux' to long walks through the woods, which in those days were explored mostly by game-poachers. With a few companions he blazed the trails we still use and gave to the forest sites romantic names which delighted Cézanne : ' The Valley of Hell '; ' Kosciusko's Grotto '; ' The King's Table '; ' The Pond of the Fairies '; etc.

I believe ' Mother Anthony's Inn ' was also in Marlotte. Georges Rivière, who in my day often came to Marlotte to visit his son-in-law, Paul Cézanne (the artist's son), was convinced of the accuracy of my assumption, but he could not verify it, as he did not meet Renoir until 1874. Gabrielle had come into our family circle too late to be of any help to me in the matter. Unfortunately, I forgot to ask Monet. And now so few are left of those connected with Renoir's life. . . .

Marlotte was then composed of only a dozen or so houses and properties, clustered about a little crossroads leading from Fontainebleau and Montigny to Bourron. The actual forest came almost to the first group of houses on the northern side. Those on the south side looked out towards the valley of the Loing, a delightful little river, with tall, graceful trees shading its banks. Corot has immortalized the banks of the Loing. Renoir and his friends were to do a good deal of painting there, also. Marlotte increased even more if possible their sense of poetic reality, as well as their determination

never to work except from Nature. However, none of them was ready yet to take the decisive step which would lead them finally to Impressionism. Many recollections, many traditions, still interfered with their desire to work only from Nature ; and it was only after the War of 1870 that they were, in Monet's phrase, ' to ensnare the light, and throw it directly on to the canvas '.

In the picture Renoir painted at Mother Anthony's it is easy to recognize Sisley, who is standing up, and Pissarro, who has his back turned. The man with the clean-shaven face is Frank Lamy ; in the background Mme Anthony can be seen, while in the foreground, to the left, is the maid, Nana. The mongrel dog lying on the floor was called Toto. He had lost one of his paws in a carriage accident. My father tried to make him a wooden one, but it did not suit Toto, who managed very well with three legs.

Marlotte has now been spoiled by showy villas, built of pretentious yellowish stone, which have spread like mushrooms throughout the entire suburban Paris region. However, the few remaining peasant houses make a pilgrimage to Marlotte worthwhile. There are still a few farms whose covered gateways Renoir was so fond of ; and handsome, wide courtyards paved with flagstones, which the peasants once stole from the ' King's Highway ' during the Revolution. Not satisfied with appropriating them for their courtyards, the country people also used them for annexes to their houses. They are of sandstone, pitted stone, which often splits from the effect of frost. That is why the houses in Marlotte were given a coat of plaster. Renoir loved pink or blue plaster walls, before these colours had become a mark of ' distinction ' to impress the neighbours.

The present Hôtel Mallet, a fairly big place, is of course not the same as the one where the painters used to stay. The original building is still in existence. While I lived in Marlotte, it belonged to M. Guillot, who had horses and carriages for hire. It stands quite intact, with its inner courtyard, on the corner of a little street which leads out into the fields. If it were not for a few pots of geraniums in the windows of the new hotel and the advertisements for apéritifs, one could still imagine oneself back in the time of Renoir's youth. I have indulged in this little game myself, expecting at any moment to see a figure dressed in an artist's smock and carrying a box of paints, an easel and canvas, come round the corner with a brisk step. And I could imagine him twisting his light-brown

goatee with the nervous gesture I knew so well, still elated by the woodland sprites who had kept him company in the shadowy forest.

What, one wonders, inspired the painters of the nineteenth century with such a passion for the Forest of Fontainebleau ? The Romantic School owed it to the 'literary' rediscovery of Nature, which had begun in the eighteenth century. They still felt the need of a Nature that was dramatic. Renoir and his friends were in the process of realizing that the world, even in its most banal aspects, is a thing of wonder and delight.

'Give me an apple tree in some suburban garden. I haven't the slightest need of Niagara Falls.'

Nevertheless, my father had to admit that the theatrical side of the forest fascinated him and his group just as it did all their contemporaries. But for the 'renegades' this sort of 'theatre' served as a starting-point for getting closer to the structure of things. Behind the facile effects of rays of light sifting down from the foliage they discovered the essence of light itself. From their interpretation of woodland scenes they eliminated all sentimental effects, all melodramatic appeal, or any telling of a story, just as they avoided it in their portrayal of human beings. Renoir's trees do not 'think' any more than his models do. This severity did not prevent Renoir and his companions from admiring 'the straight trunks of the great beech trees and the blue light filtering through the foliage forming a vault over them. You could almost believe you were at the bottom of the sea among the masts of sunken ships.' (I may add that I used these exact words of my father's in my play *Orvet*.)

Behind this literary interpretation Renoir was to discover a way of 'seeing' the essential aspect of things. He studied the movement of a branch, the colour of foliage, as though aware of them from inside the tree itself. I think that this analysis can at least partly explain his genius. He did not paint his models solely from the outside, he identified himself with them, and thus painted them as if he were doing his own portrait. By the word 'model' I mean of course any subject, whether a flower or one of his own children. From the very beginning Renoir had adopted this method, and it was to reach its apotheosis in his last works.

'Believe me: it is possible to paint everything. To be sure, it is better to paint a pretty girl or a pleasing landscape. But anything can be a subject.'

Renoir was fond of fairy-tales. But he had no need to know the

story of ' The Donkey's Skin ' to clothe his models in garments of light. For him, daily life itself was a never-ending fairy-tale : ' Give me an apple tree in a suburban garden. . . . '

When painting, Renoir became so absorbed in his subject that he saw nothing else, and was unconscious of what went on around him.

One day Monet, who happened to be short of cigarettes, asked him for a smoke. Renoir made no reply ; so his friend felt in the pocket where he knew Renoir kept his tobacco pouch. As he leant over, his beard touched my father's face ; but Renoir scarcely noticed it. Looking up, he said, ' Oh, it's you, is it ? ' and went on working.

He was just as preoccupied when out in the Fontainebleau woods, and perfectly indifferent to the wild life there. But he was eventually forced to take notice of some of its denizens. ' Stags and does are as inquisitive as humans.' The deer had got used to the silent visitor and would stand watching him in front of his easel, making slight movements, as if caressing the surface of his canvas. For a long time Renoir remained unaware of their presence. But when he stepped back to judge an effect he was trying for, the deer stampeded, bounded away, and disappeared in a dull thud of hooves on the mossy ground.

My father was foolish enough to bring them a few pieces of bread one day, and from then on he had no peace.

' They were around me continually, nuzzling me, breathing down my neck. Sometimes I got really angry and shouted, " Are you going to let me paint or not ? " '

One morning, after setting up his easel in a glade, he was annoyed by a sudden shadow which ' changed the light ' on his canvas. He was surprised to note that his usual companions were not there. He wondered if they had been driven away by one of the revolting stag-hunts so popular with the privileged classes : ' Those imbeciles in their red hunting-coats ! I'd like to shoot them all ! If there is a hell, they'll be hunted by deer until they drop from exhaustion ! '

When discussing physical suffering, animal or human, he would get so worked up that he could not continue the conversation.

Renoir soon found out why the deer had not come. He heard a rustling sound in the bushes near by, and saw a peculiar individual stumble out. The intruder looked rather frightening. His clothes

were in rags, and covered with mud ; his eyes were haggard, and his gait unsteady. Fearing that he was faced with an escaped lunatic, Renoir caught up his cane and prepared to defend himself.

At this point he broke off to proffer a few words of practical advice :

' Never raise your cane higher than your head, because then you'll give your aggressor a chance to stab you in the stomach. Use your cane as a sword. A good jab in the belly will knock the wind out of him, and that will give you time to run.'

Whenever Renoir emerged from the world of light and form— the only one that mattered to him—his attitude towards the ordinary problems of life seemed surprisingly ingenuous to those whose time is taken up by fashions of the moment.

But, to get back to the scene in the Forest of Fontainebleau, the stranger stopped within a few feet of my father and said in a trembling voice :

' Please help me, Monsieur ! Please ! I am dying of hunger ! '

He turned out to be a journalist, a partisan of the Republic, and he was being hunted by the Imperial authorities. He had just managed to escape arrest by climbing on to the balcony of the apartment adjoining his, entering the window, and running down the stairs. He had jumped into the first train leaving the Gare de Lyon, and got off at Moret-sur-Loing. He had been wandering about the forest for the last two days, not knowing what to do or where to go. Worn out and famished, he had decided to give himself up.

Renoir went back to the village, got an artist's smock and painting-kit, and brought them to the man.

' Here, take these. People will think you are one of us. Nobody will bother to ask you questions. The peasants see us coming and going all the time, and never think twice about it.'

The man, whose name was Raoul Rigaud, spent several weeks with the painters in Marlotte. Pissarro notified the fugitive's friends in Paris, and they arranged for him to make his way to England, where he remained until the fall of the Second Empire.

That is the first part of the story ; here is the sequel.

Several years later came the War of 1870, with the defeat of Napoleon III and his flight. Presently I shall describe Renoir's life during that upheaval. For the moment, I want to say that Renoir returned to Paris before the end of the Commune. Courbet had

become an outstanding political figure and considered the destruction of the Vendôme Column as the climax of his career. But his notoriety did not turn the head of his young confrère. For whatever the form of government, whether Commune, Empire or Republic, it could not remove the fog lying between Renoir and men's eyes. And he therefore continued to work tirelessly at the only problem that mattered to him—namely to try and dispel that inhibiting fog.

He painted constantly. One day, after he had set up his easel beside the Seine, some National Guards stopped to look at his work. Renoir paid no attention. The weather was perfect. The pale winter sun, reflected on the water, revealed tonalities in gold and yellow of which he had never before been aware. In the distance shells, fired by the Versailles forces, were falling on the fort of Le Muette ; but the sound was not loud enough to cover the murmur of water against the quays. All at once, one of the Guardsmen took it into his head that there was something suspect about this fellow, daubing queer signs on his canvas. He surely could not be a genuine artist. He must be a spy. And his picture was nothing but a plan of the Seine area to help the enemy in their next move against the city. The self-appointed strategist communicated his suspicions to another Guardsman ; and the news spread like wildfire. A crowd gathered. Someone suggested throwing Renoir into the river.

' I wasn't keen on a cold bath. But protesting did no good. After all, a mob has no brains.'

The National Guardsmen were for taking the 'spy' to the town hall of the Sixth Arrondissement and having him shot. ' Perhaps we could get some important information out of him.' One old lady in the crowd wanted him drowned. ' You drown kittens,' she said, ' and they don't do nearly as much harm.'

But the National Guard got their way, and my father was dragged off to the local town hall, where there was a firing-squad on permanent duty. As Renoir was being led to the place where he was to be shot, he suddenly caught sight of the man he had aided a few years before at Marlotte. By a freak of luck, M. Rigaud happened to be passing just at that moment. He was in full-dress uniform, with a tricolour sash around his waist, followed by his staff, all equally resplendent. Renoir succeeded in attracting his attention. Raoul Rigaud rushed over and threw his arms around him. The attitude of the mob changed immediately, my father was led through two lines of soldiers presenting arms, and taken by his saviour to a

balcony overlooking the square, which was packed with people come to see the spy executed.

Rigaud presented him to the crowd.

' Now, fellow-citizens,' he called out, ' let's sing " The Marseillaise " for Citizen Renoir ! '

I can picture my father, leaning slightly over the balcony and making little embarrassed gestures in acknowledgment of the cheers.

Renoir took advantage of this opportunity to ask his friend for a safe-conduct pass to see his family, who had all taken refuge in his parents' country home at Louveciennes. Before parting, however, Rigaud gave him a word of warning.

' If, by some mishap, you should fall into the hands of the Versailles troops, make sure you don't let them find this paper. They would shoot you on the spot.'

Renoir's other friend, Bibesco, had wide influence among the opposing party. Learning that my father was out at Louveciennes, he went to see him, and gave him a safe-conduct pass for the Versailles faction. Renoir found a hollow tree in a deserted garden near the dividing-line between the Reactionaries' territory and that of the Revolutionaries. And so, each time he wanted to cross the 'frontier', he hid in the tree whichever paper would compromise him and took out the one he needed. Whenever my father referred to this incident, which almost ended fatally for him, he never failed to quote La Fontaine's lines : ' Le sage dit, suivant les gens, vive le roi, vive la ligue ! '

The bombardments continued. But Renoir's passion for painting was stronger than his caution. He had begun a picture, with a model, in Paris ; and he was working at several landscapes in Louveciennes.

' The devil of it is that the light changes so quickly ! '

# 12

The episode concerning Raoul Rigaud brought me up to the Commune, while omitting the War of 1870. The national defeat did not affect Renoir's destiny. It influenced the destiny of very few people, among them the Emperor and politicians who owed their success to him. It merely served to consolidate worship of the golden calf, that unavowed deity of the nineteenth century. The men of that time called it prosperity. The golden age of the middle-man, the buyer and seller, the shrewd dealer, now began. The picture-dealers were soon to sell their ' shops' and set themselves up in ' galleries'. The aristocracy of big industrialists, which had replaced the nobility, was soon to give way to the fine flower of the well-organized sellers of merchandise.

To my father it all seemed perfectly natural.

' We have the pleasure of painting pictures,' he said. ' If, in addition, we were smothered in gold, life would be too perfect ! '

He spoke of the War of 1870 chiefly to justify his ' cork' policy once more. There was nothing boastful in his account of the war years ; on the contrary, it was tinged with melancholy. For his memories were associated with a great loss, as I shall describe.

Although Renoir had previously been exempted from military service for reasons explained earlier, he now had to report at the Recruiting Office in the Hôtel des Invalides, where the authorities found him fit for duty. When Prince Bibesco learned of this, he urged Renoir to accept an appointment on General du Barrail's staff, of which he was the Ordnance Officer.

' You can take your paints along and you'll have plenty of chance to use them. Those German women, with their blonde hair and pink cheeks, will make excellent models. Of course Berlin is not very

amusing ; but perhaps we'll be garrisoned in Munich. We can go sailing on the lakes and drink good beer ! '

But my father was very firm. The prospect of being compelled to fight did not appeal to him at all.

' I must admit I am terrified of gunfire. But I didn't want someone to take my place in the front line, while I was painting on General du Barrail's staff. If the fellow replacing me had been killed, it would have haunted me for the rest of my life. I told Bibesco that I would leave fate to decide where I would be sent.'

Bazille, on the contrary, accepted Bibesco's offer, not because he wanted to be off painting while his fellow-soldiers were launching bayonet charges, but because he could see himself galloping about on a beautiful horse, dashing through a hail of bullets, and carrying the vital message which would decide the outcome of the battle. Renoir had his doubts.

' The Prussians have thrashed the Austrians ; and, judging from the Austrians I've known, we are very much like them ! '

And so the current sent the ' cork ' first to a regiment of Cuirassiers. But the General Staff had just decided to increase the cavalry units. ' We'll get to Berlin more quickly that way.' So horses would have to be trained. With the admirable logic for which the Army is noted, my father, who had ' never put his behind on the back of a horse ', was sent to a training centre at Bordeaux. He stayed there during most of the war, and was then transferred to Tarbes, far from the sound of the gunfire that so unnerved him.

When he arrived at this squadron, he confessed to the cavalry quartermaster, at the risk of being made to serve in the infantry, that he did not know the first thing about riding. The N.C.O. turned him over to the lieutenant, who turned him over to the captain. The captain did not seem in the least surprised.

' What is your profession ? ' he asked.

' Painter.'

' You're lucky they haven't put you in the artillery.'

He was a good sort. A cavalryman by profession, he loved horses and hated the thought that they would soon be sent to ' that useless butchery '.

His daughter had a passion for painting.

' You can give her lessons.'

' And I could perhaps learn how to ride a horse.'

' There's an idea ! '

As it turned out, Renoir proved to be adept at horsemanship. Within a few months he became an accomplished cavalryman. The captain gave him the most high-strung horses to train.

' Renoir manages them very well. He lets them do what they want, and finally they do what he wants.'

The young horseman used the same indulgent methods with his horses as he did with his models.

' I had a wonderful time. The captain treated me like one of the family. While his young daughter painted, I did her portrait. She had an admirable skin. I talked to her about my friends in Paris ; and it wasn't long before she was more revolutionary in her ideas about art than I was. She even spoke of burning the pictures of Monsieur Winterhalter.'

The captain was transferred to Tarbes, and he took along my father, who was growing more and more enthusiastic about his new occupation.

' You must get to know the Tarbes breed of horses. They are the best of all, in my opinion ; robust, with just enough of the Arab to give them spirit. I've only run into one that gave me trouble. He had a trick of leaning with all his weight against the wall of the riding-school so as to try and break my leg. First I tried the whip ; then, petting him ; then, sugar. Nothing had any effect. Not surprising : he had the forehead of Victor Hugo ! '

As soon as he was demobilized Renoir went back to Paris, and found himself in the midst of the Commune. Almost all his friends had left the capital. Only a few stayed behind, including Pissarro, Goeneutte, and of course the musician Cabaner, who, living from day to day, could not afford to travel. It was through them that my father learned of Bazille's death. His friend had been killed, ironically enough, after it was obvious that the French would be defeated. He did not die romantically, galloping over a Delacroix battlefield, but stupidly, during the retreat, on a muddy road at Beaune-la-Rolande.

As for Bibesco, luckily he had been wounded several days before. Some peasants had hidden him in a barn and looked after him until he was well.

Renoir had a number of connections among the Communard revolutionaries. We know how much he esteemed Courbet. However, he refused to accept any official position offered him by his political acquaintances. He still followed his ' cork' philosophy. But

above all, he intended to stick to his conviction that the function of a painter is to paint.

'I went to see Courbet several times. He could think of nothing but the Vendôme Column. The happiness of humanity depended on its being pulled down.' He imitated Courbet's slight lisp, 'It's ze very devil, zat column!'

Renoir was loath to say much about that tragic period. He brooded over the memory of Bazille: 'that gentle knight; so pure in heart; the friend of my youth'. He was also shocked because, during the Commune and afterwards, there had been too many executions. Renoir loved life too much not to abhor the spectacle of death. 'Good people, the Communards. They had good intentions. But you don't play Robespierre all over again. They were eighty years behind the times. And why burn down the Tuileries? It wasn't up to much, but at least it was less sham than a good deal that came afterwards.'

Out at Louveciennes, Lisa had been defending the cause of Louise Michel, a terrorist responsible for setting fire to many Paris buildings. Although my father did not wish to seem ironical, one day as he was preparing to return to Paris he asked Lisa if she would like to go along with him and meet Mme Michel. 'Clemenceau will introduce you,' he said. But Leray protested loudly. 'A woman's place is in the home.' And for a long time thereafter, the entire family teased Lisa about being an 'armchair revolutionary'.

The Commune was finally liquidated. The Versailles faction took possession of Paris; and the executions carried out by the reactionaries rivalled those perpetrated by the People's Courts.

'The only execution I can accept is that of Maximilian in Manet's picture. The beauty of the black tones make up for the brutality of the subject.'

Courbet was arrested and it was rumoured that he was to be shot. No one knows whether or not Bibesco intervened at the insistence of his painter friends, but quite possibly he did. Before dropping the subject of the Commune, I must quote one more remark of Renoir's:

'They were madmen; but they had in them that little flame which never dies.'

He was not to live long enough to see the flame become a blinding light.

The Café Guerbois, where many of the young painters gathered around Manet after 1870, was rarely mentioned in my conversations

with my father. On the other hand, he often spoke of the Nouvelle
Athènes. Cézanne's son once took me there for a drink before the
First World War. The pimps and tarts from the Place Pigalle had
by then replaced Manet, Cézanne and Pissarro. I tried to imagine
Van Gogh and his brother in that setting, listening to Gauguin and
Frank Lamy on the technique of painting with a palette-knife. It was
difficult for me to picture the eager young bearded artists of the last
century behind the clean-shaven, solemn and harassed faces of the
new customers. Complete decadence had set in, an irremediable
downfall. The Nouvelle Athènes (fortunately under a different
name) was furbished up and redecorated, and became a rendezvous
for pederasts. Even so, this café, haunted by the ghosts of past
celebrities, was not able to survive. The latest attempt to save it has
been to transform it into a cheap strip-tease dive where you can see
twenty nudes for the price of a ticket to the cinema. The poor girls
amble out, showing off their shop-worn charms in the very spot
once frequented by the French School which had purified the nude
and freed it from all lewd associations. Sometimes I wonder what
my father would have said. But I know perfectly well what his
comment would have been : ' It's too draughty in here. Those poor
girls will certainly catch their death of cold.'

More than the lively discussions at the Nouvelle Athènes, the
receptions at the Charpentiers' were my father's chief social interest
before his marriage. He had come to know the family well, as he
had painted Charpentier's mother in 1869 ; but his fear of seeming
to want to 'push his way in and being considered a social climber'
had made him discontinue his visits. He met them again as the
result of an exhibition, which he and Berthe Morisot and Sisley
organized at the Hôtel Drouot[1] a few years after the War of 1870.
Berthe Morisot was the sister-in-law of Manet, a great friend of M.
Charpentier. The distinguished publisher came to the exhibition,
and bought Renoir's ' Fisherman on a River-bank ' for a hundred
and eighty francs. As he was leaving with his picture, he invited my
father to come to some of Mme Charpentier's receptions. Her
' salon' was celebrated : and deservedly so, for she was indeed a
great lady, and had succeeded in reviving the atmosphere of the
famous salons of the past. Everyone of note in the literary world
attended those Friday gatherings. Her husband published the works
of the best young authors. He took the writers of the Naturalist

[1] A large auction-gallery. (Trans.)

School under his wing just as he had done with the neo-Romantics. Zola, Maupassant, the Goncourts and Daudet were among the regular habitués of the house. Even Victor Hugo occasionally made his appearance. Charpentier was definitely on the side of the Intransigents, even before they came to be known as Impressionists. The outstanding political figures among the guests were Gambetta, Clemenceau and Geffroy, all those who had been against the Empire and MacMahon.

Charpentier had founded a newspaper called *La Vie Moderne*, of which my Uncle Edmond was managing-editor and publisher. Its chief purpose was to champion the cause of the New Painting. He also helped to open an art gallery for the work of the future Impressionists. Unfortunately the venture proved too costly, and the place had to be closed.

The friendly relations between Renoir and the Charpentiers are clearly evident in his paintings of them. He found these charming people of the upper middle class not only pleasant to know but delightful to paint.

' Madame Charpentier reminded me of my early loves : the women Fragonard painted. The little girls had charming dimples in their cheeks. The family complimented me on my work. I was able to forget the journalists' abuse. I had not only free models, but obliging ones.'

It was through the Charpentiers that Renoir met Alfred Bérard, who became one of his most devoted friends. My father used to make long visits to the Bérards in their château in the Caux country. He found an ample supply of models there and scarcely stopped painting a moment. When canvas and paper gave out, he painted on the doors and walls, much to the annoyance of the kindly Mme Bérard, who did not share her husband's blind admiration for their visitor's painting. Renoir's association with the Bérards and Charpentiers and the pictures he did in their homes have been dealt with far more adequately than I ever could, in the accounts written by the heirs of the two families : *Renoir at Wargemont*, in the case of the Bérards, and *Renoir—Children*, treating of his early acquaintance with the Charpentiers.

I should like to digress for a moment to mention certain details which throw further light on Renoir's character. They concern an anecdote my mother told me : she in turn had heard it from Bérard.

Once when my father was out painting in the Forest of Marly he suddenly remembered an invitation for that evening to a large dinner-party at the Charpentiers'. He was to be introduced to Gambetta, then at the height of his power. Charpentier wanted the Premier to commission Renoir to decorate a large panel in the new Hôtel de Ville.

Renoir gathered his equipment, hurried to his grandparents' house in Louveciennes, and dashed over to the town of Marly, arriving just in time to see the train for Paris pull out of the station. Luckily the station-master knew him and allowed him to jump on a goods train. It took him to the shunting-yard in the Batignolles district, which in those days was still a suburb. He climbed down from the train and ran like mad through the empty streets. Finally he found a horse-cab which took him into Paris.

Formal evening-clothes always annoyed him, and once he reached home, instead of changing his shirt, he saved time by putting on a strange combination of starched collar and false shirt-front, quite a popular device at that time.

At the Charpentiers' house, he solemnly handed his top-hat, scarf, gloves and overcoat to the footman, and walked into the drawing-room before the astonished footman could stop him. He was welcomed by a burst of laughter ; and with good reason. For in his haste he had forgotten to put on his dinner-jacket, and was only in his shirt sleeves. Charpentier was highly amused and, to make him feel at ease, took his coat off. All the other men did the same. Gambetta declared that it was very 'democratic'. And the dinner went on with an extra note of gaiety.

Charpentier discussed the proposed decoration frankly with Gambetta.

'This young artist is capable of reviving the art of fresco-painting. He would bring glory on your Republic.'

Gambetta then took Renoir aside.

'We can't give you any commissions, or any of your friends, either. If we did, the Government might fall.'

'Don't you like our kind of painting ? '

'Yes, indeed. It is the only painting that counts. And those others we are giving commissions to are no good at all. But, you see . . .'

'See what ? '

'You are Revolutionaries ; that's the trouble.'

My father was dumbfounded. But he could not keep from retorting :

' Well, what about you ? '

' That's just it,' answered Gambetta. ' That point has to be overlooked : and our opinions, as well. We have to get our democratic laws passed, and throw inessentials overboard. It is better for the Republic to live with bad painting than to die for the sake of great art.'

My father often told me how Gambetta attracted pretty girls ' when he was in power '. They practically fought for the privilege of sitting at his feet. He could be seen rising from a corolla of gleaming bare shoulders, and he seemed to revel in the sight. Being from the south, he was easily stirred by women.

' They knew it, the jades ; and to excite him, they wore evening-gowns cut even lower.'

But he finally fell from power. In spite of the stipends paid to the '*pompiers*', his party was defeated. My father saw Gambetta again at the Charpentiers' a few days later.

' It was frightful ! Not a single tit left ! '

I must tell of another incident, which was innocent enough but which amused Renoir enormously.

A frequent guest at the Charpentiers' receptions was Charles Cros, ' an extraordinary fellow '. Some of his friends claimed that he had invented the telephone two years before Graham Bell ; but French bankers had been too faint-hearted to back the invention. Cros himself believed that he was primarily a poet, involved in chemistry and physics out of curiosity. He had just had a book of poetry published by Charpentier, under the title *Le Coffret de Santal*. He had grown very fond of Cabaner, who set some of his poems to music and took him to a recital at the Charpentiers'. There Cabaner was to sing several of his own songs, with words by Cros. He was not only a good pianist but something of a singer : at least he had enough voice to convey the idea of melody—or rather the lack of melody, since he had broken away from that ' whore ' of music.

Everything went rosily until he came to a passage describing the flight of a blackbird. Now it so happened that Cabaner had a serious speech defect, and as it was impossible for him to pronounce the letter 'l' clearly he distorted it into a ' d '. The result was that when he uttered the word blackbird, which is ' *merle* ' in French, it had the sound of ' *merde* ', which means something more earthy. The audience

could not believe their ears, and concluded that Cabaner had
deliberately made a vulgar joke. Cros was properly mortified. When
the piece was finished he told the audience that what they had just
heard was not what they supposed, but referred to the ' homely bird
so common to our countryside, and known by the humble name of
blackbird '.

' That is a pity,' retorted the poet, Villiers de l'Isle Adam, who
had condescended to show his tormented face in fashionable society
that evening. ' Your explanation has removed all esoteric value from
your work.'

I have at home a bronze medallion of the head of a young girl.
It formed part of the central design of a mirror-frame which Renoir
had made for the Charpentiers' house. He had tried out an English
invention, which an employee in the Durand-Ruel Gallery hoped
he could put on the market in Paris. It was a product known as
MacLeish cement, composed of a mixture of plaster and glue so
strong that its makers claimed it could be used as a substitute for
marble. The frame was destroyed some years ago when the
Charpentier house was pulled down. The medallion was saved,
however. Thinking of it reminds me of my father's tireless activity
in 'experimenting'; but he was always anxious to get back to his
familiar brushes and palette. The MacLeish cement had to give way
to Italian ' *stuccos* ', which were easier to handle and less expensive.

In my account of the years before and after the War of 1870 I have
said nothing of Renoir's close friendship with two people who played
a part in his development : the painter Lecœur, and Lise, a charming
young woman who posed for him and several other painters. I have
no first-hand information about the trio's relations. All I know is
that Renoir and Lecœur spent several months in the home of Lise's
parents at Ville d'Avray.

# 13

One of the reasons why descriptions of Renoir are contradictory is that his behaviour as well as his speech varied considerably, or at least appeared to. His reactions depended on the people he happened to be with. In that respect he resembled some of Shakespeare's characters, for he adopted a mode of speech and comportment appropriate to the person he was talking to. Hamlet did not speak to the king as he spoke to the players, or to the grave-digger. And yet, who could be more consistent than this princely character, obsessed by a single idea? Renoir was quite as consistent as Hamlet or Goya or Pascal, and he thought it a useless waste of energy to concentrate on things which to him were unimportant. Although he claimed he was not at all stubborn, he pursued his road with the fixity of purpose of a pilgrim going to Jerusalem. Nothing could deter him from reaching his goal. While certain matters seemed negligible to him, such as politics or his private affairs, other small points assumed an importance which often surprised even his intimates.

Renoir did not see the world as other men see it. In his view nothing was absolutely black or white. That explains how he could live through the Commune and other important events without taking sides. He was aware that labels and classifications existed; but a label did not guarantee the contents of the bottle. He agreed that there was such a thing as a German accent and a Marseilles accent, that there was Protestant hypocrisy and Catholic bigotry, bombast on the part of those who advocated a Republic, blindness among the Monarchist adherents, and puritanical Socialism, but these were only the outward workings of individuals whom he classified differently. I know, for instance, that an 'internationale' of young girls, 'whose skin takes the light', represented in Renoir's eyes a category far more important than just a French or German group,

or a political or religious faction. The great dividing-line was between those who perceive and those who reason. Having no use for the '*folle du logis*', or imagination, he allied himself with the world of instinct, as opposed to the world of intelligence. Although he naturally did not understand Chinese, he would have felt entirely at home with an Oriental potter of, say, the second century: whereas with many of his own fellow-citizens he felt like an alien.

In religious matters he was very tolerant. He found it difficult to believe that two hundred and fifty million Hindus had been mistaken for four thousand years. Why should we be the ones to possess the truth, and not they ? Why should the Almighty arbitrarily decide to make Himself known to people along the River Seine, and neglect those along the Ganges ? And, as he said, ' If I should choose to worship a Golden Rabbit, I don't see why anyone should try to prevent me.' He gave an amused smile : ' The religion of the Golden Rabbit might be just as good as any other. I can see high-priests wearing long, slanting ears.'

He firmly approved of Catholics retaining Latin, 'not only because it is a universal language, but especially because the faithful can't understand a word of it. It is very important to address God in a secret language, different from the one for buying two penny-worth of chips.' He was also in favour of the confessional : ' It is a safety-valve—something like that big mushroom on top of loco-motives. What a relief to be able to unbosom yourself to some unknown individual who won't go blabbing to the missus at bed-time. It's the best way to prevent crime ! '

Renoir seldom if ever set foot in a church. Yet the materialistic theory of the universe did not satisfy him. He believed that our universe, despite scientific analysis and microscopes, was filled with mysterious forces.

' They tell you that a tree is only a combination of chemical elements. I prefer to believe that God created it ; and that it is inhabited by a nymph.'

It saddened him to think of the green water which beat on the rocks at Antibes as only a ' cocktail ' of oxygen, hydrogen and sodium chloride.

' They're trying to do away with Neptune and Venus. But they won't succeed. Venus is here for eternity—at least as Botticelli painted her.'

Renoir also had definite ideas about the virginity of Mary. For him, the virgin birth was a perfect symbol of that 'economy of means' which was the motivating principle of his life and painting. In scientific jargon it is nothing more than the doctrine of efficiency.

Some cooks achieve marvellous results at a great expense. They put pounds of butter into their stews and use bottles of brandy in their sauces. It is delicious, but heavy and apt to send you to hospital. In my parents' home they used to make wonderful pies with just a pat of butter. They tasted better than most pastry and were easier to digest. My mother had learned that method of cooking from Marie Corot, who was not a relative of the great artist but had been his cook. 'And she cooked the way Corot painted,' Renoir assured me.

The mountain giving birth to a mouse was for Renoir an appropriate symbol of modern production methods. But he much preferred 'making much out of little'. Men cut down forests to make the morning paper, which is seldom worth reading. Millions of tons of paper, which represent the destruction of thousands of superb pines in Canada and Oregon, are consumed for the sole purpose of printing fatuous advertisements vaunting the virtues of cosmetics or corn-cures. Montaigne, whose works were written on paper produced from a few old rags, had somewhat more to say to the world than twenty issues of a newspaper. There are painters who pile up the paint on their palettes. Each nuance is obtained by using paints from different tubes. Thanks to modern chemistry the colours have a vividness and richness which the old masters never even dreamed of. Yet the result of all this expense and scientific knowledge is rather lifeless. Renoir used only eight or ten colours, at most. They were ranged in neat little mounds around the edge of his scrupulously clean palette. From this modest assortment would come his shimmering silks and his luminous flesh-tones.

To return to his attitude towards the Virgin Mary, Renoir marvelled at the story of the young Jewess of Galilee who had, without being sullied, without losing her purity or freshness, given birth to a God : it was a message which he intended to take to heart. For him, the world was divided into two categories, one composed of those who respect the benefits of Nature, the other, of those who waste these riches ; between the desire not to alter the Creator's work, and the proud attempt to overthrow it.

While on the subject of religion, I should like to say how Renoir felt towards atheism. Many of his friends, including some very near and dear to him, were atheists. They were under the impression that he was one of them. They could not understand how anyone could be such a revolutionary in art and still believe in God. In the opposite camp were the fervent Catholics, who never doubted his orthodoxy for a moment. He was so sensitive about hurting people that he usually refrained from contradicting them. And so they formed their own ideas of Renoir, as it suited them individually, never suspecting that privately my father looked upon their controversies as so much idle chatter. However, one day, after one of his friends had subjected him to a long harangue in an effort to prove that God did not exist, he said to him:

' Do you know, if I had to choose between you and a priest, I think I'd take the priest.' And when the other cried out in protest, Renoir added: ' Priests go about in clerical dress. That is honest, at any rate. It gives me a chance to hop it whenever I see one. If you want to preach, you ought to wear some sort of costume, so people would be warned in time.'

To come out with such a blunt rejoinder Renoir had to be provoked beyond endurance. Nor would he have uttered it unless the victim had been a close friend. It was only when he felt completely at ease with anyone that he allowed himself to express his mind so freely. He was certainly like that with his children. And that is one reason why I am in a position to understand him better than most of the writers who have tried to interpret him so far. I recall, in particular, the description Michel Georges-Michel gave of him in his *From Renoir to Picasso*. My father was depicted as a sort of Rabelaisian character. Impressed, no doubt, by the robustness of Renoir's nudes, the author must have approached him in a somewhat ribald spirit. Not wishing to disappoint him, my father responded in kind. As a result, the reader is given a fantastic Renoir, who does nothing but talk of nipples and backsides: in fact, a regular peasant Silenus perpetually frolicking in the midst of a Jordaens *kermis*.

Again, Georges Rivière, my father's constant companion in his Moulin de la Galette days, has built up a conception of him more or less in his own image. His delineation is the opposite of Georges-Michel's, as it represents a staid and reserved Renoir determined to lead his life in accordance with the traditions of his country and not

allow himself to be influenced by dagos and other foreigners plotting to destroy French civilization.

When Vollard began his biography, he honestly tried to get his information from the proper sources. The data he collected were all combined in his well-known biased account, though written with the best of intentions and a great deal of talent. During his investigations he came across an old house-painter, who had taken his meals for several years in the same little restaurant as my father. He remembered Renoir distinctly: 'a nice-mannered young man, always well dressed, rather thin, always in a hurry, and nimble as an alley-cat. I took him for one of the local workmen.' But what struck the good man most was that 'whenever there was a pot of boiled beef Renoir always claimed that it was his turn to have the marrow-bone.' Vollard related the anecdote to my father in front of me, to substantiate his theory that the common people are unable to recognize 'those who are not show-offs'. He was convinced of the stupidity of the masses, though kindly in his opinion as long as they remained in their place. 'Publicity is all they can take in. They know Sarah Bernhardt is a great actress because they've read about her in the paper.'

Some time later my father told me his version of the marrow-bone story, which is probably the more authentic one. First he pointed out that for Parisians a marrow-bone is really 'a feast for the gods'. He remembered the workman very well, and described him as 'a fine man, who only wanted to be kind'. The old man had several times lifted the bone from his plate and put it on my father's, believing he was giving his table-mate a nice present. But Renoir had absent-mindedly eaten it, without much apparent relish. 'Besides, between you and me, I'm not very fond of beef marrow.' The old man was rather hurt. So in the hope of making up for his seeming rudeness, my father would once in a while pretend that he wanted to get the bone first, and in this way re-establish the popular belief that what is rare must be desirable. In this case, the marrow-bone must be good because there was only one in the pot. The old workman was mollified and reassured. And it was not long before he resumed his little courtesy of putting the lion's share into his young friend's plate, saying with a wink, 'It's full of marrow to-day.'

'But you gave it to me yesterday.'

'Did I? Well, I'm glad. You are young; you need strength, and marrow is full of iron.'

About that same period Renoir was doing a portrait of a certain Baron R.'s mistress, to whom Bérard had introduced him.

'A nice girl. Everybody in Paris had been in her bed. For the moment, the only person she was deceiving her *miché*[1] with was her pimp.' Baron R. asked only one favour of her, that she should act towards him as if *he* was her pimp. When the other fellow knocked at the door, she hid the baron in the wardrobe. Then the intruder would burst in, make a terrible scene and, playing his role, pretend to beat her. The baron lapped it all up. And what joy for him, after the ruffian had departed, to come out of his hiding-place and console the weeping girl!

Now it happened one day that the pimp was in a mood to take his part seriously, and he hit his darling so hard that it hurt. She immediately hit back. The sham fight degenerated into a veritable battle. But the pimp got the worst of it. Disgusted by his weakness, she opened the door and threw him out. She let the baron out of the wardrobe, and told him that she 'had had enough of the gay life'. From now on she intended to settle down.

At this point Renoir appeared. He had come to work on his portrait of the baron's beloved. On his way upstairs he had met the humiliated 'pimp', who poured out his woes and followed him back to the apartment. Renoir inspired such confidence in everyone that he was asked to serve as arbiter between the contending parties. He began by acting as if nothing untoward had occurred. He calmly suggested that they start the sitting right away. He was not in the least disconcerted by the young lady's dishevelled condition; on the contrary, it gave him the idea of doing a second, but different, kind of portrait of her. He sat down and brushed in a rough sketch of what he had in mind. The other two watched him, fascinated. As their anger cooled, they forgot their recent quarrel; and when he stopped working, 'because the light had faded, and made the room seem sinister', they were completely reconciled.

During previous sittings the disarming girl had told Renoir the story of her life. She had launched out on her career while still quite young. 'I stopped working when I was fifteen.' She frankly admitted that she had done a bit of street-walking. At the time of her portrait she had just reached twenty-eight, and was deliciously

[1] French slang for a prostitute's client. (Trans.)

fresh. She must have been ravishing at fifteen. Renoir told her so. She smiled.

'No one wanted me,' she replied. 'I was lucky if I could find an old codger to give me as much as two francs.'

The minute she got a rich friend to keep her, all Paris was running after her.

My father concluded by saying: 'You know, Jean, it reminds me of the marrow-bone. People don't use their heads. It's the old story of Panurge and the sheep. Rabelais is wonderful!'

This conversation took place just before lunch. Grand' Louise came in to tell us it was ready. I wheeled my father into the dining-room. We were having cutlets and mashed potatoes.

'My teeth!' exclaimed Renoir. I brought them to him, and as he inserted them into his mouth he asked me if I was hungry. Very hungry, I answered.

'I'm not,' he said. 'I simply eat because it's the thing to do.' While I cut his meat for him, he continued: 'We are all of us Panurge's sheep. Painters especially. The difficulty is to study the great masters without copying them. And yet you have to copy them to understand them. But hang it, I'm beginning to theorize. I don't know what I'm saying. This meat is tough, and I'm losing my bridge.'

To resume my father's story, the demi-mondaine had two basset-hounds which Renoir had grown rather fond of. The male was named 'Peter', and the female 'Daisy'. One morning when he came to work on the portrait, Renoir found his model looking slightly the worse for wear, 'with puffy eyes and sallow skin'. He told her to go and rest and she asked if he would mind walking the two dogs. 'I can't trust them to my maid,' she said. 'She isn't careful enough. And besides, Daisy's on heat.' She was very much worried about Daisy's virtue because the bitch was a thoroughbred, and she had paid a fortune for her. She explained that once a bitch is defiled by some other breed, the strain is ruined for ever. When my father smiled, she burst out laughing: she was 'a good sort'. To point her allusion still further she added: 'It's a good thing for us that men are more tolerant than dogs. Peter is fiercely jealous. Whenever a dog comes near Daisy, he's ready to devour him.'

Renoir went out with the two dogs, holding them securely on a double lead made of red leather. They ran into several difficulties: once a poodle almost escaped from its master in its efforts to get at

Daisy. Peter was in a paroxysm of rage, baring his teeth at the aggressor and choking as he strained at his collar.

My father managed to get his charges to the Bois de Boulogne without further mishap, and led them down an isolated path where he thought they would be quiet and safe. The weather was warm and sunny. The two dogs had calmed down. Peter had stopped growling and snapping at his mate. Renoir found a bench in a pleasant spot and sat down to meditate on his painting problems. He was awakened from his reveries by some peculiar noises, and starting up, beheld a handsome mongrel feverishly busy with Daisy, while Peter looked on, wagging his tail approvingly.

What surprised me, when my father reminisced about himself, was the number of people he had known intimately. There were, for instance, notables in fashionable society such as Caillebotte, himself a painter. He was, incidentally, to open the doors of the Louvre to the new school of painting by bequeathing his fine collection to the State. There was also Dr de Bellio, a Rumanian homeopath ; he was a friend of Bibesco, who seems to have disappeared from my father's circle about this time. Others were the Darros, linked in my mind with the captain whom Renoir served under at Bordeaux, the Cohen d'Anvers, the Catulle Mendèses, the extraordinary M. Choquet,[1] and the art-dealer, Durand-Ruel. Among the actresses, he counted the delightful Jeanne Samary, Ellen André, and Mme Henriot and her daughter. But Renoir mentioned so many names that they have become confused in my memory. And how many models there were : the Ninis and Margots, and Suzanne Valadon,[2] and the working-girls he stopped on the street. And how often these casual encounters developed into warm friendships ! I shall never tire of repeating how much people loved him. All his friends and acquaintances whom I knew personally were deeply moved whenever they talked of him to me.

Mme Henriot told me about the death of her daughter, the actress at the Comédie Française, of whom he had done several portraits. One night his brother Edmond dashed into his studio just as Renoir was preparing to go to bed.

[1] An employee in the French Customs Service. He was also an art-collector.

[2] 1865-1938. Noted French artist, and mother of Maurice Utrillo. She started her career as a model for Renoir, Degas, Toulouse-Lautrec and other painters of that period. (Trans.)

# Renoir, My Father

' There's a fire at the Comédie Française,' Edmond told him breathlessly. ' It started with a gas explosion.'

My father slipped on his coat and hurried along the Rue Saint-Georges. By the time he got there the flames had spread to the whole building. A group of friends caught sight of him and took him to where Mme Henriot was standing. Her daughter had run back to her dressing-room to get her pet dog, and had not come out again. Although the fire was growing worse, it had not yet reached the young actress's dressing-room. Renoir darted in, found the stairs and began to climb them, holding a handkerchief over his mouth. But the smoke was so thick that he could not breathe, and he fell half-unconscious against the railing. A fireman carried him out to safety just as the stairway caught fire.

When Renoir related this incident to me—and he touched on it several times—I was struck by the contrast between his indifference to danger on this occasion, and his customary caution. I must add that, even after forty years, the death of ' little Henriot ' made him choke with emotion.

' The idiot ! ' he exclaimed. ' And just for a dog—a horrible Pekinese she called " Toto ", because of the poodle at Mother Anthony's Inn I had told her about. She was slim but with beautiful curves. She was one of those privileged beings the gods had preserved from sharp angles. And she posed like an angel.'

Afraid of being ' sentimental ', he abruptly changed the subject, and said in a voice still slightly hoarse :

' If you're caught in a fire you must watch out especially for the smoke. Soak your handkerchief in water, and breathe through it. Don't run, whatever you do. Watch every step you take. If you lose your head you're done for.'

# 14

In many conversations with my father the name of Durand-Ruel came up repeatedly: 'old Durand is courageous'; 'old Durand is a great traveller'; 'old Durand is a bigot.' Renoir approved of this trait.

'We needed a reactionary to defend our painting, which the Salon crowd said was revolutionary. He was one person at any rate who didn't run the risk of being shot as a Communard!' But more often he simply said, 'old Durand is a fine man.'

Vollard was to enter Renoir's life shortly after Durand-Ruel; the Bernheims also; and Cassirer of Berlin, as well as many other important picture-dealers more concerned to make the public aware of this new form of painting than to make money.

Paul Durand-Ruel was the first, however. 'Without him we wouldn't have survived.' Renoir was thinking more of physical survival than the survival of their art. 'Enthusiasm is all very well, but it doesn't fill an empty stomach.'

I put my father on the defensive by asking, 'Do you mean that if it hadn't been for Durand-Ruel you would have stopped painting?'

'I didn't say that,' he answered irritably. 'I only meant that, if it hadn't been for him, we'd have had fewer ortolans to eat.'

In those days I was still too young to have much sense of humour. Now, at the very idea that Renoir could ever have given up painting, I have to laugh.

He went on to tell me that at the time of the World's Fair of 1855 Durand-Ruel was only twenty-five years old; and that he was already championing Delacroix against the Emperor, who liked only the paintings of Winterhalter. My father broke off for a moment, amused by an idea that had suddenly occurred to him.

'It must be said,' he remarked, 'that Durand is an old Chouan.[1]

[1] The name given to Royalist insurgents in the Vendée in 1793. (Trans.)

He used to be devoted to the Comte de Chambord, and often went to see him in Holland.'

Durand-Ruel had followed the activities of the Intransigents from the very first.

' He was intelligent enough to sense that something could be done in this direction. And I believe he really liked our painting; Monet's, especially.'

He put on several exhibitions of the ' young school ' in his gallery in the Rue Le Pelletier. My father explained to me that, after one of these tentative ventures—'not a sign of a customer'—he, together with Monet, Sisley and Berthe Morisot, had decided to try their luck with an auction-sale at the Drouot Galleries. The public gave vent to their feelings. One gentleman called Berthe Morisot a ' *gourgandine* '.[1] Pissarro punched him in the face, thus setting off such a brawl that the police had to be called. Not one picture was sold. Renoir recalled a particularly vicious article which Pierre Wolff wrote for *Le Figaro* apropos of the Durand-Ruel exhibition, and which a friend of mine has been able to unearth for me.

The Rue Le Pelletier is having its troubles. After the fire at the Opéra, a new disaster has befallen that quarter. An exhibition of what is said to be painting has just been opened at Durand-Ruel's. The innocent pedestrian, attracted by the flags outside, goes in for a look. But what a cruel spectacle meets his frightened eyes ! Five or six lunatics—one of them a woman—make up a group of poor wretches who have succumbed to the madness of ambition and dared to put on an exhibition of their work.

Some people are content to laugh at such things. But it makes me sad at heart. These self-styled artists have assumed the title of ' Intransigents '; they take canvas, paints and brushes, splash a few daubs of colour about, and sign the result. The inmates of the Ville-Evrard Asylum behave in much the same way when they pick up little stones in the road and imagine they are diamonds. It is a horrible spectacle of vanity ending in madness. Just try to persuade M. Pissarro that trees are not purple, or the sky the colour of butter ; that the kind of things he paints cannot be seen in any country ; and that no real intelligence could be guilty of

[1] Street-walker.

such excesses. You would be wasting as much time trying to make one of Dr Blanche's lunatics who thinks he is the Pope understand that he lives in the Batignolles and not the Vatican. Try and bring M. Degas to reason ; tell him about drawing, colour, execution, purpose, and he will laugh in your face and call you a reactionary. Try and explain to M. Renoir that a woman's torso is not a mass of rotting flesh, with violet-toned green spots all over it, indicating a corpse in the last stages of decay. There is also a woman in the group, as in all famous gangs ; her name is Berthe Morisot, and she is a curiosity. She manages to convey a certain amount of feminine grace in spite of her outbursts of delirium.

And this collection of vulgarities has been exhibited in public without a thought for possible fatal consequences. Only yesterday a poor man was arrested in the Rue Le Pelletier, after leaving the exhibition, because he began biting everyone in sight.

I asked my father if the article had discouraged him.

' Not at all. We had only one fixed idea—to exhibit our work, show our canvases everywhere until we could reach the real public. I mean the public not dulled by " official " art. We were sure that it existed somewhere.'

He and his colleagues were enraged by the insults heaped on Berthe Morisot, 'that great lady'. But she just laughed. Monet thought it quite natural for the critics to be so obtuse. ' Ever since Diderot, that great exponent of criticism,' he explained, ' the critics have all been mistaken. They reviled Delacroix, Goya and Corot. If they had praised us, we might have been worried.'

Pissarro was able to persuade his comrades to get up an exhibition of their own. Cézanne joined the group, and was no less loud in condemning the critics. ' They are a pack of eunuchs and block-heads ! ' Next, Degas, who usually kept to himself, rallied to the cause. Then a newcomer, Guillaumin, did the same. Pissarro and Monet were in favour of limiting the number to the few who had first taken up the cudgels. They were all a little doubtful about that 'bourgeois' Degas ; but Renoir reminded them that 'he has done more to deflate " Monsieur Gérome " than any of us.' Degas agreed to become a member on condition that the projected exhibition would not be 'revolutionary', and that it should be camouflaged

behind a prominent name. As Manet was beginning to be recognized by the Salon officials and the journalists, the little band of new painters invited him to join them. But he declined, saying, ' Why should I go with you young people when I am accepted by the Official Salon ? The Salon is a better battleground. My worst enemies are forced to look at my pictures there.'

There was a good deal of truth in this. And so they had to give in. However, there were other artists who, though somewhat academic, were independent enough to admit that ' the Intransigents had something, all the same,' and they asked if they might take part in the exhibition. My father insisted on admitting them, for they would help to reduce the quota of each one's contribution to the general expenses. Among the outsiders was Boudin, an older man, whom Renoir thought very highly of. The new organization rented the premises of the photographer, Nadar, in the Boulevard des Capucines. The locality prompted Degas to suggest calling the group, ' La Capucine ', but no one thought it would do.

The exhibition opened just a few days before the one at the Salon. What occurred is well known : it was a disastrous failure.

' The only thing we got out of it was the label "Impressionism ", a name I loathe,' said Renoir.

It was Monet's little picture, a misty landscape under a winter sun, which was responsible for the title. In all innocence, the artist had called his canvas, ' Impression '. The journalist, Leroy, writing in the satirical magazine *Le Charivari*, referred to all the exhibitors as 'impressionists', and the name stuck. The public rivalled the press in its hostility. Torrents of abuse were poured out in the form of puns, jibes and insults. People went to the exhibition in the hope of being amused. But their laughter quickly turned to anger when they saw the subjects portrayed by Degas and Cézanne : and they even scoffed at the charming young girls Renoir had painted. His ' La Loge ' came in for special ridicule. Such remarks as ' What mugs ! ' and ' Where did he dig up those models ? ' were heard on every hand. The models in question were none other than my Uncle Edmond and the lovely Nini. Paul Cézanne's son claimed that one infuriated visitor had spat on the 'Boy in the Red Waistcoat', a Cézanne canvas which recently fetched a fantastic price in London. It was reproduced, along with articles about it, in publications all over the world. It's a far cry from 1874 to 1959 ! While Renoir and his fellow-artists were smarting from this defeat, a 'Charge of the

Cuirassiers', by Meissonier,[1] was bought by an American for the remarkable sum of three hundred thousand francs.

I have before me a number of newspaper cuttings of the year 1874, and they are distressing. The following diatribe is from *La Presse* of Wednesday, 29th April:

### BEFORE THE SALON.

### THE EXHIBITION OF THE RÉVOLTÉS

... This School has abolished two things: line, without which it is impossible to reproduce the form of a living being or an object; and colour, which gives form the appearance of reality.

Daub three-quarters of a canvas with black and white, rub the remaining space with yellow, sprinkle a few red and blue spots here and there, and you have an IMPRESSION of spring which will send the more adept into ecstasy.

Smear a panel with grey, throw a few black or yellow lines across, and the fanatics will tell you that it gives an impression of the woods at Meudon.

But when it comes to the human figure, it is quite another matter. For the artist's aim is not to render form, modelling or expression. His sole purpose is to convey an IMPRESSION without any definite line, without colour, shade or light. By using such a far-fetched theory, the practitioner falls into a senseless confusion, completely mad, grotesque, and fortunately without precedent in the annals of art. For it is nothing less than the negation of the most elementary rules of drawing and painting. A child's scrawls have a naivety and sincerity as touching as they are amusing, but the excesses indulged in by this School are nauseating and revolting.

At the famous Salon des Refusés (1863), which cannot be remembered without a laugh, one could see women the colour of Spanish tobacco mounted on yellow horses in a forest of blue trees. But that exhibition was a veritable Louvre compared to the one in the Boulevard des Capucines.

After a look at the works shown—and I particularly recom-

[1] 1815-91. A French painter who specialized in dramatic war subjects.

[2] No. 54, 'The Dancing Lesson' by Degas; No. 42, 'The House of the Hanged Man' by Cézanne; No. 60, 'A Ballet Rehearsal on the Stage' by Degas; No. 43, 'The Modern Olympia' by Cézanne; No. 97,

mend Numbers 54, 42, 60, 43, 97 and 164[2]—one is inclined to wonder if there has not been a deliberate attempt to mystify the public. If not, the exhibits are the result of mental derangement, and certainly to be deplored. If the second deduction is correct, this calls for the opinion not of a critic but of Doctor Blanche.

But these pictures are all to be taken seriously ; they are seriously done and seriously discussed; and they are supposed to represent a new development in art. Velasquez, Greuze, Ingres, Delacroix, Théodore Rousseau, are banal : they have never understood Nature ; they are banal painters who have had their day : and the curators of museums should therefore consign their works to the store-room.

And let no one accuse me of exaggeration. We have all listened to these painters' arguments, and those of their admirers, at the Drouot Galleries, and we know that their pictures do not sell there any more than in the shops of the Rue Laffitte art-dealers, who pile up these rough sketches in a corner vainly hoping some day to get rid of them. We have heard them expatiate on their theories, as they cast disdainful glances at the paintings we admire. They jeer at everything careful study has taught us to love, repeating interminably in their overweening pride, ' If you knew the first thing about the fire of genius, you would admire Manet—and us as well, because we are his disciples ! '

<div align="right">EMILE CARDON</div>

But here is a more favourable article, from *Le Siècle* for 29th April 1874:

A few years ago it was bruited about in the studios that a new School of painting had just been formed. What were its objectives, its methods, its field of observation ? In what way did the art it produced differ from that of its predecessors? And what advantages did it bring to contemporary art ? At first it was difficult to appraise. The members of the jury of experts were determined, with their customary perspicacity, to keep out the newcomers. They closed the door of the

---

' Boulevard des Capucines ' by Monet; No. 164, ' The Orchard ' by Sisley. Renoir was evidently not thought worthy even of the writer's scorn.

Salon and deprived them of the benefit of publicity; and by every means, including selfishness, imbecility and envy, they tried to make them a public laughing-stock.

Debarred by the officials and other academicians, persecuted and ridiculed, the so-called anarchists banded together. Durand-Ruel, who is impervious to administrative prejudices, lent them an exhibition-room; and for the first time the public had an opportunity to discover the artistic tendencies of those who, for some unknown reason, have been called 'the Japanese of painting'. A good deal of time has elapsed since then. Heartened by a number of new members, encouraged by support from important sources, these painters have formed a Co-operative Society, and rented the photographer Nadar's former studio in the Boulevard des Capucines. And it is there, in a place of their own which they have arranged with their own hands, that they have just put on their first exhibition. . . .

. . . Let us examine what we are told is so monstrous, so subversive to the social order, in these thoroughgoing revolutionaries. On the ashes of Cabanel and Gérome I swear that there is talent, and a great deal of talent, among them. These young people have a way of understanding Nature which is neither tiresome nor banal. It is lively, it is vivid, it is delicate: in short, it is ravishing. What a sure grasp of the subject, and what amusing composition! True, it is summary, but how right every line is. . . .

. . . Now, what are we to think of this innovation? Is it to be regarded as a revolution? The answer is, no; because the basis, and to a large extent the form, of art remain the same. Is it, then, preparing the way for a new School? Again, the answer is negative; because a School lives on ideas, and not material methods or means. It can be distinguished from others by its doctrines, and not by its techniques. If it is not a revolution and if it does not contain the germ of a School, what is it, then? This time the answer is: 'a manner' and nothing more. After what Courbet, Daubigny and Corot have produced, one cannot say that the IMPRESSIONISTS invented the 'unfinished' manner of painting. But this new group vaunt and exalt it: they have made it into a system: for them it has become the keystone of art. They have set it

on a pedestal and worship it. This exaggeration is little else but a mannerism, and what is the fate of mannerisms in art ? They remain the trade-mark of the man who invented them, or else of the little band of worshippers who adopt them. This approach limits understanding instead of developing it : it makes one static, unable to reproduce, and soon condemns one to extinction.

In a few years the artists who have joined forces in the Boulevard des Capucines will split up. The stronger among them, those who are thoroughbreds, will recognize that while certain subjects lend themselves to impressionistic interpretation there are others which require a more definite treatment and sharper execution. In short, a painter's superiority lies in his ability to deal with each subject according to the manner best suited to it, and not in being the slave of this or that system. In other words, he must be able to choose instinctively the form of expression which will best embody his idea. Those who in due course have succeeded in perfecting their drawing will leave IMPRESSIONISM behind, as something which has become too superficial.

As for those others, who wilfully fail to reflect on the matter or to learn from experience, they will continue to pursue their impressions to the last gasp. The case of M. Cézanne, in his ' Modern Olympia ', should serve as a warning of the fate in store for them. They will go on from one idealization to another, until they reach such a degree of unrestrained romanticism that Nature is no more than a pretext for reverie. The imagination will then be incapable of conceiving anything except personal and subjective fantasies, which are utterly irrational because they are uncontrolled and out of touch with reality.

CASTAGNARY

It is easy to understand how this critic's disarming attitude baffled the exhibitors. Commenting on the above article during one of our talks, Renoir confessed that his resentment as a neophyte now seemed to him puerile.

' To think of anyone daring to attack Impressionism,' he said. ' What swinishness ! I felt like Corneille's Polyeucte wanting to overturn the idols. That was forty years ago. Now I am inclined to

agree with Castagnary, so far as Impressionism is concerned. But it still makes me angry to think he didn't understand that Cézanne's " Modern Olympia " was a classic masterpiece, closer to Giorgione than to Claude Monet; a perfect example of a painter who had already gone beyond Impressionism. What is to be done about these literary people, who will never understand that painting is a craft, and that the material side of it comes first? The ideas come afterwards, when the picture is finished.

' After hearing what these people say, how can one believe that there is still room for painters in France ? ' But his optimism would quickly revive: ' The French do a lot of painting, but they don't love it.' And again: ' We don't work for the critics, or for the dealers, or even for art-lovers in general; but only for the half-dozen or so painters who are competent to judge our efforts because they paint themselves.' As this last assertion seemed too positive, he added, ' We paint also for Monsieur Choquet, for Gangnat, and for the unknown man in the street who stops in front of an art-dealer's window and gets two minutes' pleasure from looking at one of our pictures.'

I should like to continue with an excerpt from the ' Art News ' column in *La Patrie* for 21st April 1874:

... I who have the honour to be talking to you have a furious desire to open an exhibition of sculpture in the Boulevard des Italiens. I have, at home, some statuettes ...

But haven't I a precedent ? Yesterday I went to an exhibition in the Boulevard des Capucines: a hundred pictures and drawings well spaced along the walls in three or four rooms. There are at least a dozen which the Salon would have accepted ; but towards several the judges would have had to be very indulgent. . . .

But the rest of the canvases . . .! Those who have not seen them cannot imagine how puzzled the visitor is. Do you recall the ' Salon des Refusés '—the first one, that is : the one where you could see naked women the colour of a bilious Bismarck, jonquil-coloured horses, trees of a Marie-Louise blue? Well, that Salon was the Louvre, the Pitti, the Uffizi, compared to the exhibition in the Boulevard des Capucines.

Looking at the first rough drawings (and ' rough ' is the

right word), you simply shrug your shoulders ; seeing the second set, you burst out laughing ; but with the last ones you finally get angry. And you are sorry you did not give the franc you paid to get in, to some poor beggar.

You wonder if you are not the victim of some hoax, all the more unpardonable because the perpetrator intends to benefit by it ; or else it must be a piece of speculative business in questionable taste. You can't even ask for a refund. You would be shown a few rare canvases, some of them more or less good, more or less serious. But these are the exceptions, of course. And you might be told, ' You see, we have really serious works here, too. If any of them are not to your liking, it is not the fault of the Society exhibiting them. Art is free. Besides, are you sure that what you see here does not represent the efforts of misunderstood geniuses, of bold innovators, and pioneers of the painting of the future ? ' Note that I said, ' you might be told.' But you are not told. It would require a great deal of effrontery to come out with a statement like that.

As I said, I went there yesterday morning. I was with ten or fifteen other visitors, men and women. Some of these victims of mass mystification, all strangers to one another, had decided to laugh (a little sourly), while exclaiming, ' Well done ! ' The others indulged in all sorts of queer and gratuitous suppositions. Here are a few examples :

' It was the Directors of the Beaux-Arts who organized this exhibition, to justify the rejection of these paintings by their jury of admissions. After seeing them, the public will say how right the Jury was in turning down such horrors.'

' Pardon me, but you are mistaken. These things were not refused by the jury, because they were not submitted to its judgment. This is a free exhibition.'

' Well, then, it was some practical joker who amused himself by dipping his brushes into paint, smearing it on to yards and yards of canvas, and signing with different names.'

' My dear lady, you are wrong again. These are real names. No one made them up.'

' In that case, they are probably Monsieur Manet's pupils.'

' You're getting warmer. They probably are Manet's pupils, but those the master refused to take on.'

' Good Heavens! Pupils Manet turned down! Who could they possibly be?'

' Look around, and you'll see.'

' But wasn't Monsieur Manet himself refused this year?'

' Yes, indeed. But that does not mean that he hasn't the right to refuse, in turn, the work of those pupils who lean too far towards realism. Here: look at Number 42.' (Cézanne's ' House of the Hanged Man'.)

' Don't you think, Monsieur, that it is more a criticism of the Manet genre? It would be very intelligent, if it were.'

' No. I don't think so. Ask those who executed these daubs, and they will tell you, with a pitying glance, that you understand nothing of the flights of genius; or about art renewing itself. " You are a lot of old fogies," they will say. " You are stuck in a rut; you are slaves of the hackneyed, with your worship of Raphael and Murillo and all the rest. The old school has had its day, and we've had enough of it. Make way for realism; bring on the Young! Hurrah for Manet, and down with the Louvre! Down with the rococo art of the Renaissance!"

' They are perfectly sincere. But that does not keep them from painting in such a way that even the most slovenly work of Manet is Correggio or Greuze compared to what the Impressionists do.'

<div align="right">A. L. T.</div>

I should like to follow this up with a little Parisian item from *La Patrie* of Thursday, 14th May 1874:

NEWS OF THE DIFFERENT EXHIBITIONS

There is an exhibition of the INTRANSIGENTS in the Boulevard des Capucines, or rather, you might say, of the LUNATICS, of which I have already given you a report. If you would like to be amused, and have a little time to spare, don't miss it.

<div align="right">A. L. T.</div>

And to conclude the list, let me offer Leroy's article—*Le Charivari* of 25th April 1874:

# Renoir, My Father

THE IMPRESSIONIST EXHIBITION
by Louis Leroy

It was a sorry day when I took it upon myself to go to the first exhibition in the Boulevard des Capucines, accompanied by M. Joseph Vincent, the landscape painter, who was a pupil of Bertin's and has been honoured with medals and decorations by several different governments.

The rash fellow had come along, all unsuspecting ; for he imagined that he was to see painting of the kind to be seen almost everywhere, good and bad ; but not an attack on good artistic traditions, or on the cult of form, or one's respect for the great masters. Alas, for form and for the great masters ! They are no longer necessary, my good friend. We have changed all that.

In the very first room, Joseph Vincent received his first shock when he beheld M. Degas's ' Dancing Girl '.

' What a pity,' he said to me, ' that the painter, with such a knowledge of colour, does not draw better. His dancer's legs are as flimsy as the gauze of her ballet-skirt.'

' You are being a trifle hard on him,' I replied. ' His drawing is very firm.'

Bertin's disciple, thinking I was trying to be ironic, shrugged his shoulders and said nothing.

Then I led him gently, with an innocent air, to ' The Ploughed Field ' by M. Pissarro. The minute he laid eyes on that bewildering landscape, he thought his glasses were misty. He cleaned them carefully, put them back on his nose, and took a second look.

' Shades of Michelangelo ! ' he cried out. ' What on earth is that ? '

' Don't you see ? ' I said. ' It represents ploughed furrows covered with hoar-frost.'

' Those ? Ploughed furrows ? That is hoar-frost ? But they're nothing but palette-scrapings, put in parallel lines on a bit of dirty canvas. There's no head or tail to it, no top or bottom, or front or back.'

' That may be so ; but it is an impression, nevertheless.'

' Well, it's a queer impression. . . . Oh ! And what is that ? '

' That's an " Orchard ", by Monsieur Sisley. I think you'll

like the little tree at the right. It is gay, but the impression . . .'

' Oh leave me alone with your impression. . . . It isn't done, and it shouldn't be done. But here's a ' View Of Melun ' by Monsieur Rouart. There's something in the water . . . And the shadow in the foreground is very odd.'

' It's only the tone-vibrations that worry you.'

' If you'd said smears instead of tones, I'd have understood better. Ah, Corot: what crimes are committed in thy name ! It is you who started this vogue for loose execution, transparent colours, and splotches, which have troubled the art-lover for thirty years. But he must accept them, he is forced to accept them, because of your quiet stubbornness. One more example of the drop of water splitting the rock.'

Though the poor man rambled on in this distraught fashion, I still could not foresee the regrettable scene which was to take place as the result of his visit to this exhibition.

He endured Monet's ' Fishing-boats Leaving Port ' without getting too worked up over it, perhaps because I tore him away from this dangerous sight before the offensive little figures in the foreground could have an effect on him. Unfortunately, I was foolish enough to allow him to stand too long in front of the same painter's ' Boulevard des Capucines '.

' Ha-ha-ha ! ' he sneered. ' That one's a real success. There's an impression, or I don't know one when I see it. But will you kindly tell me what all those little black dribbles at the bottom of the picture mean ? '

' Why, they're pedestrians,' I replied.

' And that's what I look like when I walk along the Boulevard des Capucines ? In the name of Heaven ! Are you making game of me, by any chance ? '

' I assure you, Monsieur Vincent . . .'

' But those spots were put in by the same method used for whitewashing the base of fountains. Slap-bang, swish-swash, any old way. It's frightful. If I see any more, I shall have a stroke. . . .'

I tried to calm him by showing him the ' Saint-Denis Canal ' by M. Lépine and ' The Butte Montmartre ' by M. Ottin, both rather delicate in tone. When we came to M. Pissarro's ' Cabbages ', my friend's face turned from bright red to deep scarlet.

' Those are cabbages,' I told him, in a persuasive voice.

' Oh, the poor things ! What a caricature ! I shall never eat one again.'

' But it is not the artist's fault if——'

' Stop ! Say another word and I shall do something terrible.'

Suddenly he uttered a cry when he perceived M. Paul Cézanne's 'House of the Hanged Man'. The thick impasto of that little jewel completed the damage begun by the 'Boulevard des Capucines'. Old Vincent became delirious. His madness was not pronounced at first, but the signs of it were evident when he unexpectedly switched over to the point of view of the Impressionists and came to their defence.

' Boudin has talent,' he informed me, as we stood looking at 'A Beach' by that artist. 'But why does he put too much finish on his sea-pieces ? '

' Oh, so you think his painting is overdone ? '

' Beyond any doubt. But tell me about Berthe Morisot. That young lady doesn't bother to put in a mass of useless details. When she paints a hand, as in her picture called " Reading ", she gives as many brush-strokes, lengthwise, as there are fingers, and the thing is done. The idiots who find fault in the way a hand is done, don't understand Impressionist art ; and the great Manet would chase them out of his Republic.'

' Then Monsieur Renoir is on the right track. There's nothing superfluous in his " Harvesters ". I might even say that his figures——'

'. . . are even too well done.'

' But Monsieur Vincent, just look at those three strokes of colour which are supposed to represent a man working in a wheat-field.'

' There are two too many. One would have been enough.'

I glanced at Bertin's worthy pupil and was distressed to see his face slowly turning a deep purple. Some catastrophe seemed imminent ; in fact it was M. Monet who was to give the final blow.

' Ah, here we are ! ' he exclaimed, when we reached Number 98. ' What does this canvas represent ? What does the catalogue say ? '

' " Impression : Sunrise ".'

' " Impression " ! I was sure of it. There must be an impression somewhere in it. What freedom it expresses, what flexibility of style ! Wallpaper in its early stages is much more finished than that.'

' But what would Bidault, Boisselin or Bertin have said about this impressive impression ? '

' Don't mention the names of those hideous daubers ! ' shouted old Monsieur Vincent.

The poor wretch had renounced his favourite gods.

I tried to save his failing reason by showing him ' View of a Pond ' by M. Rouart, which was a nearly perfect work ; and a ' Study of the Château of Sannois ', by M. Ottin, which was very lustrous and delicate. But in vain. He was attracted only by the horrible. M. Degas's ' Washerwoman ' (who needed to be washed herself) drew cries of admiration from him.

Even Sisley seemed quaint and precious to him. Because of his present mania and for fear of irritating him, I searched for anything tolerable in these impressionistic pictures, and I suggested that the bread and grapes and chair in M. Monet's ' Luncheon ' were good bits of painting. But he would not accept these concessions.

' No, no ! ' he cried. ' That's where Monet shows his weakness. He has sacrificed to the false gods of Meissonier. It's overdone, overdone, overdone. Now, if you had said something about " The Modern Olympia ", that would make sense.

' Let us go and look at the Cézanne again. What do we see ? A woman bent double, while a Negress is taking off the last of her veils and exposing her in all her ugliness to the fascinated gaze of a dark-skinned puppet. Do you remember Monsieur Manet's " Olympia " ? Well, that was a masterpiece of draughtsmanship compared to that of M. Cézanne.'

Finally the dam burst. Old Vincent's academic brain, attacked from too many sides at once, became completely unhinged. He stopped in front of a Paris policeman, who had been posted there to keep an eye on all these treasures, and, mistaking him for a portrait, delivered himself of a stinging criticism.

' It's pretty bad,' said Vincent. ' There are two eyes, a nose, and a mouth in front. The Impressionists would not have bothered with such details. With all the useless features the artist has put into this face, Monet could have painted twenty Paris policemen.'

' Easy, now,' said the portrait. ' You'd better move on.'

' Did you hear that ? The picture's even got a voice ! The pedantic idiot who put all that finish on his work must have spent a lot of time at it.' And, to show how serious he was about his aesthetics, old Vincent started doing an Indian scalp-dance in front of the policeman, chanting in a choked voice :

' Wah ! I am Impressionism on the march. I've got my palette-knife ready to avenge Monet's " Boulevard des Capucines ", Cézanne's " House of the Hanged Man " and " The Modern Olympia ". Wah ! Wah ! Wah ! '

It took me some time to realize that the article I have just quoted was meant to be ironic. It was really what is known as ' Boulevard wit ', which has since vanished, along with corsets, and furniture in imitation of the Renaissance. As Renoir once said, ' English humour is as superficial as Parisian wit ; but at least on the other side of the Channel they wash their feet from time to time.'

I shall not quote from the favourable reviews of the exhibition. They were written by friends such as Rivière and Edmond Renoir.

The painter who got the worst of it was my father, as he received the fewest insults. He was looked upon as too insignificant to be noticed. ' They ignored me. And it is rather disconcerting to be ignored.'

When the exhibition was over, commissions for portraits, on which the Impressionists depended for a living, became rarer. For who would have dared to hang in his drawing-room the works of artists so harshly criticized by the bright wits of the time? Moreover, such faithful partisans as Choquet, Charpentier, Caillebatte, Bérard, Gachet and the rest had bought all they could, and their walls were already covered with works of the Young School. A second public sale of some of the best of Renoir's, Sisley's and Pissarro's canvases brought in only three hundred francs. Meanwhile, the ' official ' painters sold their pictures for high prices ; they were loaded with honours and decorations ; and they lived in magnificent residences.

'And don't let anyone try to tell me that all that came from the State or the Beaux-Arts or the Institute. The public fairly wallowed in that hogwash.'

For a time my father actually considered the possibility of going back to wall-decorations in cafés again. But the 'cork' kept his chin high. 'I had tasted the forbidden fruit. And I wasn't going to give it up.'

# 15

Fortunately, there was Monet. He rose to the occasion immediately, in an amazing manner. He refused to give in to the first setback—or to subsequent ones. He proposed a plan so utterly fantastic that my father laughed whenever he thought about it, even forty years later. Monet's landscape 'Impression' had been jeered at because 'no one could see anything in it.' Monet shrugged his shoulders haughtily. 'Poor blind idiots. They want to see everything clearly, even through the fog!' One critic had informed him that fog was not a fit subject for a picture: 'Why not a scene of Negroes fighting in a tunnel?' he suggested. The general lack of understanding gave Monet an irresistible desire to do a painting still more foggy.

One day he said to Renoir triumphantly:

'I've got it! The Gare Saint-Lazare! I'll show it just as the trains are starting, with smoke from the engines so thick you can hardly see a thing. It's a fascinating sight, a regular dream-world.'

He did not, of course, intend to paint it from memory. He would paint it *in situ* so as to capture the play of sunlight on the steam rising from the locomotives.

'I'll get them to delay the train for Rouen half an hour. The light will be better then.'

'You're mad,' said Renoir.

The 'Impressionist' group had literally not enough to eat. They just managed to live by occasional invitations to dinner. My father could no longer afford the cheap little *crémerie* he usually went to. The kindly proprietress, Mme Camille, would willingly have allowed him credit, but he was afraid he would never be able to pay his bill.

At the same time, his brother Edmond was obliged to postpone two important projects: his marriage, and the publication of *The Impressionist*, a review to be devoted exclusively to the New Painting. Cézanne had gone back to Aix-en-Provence. Degas had retired to his comfortable apartment in the Rue Victor Massé. Monet, however, seemed to rise above all such contingencies. He put on his best clothes, ruffled the lace at his wrists, and twirling his gold-headed cane went off to the offices of the Western Railway, where he sent in his card to the Director. The usher, overawed, immediately showed him in. The Director graciously asked Monet to be seated. His visitor introduced himself modestly as ' the painter, Claude Monet'. The Head of the Company knew nothing about painting, but did not quite dare to admit it. Monet allowed his host to flounder about for a moment, then deigned to announce the purpose of his visit. ' I have decided to paint your station. For some time I've been hesitating between your station and the Gare du Nord, but I think that yours has more character.' He was given permission to do what he wanted. The trains were all halted; the platforms were cleared; the engines were crammed with coal so as to give out all the smoke Monet desired. Monet established himself in the station as a tyrant and painted amid respectful awe. He finally departed with a half-dozen or so pictures, while the entire personnel, the Director of the Company at their head, bowed him out. Renoir concluded: ' I wouldn't have dared to paint even in the front window of the corner grocer ! '

Paul Durand-Ruel not only took the Gare Saint-Lazare pictures, but made arrangements to give an advance to all his protégés. This proof of the vitality of the new painters proved beneficial to all concerned.

But Monet was not the only one with confidence in himself and his friends. Even the younger students of the Beaux-Arts sided with the Impressionists. When the Vendôme Column was restored, they improved on the song we already know:

> Monsieur Courbet a dit à Cabanel
> Monsieur Courbet a dit à Cabanel
> Pourquoi peins-tu avec du caramel ?
> Que penses-tu, Gérome,
> De la colonne Vendôme ?
> Ca n'vaut pas l'jaune de chrome.

# Renoir, My Father

Faudra la démolir
Pour em—— l'empire !

Hardly a day passed without some young painter coming to see Renoir. Sometimes one would say to him, ' Monsieur Renoir, we would all like to paint the way you do, but we can't.'

' But there's nothing remarkable about it. All you have to do is look around you.'

And another would assert : ' Monsieur Renoir, up till now I thought real painting was Delacroix, but now I know it's you.'

And my father's comment on all this was :

' As if there weren't enough room for Delacroix and hundreds of others, including your humble servant in his little corner.' Then he added : ' What enthusiasm you have at twenty ! Why do people have to change, and turn into gentlemen in top-hats and ladies in tight corsets ? '

One day a delegation called. There were about a dozen in the group.

' Monsieur Renoir,' they said, ' we have thrown all our tubes of black paint into the Seine.'

My father was nonplussed.

' But black is a very important colour,' he told them. ' Perhaps the most important.' He pointed out how much black there is in Nature. The mistake the academic painters made, he explained, was in seeing only the black, and in its pure state. Nature abhors ' pure ' colours.

While training horses at Bordeaux and Tarbes, my father had learned that in the eyes of a true horseman a horse is never black or white. It is only foot-soldiers who use such expressions. Horses which look black are ' brown bays '; and the white ones are ' light grey '. The hair of their coats is mixed. It is the combination of tones, seen as a whole, that gives the impression of the horse's coat being all black. And among the countless hairs in it, even the black come in different pigments. ' We too should use black, but in a mixture as it is in Nature.' Renoir was to use pure black later on, though sparingly, knowing pretty well what he was doing, ' because one learns every day.'

Throughout those trying years Monet did all he could to encourage the others in the group, and especially my father. He

opened their eyes to the necessity of adopting certain methods which were later to safeguard the art business in our time. Here is the substance of his argument, as I understand it from what my father told me :

We know that railways have supplanted stage-coaches as a means of travel. No one nowadays would think of going to Lyons in a stage-coach, because there are no stage-coaches. Then why should painters seek their livelihood by courting this or that Maecenas since there are no Maecenases left ? What do we get from our patrons ? A miserable portrait from time to time, and after living for a week on the proceeds we are as hard up as ever. Just as we can go by rail, using the cushioned seats and palatial station which are paid for by the huge number of travellers, so we ought to sell our work to dealers, whose luxurious galleries will be paid for by hundreds of customers. The day of the little individual merchant and personal bartering is over. We have entered the era of Big Business. And while our dealers are busy attracting customers, we will be able to do our painting far away from Paris, in China, Africa, or any place where we find subjects which inspire and please us.

The Impressionists knew very well that the only important dealer capable of winning the public was Paul Durand-Ruel. Always a practical man, my father pointed out that Durand-Ruel was the only one who was really interested in them. Their dilemma can be summed up in a few words : either they could grant their champion the monopoly of their work, or else they would have to continue soliciting small commissions, and face the disappointments inevitable in touting their own canvases. Renoir foresaw that the first solution, which in any case was inevitable, would throw the doors open to speculation. A dealer as daring as Durand-Ruel was bound to be a speculator because of his very courage. For it was he who ten years before had tried to get possession of all Théodore Rousseau's pictures. Under the new system the dealers who had a monopoly could make the value of their merchandise go up or down as they chose. To influence the market, they had only to flood it or cut off the supply. And then, perhaps, connoisseurs and collectors would start buying pictures to make money, not for the pleasure of hanging them in their dining-rooms.

' And what of it ? ' retorted Monet. ' The important thing for us is to be able to carry on our experiments.'

However, the arguments for or against were a waste of breath.

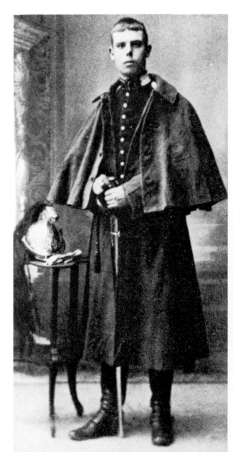

Jean Renoir as a cavalry officer, 1914

Jean Renoir (second from left) and Claude
(Coco) Renoir (sitting), 1915

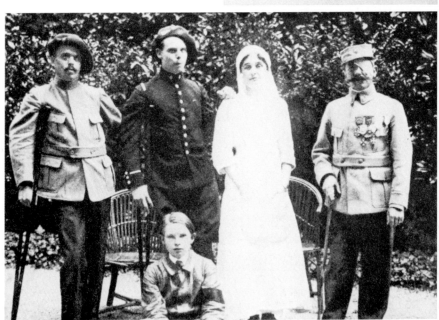

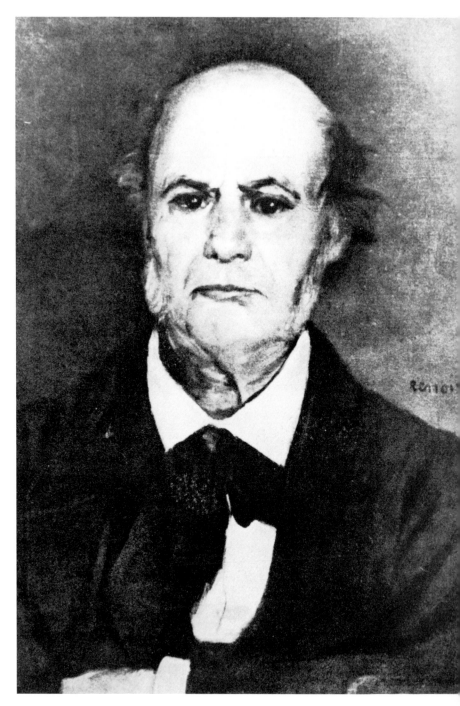

Portrait of Renoir's father by Renoir (1869)

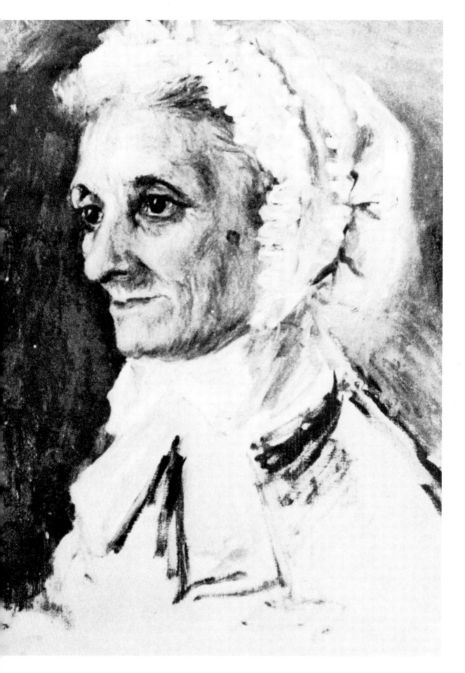

Portrait of Renoir's mother by Renoir (ca. 1867)

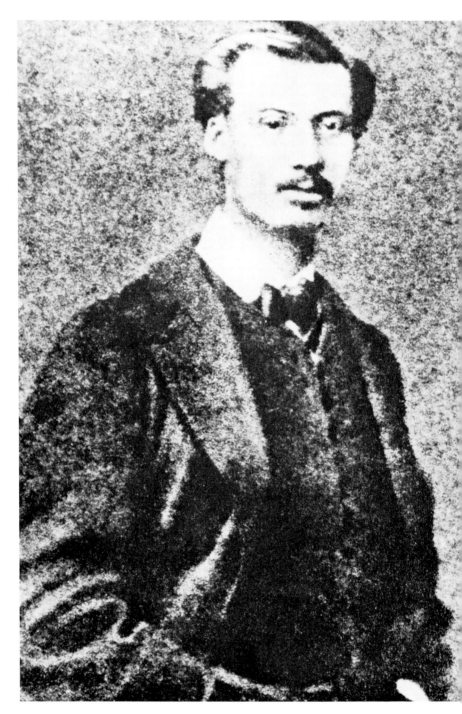

Renoir in 1861

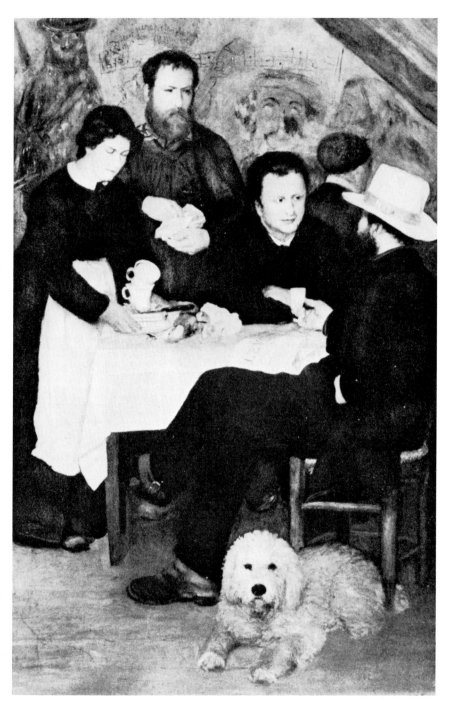

*Mother Anthony's Inn* by Renoir (1866). Left to right: Nana the waitress, Sisley, Frank Lamy, Mother Anthony, Pissarro, the dog Toto

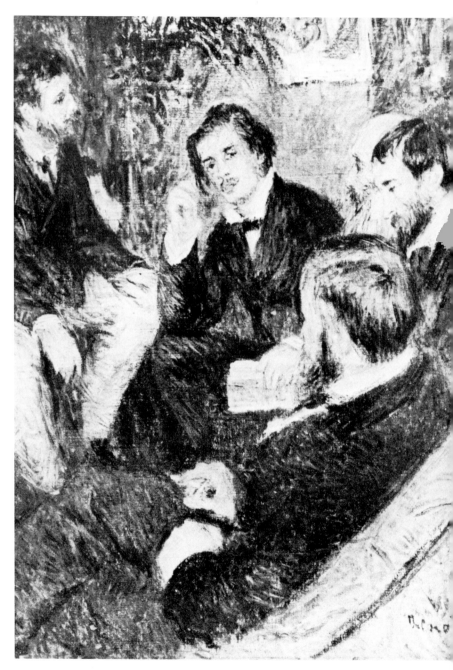

*The Studio* by Renoir (1876). Left to right: Lestringuez,
Georges Rivière, Pissarro, Cordey, Cabaner

Portrait of Renoir by
Bazille (ca. 1868)

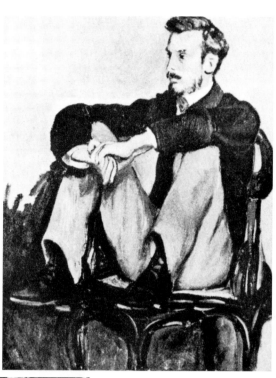

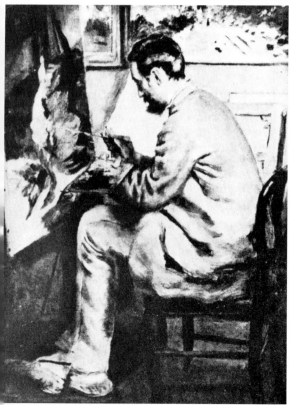

Portrait of Bazille by
Renoir (ca. 1868)

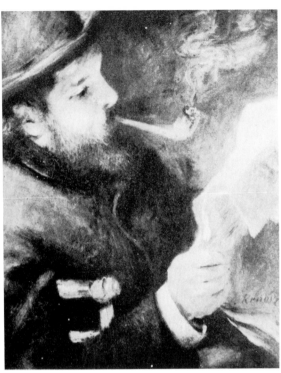

Claude Monet Reading by
Renoir (ca. 1870)

Sisley and his wife
by Renoir (ca. 1868)

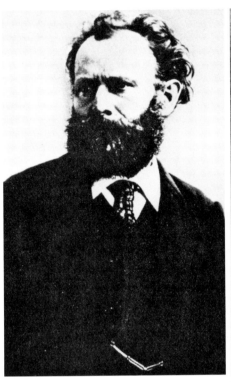

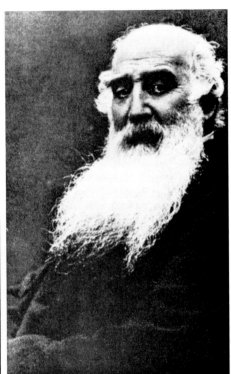

Edouard Manet, ca. 1870

Camille Pissarro, 1895

Paul Cézanne, ca. 1860

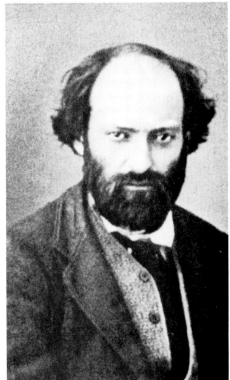

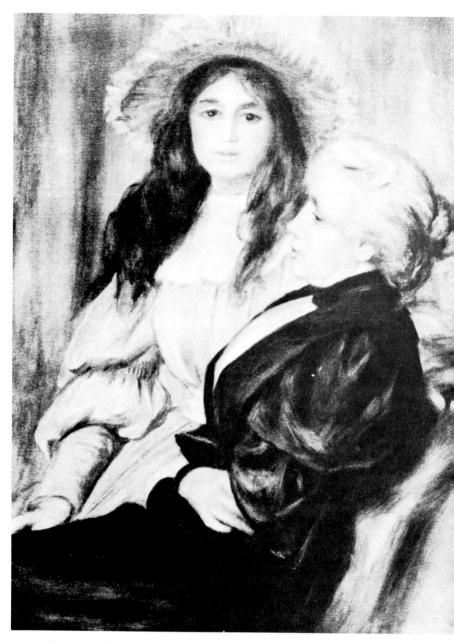

Portrait of Berthe Morisot and her daughter by Renoir (1894)

Portrait of
Paul Durand-Ruel
by Renoir (1910)

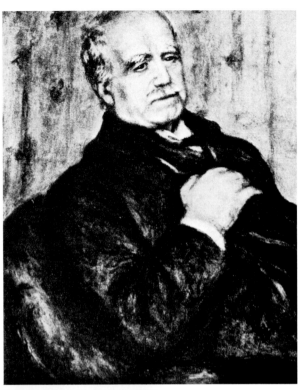

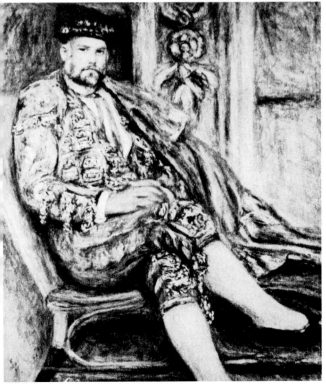

Second portrait of
Vollard by Renoir, 1917

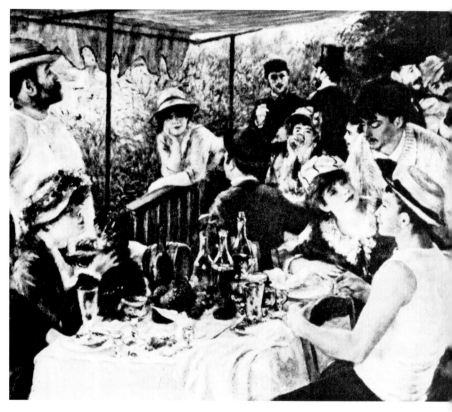

*The Boatmen's Luncheon* by Renoir (1881). Left to right:
the future Mme Renoir, unknown, Alphonsine Fournaise, Mlle
Henriot (drinking), Lestringuez leaning over Ellen André
and a friend, perhaps Rivière

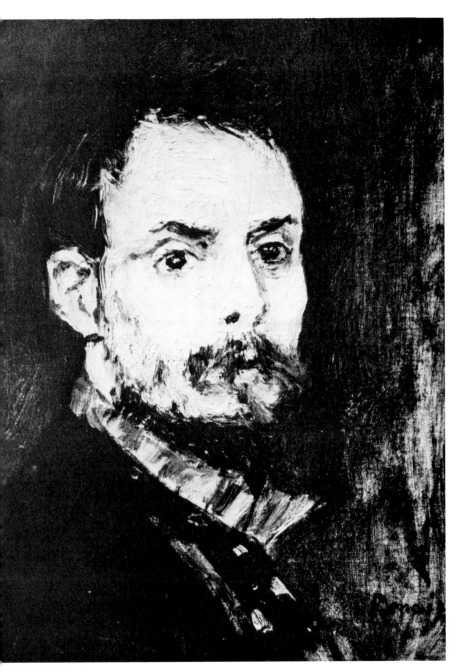

Self-portrait by Renoir (ca. 1880)

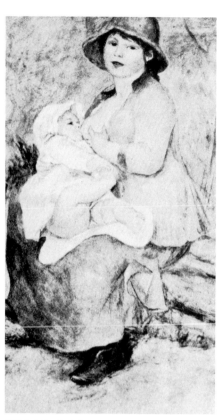

*Maternité* by Renoir (1885)
(Mme Renoir and Pierre)

*The Farm at Essoyes* by
Renoir (ca. 1900)

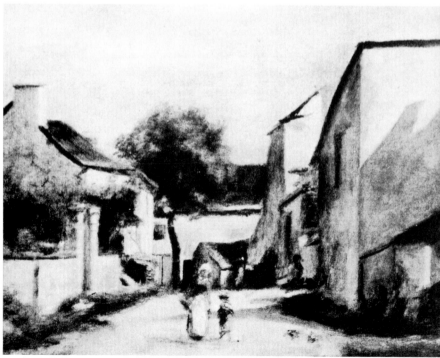

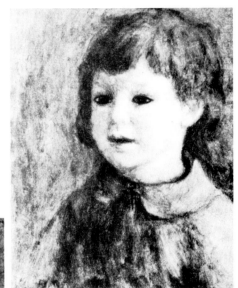

Jean Renoir by Renoir (1903)

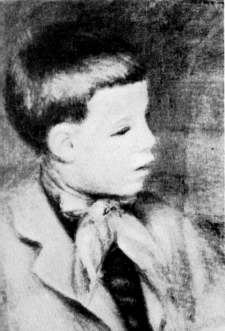

Claude Renoir by Renoir (1905)

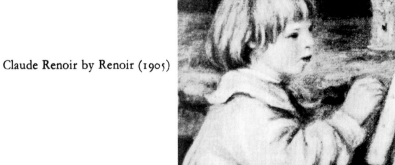

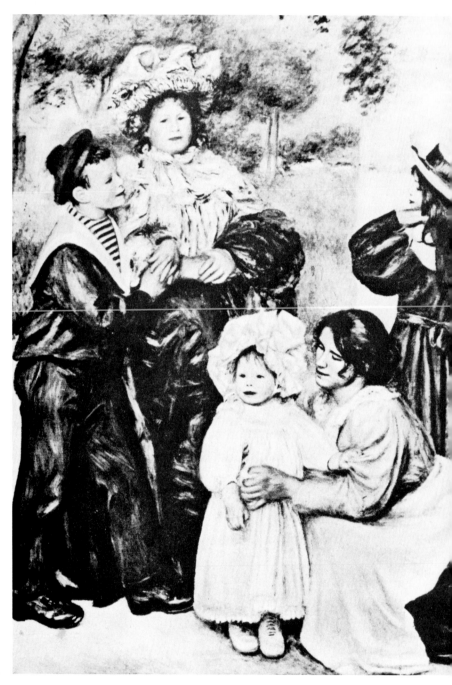

*The Artist's Family* by Renoir (1895). Left to right: Pierre
Renoir, Mme Renoir, Jean Renoir, Gabrielle, Marie Isembart

The system was already under way, and Paul Durand-Ruel was to inject unexpected vitality into it. He had invented an entirely new profession. His business acumen was put at the service of the creative genius of painters, and the combination of the two was to give Paris an artistic lustre unequalled since the Italian Renaissance.

The Impressionists attached considerable importance to the latest developments in photography. Their friend Charles Cros saw in it a means of studying the problems of the analysis of light and, in consequence, of making further experiments with Impressionism. Seurat, whom my father knew only slightly, believed that movement could be studied through photography. He was very much interested in the 'photographic gun' invented by Marey.[1] Renoir regarded photography as both a great good and a great evil, 'like all inventions since the world began'. He gave due credit to Niepce and Daguerre for having 'freed painting from a lot of tiresome chores, starting with family portraits. Now the good shopkeeper has only to go to the photographer around the corner. So much the worse for us, but so much the better for the art of painting.' On the other hand photography, to my father's mind, was a threat to amateur painters. 'All those young girls who do mawkish water-colours at least get some idea of what painting is. To appreciate Mozart it does no harm to know how to play the piano. To appreciate old Corot it's a help to try your hand at a few landscapes. Photography is going to kill the amateur painter and, indirectly, the art-lover ; and it may even kill the painter, since the art-lover is his source of livelihood.' As regards that, my father 'missed it by a mile', as he would say himself if he were here and could see the incredible flowering of 'knights of the brush'.

To round off this discussion of photography, I should like to quote a little play on words which Renoir attributed to Degas. It must have occurred as the climax of a conversation between the well-known society-photographer Nadar and the painter. The former was trying to prove that photography was superior to painting for giving a likeness. In the hope of putting his adversary in his place, Nadar had said, ' Don't forget that I too am a painter.' Deliberately affecting the accent of a roughneck, which made a comic contrast

[1] 1830-1904. Doctor and physiologist; invented chrono-photography, which he used to study the movements of animals. It led to the kinemato-graph, or moving-picture camera.

to his conventional appearance, Degas replied, ' Va donc, ah, faux artiste, faux peintre, faux . . . tographe ! '

The 1874 exhibition was not the only one. In our talks Renoir would seldom refer to these ventures except to date early friend-ships. Many of these friends were Government employees. It seems that the different branches of the Government services had proved fertile ground for the development of artistic and literary tastes.

In this connection my father would often mention his friend Lestringuez. As a boy, I had myself known M. Lestringuez. His daughter Marie was always one of my dearest friends, and his son Pierre lent me gallant support in several of my motion-picture ventures.

When I was a child, we often went to luncheon with the Lestringuezs at Neuilly. They lived in a large house, which was always kept in perfect order and smelt of waxed floors and polished leather. In my childish imagination it was the last word in elegance. And how it contrasted with our apartment, which smelled chiefly of turpentine and whose floors were never waxed because my father was afraid that ' the children might slip and bark their knees '. I was fascinated by M. Lestringuez's red beard, by his highly intelligent eyes and by the slight curvature in his back. But what struck me as odd was that his children always addressed him formally as ' *vous* ' and that they never spoke at meal-time. Nor did Mme Lestringuez ever interrupt her husband. Her habit of mixing up names delighted us. ' May I present Mr Pike.' The person designated would try to set her right : ' Pardon me, Madame, but my name is Hake.' But she would go serenely on and say of the guest just introduced, ' Yes, you know, Mr Haddock has just come back from a long trip,' etc., etc. Of course she did it on purpose. Such pleasantries were always spoken in the off-hand manner customary among well-bred Parisians. Everything about the Lestringuezs' home in Neuilly justified Gabrielle's admiring remark : ' They're real swank, they are ! ' I liked them very much, though I did think they were a bit stilted and formal. And it came as a surprise later on when my father mentioned that M. Lestringuez had been rather eccentric in his youth. His great passion in the days of the Impressionists was for the occult sciences. His knowledge in this field was immense. With Villiers de l'Isle

Adam he had gone in for quite dangerous experiments. Renoir had always refused to take part. The life beyond the grave had little interest for him. 'We'll see about that afterwards. As a dead man, I may be able to enjoy death. As long as I am alive I intend to enjoy life.' However, when it came to hypnotism, he was vastly amused by his friend's demonstrations. 'He could put you to sleep in an instant. One night he hypnotized Frank Lamy, ordered him to undress, and sent him into the street in his underpants.' He worked in the Ministry of the Interior and claimed that he could overthrow the Republic just by hypnotizing all the high-ranking civil servants there. 'The only reason I haven't done it so far,' Lestringuez declared, 'is that I would have no one to take the place of Mac-Mahon.[1] The only ruler I am interested in is Charles IX and he is dead.' He liked Charles IX for his part in the Massacre of Saint Bartholomew's Day, 'a serious effort to keep down the population, the second great peril to our civilization.' The first peril, according to Lestringuez, was the use of bitumen in painting.

Lestringuez often brought his friend Chabrier, the composer, to see my father. My mother mentioned him several times to me because he had been responsible for her decision to give up the piano. She used to play, just as a great many other young ladies do.

'Friends complimented me on my playing. Renoir made me read some of Schumann's melodies at sight. He had known Madame Schumann well before the War of 1870. Then, one day, Chabrier came; and he played his "España" for me. It sounded as if a hurricane had been let loose. He pounded and pounded the keyboard. It was summertime. The window was open. While he was playing, I happened to look into the street. It was full of people, and they were listening, fascinated. When Chabrier reached the last crashing chords, I swore to myself that I would never touch the piano again. An amateur player is really ridiculous. Like the people who, just because they know Renoir, want to take up painting. How can they? Besides,' she added, 'Chabrier had broken several strings, and put the piano out of action.'

Renoir had the greatest respect for Chabrier as a man, apart from his respect for him as a musician. 'He was kind, generous, and exceedingly handsome. And that was his undoing. He was too fond of the opera stars, and not only for their voices.'

A few years later Renoir saw the composer again at a performance

[1] Second President of the French Republic from 1873 to 1879. (Trans.)

of one of his oratorios. The two men were of about the same age.
My father was as thin as a rail but as agile as ever, and he could climb
stairs four steps at a time. Chabrier had aged and grown stout, and
he could only walk painfully with the aid of a cane.

'He recognized me, and fairly wept for joy. But he didn't
recognize his own music. He even asked who had composed it.
Ah, those jades, it's better just to paint them.'

Let me return now to Renoir's friends while he was still a
bachelor. They used to meet in his studio at 35 Rue Saint-Georges.
It was on the top floor, over the apartment occupied by my Uncle
Edmond, who had become the official champion of Impressionism.
Despite the public's mistrust, he had succeeded in finding a market
for his writing. 'A brilliant mind and an authority in his field,' was
the way Renoir summed him up. The following story illustrates the
difference in character between the two brothers.

The incident took place on the Promenade des Anglais in Nice,
probably some time after 1900. The Jetty Casino had caught fire,
and a large crowd gathered to watch. My father had just come out
of a near-by hotel, where he had been paying a call on his friend
Camondo.[1] He had a good deal of trouble trying to get through the
mass of people. All at once he became aware of a voice, which could
be heard above the general noise and confusion, snapping out clear
and sensible orders. 'That voice sounds familiar,' my father said to
himself, as he was pushed this way and that. The voice continued,
and the mob obeyed docilely, forming into lines along the pavement
in order to let the fire-brigade pass. He caught sight of the man
directing operations, and saw that it was his brother. Edmond was
perched on top of a cab; and as though it were the most natural
thing in the world, the fireman in charge, the mayor and the police
were all following his directions, which he gave with the greatest
good-will and self-assurance. Renoir had an impulse to join him,
but could not because the crowd shifted in order to make way for
the ambulances, which were just arriving on the scene. Before he
knew it, he was swept out of reach of his brother.

Between 1874 and 1890, Georges Rivière was undoubtedly one
of Renoir's closest friends. His duties at the Ministry of Finance
allowed him considerable leisure, spent almost entirely in my father's
company. Eventually he was made head of the bureau, and then
became Secretary to the Minister of Finance. He married, and had a

[1] Isaac de Camondo, a celebrated art collector.

family which kept him so occupied that he rarely had time to visit the Montmartre associates of his younger days. He was nevertheless to reappear later on, as we shall see. In his book *Renoir et Ses Amis* there is a reproduction of a painting by my father of the habitués of the studio in the Rue Saint-Georges in 1876. It shows Lestringuez, Cabaner, Pissarro, Rivière himself, and Cordey, a painter who was one of Renoir's best friends. I think the last-named even studied for a time at the Atelier Gleyre, and had known Bazille. My father admired him because he ' painted well ' and was a regular worker. Cordey liked to compare painting to gymnastics. ' Painters should keep in form just like athletes. They should have a clear eye, their movements should be precise, and they should have good legs so that they can go to the country and paint landscapes.'

Pissarro, who remained ' the brain of the young painting movement ', drew sound conclusions from the exhibition of 1874. First, it was useless to make concessions. Renoir's ' La Loge ', which looked as if it had been painted by a classic artist, had been scorned to the point of being almost ignored. Second, the public, in whom the Impressionists had had absolute faith before the exhibition, was not the infallible judge they had supposed it to be. Thirdly, birds of a feather should flock together. The fact that some lukewarm sympathizers had joined the Intransigents had not brought in a single new customer.

Renoir agreed entirely with Pissarro, for whose ' perfect judgment ' he had great respect. Even so, he had his own views. There are general truths, but there is also the individual's need to adapt himself to circumstances—' above all, the knowledge of what one can, or cannot, do.' One should never ' fool oneself '. Here, perhaps, is a trace of the ' cork '. I said as much to Renoir and he answered curtly, ' Well, why not ? ' And he went on : ' A few kicks in the behind never do any harm. The funny thing is they are never given you for any good reason. But they wake you up, and that's the important thing.' Those who had criticized ' La Loge ' were unfair, and Renoir knew it. ' Perhaps it's vanity,' he said, ' but I think it's well painted.' Nevertheless, the jolt he had received led Renoir to ponder again the eternal dilemma between Nature and studio. ' After all, a picture is meant to be looked at inside a house, where the windows let in a false light. So a little work must be done in the studio in addition to what one has done out of doors. You should get away from the intoxication of real light and digest your im-

pressions in the reduced light of a room. Then you can get drunk on sunshine again. You go out and work, and you come back and work; and finally your picture begins to look like something.'

As the result of his setback in the first exhibition, Renoir decided to study in the museums again. Later, he visited Italy, Spain and Flanders, so as to deepen his understanding of the old masters.

Another person who attended the gatherings in the Rue Saint-Georges was Lhote. He worked in the Havas News Agency, and he used to go and see Renoir because he loved painting. However, he never bought any pictures because he would not have known where to put them. He was a nomad. He had gone all over Europe on foot. He had also been an officer in the Merchant Marine, and had roughed it in South America and Asia. He was able to give Renoir, who at this date had never been out of France, a detailed description of the Velasquez in the Prado and the Giottos in Florence. Instead of painting, he collected adventures with the ladies. My father was very fond of Lhote, so different from himself. Lhote for his part proved a most loyal friend. The two of them went on several trips, including one to Jersey, where they spent some weeks together, Renoir painting away, while his friend watched him or else chased the girls in the little town. They boarded with the family of an English clergyman. Lhote was very short-sighted. One day he was flirting with the clergyman's daughter, a pretty little blonde of eighteen, and she gave him such a push that his glasses fell off. As he groped about to find them, he went into the next room to ask my father, who was taking coffee with their host, to help him look for them. It was rather dark, and poor Lhote could hardly see. The clergyman got up to join in the search, and Lhote, running into him, thought it was the daughter of the house. He threw his arms around him and started to kiss him. The other was so astonished he could only protest, ' Please, Mr Lhote ! In England, you know, men don't kiss each other.'

The next morning the clergyman's daughter lured Lhote into a far corner of the garden, and kissed him full on the mouth. ' Don't you think this is a lot nicer than kissing my father ? ' she asked.

A few days afterwards, as Renoir was on his way to the place among the rocks where he was painting, he came upon the pair in a

frankly unequivocal position. Embarrassed, he retreated as quietly as he could. They did not notice him and continued their love-making. He could hear the young girl murmur as she swooned away, ' Oh, Mr Lhote, what would my papa say if he knew you were courting me ! '

# 16

'It's all very well to be sentimental about the past. Of course, I miss those plates decorated by hand, and the furniture made by the village carpenter: the days when every workman could use his imagination and put something of himself into whatever little practical object he was making. To get that pleasure nowadays you have to be an artist and sign your work, which is something I detest. On the other hand, under Louis the Fifteenth I would have been obliged to paint nothing but specified subjects. And what seems most significant to me about our movement is that we have freed painting from the importance of the subject. I am at liberty to paint flowers, and call them simply flowers, without their needing to tell a story.'

It was the same with music. Renoir loved Bach because his music did not tell a story. It was pure music, like the painting he wanted to do.

'Then, too, you change very little. I am of my time, and I have all the reactions of a man of my time. Do you know what made me realize it? The privy!'

Although accustomed to my father's unexpected comparisons, I must say that his use of this one to symbolize the march of time did rather surprise me. However, it stemmed from an exact observation of customs introduced with the industrial age. Renoir had no trouble finding examples. One, for instance, was that of Louis XIV receiving his courtiers as he sat on a *chaise percée*, and feeling in no way embarrassed at relieving himself publicly. What most struck my father about this old method of attending to a natural function was that no one felt disgusted. Again, in the eighteenth century, the place which served for a lavatory in all the inns in Europe was nothing more than a hole over which several planks were laid, and the person using it had, in consequence, to be

careful to keep his balance. Instead of soft tissue-paper, a hemp rope was hung from the ceiling.

'Only that,' said Renoir, 'can make up for the ugliness of Garnier's Opera House! . . . And you ask about the smell? Well, what about the smell? Weren't people's noses the same then?'

This explanation did not satisfy him. On the contrary, he believed that modern progress has made us lose the use of our senses, just as the advent of the motor-car has made people lose the use of their legs. 'We live in the midst of abominable smells, and we get along fairly well all the same. The stink from motor-cars poisons us '— what would he have said of it now?—'it is like the gas you smell in all the stairways of Paris buildings. But that is nothing compared to patchouli.'

This exotic word was the name of a perfume which women were mad about at the end of the last century. Needless to add that Renoir had a special dislike for it. 'It's bad enough when a blonde doesn't wash; and when she puts on patchouli as well, it's enough to make you keel over.'

Renoir's nose, like his eyes and his other senses, could detect everything.

'Jean, open the window! There's a smell of burning fat in here.'

I had not noticed anything; but on going to the kitchen I discovered that La Boulangère was frying bacon to season the haricot beans.

To bring this subject to a close, Renoir believed that comfort, cleanliness and the constant use of water might replace an element of life he thought indispensable: luxury.

'I have a bathroom I cannot do without. But can I use the bathroom without losing my taste for a Louis the Fifteenth sculptured frame decorated with gold leaf? If the day ever comes when I'm satisfied with just a plaster frame, gilded with synthetic gold, then I'll have paid too dearly for the comfort of my bathroom.'

Another name associated with the Rue Saint-Georges period is that of Lascou, 'a magistrate who took it into his head to make me like Wagner. He almost succeeded, at first.' The mere fact that French national sentiment was against Wagner made my father all the more sympathetic towards him. Calm as he usually was, on one occasion Renoir exchanged insults and even came to blows with some of those who could not tolerate the German composer.

'It was a stupid thing to do, but no harm in it. It does you good

to get excited once in a while about something else besides your own hobby.'

I don't know in what Paris theatre the incident took place, but Renoir must have enjoyed himself immensely. ' Top-hats, grotesque as they are, turned out to be a wonderful protection against being hit by a cane. The foyer was littered with them.'

Lascou was later on to introduce my father to Wagner. Their meeting resulted in the well-known portrait of the great musician, and two or three sketches, executed in three-quarters of an hour. It was all the time the composer would spare him. They were done, I believe, in Palermo, therefore towards the end of the Rue Saint-Georges period. During the sitting Wagner expressed opinions about painting, which ' rubbed me the wrong way. By the time I had finished, I thought he had less talent than I did at first. More-over, Wagner hated the French because of their hostility towards his music. While I was working, he repeated several times that the French only liked German-Jew music.' Renoir grew annoyed, and countered with a eulogy of Offenbach, ' whom I idolized. And Wagner was beginning to get on my nerves ! ' To my father's great surprise, Wagner nodded in approval. ' Id is " liddle " music, but id's nod bad. If he wasn't a Jew, Offenbach would be Mozart. When I spoke of German Jews, I meant your Meyerbeer.'

Some time afterwards Renoir attended a performance of *Die Walküre* at Bayreuth.

' They've no right to shut people up in the dark for three solid hours. It's taking a mean advantage of you.' He was against darkening the theatre. ' You are forced to look at the only place where there's any light: the stage. It's absolute tyranny. I might want to look at a pretty woman sitting in a box. We might as well be frank about it: Wagner's music is boring.' Despite his change of attitude, he continued to see Lascou.

' He amazed me. Think of it: a magistrate of the criminal court who travels all over Europe with his own piano in the luggage van the way other people take their trunks ! '

My father often returned to the question of turning out the lights in a theatre. ' For me, there's just as much of a show in the audience. The public is as important to me as the actors.'

He told how in Italy in the eighteenth century, when theatre balconies were entirely made up of boxes, people looked upon the theatre as a meeting-place. You did not go there just to see a play.

You went to see your friends. Access to the box was through a miniature boudoir, a continuation of the foyer of the 'palazzo'. You took tea in it, you smoked, and you gossiped. When the tenor and the contralto burst forth into a brilliant *duo*, the audience fell silent and listened religiously. But there was no trick of dimming the lights to force you to listen.

'What annoys me most about the modern theatre is that it has become so solemn. You would think you were at Mass. When I want to hear Mass, I go to church.'

As the author and producer of plays and films, I cannot share my father's enthusiasm for people's habit of chatting during a performance. When the showing of one of my films is interrupted by the noise of youngsters shelling peanuts, I don't like it at all.

In his youth my father never missed a single operetta by Offenbach. He was also a devotee of Hervé.[1] What chiefly delighted him was the heightened awareness he felt the minute he entered the doors of a theatre. It was the festive side that was important to him. The rest of us usually go to a play because of our interest in the plot, or for the characters portrayed, features for which my father did not give a hoot. He went to the theatre as others go for a Sunday walk in the country, to enjoy good air, flowers and the pleasure of being with others doing the same thing. And he had the gift of being able to concentrate on some single impression among a dozen other impressions.

His favourite actress was Jeanne Granier. She had 'a thread of a voice; but it was so distinct, so controlled, and so full of feeling.' The then Prince of Wales, who was to be Edward VII of England, never missed a performance of Jeanne Granier at the Variétés when he was in Paris. The public assumed that his admiration for the star was not confined to her artistic talents. Each time she finished a song the audience would break into loud applause, as though to congratulate him on his good taste. And the future King of England genially bowed to the crowd, not in the least embarrassed by the implied allusion. On the contrary, he was quite pleased by their friendly intimacy, so typical of Paris.

Offenbach lived in a handsome residence at the lower end of the Rue La Rochefoucauld. Every now and then after work my father would stroll down the Butte Montmartre late in the afternoon, and drop in to have a cigarette with the composer. He would find the

[1] 1825-92. A composer of popular operettas. (Trans.)

household hardly yet awake. For the Offenbachs, the evening was their early-morning hour. M. Offenbach would just be taking a cup of coffee and a croissant; his first regular meal was supper at midnight. Renoir sometimes accompanied him to the Variétés. ' It was the most beautiful theatre in Paris. You felt the excitement of it even before the curtain rose. Besides, a theatre is not a real one unless it is all red, white and gold. Hortense Schneider was the reigning queen of the place. What a good sort she was ! . . .'

One day in her dressing-room Zola and my Uncle Edmond were discussing ' the theme in painting '. My father began to grow restless, and turning to Hortense Schneider, who for her part could hardly conceal her yawns, he said : ' That's all very fascinating, but let's talk of more serious things. How is your bosom these days ? '

' What a question ! ' answered the diva, smiling ; then she opened her bodice and gave him a dazzling proof of the excellent condition of her bodily charms. My father and his brother burst out laughing. But Zola turned ' as red as a peony ', stammered something no one could hear, and fled as fast as he could. ' He was a regular provincial,' said my father. He admired Zola greatly, but would not forgive his lack of understanding towards Cézanne. ' And then, what a queer idea, to believe that working people are always saying " *merde* " ! '

I turn now to another delightful actress, Jeanne Samary. I have in my possession a reproduction of the large portrait my father did of her. How I regret never having known her. She personified the theatre : you sense in her a wonderful mixture of regal authority and innate humility in front of the public. One can imagine her doing her morning marketing in the Rue Lepic, her basket full of fresh vegetables. She must have carefully felt the melons to see if they were ripe, and looked with a critical eye at the whiting to make sure it was fresh. At night, when she put on her lovely white dress and her make-up to go on stage, she became a queen, an agreeably curved queen, whose body fairly invited caresses. Best of all, she was a real ' Renoir '. She belonged to that immense family which includes my mother and Nini, Bérard's little girls, Gabrielle, Suzanne Valadon and all of us Renoir children. We all resemble one another, and I still look at this picture of Jeanne Samary as I would at the portrait of a dead sister.

Renoir had met her at the Charpentiers' ; but it was her parents

who had first sought him out: 'If you ever need a model . . .
Jeanne admires you so much.'

How could you resist such an overture, especially at a moment
when the art-dealers were so uncertain about you? One of them
had just sounded out Renoir to see if he would paint some imitation
Rousseaus. 'With your skill, people will be none the wiser.' This
'honest' dealer had been impressed by several landscapes painted
by Renoir before 1870, showing a strong influence of Diaz and the
Fontainebleau School. In this connection, I should like to make
another slight digression.

At the time when he was becoming a commercial success my
father once visited the collection of a London connoisseur. The
Englishman led him into a little drawing-room where he proudly
showed Renoir a superb Rousseau, which was set off by special
lighting.

'Here,' he said, 'is the masterpiece of my whole collection: a
Rousseau that very few know about.'

'I know it quite well,' replied my father, recognizing one of the
landscapes he himself had done in his younger days. But someone
had changed the signature. He was careful not to enlighten the
collector for fear of spoiling his pleasure: 'It would have made him
ill if he'd known.' Renoir never disabused the owners of forgeries.
'Either they buy a painting as a speculation, in which case so much
the worse for them; or else they really like the picture, and then,
why disappoint them?'

The Samarys lived in the Rue Frochot. I myself am living in the
Avenue Frochot as I write these lines. From one of my windows
I can see the rear of the building where they had an apartment. I
wonder which floor they were on. Perhaps the second, where I
imagine a young couple are now preparing supper, the husband
sharpening the carving knife while the wife sets the table. Little do
they suspect that one of the most charming women of the last century
used to lean out of that window, where a pot of geraniums now
stands. Or maybe the Samarys were on the top floor, where an old
gentleman smokes his pipe, watching the pigeons. He should know.
In his solitude he has time to be curious about the past.

This Montmartre, once the domain of my father and his friends,
has now changed. The amusement-industry has saddened it. But a
few wandering ghosts, like that of Jeanne Samary, somehow save
the quarter from the false dignity which gives the west side of Paris

such a stuffy look. Here in Montmartre you can run across young girls in the streets, coming from their courses in diction and repeating Molière's lines to themselves. Who knows, one of them may become another Samary.

The actor Dorival, who heard it from Mounet Sully, who in turn had learned it from the Samarys themselves, said that Renoir was usually in such a hurry to get to work on her portrait that he forgot to say ' good-day '. The light was good only between the hours of one and three in the afternoon. The apartment faced east and west. But the rooms on the east side were very small. The living-room became impractical for work after three o'clock, because of the direct rays of the setting sun. One wonders why Renoir was so obstinate as to want to paint in such poor light. Perhaps because of his theory about working both from Nature and in the studio : a need to interpret his model in an informal setting and an atmosphere of intimacy, just as he liked also to watch her in all the artifice of her profession. He often went to see her perform at the Comédie Française : ' It shows how much I wanted to see her ; for that's one place you don't have much fun. Luckily, she played Musset fairly often.'

Renoir did several sketches of Samary at her parents' home. He probably painted there her little portrait now in the Comédie Française Collection. For the large portrait, now in Russia, he had her come to his studio in the Rue Saint-Georges.

' I was too well looked after when I went to her house. Her mother had a mania for serving little cakes and I would stuff myself with them after the sitting, as I listened to Jeanne. She had an agreeable gift for retailing gossip. A woman's voice is so pleasant when it isn't affected.'

There was never any question of his marrying her.

' Renoir is not the marrying kind,' said Samary. ' He marries all the women he paints—but with his brush.'

One of my father's great friends in the Rue Saint-Georges days was ' le père Choquet '. Renoir called him ' the greatest French art-collector since the days of the kings—or perhaps of the whole world, since the Popes '. By ' the Popes ' my father meant Julius II, ' who could make Michelangelo and Raphael paint by leaving them in peace.'

M. Choquet was an employee in the Customs Office. His salary was very small. He would save on his meals and clothes so that he

could buy antiques and even small objets d'art, particularly French
ones of the eighteenth century. He lived in a garret and went about
dressed in rags, yet he owned clocks designed by Boulle. He almost
got dismissed several times because his superiors thought it
undignified for a Government employee to wear shirts with torn
sleeves. But a benefactor whose identity my father never unveiled
intervened whenever he was in danger of losing his job. ' Luckily,
there are such things as benefactors, otherwise life would be too
unfair.'

Choquet eventually inherited a little money. He then consented
to dress decently ; and he moved into a handsome apartment with
all his art treasures. He was one of the first to realize that Renoir,
Cézanne and their group were the direct heirs of the great tradition
of French art which M. Gérome and the academicians were betraying
while asserting that they were continuing it.

'It's just like politics,' said Choquet. ' They keep the same labels,
but the goods are spurious.'

He compared the painting of these pontiffs of art to certain
democratic régimes, which shoot the workers on the pretext that
they are defending the cause of the people. M. Choquet was a ' hot-
head ', and his benefactor must have had pull with the Customs
officials to persuade them to keep on such an unruly employee.

Before long people in Paris began to take notice of M. Choquet.
Renoir attributed his sudden popularity to the rise in the prices of
Watteaus. Choquet owned several Watteaus. He had paid only a
few hundred francs for them when they were out of fashion. People
talked also of his commodes, his pier-glasses and his Louis XV and
XVI chandeliers. The antique dealers were beginning to grow
important. Wearied with Gothic à la Victor Hugo, the snobs
wanted to ' play Trianon à la Marie Antoinette'. And prices
' kept climbing higher and higher '. If old Choquet had wanted to
sell, he could have made a fortune. The ex-Government-employee,
who had been so looked down on, suddenly became a sage, sought
after by everybody. It was considered a great honour to be invited
to his house. The curiosity he aroused gave him an opportunity to
display his Renoirs in authentic Louis XV frames. For the Cézannes,
however, he thought a Louis XIV frame brought out the volumes
better.

My father told me the well-known anecdote about Choquet and
the younger Dumas. Wanting very much to ' be in the know ' the

writer was eager to see Choquet's collection. His play *La Dame aux Camélias* was then having a great success. Feeling sure he would have an entrée anywhere, he went to Choquet's place without first making an appointment. The little Breton maid asked him to wait in the small reception-room, and took his card to her employer. Now it happened that Choquet had known the elder Dumas, ' the real one', the author of *The Three Musketeers*, and he could not forgive the son for having refused the inheritance bequeathed to him because he did not want to pay the enormous debts left by his father. Choquet is supposed to have said:

' It was the father who was the child, and the son who was really the old man. The only excuse for La Dame aux Camélias would have been to have her pay the debts of La Dame de Monsoreau.'

Choquet appeared in the reception-room where the younger Dumas was waiting, and with an anxious look on his face, fingered the visiting card.

' I see the name of my old friend, Alexandre Dumas, on this card. But he is dead. You are an impostor.'

' But I am his son.'

' Oh ? So he has a son ? '

Renoir heard another story about the Dumas from Choquet. Once, in the days while the son was still young, he went unexpectedly into the drawing-room and found his father kissing a young woman sitting completely naked on his knee.

' Father,' said the son, ' this is disgusting ! '

The elder Dumas pointed to the door, and said dramatically: ' My son, you must respect my grey hairs.'

The scene may have taken place in my house in the Avenue Frochot. Certain people who go in for tales of old Paris assert that it was built by the elder Alexandre Dumas at the time of his first success. The walls of the Paris fortifications separated this group of houses—then a sort of art colony—from the present Place Pigalle, formerly just a village square. Dumas and his set had been given permission by the military authorities to make a postern gate at this part of the wall for use when they went hunting in the little woods on the hill of Montmartre. If my conjecture is correct, Dumas must have had his study on the floor where my brother Pierre was living at the time of his death.

Renoir was sorry he had not known the elder Dumas better.

' What a life he had ! And to be the son of a man who was

both a Negro and a general in Napoleon's army . . . It gives you
something to think about ! ' My father admired the dignified bearing
of the black race. ' They are lucky because they really know how to
walk. They are the only people who look splendid in a uniform.
Othello must have been magnificent. As for old Dumas, what a fine
man ! They say he wept real tears when he found he had to kill
Porthos.'

My father mentioned to me once or twice the ground-floor
apartment he lived in for a time in the Rue Moncey. I am not sure
whether it was before or during his stay in the Rue Saint-Georges:
the latter, I think. At that time a modest apartment could be rented
for almost nothing. When he was particularly taken with some
subject for painting, he liked to live with his ' nose right in it '.
Hence his move to the Rue Cortot in order to paint the ' Moulin de
la Galette ', as well as several other canvases of the Butte. His entire
furniture consisted of a mattress (which was put on the floor), a table,
a deal commode, and a stove—to keep the model warm. Whenever
he moved to some other address, he usually left these few possessions
behind. His studio in the Rue Saint-Georges was his permanent
abode, where he stored his pictures and other belongings. Another
possible reason behind his move to the Rue Moncey was that his
brother Edmond, who had become a very active journalist, brought
too many people to see him. Renoir did not like to be disturbed until
' after the sitting '. And he was, perhaps, going through one of those
spells when ' I couldn't stand seeing another starched shirt. The
very sight of a flunkey nauseated me.' To run away, to disappear,
was the best way of not allowing himself to ' be gobbled up '.

The environs of the Rue Moncey had a bad reputation. The Porte
Clichy was a meeting-place for *apaches*. At the point where the
Clichy and Saint-Ouen Avenues now branch off there was formerly
a long area filled with shacks inhabited chiefly by rag-pickers, and
also by less desirable characters. The pimps in that section wore a
peak-cap, tight-fitting trousers, soft-soled shoes, and side-burns.
The girls went around in short narrow skirts of shiny silk and hid
their money in the top of their stockings. ' You'd have thought you
were in one of Bruant's popular songs.'

A model of Renoir's named Angèle told him of an inexpensive
little house which had a garden where he could paint. Renoir went
to see it. An old apple tree, with a child's swing hanging from it,
won his heart ; and he rented the place without giving a thought

to the character of the neighbourhood. One night as he was return-
ing home, he was set upon. He tried to run, but was caught and
pinned against a fence. Suddenly one of the roughs recognized
him. ' Why, it's Monsieur Renoir ! ' My father threw out his chest,
enormously pleased at being so celebrated. ' I've seen you with
Angèle. We're not going to strangle any friend of Angèle's. It's not
safe around here. We'll see that you get home all right.'

Angèle, the pretty model for the painting of the girl with a cat
—she posed like a goddess—was very much a product of the
neighbourhood. Her devotion to Renoir was truly touching.
Sensing that he was short of money for his rent, she offered ' to go
out and " do " one of the outer boulevards'. My father was at a loss
to find a way of refusing this unexpected generosity. While he was
working on ' The Boatmen's Luncheon ' she picked up a young man
of good family, who married her. Several years later she came back
to see ' the boss '. Her husband was with her and the pair could
not have been more bourgeois and provincial. They were dressed
in the most conventional way, their manners were very formal, and
their speech was exceedingly proper. After a few minutes, Angèle
thawed out somewhat. ' Armand knows I posed in the nude for
you,' she confessed with a blush. ' He knows, too, that I went with
a bad crowd.' And while Armand was on the other side of the room
gazing at a picture, she whispered in Renoir's ear, ' But he doesn't
know that I used to say " *merde* ".'

While painting his ' Moulin de la Galette ' Renoir moved into a
dilapidated house in the Rue Cortot.

' I was completely taken up with my craze for sketching from
Nature, like Zola driving in a carriage through the wheat-fields in the
Beauce before starting to write *La Terre*.'

I have no idea how close Zola got to the peasants, but I do
know that my father, as was his habit wherever he went, immersed
himself completely in the atmosphere of the village of Montmartre,
' which had not yet degenerated into the picturesque '. Most of the
population was lower middle-class, attracted by the good air and
low rents, a few market-gardeners, and a large number of workers'
families, whose sons and daughters hurried down the north side of
the hill every morning ' to ruin their lungs ' in the factories of near-
by Saint-Ouen.

There were already many bistrots ; but especially there was the
Moulin de la Galette, where every Saturday night and Sunday the

shop girls and clerks from the north side of Paris used to come and dance. The present ' Moulin ' building did not then exist, of course ; there was merely a big shed constructed around two windmills, which had just ended a long and honourable career of turning out flour. As factories began to replace the wheat-fields in the flat land around Saint-Denis, supplies of grain for the Montmartre windmills dwindled to nothing. Happily, the open-air café came in time to save this charming relic of another day from being pulled down. Renoir loved the place because its simple amusements typified so well the ' good-natured ' side of the common people of Paris. It was ' never a gross kind of liberty ' they indulged in, or any vulgar licence.

When he first arrived, the street urchins stared curiously at this stranger who was always in a hurry as he strode along the ill-paved back streets, suddenly halting to look at a Virginia creeper growing over an old wall ; or at a young working-girl in that attitude of feigned indifference which women assume when they are being noticed. The first young woman he spoke to made him the traditional reply, ' I don't go in for that sort of thing, Monsieur.' She was very pleasing. ' She had lovely hands, the ends of her fingers were a little swollen from being pricked by needles.' Renoir asked her if she was a seamstress.

' Yes,' she said, ' but I live with my mother, and I go home every night.'

The girl evidently found Renoir to her liking, for she kept glancing up at him under her long lashes with an air of false modesty. He was perplexed to know what to do : ' How to make her understand that I wanted to paint her, and nothing else ?' He had an inspiration. ' Introduce me to your mother.' He had hit upon a method for getting all the models he wanted, ' without being taken for a satyr '.

Jeanne's mother was flattered by the visit from this ' very nice ' young man. The money he offered for having her daughter pose for him ' would put butter on the spinach '. She suggested that he also use her other daughter, Estelle, a little brunette with pretty ears, as a model. ' I spent my time telling her to put her hair up.' The mother was a laundress : ' hard work that doesn't bring in much '. The daughters did sewing now and then. The father was a mason, but fortunately for him a hernia kept him within the limits of a bistrot at the corner of the Rue des Saules. A few glasses of

'piccolo', the harsh wine of the Parisian hills, and the agreement was settled.

The natives of Montmartre were not long in adopting this young man, who was ' so alive, like quicksilver', according to one of his models. His striped grey suit, flowing blue tie with white polka-dots, and his little round felt hat, became a familiar sight in the quarter. Mothers came to him in droves, boasting of their daughters' qualifications. One of them, to impress Renoir, told him that ' Hortense won a prize in arithmetic when she was only ten.' The child prodigy had grown into ' a great gawk of a girl, flat as a pancake and cross-eyed '. Renoir amicably admired her endless examples of different mathematical problems, and pretended to take a great interest in a complicated multiplication sum, and her method of checking the answer. He promised to introduce the poor girl, ' whose success as a scholar risked ruining her chances in life', to Lhote, hoping his friend might find her a job as secretary at the Havas Agency. It turned out that Lhote, ' near-sighted as a mole ', was swept off his feet by the ugly creature. He got her a job at his office and made her his mistress. She was overcome with pride at having captured such a fine gentleman, and grew so self-assured that she began to play the *femme fatale*. It was not long before the entire Havas office had succumbed. As Lhote said of her, she was a ' veritable mattress '. Several years later her mother came to see Renoir. He was uneasy at first, but was reassured when he learned that it was only to thank him. ' My daughter is now with a Symbolist poet. She only goes with intellectuals. If it hadn't been for you, she would still be going out with boys who don't even know how to spell ! '

Thanks to their mothers, Renoir was able to get the models he needed for his ' Moulin de la Galette '. The male dancing-partners were his usual companions : my uncle Edmond, Rivière, Lhote, Lestringuez, Lamy and Cordey.

The house in the Rue Cortot was falling to pieces but Renoir did not mind. It provided the advantage of a large garden, with a magnificent view of the countryside as far as Saint-Denis. ' A mysterious, stately garden, like Zola's *paradou*—what was once part of a fine residence.'

In this little oasis he painted numerous canvases ; for he never worked on just one subject at a time. ' You have to be able to put a canvas aside and let it " rest ".' And he often said, ' You must

know how to loaf a bit.' By loaf he meant pausing long enough for the essential aspects of a problem to emerge and assume their proper importance. This life of ours, which Renoir observed with so much fervour, presented itself to him as his canvases presented themselves to the eyes of the curious as they watched him paint. It represented a whole, the meaning of which could only be taken in little by little. 'Only too glad if one can guess what will come out of it.' He would sometimes say, also: 'To foresee everything, you would have to be God Himself; and trying to get there bit by bit won't take you very far. Even one little part is made up of countless elements.'

Renoir would have been delighted to know that the atom could be split, and he would have asserted his belief that it is possible to divide and re-divide the resulting particles. As for the relative importance of these particles, his sense of equality drew some amusing reflections from him. He imagined that the microbes of a bad cold, for instance, regarded their own solar system—the inside of his nose—as the centre of the world. By the same token, he suggested that we humans might be the microbes of some immense body, the substance and character of which are beyond our ken. He would then wind up with the statement that he was glad to be a simple human being. 'It wouldn't be much fun to paint a female microbe.'

His slowness of perception irritated him at times. 'At the start I see my subject in a sort of haze. I know perfectly well that what I shall see in it later is there all the time, but it only becomes apparent after a while. Sometimes it is the most important things that come out last.'

At other times he considered his slowness an advantage. I must remind the reader that Renoir's slowness was only relative, and that he worked with incredible speed. Yet he would be contradictory, and his advice to me was never to be hasty, no matter what profession I took up when this 'idiotic war' was over and I had recovered from my wound. He warned me not to make decisions before I had carefully weighed all the factors.

One needed only to watch him painting to see his way of observing things and getting to the heart of the subject. Some painters, like Valloton, begin at one side of the canvas, putting in all the balanced values as they go along, with the result that, when they reach the opposite side, the picture is complete in all respects. 'I

envy Valloton,' my father said. ' How can he be so clear-headed ? ' Renoir began by putting incomprehensible little touches on the white background, without even a suggestion of form. At times the paint, diluted with linseed oil and turpentine, was so liquid that it ran down the canvas. Renoir called it ' juice '. Thanks to the juice, he could, with several brush-strokes, establish the general tonality he was trying for. It covered almost the whole surface of the canvas—or rather, the surface of the eventual picture, for Renoir often left part of the background blank. These ' open ' spots represented indispensable values to him. The background had to be very clear and smooth. I often prepared my father's canvases with flake-white mixed with one-third linseed oil and two-thirds turpentine. It was then left to dry for several days.

But to return to the actual execution of the picture. He would begin with little pink or blue strokes, which would then be intermingled with burnt-sienna, all perfectly balanced. As a rule Naples yellow and madder red were applied in the later stages. Ivory-black came last of all. He never proceeded by direct or angular strokes. His method was round, so to speak, and in curves, as if he were following the contour of a young breast. ' There is no such thing as a straight line in Nature.' At no time was there any sign of imbalance. From the first brush-strokes the canvas remained in perfect equilibrium. Renoir's problem was, perhaps, to penetrate his subject without losing the freshness of the first impact. Finally, out of the mist the body of the model or the outlines of a landscape would emerge, as on a photographic plate immersed in a developing-bath. Certain features, totally neglected in the beginning, took on their proper importance.

He succeeded in taking complete possession of his subject only after a struggle. When painting, he sometimes appeared to be fighting a duel. The painter seemed to be eyeing the movements of his opponent and watching for the least weakness in his defences. He harassed the subject ceaselessly as a lover harasses the girl who puts up a struggle before yielding. He seemed also to be engaged on a hunt. The anxious rapidity of his brush-strokes, which were urgent, precise, flashing extensions of his piercing vision, made me think of the zigzag flight of a swallow catching insects. I purposely borrow a comparison from ornithology. Renoir's brush was linked to his visual perceptions as directly as the swallow's beak is linked to its eyes. This description would be incomplete if I failed to point

out that Renoir in the act of painting had a wild side to him which startled me several times when I was small.

Sometimes the forms and colours were still indefinite at the end of the first session. Only on the following day was it possible to sense what would come. For the onlooker, the overwhelming impression was that the subject, defeated, was disappearing and the picture was coming out of Renoir himself. Towards the end of his life, Renoir had so perfected his method that he eliminated ' little details ' more quickly, and got down at once to what was essential. But to the day of his death, he continued to ' caress and strike the motif ' the way one caresses and strikes a woman so that she can express all her love. For that is what Renoir needed : that state of abandon on the part of the model, which would allow him to touch the depths of human nature, freed of all cares and prejudices of the moment. He painted bodies without clothing, and landscapes devoid of the picturesque. The spirit inherent in the girls and boys, the children and trees, which filled the world he created, is as purely naked as Gabrielle's nude body. And, last of all, in this nakedness Renoir disclosed his own self.

Every morning my father would, with the help of a friend, carry his large canvas to the Moulin de la Galette and start painting. When his models were not available, which happened often, he would work on something else. Then, too, he had his moments of ' loafing ', which I have already mentioned. He painted any number of canvases during his Montmartre period.

I have gone once in a while to have a drink in the restaurant at the top of the Rue des Saules, where my father painted ' The Swing '. Alas, the pretty garden is now a glassed-in terrace. Montmartre pays dearly for the glory of having fostered influential painters. The tourists—even those who know nothing of Renoir or Toulouse-Lautrec—pour into all these places, idealized because genius once passed that way. With their loud clothes and their clicking ciné-cameras, these crass visitors have made the quarter almost impossible. However, their noisy presence has not driven away the ghosts of Angèle, or Jeanne, or Estelle or any of the others. You can come across their great-granddaughters, tripping down the stairs of the Butte, a trifle more made-up than their ancestors of the famous paintings, a little less sure of meeting a prince-charming, resigned to the discipline of an office and endless time spent in the Métro. They have lost the mad insouciance of their forebears, beset by hard-

ships though they were. Together with a bit of comfort, modern times have brought them anxiety for the morrow. And yet their smiles and the mischievous gleam in their eyes would make the heart of a Renoir beat faster if it were our good fortune to have one come to the Butte again.

# 17

Renoir was always discovering and rediscovering the world at every instant of his existence, with every breath of fresh air he drew. Whether he painted the same girl or the same bunch of grapes a hundred times, each occasion was a marvellous revelation to him. There are few adults who really discover the world any more. They think they know it, and are satisfied with mere surface appearances. But one tires quickly of appearances. Hence that affliction of modern society : boredom. A child is continually being astonished by things. An unexpected expression on its mother's face can make it dimly aware of some mysterious thought or indefinable sensation. It is because of this eager childlike curiosity that Renoir was so fond of children. The feelings aroused in him by a woman's body were perhaps associated with the idea of maternity. It was a very pure emotion with him. And yet I do not believe that he actually thought of a nursing mother when he saw a beautiful breast ; or of child-bearing when he beheld a well-rounded belly. He left such naturalistic interpretations to the ' intellectuals '. I am sure that he had the gift of expressing all his emotions through the medium of painting. The pleasure he got out of life as a man coincided with the pleasure he felt as a painter. Once, towards the end of his life, I heard him make the following rejoinder to a journalist who seemed to be astonished by his crippled hands :

' With such hands how do you paint ? ' the man asked, crudely.

' With my prick,' replied Renoir, really vulgar for once.

It took place in the dining-room at Les Collettes. There were a half-dozen or so visitors present. No one laughed at his quip. For what he said was a striking expression of the truth ; one of those rare testimonies, so seldom expressed in the history of the world, to the miracle of the transformation of matter into spirit.

The young Montmartre girls who posed for Renoir were not all

models of virtue. The morals of the quarter were far from strict, and scores of youngsters did not know who their fathers were. While their mothers were away working, or ' something else ', the grandmothers took charge of the small fry. But the older women, also, had to go out and do housework or washing. The children roamed the streets, snotty-nosed, unkempt, and sometimes even without food. My father spent his time handing out milk and biscuits, ' and even handkerchiefs, which invariably found their way into a grown-up's pocket. The next day I would meet the kid again with his nose dripping worse than ever.' He was especially worried about infants left alone indoors in their cradles. ' What would happen if a fire started ! ' And he was terrified lest a cat lie on the baby's chest and smother it. The whole district was infested with cats. He conceived the idea of starting an organization to get women without work to look after the babies of mothers who had to be away from home temporarily. The headquarters would be called ' Le Pouponat '.[1] He began a campaign to raise funds for it, and he persuaded the owner of the Moulin de la Galette to give a benefit fancy-dress ball. M. Debray was an unusually kind man, ' liberal with both drinks and sandwiches for the famished young girls '. There were to be special numbers during the evening, and various singers promised to take part. Straw-hats, decorated with red velvet ribbons, were to be given out as favours. With the help of all the young girls in the neighbourhood my father spent several days preparing these hats.

The ball was a dazzling success. The Moulin de la Galette could not hold all the dancers. The volunteer bands were marvellous ; and the different ' numbers ' brought down the house. The fun went on all night. The next morning when Renoir totted up the receipts, along with Rivière, Lhote and the rest of their friends, they found that the money would just pay for the medical care of a poor girl suffering from phlebitis after a miscarriage. They were obliged to take up a collection to buy baby-clothes and blankets for some new-born children in dire need. The explanation for the financial failure was that, although the crowd had not lacked enthusiasm, it was composed mainly of young people of modest means. Moreover, most of them had been able to persuade friends among the ticket-sellers to let them in free. Renoir had to drop his charitable venture for the time being. Later on, however, he told Mme Charpentier

[1] A word coined by Renoir from '*poupon*', meaning ' baby '.

about it, and she raised the necessary funds to create a real day nursery in Montmartre. It was inaugurated while he was on his first trip to Italy, I believe ; and he was overjoyed when he heard the news. 'Babies wet their nappies, you know, and if they're not changed, are likely to catch pneumonia—just like you. And yet Lord knows you were well looked after by your mother and Gabrielle.'

Just as Montmartre had served as an artistic inspiration for Renoir, the banks of the Seine between Chatou and Bougival stimulated him to the same degree, especially in the years before his marriage. The large 'Boatmen's Luncheon ', now in the Phillips Memorial Gallery in Washington, was the crowning achievement of a long series of pictures, studies and sketches at the Grenouillère Restaurant in Chatou. It was the railway line to Saint-Germain which made the success of the place possible. The station at the Chatou bridge was only twenty minutes from Paris by train, and the restaurant, out on the island of Chatou, could be reached in a few minutes' walk from the station. Bibesco had taken my father there before the War of 1870. The spot had been discovered by young lovers who liked to wander under the great poplar trees. As outdoor sports were then becoming popular, a far-sighted Bougival hotel-keeper called Fournaise decided to enlarge a small house on the island where he sold lemonade to Sunday visitors. He built a landing-place at the river's edge. He himself was something of an oarsman and had bought some excellent boats, which he rented to his Parisian customers. He even had several skiffs, as slender as knitting-needles and very speedy : but these he would hire only to experts. It was not long before the Fournaise restaurant had developed into a sort of boating-club. Both upstream and down-stream from the restaurant, the river bends in a well-proportioned curve. Renoir had painted there as early as 1868.

The name 'Grenouillère '[1] derived not from the numerous batrachians which swarmed in the surrounding fields, but from quite a different species of frog. It was a term applied to ladies of easy virtue : not exactly prostitutes, but rather a class of unattached young woman, characteristic of the Parisian scene before and after the Empire, changing lovers easily, satisfying any whim, going non-chalantly from a mansion in the Champs-Elysées to a garret in the Batignolles. To them we owe the memory of a Paris which was

[1] Frog-pond. (Trans.)

brilliant, witty and amusing. Among that group, moreover, Renoir
got a great many of his volunteer models. According to him, the
'*grenouilles*', or 'frogs', were often 'very good sorts'. Because
French people love a medley of various classes, actresses, society-
women and respectable middle-class people also patronized the
Fournaise restaurant. The tone of it was set by young sportsmen in
striped jerseys, who vied with one another in rowing, beating
records and becoming accomplished boatmen. When Bibesco first
took Renoir to the Grenouillère, he brought along a captain in his
regiment, the Baron Barbier. The baron was a most congenial
fellow, totally ignorant of painting, and interested only in horses,
women and boats. He and my father struck up a great friendship.

Apart from the beauty of the place and the ample supply of
models, one advantage especially attracted Renoir : its proximity to
Louveciennes. Despite his busy life, he did not forget his mother.
He loved and admired her more than ever. ' As she grew older, she
became as strong as steel.' Most of the population of Louveciennes
was made up of prosperous market-gardeners. Their pears are still
famous, and grace the tables of many a Parisian epicure. There was
also a whole colony of tramps, who survived by doing odd jobs in
the orchards ; but mostly they lived on charity. Their hovels stood
along the edge of the Forest of Marly, not far from my grandparents'
house. Walking with the aid of a cane, Marguerite Merlet would
visit these huts every day, and in her brusque, aggressive manner,
distribute pieces of bread and bacon and sometimes cakes. In return
she insisted that the youngsters wash. They did not care for that, of
course ; but the old lady frightened them. Nor would she leave
until she had inspected their ears and fingernails. Her mania for
cleanliness was her way of showing her love for children, a sentiment
she had transmitted to her son. ' You'll get yourself murdered yet,'
my grandfather warned her. The inmate of one of the shanties did
get cross with her one day. He did not want his children to wash.
He lived in filth himself and was perfectly satisfied. He said,
' When you're poor and haven't got an overcoat, the dirt keeps you
warm.' He raised his fist and threatened my grandmother. But she
flourished her cane at him, and the oaf retreated : after which, the
horde of children meekly undressed and slithered into the laundry-
tub.

Marguerite Merlet had long since given up following her son's
career. She had been delighted with his pictures at the beginning,

before 'the Impressionists' came along. But after he had 'begun
to put blue everywhere', it was too much for her. 'It will take
fifty years for people to understand you, and by that time you'll be
dead. Much good that will do you!' She would say, 'Other
people are no cleverer than I am, and I don't understand it a bit.'
To which she added, 'I belong to an older generation; but you
belong to the new one. I am for Watteau and your Marie Antoinette
plates.' She encouraged him to continue, nevertheless. 'If you've
got an itch, you have to scratch it. And after all, if you die of hunger,
that's your look-out!'

From Louveciennes to the Grenouillère it was only an hour's
walk. Renoir had made friends with the Fournaise family. Mme and
Mlle Fournaise figure in several of his pictures. He also did a portrait
of M. Fournaise.

The Fournaises would rarely give Renoir a bill.

'You've let us have this landscape of yours,' they would say.

My father would insist that his painting had no value: 'I'm
giving you fair warning; nobody wants it.'

'What difference does that make? It's pretty, isn't it? We have
to put something up on the walls to hide those patches of damp.'

My father smiled as he thought of those kind people again.

'If all art-lovers were like that!'

He was to give them a number of pictures, which later became
immensely valuable. And the Fournaises were not the only examples
of this kind. I could cite any number of families, and important ones,
who, thanks to the pictures Renoir had left with them, saved them-
selves from financial difficulties and even complete ruin.

'I am certainly a lucky man. I am able to help my friends, and
it costs me nothing.'

My father sometimes came across Maupassant at the Fournaises'.
The two men were friendly enough but frankly admitted they had
nothing in common. Renoir said of the writer, 'He always looks
on the dark side'—while Maupassant said of the painter, 'He always
looks on the bright side.' There was, however, one point on which
they did agree: 'Maupassant is mad,' asserted Renoir. 'Renoir is
mad,' declared Maupassant.

One day as he was painting a young woman sitting in a boat,
someone came up behind my father on tiptoe and put his hands over
his eyes for a joke. It was the Baron Barbier, who had just returned
from Indo-China, 'cleaned out to the last sou', as he expressed it.

# Renoir, My Father

The Government of the Republic had made him Mayor of Saigon. Instructions had been given to win over the mandarins. Now the mandarins loved champagne, and the English consul had flooded the town with it. The prestige of France hung in the balance. Barbier's whole fortune had been spent in upholding the honour of his country. After the last bottle of champagne had been drunk, he had handed in his resignation and retired to France. Luckily, he was given a pension for wounds received in Algeria, at the Battle of Reichshoffen, and in the Crimea.

My father was enormously pleased to see him again, and told him that he was planning a large picture of boatmen lunching with friends on the terrace of the Fournaise restaurant. Barbier offered to serve as stage-manager, getting boats for the background and rounding up models. ' I know nothing about painting, and still less about yours ; but I'd be glad to do you a favour.'

It took Renoir several years to make his project 'mature'. He had a number of pictures under way ; then, too, his sketches for the subject did not please him. He finally made up his mind in the summer of 1881. ' I am going to start the " Luncheon ",' he told Barbier, and his friend immediately got in touch with the faithful. I am not certain of the identity of all the people in the picture. Lhote is there, in the background, wearing a top-hat ; Lestringuez is to be seen leaning over a friend, who is perhaps Rivière. The young woman with her elbows on the railing is Alphonsine Fournaise, ' the lovely Alphonsine ', as the habitués of her parents' restaurant called her. She died penniless in 1935, at the age of ninety-two, having invested all her money in Russian bonds. The young person drinking is ' little Henriot '; and the woman looking at Lestringuez must be Ellen André. The figure in the foreground, patting a little dog, is my mother.

I paid a visit to the place last year. How depressing it was ! Nothing but factories, mounds of coal, blackened walls and dirty water. The leprosy of modern industry had eaten away the little woods and luxuriant grass. North African labourers, weighed down by their wretched fate, were forlornly unloading large metal drums from a barge smeared with grease. Baron Barbier, the boatmen, the carefree young girls, have all disappeared from this part of the river. They live now, for eternity, in the imagination of those who love painting and dream of days gone by as they gaze at ' The Boatmen's Luncheon '.

# Renoir, My Father

We know that, up to this time, Renoir had managed to reduce his daily needs to a minimum.

' You always have to be ready to start out in search of a subject. No baggage. A tooth-brush and a piece of soap.'

He wore a beard, not that he liked it particularly, but because he saved time by not having to shave. His suits were made to measure from good English material ; but he did not own many. As a rule, he had only three, two of which were nearly always of grey pin-stripe cloth. The oldest he wore when painting in the country. He also had a full dress suit. He never wore a dinner-jacket, or a frock-coat, which ' is only good for funerals ', or a business suit, ' which makes you look like a bank clerk ', but changed directly from his working-clothes to his more formal suit. Even during his greatest poverty, he never wore cotton shirts. ' I'd rather have a linen shirt in rags than a brand-new cotton one.' As to food, I have already mentioned that he lived on haricot beans while sharing a studio with Monet. Usually he took his meals in a *crémerie*. When painting outside Paris, he stayed in little inns, like Mother Anthony's in Marlotte, which were still charming places. In Paris he made his bed every morning, lit the fire and swept his studio. When ' it got too dirty ' he enlisted the aid of one of his models, or, more often, one of their mothers, and left the place for twenty-four hours so that she could give it a ' thorough scouring '. He never kept anything that was old or worn out. When his second-best suit or his shoes became shabby, he would give them away. As I have already mentioned, he did the same with his furniture. He went through life with the pleasant sensation of not really having any possessions : ' Just my two hands in my pockets,' as he put it. He would even get rid of his pictures. And he would start the fire with his water-colours and drawings.

But during the winter of 1881 he began to have doubts about the advantages of such a carefree life. ' It's all very well in theory not having any personal ties, but you can't live that way. My tie with the world was going out occasionally to dinner. It wasn't much ; but when you are all alone, your evenings are pretty forlorn.'

The *crémerie* where my father usually went was just across the street from his studio in the Rue Saint-Georges. But I should explain, perhaps, what is meant by the term. They were little shops, usually run by a woman, which, in addition to selling cream, milk, butter and eggs, had three or four tables in an adjacent room where customers could sit down and eat the *plat du jour*. There was always

a little stove in one corner, and it not only warmed the place, but served to heat up the veal, or mutton stew or the pot-au-feu. The beef dish was available most often because it required so little trouble to prepare. The dessert was always a piece of cheese. Those wanting wine with their meal could get it from the dealer next door. The regular customers nearly always turned up at meal-times, just like members of the family. Their social status was as modest as the price of their meal.

The owner of the little eating-place in the Rue Saint-Georges was a widow of fifty with two daughters, one of whom worked as a dressmaker's assistant and the other in a shoe store. Her greatest ambition was to marry one of them to Renoir. She could not do enough for him, setting aside the best bit of Brie cheese for him, ' not too runny, but ripe enough '. He had a great weakness for Brie, which in his opinion was ' the king of all cheese. But you can only eat it in Paris. Once it goes beyond the city limits, it's no good.' As for the daughters, they were justly proud of their domestic talents ; and they would slip into his pockets titbits cooked with loving care, or carefully mend his handkerchiefs. Their mamma, in her matrimonial plans, gave more thought to my father, perhaps, than to her daughters. ' He is so well-bred, and so helpless. And he's so thin it wrings your heart. He shouldn't be left to live alone. He should have a wife ! '

She never suspected that he had already found her, in one of the faithful habituées of her little restaurant. If he had not yet proposed to the young lady, it was because he felt uncertain whether he would be able to provide for her or for any children they might have. The very thought of having a wife ' who went out to work ', a custom not approved of in those days, was repugnant to him. In fact, he often said to me : ' If you ever marry, keep your wife at home. Her business is to look after you and your children, if you have any.'

Mme Camille came from that part of the Department of the Aube which lies between Champagne and Burgundy. The inhabitants are known for their strong Burgundian accent, and have an unmistakable way of rolling their r's. Imagine her joy the day she discovered another woman from the Aube living near by in the Rue Saint-Georges. And her neighbour's r's were as resonant as her own. Mme Charigot, whose first name was Mélanie, had been deserted by her husband, and she supported herself by dressmaking. She had

a daughter, Aline, who was equally adept at sewing. I am greatly moved as I write all this, because it concerns my mother.

It is she who is shown, about to step into a boat, in a little picture painted some time before the 'Luncheon'. Renoir had known her for several years. She had posed for him when she had time; almost always out of doors, probably during her holidays. Being a conscientious worker, she earned a good living with a dressmaker, whose workrooms were in a small apartment on the mezzanine floor in the lower part of the Butte. She employed three girls to do the sewing, and made copies of dresses from the smart shops in the Rue de la Paix for the tradespeople of the Notre Dame de Lorette quarter. She made clothes also for some of the 'irregulars' of the Pigalle neighbourhood, but grudgingly, 'because,' she said, 'they keep the distinguished clientele away.' She was a native of Dijon, and she had an accent as noticeable as that of my mother, for whom she predicted a brilliant future. 'If you continue like this, you will go far. When I first landed in Paris, I was as penniless as you.' But in the good woman's opinion, marriage was the best road to success. Her husband, a representative of a silk firm, had helped her set up her establishment. His advice to Aline was : ' Get yourself a rich one : and not too young. With a pretty little face like yours it won't be hard to find one.' But Aline Charigot had thoughts only for the painter in the Rue Saint-Georges : not young, obviously, and without a penny. 'And whenever he did have any money, he gave it all away.' He was forty, and she was only nineteen. She would have liked him to ask her to pose all the time. 'I didn't understand anything about it; but I loved watching him paint.'

Mme Camille and her daughters finally guessed what was going on. They very sensibly gave up their hopes, and did all they could to help along this budding love. Parisians have a passion for intrigues—I mean as onlookers, and especially as confidants. And when an affair is a clandestine one, it becomes a positive treat. All the ladies concerned never stopped questioning their young friend about it, or giving her advice :

' Has he proposed yet ? '

' Make him take you to the theatre.'

' You should mend his socks, clean house and cook for him. You must fatten him up.'

' You must convince him that he can't live like a bohemian.'

' At his age he should marry ; or soon he'll find out it's too late.'

'Don't tell your mother, whatever you do. She'd spoil everything.'

My grandmother on my mother's side was, in fact, unbearable. Firmly entrenched in her respectability and her domestic virtues, she never refrained from pouncing on the slightest weakness in others. ' She had a knowing smile that made you feel like killing her.'

One day, when she came by chance to Renoir's studio, accompanying her daughter for the finishing touches to a picture painted by the Seine, she had planted herself in front of it, and, shaking her head, demanded sarcastically : ' And you earn your living at that sort of thing ? Well, you're lucky ! '

Aline was not one to be intimidated. She ordered her mother to leave, and told her that if she did not obey she would keep for herself all the money she earned. In face of such a threat, Mme Charigot bowed her head and went out of the studio, repeating the familiar plaint of all old Burgundian women, ' Eh, là ! Dear God, what troubles I've got ! '

My father once said to me :

' There's nothing underhand about your mother. She is never sentimental.'

He discovered in her the same dignity he so admired in his mother, ' with the difference that your mother was fond of good food.' This weakness delighted him. An abstemious man himself, he hated diets, and considered such self-imposed sacrifice as a sign of egotism. Though he did not mind being deprived of good things, he could nevertheless appreciate them. And he liked having well-fed people around him. Once a week the *crémerie* woman would invite her friends in for a feast of haricot beans and bacon, a great Burgundian treat. She had them sent up to her from Dijon : real beans, grown like vines in stony soil ; not the kind that grow in fields like wheat or clover. ' It was a pleasure to see your mother eat. Different from society-women, who give themselves stomach pains trying to remain thin and pale.'

My earliest recollection of my mother is that she was already well filled out. I can imagine her at twenty with lovely curves and a ' wasp waist'. The pictures in which she appears are of some help in forming a clearer conception of her. I have mentioned earlier how Renoir was attracted to the ' cat' type of woman. Aline Charigot was the perfect example of the species. ' You wanted to tickle her under the chin.' My father's reserve about that period of his life

leads me to suppose that a great love existed between them. According to Rivière: 'There were times when he would put down his palette and gaze at her instead of painting, asking himself why he toiled, since what he was trying to achieve was there already.' But this little 'literary crisis' passed quickly enough. For after all, my mother is to be seen in any number of his pictures.

It would seem that the lovers spent most of their time on the banks of the Seine. The Fournaise restaurant was their favourite meeting-place. It was easy to reach. By going through the Rue Saint-Lazare it was only a few minutes' walk to the station from the Rue Saint-Georges. There was a local Saint-Germain train every half-hour that stopped at the Chatou Bridge station. At the Fournaises' the pair found a group of friends who seemed to watch over their idyll with tender interest. The painter, Caillebotte, looked after Aline Charigot like a young sister. Ellen André and Mlle Henriot adopted her; they decided to take her in hand, and try 'to polish up this sweet country girl'. Aline was very touched by their friendliness. She listened to them, but went on doing as she pleased. 'I didn't want to lose my accent and become an imitation Parisian.'

The place was delightful; a perpetual holiday. She was fond of rowing, and was continually out on the water. Renoir admired her skill. 'She had hands that could do things.' He taught her to swim, first by having her hold on to a buoy. Careful by nature, he stayed within reach and kept hold of a rope tied around her body. 'You never know. If she had got cramp, I could have pulled her in quickly.' But it was not long before they were able to dispense with the rope, for 'she swam like a fish.'

At night there was always someone about who volunteered to play the piano for dancing. The tables on the terrace were pushed back into a corner. The piano was in a little reception-room, and the music floated out through the open window. 'Your mother waltzed divinely. I'm afraid I stepped all over her feet. The star dancer was Barbier. When he started whirling your mother around, everybody stopped to watch them.' Sometimes Lhote, accompanied by Mlle Fournaise, would break into his favourite refrain, the song of the heroic soldier in *Mam'zelle Nitouche*: 'Because he was, because he was, because he was made of lead.' And everyone joined in the chorus.

I should like to give an idea of the physical proportions which Renoir considered as ideal in a face: the eyes should be half-way

between the top of the head and the tip of the chin. If the upper half of the head was too big, in his view it was the sign of an enlarged brain—' the brain of a megalomaniac or, more simply, an intellectual; not to mention water on the brain '. If the top half of a face was too small, it signified good, honest stupidity. If the lower part was too pronounced, it meant stubbornness. ' Never marry a woman with a large chin. She'd rather be torn to pieces than admit she was in the wrong.'

He liked women who had a tendency to grow fat, whereas men, he thought, should be lean. He liked small noses better than large ones, and he made no secret of his preference for wide mouths, with full, but not thick, lips ; small teeth; fair complexions ; and blonde hair. 'Pouting lips indicate affectation; thin lips, suspicion.' Once he had drawn up these rules, emphasizing the importance of dividing the face at the line of the eyes, my father would add : ' After that you have to follow your instinct. With rules you're sometimes apt to go wrong. I've known exquisite girls with a slipper-chin, and unbearable bitches with perfectly proportioned features.' It so happened that Aline Charigot was not unbearable ; that the proportions of her features and body accorded with the canons Renoir had formulated ; that her slightly almond-shaped eyes sent the impressions they received to a well-balanced brain ; that she had a light step—' she could walk on grass without hurting it '; that she kept the vigour of the sharp little winds that sweep over her native hillsides ; and that she knew how to twist her unruly hair into a simple chignon, sweeping it up with a slow curving movement that Renoir liked to watch because it was ' truly round '.

As he allowed his memories to take possession of him, my father, twisted by his rheumatism, glanced once more at the red-velvet chair where his dear departed used to sit and watch him paint. The chair is still in existence. It is in my home, next to the sofa which embellished the drawing-room of the different apartments we had, beginning with the Château des Brouillards and ending with the one in the Boulevard Rochechouart. Together with his gloves, a ball-and-peg game called *bilboquet* and some handkerchiefs, it is one of the magic carpets which take me back to the years I am trying to evoke.

I now come to the most important point in the meeting of these two beings : the mystery which is inexplicable to purely scientific minds, but is clear as day to those with a touch of mysticism. I mean to say that, from the moment he took up a brush to paint,

perhaps even earlier, perhaps even in his childhood dreams, thirty years before he ever knew her, Renoir was painting the portrait of Aline Charigot. The figure of Venus, on the vase which disappeared from my home during the Nazi occupation, is a materialization of my mother ten years before she was born. And the famous profile of Marie Antoinette, which my father painted so many times in the workroom of the porcelain factory, had a short nose! His employer once said to him : ' Watch out. The customers won't recognize their idol. You must make the nose a little longer.' Naturally, Renoir did portraits of women who differed from one another physically. His interest in human beings made him strive to achieve real likenesses. Yet whenever he painted subjects of his own choosing, he returned to the physical characteristics which were essentially those of his future wife. No one knows whether he deliberately chose such models or whether his imagination guided his hand. Oscar Wilde, whom he was to meet in later years, offered a much simpler explanation when he made the quip apropos of Turner : ' Before him, there was no London fog.' The theory that painters ' create the world ' is borne out strikingly in Renoir. For it was not only my mother who was to be born in Renoir's pictures, but we, his children, also. He had done our portraits even before we came into the world, even before we were conceived, physically. He had represented us hundreds of times ; and all children, as well ; all the young girls with whom he was unconsciously to people a universe which was to become his own. That Renoir's world has come into being can no longer be doubted. I am constantly being waylaid by parents who show me their children and say : ' Don't you think they are perfect little " Renoirs " ? ' And the extraordinary part is that they are! Our world which before him was filled with people with elongated pale faces has since his time seen an influx of little round, plump beings with beautiful red cheeks. And the similarity is carried further by the choice of colours for their clothing. He is responsible for that too. His contemporaries have ranted enough about ' the gaudy finery with which he decked out the cooks and maids who served as his models'. This criticism by a forgotten journalist was repeated to me by my father himself. Renoir let them talk. Anyone able to create a world filled with health and colour is beyond criticism. ' Let the literary crowd indulge their passion for anaemia and " whites ".' And then, to point up his remark, he added, ' You'd have to pay me to sleep with the Dame aux Camélias.' He would

have resented anyone telling him the exact nature of the task he was
so humbly trying to accomplish. To create even a little corner of the
universe was the work of God, and not that of a capable porcelain-
painter who had become a good workman in painting. On the
contrary, he was convinced that it was the world which was creating
him; and that he was merely reproducing this life of ours, which
enraptured him like a passage in a great symphony. 'The cork in
the flow of the stream.' He only wanted to interpret faithfully the
marvels he perceived so clearly for the benefit of those unable to
perceive them. He would have been incensed if anyone had dared
to tell him that the life which he filled his pictures with so abundantly
came from within him. He would have felt just as insulted as if
someone had called him an intellectual. He only wanted to be a
mechanism to take in and to give out, and to that end he was careful
not to squander his strength, and to keep his vision clear and his
hand sure. 'If it came from me alone, it would be merely the
creation of my brain. And the brain, of itself, is an ugly thing. It
has no value except what you put into it.'

Here are some of his other reflections on the same subject:

'To express himself well, the artist should be hidden. Take the
actors of ancient Greece with their masks, for example.' And again:
'The unknown artist of the twelfth-century Virgin in the Cluny
Museum did not sign his work. Even so, I know him better than if
he actually spoke to me.'

One day I was trying to pick out a Mozart sonata on the piano.
Like all poor pianists, I unconsciously emphasized the 'sentiment' as
I played. All at once, my father interrupted me.

'Whose music is that?'

'Mozart.'

'What a relief. I was afraid for a minute it was that imbecile
Beethoven.' And, as I expressed my surprise at his severity, he went
on: 'Beethoven is positively indecent, the way he tells about
himself. He doesn't spare us either the pain in his heart or in his
stomach. I have often wished I could say to him: " What's it to me
if you are deaf? " It's better for a musician to be deaf, anyway. It's
a help, like any obstacle. Degas painted his best things when his
sight was failing. Mozart had a far harder time than Beethoven, yet
he was modest enough to hide his troubles. He tries to amuse me
or to move me with notes which he feels are impersonal. And he is
able to tell me much more about himself than Beethoven with his

noisy sobbing. I want to put my arm round Mozart and try to console him. After a few minutes of his music I feel that he is my best friend, and our conversation becomes intimate.' Renoir was convinced that there was, happily, a constant contradiction in human affairs which would eventually restore the balance destroyed by the stupidity of the vain. ' The artist who seeks to present himself entirely naked to his public ends by revealing a conventional character, which is not even himself. It is merely romanticism, with its self-confession, tears and agony, in reality the posings of a third-rate actor. But it sometimes happens that a Raphael who only wished to paint nice girls with little children—to whom he gave the title of "Virgin"—reveals himself with the most touching intimacy.'

In those days of our talks together, Renoir could express these principles with a certain confidence. In ferreting out the eternal lie, the illusions which conceal the reality of things, he had a long life of varied experiments to fall back on. He was at pains, moreover, to point out that his truth was far from being the ultimate truth. ' I've spent my life making blunders. The advantage of growing old is that you become aware of your mistakes more quickly.' And he would say, also : ' There isn't a person, a landscape or a subject that doesn't possess at least some interest—although sometimes more or less hidden. When a painter discovers this hidden treasure, other people immediately exclaim at its beauty. Old Corot opened our eyes to the beauty of the Loing, which is a river like any other ; and I am sure that the Japanese landscape is no more beautiful than other landscapes. But the point is that Japanese painters knew how to bring out their hidden treasure.'

His remarks make me think of the American West, which many well-intentioned people consider ' picture-postcard ', leaving it to the vulgar tourist to admire such obvious attractions as the majestic sequoias or the Grand Canyon. I myself think the West of America very beautiful. All it needs is a group of painters of the stature of the Italian masters of the Quattrocento or the French Impressionists in order to discover behind the postcard eternal values.

What sight could be sadder than the modern suburbs of Paris ? Yet in spite of the dreariness of these streets, an undeniable poetry clings to them from the days of Utrillo and the good Sunday painters of the time. Obviously there is little opportunity for meditation in the way life is organized in present-day America, and that fact may

delay the formation of a group of young people free enough to devote themselves to the non-scientific study of Nature.

At the time of his first meeting with my mother, Renoir was going through a serious crisis. ' I hardly knew where I was any longer ; I felt as if I were drowning.' After struggling along for ten years and growing more confused by seemingly contradictory experiments, he had begun to have his doubts about Impressionism. Aline Charigot had a simpler way of looking at things. With her good peasant common-sense, she knew that Renoir was born to paint just as the grapes of a vine are destined to produce wine. He must therefore paint—whether badly or well, whether he was successful or not, he must never stop painting. What is more distressing than a vine gone to waste, and how much toil is necessary to nurture it so that it will yield. It might be better for them to go to her native village of Essoyes, where it cost almost nothing to live. There Renoir could devote all his time to his experiments without being bothered by the wine-growers, who had other concerns besides the future of painting. Her plan was thwarted by two serious obstacles : first, there was Mme Charigot, who forbade her daughter to tie herself for life to her ' poverty-stricken sweetheart'; and second, Renoir himself still needed to be in the atmosphere of Paris, in the thick of the fight. ' To isolate yourself, you have to be exceedingly strong.'

In desperation, Aline Charigot went back to her employer, and tried as far as possible to avoid seeing Renoir. My father then went off to Algeria where he discovered a marvellous world. After that, he spent the summer with the Bérards in Wargemont. But neither the Oriental splendours of Algeria nor the apple-orchards of Normandy made him forget my mother, whom he was to see again in September of that year.

When I questioned her about that period of her life, her answers were more than vague. Not that she wished to hide anything from me : but like all people of strong character she lived entirely in the present. The kind of fertilizer needed for the orange trees at Les Collettes interested her much more than the past.

After her death, my father's solitude inclined him to withdraw into himself. Nevertheless, from what he did tell me it has been possible to reconstruct this period. Aline Charigot would not consider marriage except with the idea of having children, and of having complete charge of them. That would mean worries, of course, crying babies, noise, wet nappies, sleepless nights and

all the rest. And none of it would fit in with the requirements of a gentleman who devoted himself to painting with the fanaticism of a Stylite monk saving his soul by sitting on top of a column.

They decided to remain ' good friends '. She had made up her mind to forget him, and urged him to go off on his travels again. For his part, he felt an imperious need to see the pictures of the great masters in their own countries: Velasquez in Madrid and Titian in Venice. He refused to give up his conviction that pictures ' can't be carted about' and that they should be seen under the native skies of the artists who had painted them. In 1881 Renoir began a period of passionate travelling, which resulted in vital decisions for his personal life and his career.

# 18

Renoir travelled third class because he could not afford to do otherwise. Even if he had had the means, he would have avoided going first class. The additional comfort for one's backside was not worth the difference in price. Towards the end of his life poor health obliged him to travel de luxe, and he did not like it. Or rather, it was the passengers who irritated him.

'They hardly sit down before they begin to read a financial newspaper. And then, the little side-glances to size up the person next to them, and pigeon-hole him socially! The most pretentious people, though, are those who travel on a pass.'

He was secretly amused by certain passengers who attempted to appear important by assuming a grave and slightly bored expression. Some looked as if they were millionaires overwhelmed by having to administer too large a fortune ; or businessmen responsible for big deals ; or diplomats carrying dark and dangerous secrets.

'I felt like an intruder in first class, with my paint-box and big sun-shade—like a coal-heaver who has got into a fashion-show by mistake.'

But second class seemed to him even worse, as the passengers there were all the more on their dignity because they could not afford to travel first. 'And what distinction!' When by chance some 'artist' noticed his painting-kit and turned the conversation to painting, that was indeed something! Ordinarily so affable and 'chatty', my father could, if he felt like it, become a regular bear. When he got too irritated, his wit could be very caustic. Once, a man seated opposite nearly drove him wild with his comments on Meissonier. My mother was then expecting her first child, who was to be my brother Pierre, so Renoir had taken first-class seats. The enthusiast for the painter of military scenes was holding forth at great length and mentioned the enormous prices paid by Americans

for that kind of art. Exasperated, Renoir replied that he himself knew nothing about great painting, as he specialized in pornography. He did his work mostly for brothels, with staggering success because he could depict the male sexual organ so well. Naturally, my mother was greatly embarrassed. She did not much care for that kind of humour.

Renoir nearly always travelled by easy stages. He could not understand the frantic haste of his contemporaries. ' The more time we save the less we get done, it seems to me. I heard of an author who because he had a typewriter was able to complete a book in three years. Molière or Shakespeare could turn out a play in a week with just a quill pen, and it was a masterpiece.'

For Renoir, local trains had the added advantage of throwing him into the midst of more genuine people. ' The farmer's wife who goes to the nearest market-place to sell her cheese is truly herself. But when she takes an express-train she loses her identity : she becomes that anonymous creature called a passenger.' He rarely spoke of the fungus that spreads among immortal sites, known as the tourist. In his day they were still a rare phenomenon and happily nearly always English—that is to say, rather discreet.

Renoir did not travel alone. I know that Lhote went with him on one of his trips to Italy. They stopped at Dijon for a few days, and wandered up and down the old streets. ' What I like most in Burgundy are the roofs. They have something Chinese about them, curving up slightly at the ends.' He was a great admirer of Charles the Bold. ' The angels in his churches are a trifle mannered, but it is a mannerism I'd be very glad to have.' He regretted the passing of the mixed civilization between France and Germany, which was to be prolonged in the Flemish countries. ' Too bad it miscarried. The Swiss played us a queer trick there.'[1]

Every now and then he would get off the train for the most unexpected reasons : troublesome fellow-passengers ; or a wish to get a closer view of a village church whose tower seemed to beckon him. Not only did his eyes feast on the marvels of the countryside : he also learned a great deal about regional cooking. The people who travel in third-class carriages are usually generous. They would ask Renoir to share their basket of provisions. With a pitying glance at the sandwich he pulled out of his pocket, one good woman said :

[1] A reference to the victory of the Swiss over the Burgundians in 1476.

'Is that all you've got for lunch? It's no wonder you're so thin.'
Some had set out with enough food to take them round the world.
And as the miles skimmed by, my father switched from Burgundian
gougère—puff-paste with a cheese filling—to Provençal daube—
beef cooked in red wine; from the year-old native wines of the
Côte d'Or to the full-flavoured rosé from the Rhône district, all
consumed amid talk about the prospects for the harvest, family
troubles, taxes, the war in Tonkin, and the tortures of wearing a
corset—'when you're not in the habit of wearing one'. It sometimes
happened that, after swallowing the first mouthfuls, a portly farmer's
wife was unable to hold in any longer. She would then apologize,
unbutton her blouse, and ask the woman next to her to unlace her
at the back. And once her rolls of fat were freed from their con-
fines she could relax and dig into the hare pâté with gusto.

Accents and idioms changed with each region. The drawling
speech of the '*gones*' of the Lyons area replaced the Burgundian
rolling 'r', only to give way to the ringing Provençal of the
market-gardeners of the Durance River. The ice was quickly
broken; and the amiable Parisian with his queer-looking outfit was
soon made to feel at home. Stories were told at a great rate. My
father tried to remember a few. He recalled a certain dragoon,
encumbered by his sabre, his helmet, and a large cardboard box
containing a bridal-dress, which was a present for his fiancée from
the wife of his captain. He was all the more hampered by the big
box because in those days a cavalryman in uniform was forbidden to
carry parcels in public. The captain had made him promise to send it
by post; but the dragoon, being a thrifty peasant, preferred to risk
getting caught rather than spend the money on stamps. 'If an
N.C.O. should put his nose in the door you can say the box belongs
to you,' he said to a young woman who was nursing a baby. He
was on his way to Blaisy-*bas*, a village not far from Dijon, and
he pronounced it 'Baibaaa', running all the syllables together.
Another Burgundian in the compartment inquired if Blaisy-*bas*
(Lower Blaisy) was not part of Blaisy-*haut* (Upper Blaisy). The
dragoon assured him it was; and, when this matter of geography
was cleared up, the women asked if he would show them the bridal-
dress. But the fellow refused to undo the parcel. 'It is so bee-uti-
fully wrapped up,' he said. 'It's the package that's the most bee-uti-
ful!' To console the disappointed women, he told them a story,
which my father had some difficulty understanding on account of the

accent; but it must have been funny because everyone was convulsed with laughter. Renoir laughed too, just out of pleasure at seeing them laugh, and because gaiety is contagious. It was some tale about a wedding-feast, one of the real Burgundian kind that lasts for days and nights on end. I myself have attended those magnificent orgies : three days and nights at table. None of the guests gets up unless he has to, or stops eating and drinking before he droops from repletion. A few hours' delicious sleep in the hay-loft, and back to the party.

The festivities the dragoon described took place at his sister's wedding. His mother, who was a pinch-penny, had tried to take advantage of the occasion by serving an old rooster along with the roast chickens. But no one was taken in, and they passed it from one to the other with pointed remarks about the amorous activities of the patriarch. The hostess herself was finally obliged to eat up the tough old bird.

Here is another recollection. He had gone with Lhote to Bourg-en-Bresse to see the well-known church of Brou near there. Renoir's opinion of it was : ' Decadence already, but what grace ! And how could anyone help but fall in love with Marguerite of Austria ! Her motto, " Fortune-Misfortune ", repeated all over the church like a *leit-motif*, gets us away from our age of grocers.'

The train was packed, and to get into it at all they had to give up the idea of third class and try their chance in a second-class compartment, in which there were half a dozen gentlemen, all reading newspapers. Once Renoir had stowed his painting-kit on the luggage-rack as well as he could, the two friends managed to squeeze in between their fellow-passengers, who studiedly continued reading. The newcomers exchanged glances as if to say, ' This isn't going to be much fun ! ' To liven things up, Lhote decided to carry on with a joke begun that morning in the station restaurant where Renoir had absent-mindedly eaten the last *brioche* in the place, leaving nothing for Lhote, who was flirting with the girl at the cash-desk. In those days it was the custom to dub anyone a ' Swiss ' who drank alone, went to amusements alone : in short, was reluctant to share anything—doubtless an allusion to Swiss neutrality. Having been done out of his breakfast, Lhote had called Renoir a ' dirty Swiss '. In the hope of dispelling the gloom in the compartment, Lhote said again to Renoir, ' Go on, you dirty Swiss.' Frigid looks from behind the newspapers dissected poor Lhote as though he were some

insect. My father then noticed that the newspaper which the gentle-
men were reading was *La Gazette de Lausanne*. As Lhote, because of
his poor sight, had not noticed this little detail, Renoir kicked him
gently on the shin as a warning. But, thinking his friend was egging
him on, he again exclaimed, ' You dirty Swiss ! ' and began to make
faces as Renoir's kicks grew more violent. Finally one of the
gentlemen said to Renoir : ' You needn't worry. We are not Swiss.'
They were all watch-makers from the vicinity of Besançon. ' It is
probably the watch industry that makes us look as if we came from
Geneva,' another man said. With that the conversation became
general ; and the talk was entirely concerned with flat watches and
thick ones, jewel-movements, escapements and so on. Before the
day was over, Renoir had learned all there was to know about how
watches and clocks are made. ' Very pleasant gentlemen,' was his
conclusion. ' Real eighteenth-century bourgeois.'

Renoir would often break the thread of his story and lapse into
silence. Darkness would invade the studio in the Boulevard Roche-
chouart, helping him to drift back into the past. I would take
advantage of the interval to lift him up and hold him firmly while
Grand' Louise refilled his rubber cushion with air. Then, with the
utmost care, we would lower him into his chair and settle him in the
best position.

' What nasty material rubber is ! . . . Give me a cigarette, will
you ? ' He drew a few puffs, then let it go out. He was really not a
great smoker. He never inhaled, and he did not like expensive
cigarettes that ' burn up by themselves '. ' You let it fall, you forget
about it, and first thing you know you've burnt a hole in a Bokhara
carpet.' I suppose that if the imaginary carpet had been made of
imitation velvet, he would have been less impressed by the accident.
Yet his respect for things, even ugly ones, was the same as the
respect he felt for human beings or animals, ' even the ill-favoured '.

One night he peered at a box of biscuits lying unopened on the
table. On the label was a picture of the factory where they had been
made.

' The middle classes are responsible for the ugliness of modern
towns. Their greed for money destroys everything. Thanks to
them we now have forests of smoke-stacks and miles of slums. But
perhaps it is man himself, not just one class, who is going through
a bad period. After all, a great many of the middle classes are
upstarts. If they had not been clever, they would have remained

poor. It's only money that enables people to build monstrosities like the Opera House, or to buy a Jean-Paul Laurens.'[1]

He told me of a conversation at a luncheon with Clemenceau, Geffroy and some 'literary' men. As they were all belittling the middle classes, my father said :

'We are not aristocrats, because we have no hereditary titles. We don't belong to the working class, because we don't labour with our hands. If we're not of the middle class, what are we, then ? '

'We are intellectuals,' replied Geffroy.

Renoir was shocked. That term, which cynically implied the superiority of the *homo sapiens* over the *homo faber*, was intolerable to his ears.

'I much prefer being middle-class,' he announced, to the consternation of the other guests. 'But,' he added, 'after all, I work with my hands, and that makes me a working man—a workman painter.'

The smoke from his cigarette suddenly reminded him of an amusing episode on one of his travels.

'I was in Spain, and still exhilarated from having seen the Velasquez there. I went into a tobacco shop to buy some cigarettes. A fine-looking hidalgo was choosing a cigar. As I couldn't speak Spanish, I could only make out two words of what he was saying to the clerk. They were " *colorado* " and " *claro* ", and he said them several times. They were a revelation to me; of course: "coloured" and "clear"! I had discovered the secret of Velasquez! '

I tried to bring our conversation back to the subject of art in general. I was not to have a chance to visit Italy myself until much later ; but I had a certain knowledge of it through the reproduction of paintings. However, my father refused to take the cue.

'You don't talk about paintings : you look at them. A fat lot of good it would do you if I told you that Titian's courtesans make you want to caress them. Some day you'll see the Titians for yourself, and if they have no effect on you, then you don't understand the first thing about painting. And I wouldn't be able to help you.' Yet, apparently contradicting his previous statement, he said : 'You don't look at painting. You live with it. You have, for example, a little picture in your home. You pay it hardly any attention ; and if you do, you certainly don't analyse it. It becomes part of your life.

[1] 1838-1921. A painter of historical subjects. His pictures are in a decidedly academic style.

It acts on you like a talisman. The museums are only a makeshift.
How can you get excited over a picture with a dozen or so people
around you, whispering asinine remarks ? If you go early in the
morning you have a better chance.'

It was not often that he criticized anything in a mood of irritation;
but when he did, he expressed himself in no uncertain terms.

' Leonardo da Vinci bores me. He ought to have stuck to his
flying-machines. His Apostles and Christ are all sentimental. I am
very sure that those good Jewish fishermen could risk their skins for
their faith without needing to look like dying ducks in a thunder-
storm.' On the other hand, when Franz Jourdain, the architect of
the Samaritaine department-store, asked him if he liked Rembrandt
better than Rubens, Renoir replied, ' I don't give out awards.'

A number of books have been written about Renoir's travels in
Italy, some of them very well documented. The impression I got
from my talks with my father was that his early enthusiasm for
Italian art of the Renaissance wore off a little, whereas his admiration
for the Italian people of his own time increased as he got to know
them better. ' Nobility in the midst of poverty ; people who labour
in the fields with the gestures of an emperor.' Through the
mediation of these 'emperors' he was able to grasp the art which
expresses them most completely, that of the Primitives : ' A fresco
in a village church by an unknown artist, the forerunner of Cimabue
or Giotto ; a colonnade of the twelfth century ; the humble roof
of a convent that may have sheltered some disciple of Saint Francis.
So far as I am concerned, Italy is *The Little Flowers*, and not any of
your theatrical exaggerations.'

He particularly liked the south Italians : ' perhaps because by the
time I got to Naples I had begun to understand a few words.' It was
there that he had the revelation ' which justified the whole trip ':
the Pompeian frescoes in the Naples Museum. ' I was tired of the
skill of the Michelangelos and the Berninis : too many draped
figures, too many folds, too many muscles ! I like painting best when
it looks eternal without boasting about it : an everyday eternity,
revealed on the street corner : a servant-girl pausing a moment as
she scours a saucepan and becoming a Juno on Olympus.'

In the figures in the frescoes, which had been so miraculously
preserved, he descried the fishermen and fishwives of Sorrento.
' The Italians don't deserve any credit for great painting. They just
have to look around them. Italian streets are crowded with pagan

gods and Biblical characters. Every woman nursing a child is a Raphael Madonna.'

He talked again about this last impression, dwelling on the curve of a brown breast and the chubby hand that clutched it. The Pompeian frescoes struck him for many other reasons. ' They didn't bother about theories. There was no searching for volumes, and yet the volumes are there. And they could get such rich effects with so little ! ' He never ceased to marvel at the colour-range of those ancient artists : earth colours, vegetable dyes, seeming rather dull when used by themselves, but brilliant by contrast. ' And you feel they were not striving to bring forth a masterpiece. A tradesman or a courtesan wanted a house decorated. The painter honestly tried to put a little gaiety on the wall—and that was all. No genius ; no soul-searching ! '

We know that as he grew older and gained in knowledge, Renoir was to simplify his palette. It was probably after seeing Naples and the Pompeian paintings that this trend began.

' The trouble about Italy,' he said to me one day, ' is that it is too beautiful. Why bother to paint when you get so much pleasure out of just looking around you ? ' And after reflecting a moment, he continued : ' It's too bad that I am old and ill. It would be possible for me to paint now in Italy or Greece or Algiers. I know enough for that, now. To resist what is too beautiful and not be gobbled up by it, you've got to know your job.'

I followed his meaning by watching his emaciated face, which was turned oddly to one side, making a slight crease in his beard. One could catch a gleam of amusement in his eye, as he came out with one statement and then seemed to contradict it with another.

' Besides, an apple on the edge of the table is all you need. Look at the masterpieces Cézanne did with an apple, or with models I wouldn't even allow to clean out the courtyard.' And he kept on playing with these ideas. ' Yet people painted better in Italy than anywhere else ; and now they paint better in Paris than anywhere else. Perhaps it's something in the air.' Then, as if sweeping away the thought with a wave of his twisted hand : ' No. It's the art-lovers who do the painting. French painting is the work of Monsieur Choquet. And Italian painting is the work of a few Borgias, Medicis and other tyrants whom God blessed with a taste for colour.'

While in Naples, Renoir stayed in a little inn patronized especially by the clergy. ' When we sat down to eat spaghetti with tomato

sauce, I was the only one not dressed in black.' He had great discussions on theology with the man next to him, a gaunt priest with a huge nose. In accordance with the French tradition of Pascal and the Jansenists, Renoir defended the concept of Infinite Grace : ' To paint " The Marriage of Cana ", Grace was necessary, as it was also for painting those frescoes preserved by God's mercy under the volcanic ashes.'

The priest replied that the artists who had painted the frescoes at Pompeii could not have been blessed with Divine Grace because they were pagans. To prove that Grace was really the work of man, this spiritual yet paradoxical Italian recounted to my father the story of St Januarius and General Championnet. To sum it up in a few words : St Januarius is not only the patron saint and protector of Naples, but twice a year, in May and September, he clearly indicates his approval or disapproval of important events affecting the city. A few drops of the blood shed at his beheading have been preserved in two ampullas in one of the cathedral chapels. The blood liquefies if the Saint looks on an event favourably, but remains congealed if he disapproves.

It so happened that General Championnet had conquered Naples in 1799, a few days before the customary miracle was to take place. He suspected that the Neapolitan clergy had enlisted the aid of the Saint against the French miscreants and revolutionaries. On the appointed day a huge crowd had assembled in front of the cathedral only to learn that the martyr's blood was still solid. The mob turned hostile and began to utter threats of death, and it looked as if there might be an uprising. Championnet sent word to the bishop, warning him that if the miracle did not occur, he would be obliged to have him shot. The blood liquefied immediately, and the Neapolitan populace acclaimed the French invaders.

The priest in question was from Calabria, and his descriptions of his part of the country gave my father a desire to see it. And so Renoir set out with a letter of introduction from the bishop, which his friend had obtained. In those days there were few railways or even roads in Calabria ; and he did part of the journey in a fishing-boat, going from one port to another, and the rest on foot. The bishop's letter opened the doors of vicarages : and often a parish priest who had only a pallet to sleep on would turn it over to him, and go himself to sleep in the stable along with the donkey. The poverty of the region was almost unbelievable. Yet everyone put

himself out to receive the visitor. The meals were more than simple. In some villages the inhabitants lived entirely on beans, and had seldom tasted spaghetti or macaroni, which most foreigners imagine are so plentiful in the South of Italy.

Because of the lack of bridges Renoir was several times faced with the problem of how to get across streams swollen by heavy rains. On one occasion there seemed at first to be no solution. But a peasant woman who saw him called to a dozen or so others working in the fields, and they all came to the rescue, laughing and chattering in their dialect, not a word of which he could understand. They picked up my father and his baggage, waded into the river, and forming a line across it, passed him from one to the other like a rugby football. He tried to show his appreciation of their kindness. He did not have much money, but that did not matter, for these village people, who lived mostly by barter, rarely used it, and seldom even saw a coin. What they most wanted was to have him paint a picture of their 'bambino'. In a mountain village church Renoir restored the frescoes, which had been destroyed by the humidity. 'I didn't know much about fresco-painting. I found some paints in powder form at the mason's in the village. I wonder if what I did lasted.'

I asked him if he had met any of the notorious bandits. 'I missed them,' he replied. And he refused to believe that they were as ferocious as rumour held. 'All the Calabrians I met were generous ; and so cheerful in the midst of their poverty. They made you wonder if it's worth while to spend your time earning money.'

He told me that he had discovered the value of white in Algeria. And he made me realize how exciting that colour is to the eyes, as I was to learn myself when I went to North Africa. 'Everything is white : the burnous they wear, the walls, the minarets, the road . . . And against it, the green of the orange trees and the grey of the fig trees.' The way the Arab women walked filled him with admiration ; and their mode of dress, as well : ' clever enough to know the value of mystery. An eye half-seen through a veil becomes really alluring.' It dawned on me little by little that Renoir's ideal was directed towards a world of aristocrats ; and that he had less and less chance of finding this kind of aristocracy in the Western world. ' The gait of an Arab woman walking with a pitcher of water on her head ! She is Rachel, coming from the well. . . .'

He did very little painting in Algeria, for he was busy studying

a world which the so-called civilized peoples were doing their best to destroy. 'If it was only the factories and tramways and offices, you could put up with that, at a pinch. There are still shepherds in the mountains who look like princes in *The Arabian Nights*. The worst of it is they are taught Arab art; and they are sent specialists in rug-making and theorists in ceramics.'

Renoir always dreamed of a world in which neither animals nor plants had been harmed by man's needs, nor man himself humiliated by degrading tasks or customs. 'Being a beggar is no disgrace, but buying or selling shares in the Suez Canal Company is.' In his eyes nothing could be more grotesque than the clothing worn by Westerners. The stiff collar men wore was a special target for his sarcasm. He could not conceive how anyone would want to put his neck into a starched cylinder, and for him it symbolized the vanity of 'respectable people'. He linked this feature of dress to modern society's 'destructive desire for security'. 'You keep your chin up with a collar—and that leads to insurance.' By 'insurance' he really meant insurance companies, a monstrous fungus of modern society. He wondered if the nobility of the Arabs did not stem from their fatalistic disregard of the morrow. Another explanation lies perhaps in the feeling of equality among Moslems, an equality hard to explain because it has nothing to do with social or financial status. It derives more from the satisfaction of being a member of a religious, rather than a social, group. On several occasions he had noticed a well-to-do Moslem talking with a ragged individual. 'Harun-al-Rashid conversing with a beggar: he knows that in the sight of Allah he is not a bit more important.' I was later to verify the accuracy of his impressions, and to come to a similar conclusion: that the label does not necessarily indicate or guarantee the quality of the contents. Our so-called equality hides flagrant inequalities; and the seeming inequality among Arabs sometimes screens a real feeling of fraternity.

I do not know exactly where Renoir was on his peregrinations when the thought of Aline Charigot began to tug at his mind again. Each day he was more and more convinced that life without her was not complete. He wrote to her, and returned to Paris. She was waiting for him at the station. And from that moment on, they were to remain together for the rest of their lives.

My mother brought a great deal to my father: peace of mind; children whom he could paint; and a good excuse not to have to

go out in the evening. 'She gave me the time to think. She kept an atmosphere of activity around me, exactly suited to my needs and concerns.' His concerns were great indeed, just then. The whole of Impressionism was called in question. He would be drawing precise contours with a fine pencil; outlining forms, 'like Monsieur Ingres'; alternating with thick applications of paint; using the palette-knife; then, suddenly—perhaps on the same day—barely covering the canvas with a delicate wash, like a water-colour.

The couple settled in the studio in the Rue Saint-Georges. Mme Charigot offered to help with their housekeeping. Her daughter accepted, as she was afraid that she herself would not be up to it. Her work in dressmaking had not given her much time to learn how to cook. And my grandmother was expert in preparing all kinds of 'tasty dishes'. For a while everything went perfectly. Renoir feasted on soufflés, blanquette of veal, and caramel custard. He would have preferred a more 'peasant' kind of food, but he appreciated the refinements of the good old lady. Unfortunately her culinary talents were accompanied by certain drawbacks, for she could not resist making uncalled-for remarks at every opportunity: 'So you don't want any more veal? Perhaps you would like a little pâté de foie gras? . . .' She would make frequent insinuations about her son-in-law's financial difficulties. 'Dying of hunger, and he wants foie gras.' At times, when an idea occurred to him, he would get up from the table and note it down with a charcoal pencil. 'So,' Mme Charigot would comment, 'that's the way a gentleman behaves!' Her daughter would restrain herself, but point threateningly to the kitchen door: whereupon the old lady would take her plate and finish her meal alone by the kitchen stove. Renoir remained completely unaware of the little scene; and Aline Charigot would appease her mother by buying her some marrons glacés, her favourite sweet. As a matter of fact, it was my grandmother herself who told me about it in later years, saying serenely, 'If I had really been unscrupulous, I could have had marrons glacés every day.'

My father was anxious that his wife should share his enthusiasm for Italy, and they started off on a trip to Sicily. Once there, Renoir had the misfortune to lose his pocketbook. While waiting for Durand-Ruel to send them funds, they stayed with peasants near Agrigentum. My mother helped with their work in the fields. When the money finally arrived, she tried to persuade them to accept some

sort of remuneration ; but they refused, and were actually offended. Renoir and his wife had no gift for languages and, as they could not speak with the friendly Sicilians, they had to communicate entirely by gestures. It then occurred to my mother to give the peasant woman the religious medal she had around her neck. They all took leave of one another amidst a flood of tears.

Shortly before my brother Pierre was born, my mother advised Renoir to rent an apartment away from his studio. ' Then,' she said, ' the baby will be able to cry to his heart's content.' She found a flat with four rooms and a large kitchen in the Rue Houdon ; a studio near by in the Rue de l'Elysée des Beaux-Arts ; and some rooms for her mother on the Butte, in Montmartre, ' a good walking-distance from them '. It was the eldest daughter of Mme Camile, the *crémerie* woman, who helped her to ' track down ' the latter place. Incidentally, to console herself for having lost Renoir, she had fixed her choice on the owner of a shoe-shop in the Rue Lepic, where she ruled supreme. Her sister had married a watch-maker, whom I myself remember very well, and I can still see M. Mahon in his shop in a street near the Elysée, bent over his work-table, his magnifying glass fixed to his eye like some curious appendage. For years we had watches made by him.

My mother was determined not to let Mme Charigot 'coddle the baby and spoil him to death '. She was particularly afraid that her mother would rock the cradle the minute he cried. She thought it a crime to give in to children ; in any case, it did them no good. ' It's much easier to let them have their way, but it makes life harder for them later on.' Renoir thought it too bad that they could not put it in a paddock, like a little horse, and let it grow up by itself. How-ever, he soon realized that his suggestion was a trifle Utopian ; for ' with our tendency to rheumatism, bronchitis, anaemia and con-stipation, we would die if left in a natural state. We have to have woollen blankets, and be fed at regular intervals.' He remembered the pneumonia he had almost died of in 1882 ; and how he had been saved by Dr Gachet, the art-collector of Auvers-sur-Oise ; and the affectionate care given him, at the time, by his future wife and Mme Camille and her two daughters.

I should now like to quote from a few notes which were found among my father's papers. They forcibly express his unshakeable faith in the necessity for ' the loving observation of Nature '. They perhaps represent also his last tribute to Impressionism. They were

jotted down for the purpose of compiling a 'Grammar for Young Architects'.

We know that in Renoir's opinion the ugliness of buildings towards the end of the nineteenth century and the vulgarity of design in articles in common use were a far greater danger than wars. 'We get too accustomed to these things, and to such a point that we don't realize how ugly they are. And if the day ever comes when we become entirely accustomed to them, it will be the end of a civilization which gave us the Parthenon and the cathedral of Rouen. Then men will all commit suicide from boredom; or else kill each other off, just for the pleasure of it!'

### FROM AUGUSTE RENOIR'S NOTEBOOK

Everything that I call grammar or primary notions of Art can be summed up in one word: Irregularity.

The earth is not round. An orange is not round. Not one section of it has the same form or weight as another. If you divide it into quarters, you will not find in a single quarter the same number of pips as in any of the other three; nor will any of the pips be exactly alike.

Take the leaf of a tree: take a hundred thousand other leaves of the same kind of tree: not one will exactly resemble another.

Take a column. If I make it symmetrical with a compass, it loses its vital principle.

Explain the irregularity in regularity. The value of regularity is in the eye only ... the non-value of the regularity of the compass.

It is customary to prostrate oneself in front of the (obvious) beauty of Greek art. The rest has no value. What a farce! It is as if you told me that a blonde is more beautiful than a brunette; and vice versa.

Do not restore; only remake the damaged parts.

Do not think it is possible to repeat another period.

The artist who uses the least of what is called imagination will be the greatest.

To be an artist you must learn to know the laws of Nature.

The only reward one should offer an artist is to buy his work.

An artist must eat sparingly and give up a normal way of life.

Delacroix never won a prize.

How is it that in the so-called barbarian ages art was understood, whereas in our age of Progress exactly the opposite is true?
When art becomes a useless thing, it is the beginning of the end.
. . . A people never loses half, or even just a part, of its value. Everything comes to an end at the same time.

If art is superfluous, why caricature or make a pretence of it? . . . I only wish to be comfortable. Therefore I have furniture made of rough wood for myself, and a house without ornament or decoration. . . . I only want what is strictly necessary. . . . If I could obtain that result, I should be a man of taste. But the ideal of simplicity is almost impossible to achieve.

The reason for this decadence is that the eye has lost the habit of seeing.

Artists do exist. But one doesn't know where to find them. An artist can do nothing if the person who asks him to produce work is blind. It is the eye of the sensualist that I wish to open.

Not everyone is a sensualist just because he wishes to be.

There are some who can never become sensualists no matter how hard they try.

Someone gave a picture by one of the great masters to one of my friends, who was delighted to have an object of undisputed value in his drawing-room. He showed it off to everyone who came to see him. One day he came rushing in to see me. He was overcome with joy. He told me naively that he had never understood until that morning why the picture was beautiful. Until then, he had always followed the crowd in being impressed only by the signature. My friend had just become a sensualist.

It is impossible to repeat in one period what was done in another. The point of view is not the same, any more than are the tools, the ideas, the needs or the painters' techniques.

A gentleman who has become newly rich decides that he wants a château. He makes inquiries as to the style most in fashion at the time. It turns out to be Louis XIII ; and off he goes. And of course, he finds an architect who builds him an imitation Louis XIII. Who is to blame ?

To own a beautiful palace, you should be worthy of it.

The art-lover is the one who should be taught. He is the one to whom the medals should be given—and not to the artist, who doesn't care a hang about them.

Painters on porcelain only copy the work of others. Not one of them would think of looking at the canary he has in a cage to see how its feet are made.

They ought to have cheaply-priced inns in luxuriant surroundings for those in the decorative arts. I say inns ; but, if you wish, schools minus teachers. I don't want my pupils to be polished up any more than I want my garden to be tidied up.

Young people should learn to see things for themselves, and not ask for advice

Look at the way the Japanese painted birds and fish. Their system is quite simple. They sat down in the countryside and watched birds flying. By watching them carefully, they finally came to understand movement ; and they did the same as regards fish.

Don't be afraid to look at the great masters of the best periods. They created irregularity within regularity. Saint Mark's Cathedral in Venice : symmetrical, as a whole, but not one detail is like another !

An artist, under pain of oblivion, must have confidence in himself, and listen only to his real master : Nature.

The more you rely on good tools, the more boring your sculpture will be.

The Japanese still have a simplicity of life which gives them time to go about and to contemplate. They still look, fascinated, at a blade of grass, or the flight of birds, or the wonderful movements of fish, and they go home, their minds filled with beautiful ideas, which they have no trouble in putting on the objects they decorate.

To get a good idea of what decadence is, you have only to go and sip a beer in some café on one of the boulevards, and watch the passing crowd. Nothing could be more comical. And magistrates with side-whiskers ! Could anybody look at a gentleman 'tattooed' that way, and not die laughing ?

Catholics who, like all the others, have fallen for the tinselled rubbish and the plaster statuettes sold in the Rue Bonaparte, will tell you there is no salvation outside the Catholic religion. Don't believe a word of it. Religion is everywhere. It is in the mind, in the heart, in the love you put into what you do.

Don't try to make a fortune, whatever you do. Because, as soon as you've made your fortune, you'll die of boredom.

I believe that I am nearer to God by being humble before this splendour (Nature) ; by accepting the role I have been given to play in life ; by honouring this majesty without self-interest, and, above all, without asking for anything, being confident that He who has created everything has forgotten nothing.

I believe, therefore, without seeking to understand. I don't wish to give any name, and especially I do not wish to give the name of God, to statues or to paintings. For He is above everything that is known. Everything that is made for this purpose is, in my humble opinion, *a fraud*.

The sick and the infirm ought to be fed, without having to beg, in a country like France.

Go and see what others have produced, but never copy anything except Nature. You would be trying to enter into a temperament that is not yours and nothing that you would do would have any character.

The greatest enemy of the worker and the industrial artist is certainly the machine.

The modern architect is, generally speaking, art's greatest enemy.

We are proud of the renown of our old masters, and the countless works of art this marvellous country has produced. But we must not behave like those nobles who owe their titles to their ancestors and spend their last sou to hear themselves addressed as ' Monsieur

le Baron ' by the waiters in cafés—which costs them twenty francs each time.

Since you love the Republic so much, why are there no statues of the Republic as beautiful as the Athenas of the Greeks ? Do you love the Republic less than the Greeks did their gods ?

There are people who imagine that one can re-do the Middle Ages and the Renaissance with impunity. One can only copy : that is the watchword. And after such folly has continued long enough, go back to the sources. You will see how far away we have got from them.

God, the King of artists, was clumsy.

Not only do I not wish to see one capital of a column exactly resemble another, I do not wish it to resemble itself ; or to be uniform any more than are the heads, feet and hands which God created. I do not wish a column to be perfectly round, any more than a tree is.

I say to young people, therefore : throw away your compasses, otherwise there is no Art.

Consider the great masters of the past. They were aware that there are two regularities : that of the eye and that of the compass. The great masters rejected the latter.

I propose to found a society. It is to be called ' The Society of Irregulars'. The members would have to know that a circle should never be round.

The principles set forth in these notes express eternal truths, and they are stated in simple, logical terms which everyone can understand. Where the dilemma arises is in knowing how to apply them. I was to learn from my father later on that in art, just as in politics, the fiercest opponents often agree on theories. It is only when it comes to putting principles into practice that a battle ensues. Here Renoir extols the teachings of the old masters, yet he advises against copying them. Only Nature should be copied. And that is Impressionism. But he was soon to return to the more humble attitude of his youth, that is : in order to absorb what the old masters

had to teach, one should copy them. In other words, he was torn
between two procedures : direct perception, on the one hand, and
tradition, on the other ; it was a question of method and not of
principle, to which was added the problem of working from Nature
as opposed to working in the studio. And that brings me finally to
the vexed question of how far the personality of the artist should
enter into his work.

These problems harassed my father just as they have always
troubled, and always will trouble, those who create. They ceased
to worry him, however, the moment he got back to his easel. Monet
compared him to a timid duellist, who forgets his fears as soon as
he faces his adversary, sword in hand.

Apropos of copying the work of other masters, I have in front
of me a little landscape of Corot's—done by Renoir. It is a delightful
piece, and for me it opens new horizons on the question of imitating
masters. The fact is that what can be discerned through the grey
trees and pale sky is really a ' portrait ' of Corot by his humble
admirer. For this charming exercise reaffirms the great truth which
my father was too modest to acknowledge in his notes, namely :
that a work of art is the candid, and often unconscious, expression
of the personality of the artist who created it. When, towards the
end of Renoir's life, my younger brother and I made some pottery
under his direction, he told us how mistaken the practitioners of
modern art were in trying to copy Nature before they had assimilated
it. He gave as example the awkward-looking entrances of the Paris
Métro, decorated with direct copies of the liana vine or flowers,
compared to Persian carpets, so magnificently stylized, or Delft ware
imitated from the Chinese. He reminded us that Cézanne had used
artificial flowers for his flower-piece paintings. He had to admit that
there is such a thing as genius : ' There are people, groups and
individuals, who have that little spark. And they communicate its
warmth to us, no matter what medium they use.' He remained
pensive for a moment, as he studied an Urbino platter hanging on
the wall. ' The trouble is,' he said finally, ' that, if the artist knows
he has genius, he's done for. The only salvation is to work like a
labourer, and not have delusions of grandeur.'

I could go on quoting indefinitely Renoir's statements confirming
his belief either in submitting to direct impressions, or respecting
classical rules and working in the studio. His assertions showed him
to be one minute an impenitent Impressionist, determined to follow

the same line as his friend Claude Monet; and the next, an intransigent classicist, a stubborn disciple of M. Ingres.

The project of organizing a ' Society of Irregulars ', to which he referred several times, nobly expresses the general principles of Renoir's credo. In practice, it represents the first tendency: that of Impressionism. The second tendency—the one in the direction of classicism—is stated, though with less conviction, in the preface which my father wrote towards the end of his life to Mottez's translation of Cennino Cennini's book.[1] After Renoir had returned from Italy, and had married and settled down to family life, the second tendency seems to have predominated in what he said and in his works. One thing is certain: during the most varied periods of his career, the outer world, together with the technical means towards which his tireless curiosity attracted him, played an enormous role in his creative process.

Renoir recognized that in the modern world work must be divided among specialists in each field; but he would not accept any such ruling for himself. If we have sore feet, we go to a chiropodist; if we have tooth-ache, we see a dentist about it; if we get depressed, we pour out our troubles to the psychoanalyst. In the factories one workman tightens the bolts, while another adjusts the carburettors; out in the country one farmer grows apples, and nothing but apples, and another plants wheat. The end-result is magnificent; millions of carburettors; tons of wheat; apples the size of melons. The nourishment destroyed in fruit and vegetables by increasing their size is made up for by the use of appropriate vitamins. And all goes well. People eat more, go to the cinema more, and get drunk more often. Life expectancy is longer; and women have the benefit of painless childbirth. The entire output of Renoir's work, so full of natural vitamins, is a cry of protest against this system: as his life was, also.

The world of Renoir is a single entity. The red of the poppy determines the pose of the young woman with the umbrella. The blue of the sky harmonizes with the sheepskin the young shepherd wears. His pictures are demonstrations of an over-all unity. The backgrounds are as important as the foregrounds. It is not just

[1] ' He wrote, *c.* 1390, the earliest technical treatise on painting, *Il Libro dell'Arte*, which is the source of most of our knowledge of early Tempera technique.' (From *A Dictionary of Art and Artists* by Peter and Linda Murray, Penguin Books.) (Trans.)

flowers, faces, mountains, which are put in juxtaposition to each other : it is an ensemble of elements which go to make one central theme, and they are bound together by a feeling of love which unites the differences between them. When one evokes Renoir, one always comes back to that vital point. In his world mind is liberated from matter, not by ignoring it but by penetrating it. The blossom of the linden-tree and the bee sipping the honey from it follow the same rhythm as the blood circulating under the skin of the young girl sitting on the grass. This is also the current in which the symbolic 'cork' is carried along. The world is one. The linden, the bees, the young girl, the light and Renoir are all part of the same thing, and of equal importance. And the same holds true of the seas, the cities, the eagle soaring above the mountains, the miner deep in the mine, Aline Charigot feeding her little son Pierre at her breast. In this compact whole each of our gestures, each of our thoughts, has its repercussions. A forest fire will bring on a flood. A tree transformed into paper, and then into words, can drive men to war : or awaken them to what is great and beautiful. Renoir believed in the Chinese legend that a mandarin can be killed at a distance by an unconsciously lethal gesture made in Paris.

I now come back to the question of his theories. These, together with his constant technical experiments, served him as a springboard. He would try to find a certain quality of red by experimenting with contrasts. Again, having temporarily rejected ivory black, he would indicate his shadows with cobalt blue. And this blue shadow would determine the composition of the whole picture, and even the subject. He would select this or that spot in the countryside because the shadow was blue there ; and it is the cobalt blue, and not the original inspiration of the work, that creates the message we get from the picture.

To help us to understand Renoir's creative process better, I must quote one of his cryptic remarks : ' I am not God the Father. He created the world, and I am content to copy it.' And to show that he did not mean copying in the literal sense of the word, he told us the classic story of the ancient Greek painter, Apelles. In a competition that took place on the Acropolis, a rival of the Athenian master had submitted a picture which seemed to surpass any of the other entries. The subject of the picture was grapes, which were so realistically depicted that the birds came and pecked at them. Then Apelles, with a knowing wink, as though to say ' Now you're going to see some-

thing!' presented his masterpiece. 'It is hidden behind this drapery.' The judges wanted to lift the drapery, but they could not —for it was the subject of the picture!

I only wish it were possible to give an idea of Renoir's laughter when he had finished the anecdote. The one that followed, about the shoemaker, he found less amusing. It concerned Apelles also, and ran something like this:

While the exhibition was going on, the master hid behind his picture in order to overhear what was being said about it. A shoemaker remarked that there was something wrong with the sandal on one of the figures in the painting. Apelles came out of hiding, thanked the shoemaker and corrected the error. The next day the fellow found the leg too thin. 'Cobbler,' said Apelles, 'stick to your last.'

Renoir added, in passing, that the Greeks probably did not know any other painting than mural art and that of decorating statues; and that such stories were purely literary inventions. He said, furthermore, that if the day ever came when a painter succeeded in giving an illusion of a forest which included the smell of damp moss and the murmur of a brook, painting would be finished for good and all. For, instead of buying the picture, the art-lover would go and walk in the woods.

My insistence on the importance of external circumstances in Renoir's painting applies to all great artists, including Picasso, Braque and Klee. It may seem to contradict what I had to say about Toulouse-Lautrec. But I maintain that the accident he had in his childhood played only a secondary role in his life, and perhaps none at all, when it came to the question of expressing himself. He was first and foremost motivated by the unusual personality of his models. And to their personality he of course added his own, to a fantastic degree. Then he started out again from his observations, closing the circle and indirectly asserting that the world is not a bourgeois apartment-house whose occupants pretend to ignore one another. Even if he had not had his accident, he would always have sought, and found, the type of models necessary to his art in the cafés of Toulouse or even in the Moulin Rouge in Paris, to which his destiny seemed to lead him more than did the need to forget his deformity. What I mean is that had he been deprived of the pathetic faces of the creatures he painted, he would have had a harder time finding himself.

More important than theories to my father was, in my opinion, his change from being a bachelor to being a married man. Always restless, unable to remain long in one place, jumping into a train with the vague notion of enjoying the misty light of Guernsey, or else immersing himself in the rose-coloured atmosphere of Algeria, he had, since leaving the Rue des Gravilliers, lost the meaning of the word home. And here he was, installed in an apartment with his wife, taking his meals at regular hours, his bed carefully made every day, and his socks mended for him. To all these benefits another was soon to be added in the form of his first-born child. The birth of my brother Pierre was to cause a definite revolution in Renoir's life. The theories aired at the Nouvelle Athènes were now made to seem unimportant by the dimples in a baby's bottom. As he eagerly sketched his son, in order to remain true to himself he concentrated on rendering the velvety flesh of the child ; and through this very submission, Renoir began to rebuild his inner world.

# 19

Renoir puffed thoughtfully at his cigarette and tried to find a less uncomfortable position for his pain-racked back. Then, feeling a little more at ease, he let himself lapse into a reverie, which I did not dare disturb. Suddenly, he turned to me and remarked:

'Durand-Ruel was a missionary. It is lucky for us that his religion was painting.' Fearing this might be too sweeping a statement, he qualified it. 'He had his moments of doubt, too. Every time I tried out something new, he was sorry I hadn't kept to my old style, which was safer and had already been accepted by the art-fanciers. But put yourself in his place. In 1885 he almost went under, and the rest of us with him.'

According to Renoir, Durand-Ruel's only fault was that he wanted a monopoly. ' He would have liked to get control of all the new painting. Mild-mannered people can be like that.' And he further observed that although Paul Durand-Ruel was a 'respectable middle-class man, a good husband, an ardent Royalist, and a practising Catholic, he was also a great gambler. Only he gambled for a good cause. His name will last. It's a pity there are no politicians like him. He would make an ideal President. And why not a King of France ? Although, in view of his austere life, his court might be rather dull.' He compared him to Clemenceau, ' who is a very strong character, but always a politician, and a great believer in words.'

A friend had told him the story of Roland Garros, the remarkable pilot who invented the method of firing a machine-gun through the propeller of a war-plane. He was brought down by the Germans in the First World War, and though taken prisoner, had succeeded in escaping. As an officer he was well known for his success in training young pilots. ' In Germany they would have put him in charge of a training school for aviators. But Clemenceau, who could

not resist making a fine phrase, said to Garros : " You are a hero. I grant you permission to return to the Front." ' The hero returned to battle and was brought down again, this time for good—and buried with full military honours, an event played up by the news-papers specializing in spectacular patriotism. ' Durand-Ruel would never have paid Monet or me any such compliment. It suited him better to see us turning out pictures than to read panegyrics about us in the papers—even if our death would have caused the pictures we had already sold him to go up in price.'

Great periods of art produce not only great artists but great collectors ; and, ever since tradespeople outwitted the ruling classes, great merchants as well. The last quarter of the nineteenth century in France, which ranks with the Italian Renaissance, owed its extraordinary flowering in art to the fact that it produced a Choquet and a Cézanne, a Caillebotte and a Renoir, all at the same time. It was, moreover, indebted to the remarkable foresight of such men as Durand-Ruel and subsequently Vollard and the Bernheims. Durand-Ruel, I should mention, had the travel habit, and his record in that respect was beaten only by Renoir. The slightest excuse sent him dashing off to London, Brussels or Germany, going wherever he hoped he might be able to stir up interest in the painting which he so passionately admired and to whose ultimate triumph he devoted his life and money.

My father often talked to me about the trip Durand-Ruel took to New York. The exhibition which the distinguished art-dealer put on there marked the turning-point in the lives of the Im-pressionists. ' We perhaps owe it to the Americans that we did not die of hunger.' There were two exhibitions in the same year, 1885, or as my father sometimes said, 1886 : one at the Georges Petit Gallery in Paris, and the other in New York. The two shows were made up of pictures by the same group of artists, namely Manet, Monet, Renoir, Pissarro, Sisley, Mary Cassatt, Berthe Morisot and Seurat. Lionello Venturi, the distinguished Italian art expert, main-tained that the exhibition was held at the American Art Association. But my father was sure that it was in the old Madison Square Garden, the original one in Madison Square. He was always amused by the thought of it : ' People would go and look at my pictures between boxing-matches.' He also remarked : ' Either we French are an élite, or else we are an inert mass and afraid of the slightest novelty. The American public is probably no more alert than the

French, but it doesn't think it necessary to sneer at things it doesn't understand.' Renoir would try to imagine the pretty young blonde American girls with bright complexions and sturdy legs wearing sensible shoes that don't ruin the feet—' the kind of girls I like to paint.' And he would give an imitation of what he supposed was their American accent as they exclaimed over the pictures they saw : ' Ow ! what a cute little red ! Ow ! what a dear little green ! ' He believed that Mary Cassatt had been indirectly responsible for the exhibition. He liked her very much, though as a rule he did not care much for women painters—' except Berthe Morisot, so feminine she would make Raphael's " Virgin with the Rabbit " jealous '. On one of his painting-trips he had met Mary Cassatt in Brittany. ' She carried her easel like a man.' One day she said to him, stressing her r's as she spoke :

' I adore the brown tones in your shadows. Tell me how you do it.'

' The way you pronounce your r's,' he replied.

I recall his speaking a number of times of how the letter ' r ' sounded in English : ' The rays of the sun must have something to do with it. In Italy and Toulouse people roll their r's like a drum. In Paris it is less noticeable. Then you cross the Channel, and, as you stand shivering in Turner's fog, suddenly the r's disappear.'

I reminded him that the young people called the ' Incroyables '[1] had affected a Negro accent, and made a point of dropping their r's, as in Charles Lecoq's operetta *Mademoiselle Angot*. 'Il faut avoi' Pé-uque blonde et collet noi' ! '

' Well, that just shows you that all theories are false,' declared Renoir.

He and Mary Cassatt were staying at the same inn, and in the evening they would discuss various technical problems over a pitcher of cider. Once she said to him :

' There is one thing against your work : your technique is too simple. The public doesn't like that.'

Her remark rather flattered him. I can see him sniffing a bit, rubbing the end of his nose and nervously fingering the lapel of his coat, as he smiled maliciously at Mary Cassatt.

' Don't worry,' he said. ' Complicated theories can always be thought up *afterwards*.'

[1] Name given at the time of the Directoire to a group of young conspirators who affected an exaggerated style of dress.

# Renoir, My Father

There was one incident (perhaps apocryphal) which Renoir particularly enjoyed recounting. It concerned the method by which 'père Durand' succeeded in calming the suspicions of the Customs authorities on his arrival in America. Durand-Ruel feared that some of the inspectors might be shocked by Renoir's nudes, and he tried to think up some argument that would convince them that pictures of naked young girls were art and not pornography. It was a delicate matter because of the difficulty of deciding where the dividing-line lies. My father would naturally hold that what is beautiful is pure, and what is ugly, immoral: that Botticelli's ' Venus ' is moral, whereas, despite the armour-like clothing on the female figures he painted, Winterhalter's portraits are pornographic. In other words, it all depends on the spirit within the body, whether they are clean or foul, debasing or inspiring.

But Renoir was not in New York to help the art-dealer in pleading his cause. Luckily Durand-Ruel thought of an excellent scheme. Having learned that the chief official of the Customs service was a Roman Catholic, he called on that august gentleman on a Sunday morning, attended Mass with him, and ostentatiously put a large sum of money in the collection-plate. The next day his pictures were allowed in without a hitch.

Meanwhile the exhibition at the Georges Petit Gallery in Paris proved to be a new setback to the Impressionists. Although the hostility originally shown them had died down, it now flared up again more virulently than ever. Renoir's theory was that this new wave of hatred had to do with a widespread vindictive spirit left over from the 1870 defeat. Everyone was stirred up over the political intrigue centred around General Boulanger. Mlle Amiati, the star at La Scala and the Eldorado, made a tremendous hit, singing ' Boulanger, the Schoolmaster in Alsace ', draped in a tricoloured peplum. Mounet Sully declaimed ' The General's Dream ' to frenzied crowds. Déroulède was looked upon as the national bard. Youngsters went about chanting the song:

> L'air est pur, la route est large,
> Le clairon sonne la charge,
> Les zouaves vont chantant ;
> Et là-haut sur la colline
> Dans la forêt qui domine,
> Le prussien les attend.

# Renoir, My Father

By an intricate process of reasoning, everything not obviously in the French patriotic tradition was automatically suspect. It followed, then, that all these Impressionists, who painted so very differently from the Salon artists, and who dared to portray flowers, rivers, and young girls reclining, instead of depicting the charge of the Cuirassiers or ladies with tense faces dressed in Greek tunics and waving flags, were surely secret agents of some foreign country—perhaps even Germans in disguise. Fortunately anti-Semitism had not yet become rampant, otherwise the antagonism towards the new group would have increased; for Pissarro, a Jew, was one of its members, and Renoir was a friend of Catulle Mendès, the writer, and of Cahen d'Anvers, whose portrait he had painted. 'The odd thing is that those paintings of heroic subjects in the Salon had nothing to do with French artistic tradition. What connection is there between Meissonier and Clouet or between Cormon[1] and Watteau?'

In politics, Renoir's friends probably had certain leanings, though differing among themselves, but they were all too busy with their painting to take much interest in them. Manet was the perfect type of middle-class Liberal. Pissarro was for the Commune. Degas would have been a Royalist if he had had the time for it. Renoir liked human beings too much not to approve of all parties whatever their colour. He liked the Commune because of Courbet's association with it; and the Catholic Church because of Pope Julius II and Raphael.

While on the subject of politics, I should like to say a word about the Dreyfus Affair. Almost everyone knows, of course, how once more all France was divided when the Jewish artillery captain was unjustly convicted on a charge of espionage. 'Always the same camps,' said Renoir, 'but with different names for each century. Protestants against Catholics, Republicans against Royalists, Communards against the Versailles faction. The old quarrel has been revived again. People are either pro- or anti-Dreyfus. I would like to try to be simply a Frenchman. And that is the reason I am for Watteau and against Monsieur Bouguereau.' At present the division is on a world-wide scale: and the abscess will have to be lanced sooner or later. One or other of the two doctors in charge of the

[1] 1845-1924. Academic French painter; received the Grande Médaille d'Honneur.

operation is going to insist on his method of treatment. In the meantime it is to be hoped that the patient will survive.

Renoir knew how grave the question was, but he also realized that when the hour for settling it struck the answer would not be long in coming. He feared the answer might take the form of anti-Semitism among the lower middle class. He could envisage armies of grocers and similar tradesmen, wearing hoods and treating the Jews the way the Ku-Klux-Klan treated the Negroes. His advice was to stay quiet and wait for the ferment to pass. ' That fool of a Déroulède did a great deal of harm.' Pissarro was all for taking some sort of action ; Degas wanted action too, but of an opposite kind. Renoir admired both men enormously, and he had real affection for Pissarro. He did his best to avoid embroiling himself with either, though in the case of Degas, he ' just missed it by a hair's breadth ' when Degas asked him in astonishment, ' How can you stand associating with that Jew ? '

Dropping in at Renoir's studio one day, Degas had complimented him on a little landscape he had done of the seventeenth-century waterworks at Marly. My father made him a present of it, and in return Degas gave him a pastel drawing of some horses. About the same time Pissarro asked my father to join him and Guillaumin and Gauguin in a small exhibition they were putting on. When Degas heard of it he asked Renoir anxiously: ' Surely you're not going to do a thing like that, are you ? '

' Who ? Me ? ' Renoir replied, wanting to lead on Degas a bit. ' Me exhibit with a gang of Jews and Socialists ? You must be mad ! '

But Degas's feelings were hurt, and next day he returned Renoir's picture by special messenger. Renoir tipped the man and sent him back with ' the horses '. As it turned out, he did not take part in the proposed exhibition. The real reason for his decision was that he could not bear Gauguin's painting. ' His Breton women look too anæmic.'

While we are on the subject of politics, Renoir was sharply critical of the Western countries for their hypocrisy towards certain customs. He argued, for instance, that one should accept the caste-system of the Hindus, which they had practised for four thousand years. At any rate it satisfies the petty vanity of most individuals, because there is always a class below theirs, and the weak are protected by strict rules controlling their occupations. It might be

called an hereditary trade union, which has its advantages after all. Otherwise there is the alternative of being a Christian and a believer in democracy. All men are born equal. If that is so, then the Negro should not be made to stoke a ship's boilers while the white man takes his ease in well-cushioned chairs in de luxe accommodation above.

He was also much concerned about the validity of the income tax. His friend, Georges Rivière, had helped the Finance Minister, Caillaux, to draw up the plan for it. He tried to prove to my father that it was more fair to be taxed in proportion to one's salary or income than to pay on the number of windows in one's home.

'The man who likes air, and large windows in his house, is the one who gets hurt,' said Rivière.

'I'd rather be hurt than spied on,' answered Renoir.

Another of his antipathies was the records kept by the police. He was exasperated by the thought that the secret police could keep track of one's activities. 'It's the end of all liberty,' he declared. 'It makes it impossible for a murderer ever to reform, because he has permanently been marked as a murderer.' He thought that punishment should help to wipe out the crime, 'for how do we know what a crime is?' He believed in natural justice, and punishment 'by boomerang'. It seemed to him that 'hell begins on earth, long before we die.' He was against capital punishment, and a firm believer in flogging. The celebrated phrase 'Do away with killing as a punishment; let murderers take the lead by doing away with killing,' seemed to him idiotic. 'The guillotine won't bring back the victim to life; whereas a good flogging doesn't kill, and it makes a man reflect.'

During the First World War he proposed some astonishingly simple suggestions for settling the conflict: 'Do away with firearms, and replace them with bags of pepper. You throw the pepper in the enemy's eyes. It hurts like the devil, but it isn't dangerous. And it costs the tax-payers less than heavy artillery. It would put an end to the fighting because the combatants would be too busy rubbing their eyes.' He also suggested abolishing aeroplanes and using Montgolfier balloons, as now the material could be made fireproof and they would therefore be absolutely safe to use.

You never knew whether he was serious or only joking. Probably it was a bit of both. He was not arbitrary about his sentiments any more than he was about his painting.

# Renoir, My Father

Not long before his death my father said to me:

'What you will inherit from me you can feel free to accept without reserve. I have never earned a penny by anyone else's labour. I have never owned shares in a factory. I have never, even indirectly, been responsible for sending a miner to his death by explosion hundreds of feet underground.'

The Stock Exchange seemed to him nothing less than monstrous. In the Middle Ages the Church excommunicated all who lent money at interest, as well as those who borrowed at interest. 'The bankers used to go to hell. Now they go to heaven, with pretty little wings and a halo over their heads.' He felt that by sanctioning usury the Church had started the world down the road to vulgarity. 'It is the transition from the Romanesque to the Gothic and then to the Flamboyant, which is charming but has something of the whore about it.'

I now return to the financial situation of the group of young painters. The failure of the exhibition at the Georges Petit Gallery was a bitter pill for Renoir and his friends to swallow. They were no longer young. Setbacks are easily forgotten when you are just starting out. But when after twenty years of effort and privation you have not been able to win over the public which you believed was the supreme judge of your work, you have the right to ask if it would not be better to give up. 'And yet what could I have done? I know how to do only one thing, and that is to paint.' In spite of his discouragement, Renoir was never far from his easel. 'I have never let a day go by without painting—or drawing, at any rate. You've got to keep your hand in.' He was not one to succumb to romantic despair, or to withdraw from a world unable to appreciate 'great art'. 'I went my simple way. Besides, what else can you do in life? And I was carried along by an irresistible force. You remember the "cork"? Even so, as you grow older you know too much about things, and it is difficult to sense the direction of the current. Your mother helped me, though, without saying anything. She wasn't interested in theories.'

His lovely blonde wife, whose skin was as delicate as that of a duchess, had the Burgundians' taste for fine wines and equally fine cooking, yet if she had to she could live on a crust of bread. And she could put her house in order 'between sittings, without my even noticing it!' She was discreet about the housework, which she knew annoyed her husband. As soon as he had left the house and

turned the corner of the Place Pigalle, on his way to see if things were improving at Durand-Ruel's, all the windows in the apartment flew open and the cleaning began. In two minutes the sheets were put out to air and the linen hung on a line in the kitchen. By the time he got back he found his wife busy with her preparations for the midday meal : and that was a task he approved of. Feeding human beings is a worthy occupation : sweeping up the dust is bad for the lungs. He would sit down beside her and help her to scrape the carrots. She felt happy then and started a little song—though a bit off-key, as she told me afterwards. Then he would put down his knife, take out his pad and pencil, and start sketching her.

Before concluding these details—much too brief, unfortunately —relating to the period just before my arrival on the scene, I must return to Durand-Ruel's exhibition in New York. The fact that several of Renoir's works were sold, among them ' The Boatmen's Luncheon ', now in Washington, proved to be of greater value to him than the money actually received, for it restored his self-confidence, then at a low ebb. ' It gave me the feeling that I had crossed the frontier.' He had no need of that as an incentive to continue. Yet this unhoped-for success gave him an added impetus and relaxed his mind. ' I can't paint if it doesn't amuse me. And how can you be amused when you're wondering if what you're doing is making people grind their teeth ? ' This success was to enable my mother to surround her husband with an atmosphere of calm, which she had long ago decided to make her aim in life.

No matter how many cordial friendships they formed, or how insistent the many invitations they received, she never had the slightest desire to become a society-woman. For this she deserved great praise. Her youthful gaiety had given her a fondness for social festivities. I have already told how much she liked to dance with the young oarsmen on the terrace at Bougival. But she knew that her husband needed rest, and that he loved the early morning light.

I trust that no one will think that my mother was a martinet, organizing everything for the sole purpose of increasing her husband's output. She would have been quite happy if he had done no work at all ; all the happier, perhaps, because then she would have had him completely to herself. But as the happiness of the man she loved depended on painting, she saw to it that he was allowed to paint in peace. And by dint of looking at it continually, she learned

to love and understand his painting. She expressed her feeling about a picture in a few simple words. And she carefully avoided 'playing the artist's wife'. She wished to remain what she was, the daughter of wine-growers, expert at wringing a chicken's neck or wiping a child's behind or pruning grape-vines. When my brother and I were young, she used to take us to Essoyes for the vintage season. We both had proper harvesting baskets, which we carried on our backs, like the men, and filled with bunches of grapes, cut with our own pruning-hooks. We would empty our loads into the tub, then watch the different processes of pressing, and finally taste the sweet juice of the grape before it was poured into the big vat for fermentation. The juice acted as such a strong laxative that we soon had to run behind the bushes for relief, much to the benefit of our health. The Charigot family no longer owned a vineyard, so we would go to some cousin's place to help with the grape-gathering. Such associations, together with her 'catlike' face, are what Renoir had found especially pleasing about Aline Charigot. And his slender figure, his restless energy, the affection he radiated, and his painting, in turn appealed to her. It was an excellent marriage.

I have already told how my mother decided to give up playing the piano after hearing Chabrier perform. When she and Renoir gave intimate little dinners, among those invited from time to time were such brilliant talkers as Lestringuez, Mallarmé, Théodore de Wyzeva, Zola, Alphonse Daudet, Catulle Mendès, Odilon Redon, Claude Monet, Verlaine, Rimbaud, Villiers de l'Isle Adam, Franz Jourdain and Edmond Renoir. Amidst the scintillating conversation she was inclined to keep silent. As her knowledge of vineyards was not in keeping with the witty paradoxes of her guests, she felt that her talents showed to better advantage in the food she served. Cooking-lessons had now taken the place of piano-lessons. Her teachers in this matter were first of all her mother-in-law, Marguerite Merlet, whom she visited at Louveciennes whenever she had the time, and then, no less a person than Renoir! Afterwards, always seconded by her husband, she was to draw on other sources of culinary information. My father's interest in gourmandizing was all the more surprising because he himself ate so little.

It was not long before Mme Renoir's dinners became notable affairs. Even to this day her bouillabaisse is still recalled among close friends of the family, including the Cézannes and the descendants of the Manet-Morisots. Whenever money was scarce, chicken sauté

with mushrooms was replaced with a simple pot-au-feu. No matter how hard times were, somehow my mother always managed to receive her husband's friends magnificently.

By confining her activities to what she knew best, she won the admiration and respect of all who met her. Her cheerfulness and proficiency in domestic matters made her a great lady. Degas, whose critical eye spared no one, held her in the greatest esteem. Once during the opening of an exhibition at Durand-Ruel's he glanced at the simple little dress my mother was wearing, and comparing it with the elaborate attire of the other women present, said to my father, ' Your wife looks like a queen surrounded by mountebanks.' And commenting on her quiet voice, which contrasted noticeably with the noisy chatter of the others, he added : ' What frightens me more than anything else in the world is taking tea in a fashionable tea-room. You would think you were in a hen-house. Why must women take all that trouble to look so ugly and be so vulgar?'

Renoir did not reply. We may remember that he had a preference for ' hands that can do things '. Yet he liked women and people in general far too much not to want to see the best side of them first, and then laugh at their faults and absurdities. Certain men are good because they are stupid. My father was good because he was intuitive. Degas also was intuitive. Perhaps beneath his bristling porcupine attitude there was a streak of real kindness. His black frock-coat, well-starched collar, and top-hat, concealed the most fundamentally revolutionary artist among the young painters.

I am not sure whether it was at this same exhibition that Renoir overheard a conversation between Degas and Forain.[1] The latter was quite proud of being one of the first people in Paris to own a telephone.

Degas : ' Does it work well ? '

Forain : ' Very well. You turn a little handle, and a bell rings at the other end of the wire in the apartment of the person you are calling. When he unhooks the earphone, you talk just as easily as if you were in the same room.'

After reflecting a moment, Degas asked : ' And does it work just as well the other way round ? The other person can also turn a little handle and ring you up ? '

[1] Jean Louis Forain (1852-1931). French painter, etcher and lithographer ; known for his savage political cartoons and social satires. (Trans.)

' Of course,' replied Forain, beaming.

' And when the bell rings, you get up and answer it ? '

' Why, yes. Certainly.'

' Just like a servant,' concluded Degas.

What surprised my father was that Forain, the great caricaturist, a man of wit and talent, had actually been taken in without having the faintest suspicion of what Degas was driving at.

I should like to mention one of my parents' singular habits, which my mother told me about. They used to like to go to the theatre from time to time. And just as is done today, they would ask a young girl who lived near by to come in and look after little Pierre. She was a reliable girl and they had complete confidence in her. Nevertheless, when they went to the theatre they would leave during the intervals, jump into a cab and drive back home for a few minutes to see if the baby was still asleep. It was not senti-mentality on their part, it was just that they were apprehensive. ' There might be a fire,' Renoir said, ' or I might have forgotten to turn off the gas.' Later, when I was born, they did just the same, though Gabrielle was there to look after me.

In talking to me of the time when he lived in the Rue Houdon, my father happened to mention Van Gogh's death. ' Not a very flattering event. Even old Durand was not aware of what Van Gogh's painting meant.' This indifference towards a man who was obviously a genius was in his view a condemnation of ' this whole century of babbling idiots '. I asked if he believed that Van Gogh had been insane. He replied that to be a painter you had to be a little mad. ' If Van Gogh was mad, then I am too. And as for Cézanne, he would be a strait-jacket case.' And he added : ' Pope Julius the Second must have been insane. That's why he understood painting so well.'

The godfather Renoir had chosen for my brother Pierre was one of the most devoted of Renoir's many friends. Gustave Caillebotte belonged to a family of bankers. His brother Martial had followed his father's profession, but Gustave wanted to be a painter. And he painted with as much passion as any member of the Impressionist group. He and my father had first become acquainted in 1874. He had exhibited his pictures along with Renoir, and had had his share of the criticisms and insults. The canvas he had shown in the Durand-Ruel exhibition of 1876 depicted a group of house-painters, executed in very realistic style. Renoir praised it, and Caillebotte,

being an exceedingly modest man, had blushed. He was only too well aware of his limitations. ' I try to paint honestly, hoping that some day my work will be good enough to hang in the ante-chamber of the living-room where the Renoirs and Cézannes are hung.'

His wife Charlotte was equally fond of painting. Perhaps that drew her to my mother, for whom she had real affection. When calling on my mother one day she said : ' I know you have some-thing better to do than to gossip with me, and I can't help you iron Pierre's baby-clothes—I would burn them if I did.' She amused my mother by the languid way in which she voiced her disappointments in a tone of comic resignation. ' We had very poor seats for the opening of *The Power of Darkness*. Fortunately the play bored us to death.' She told all her friends about the Renoirs' bouillabaisse. ' I have a chef who used to cook for the Prince of Wales. He knows every cookery book by heart. Madame Renoir gives a few vague directions to her husband's model, who keeps an eye on the kitchen between sittings. And what happens ? My bouillabaisse is uneatable and hers is marvellous.'

Caillebotte had gathered the most important collection of his friends' works. His enthusiastic purchases were often made just in the nick of time for those who benefited by them. How many artists in financial straits at the end of the month were saved by his generosity and far-sightedness ! ' He had his own little plan. . . . He was a sort of Joan of Arc of painting.'

Caillebotte died in 1894, after making Renoir the executor of his will. The resulting negotiations proved very complicated, for he had left his collection to the Louvre in the hope that the Govern-ment would not dare to refuse it and that in this way the official ostracism from which the modern French School still suffered would be finally overcome. That was the ' little plan ' Renoir referred to.

In carrying out his legal duties, my father had first of all to deal with a certain Monsieur R., who was a high official of the Beaux-Arts. 'A good sort, but very annoyed at having to make a decision.' The gentleman paced up and down in his office in the Louvre, while Renoir examined the sculptured doors and took the liberty of running his hand over the moulding, remarking aloud, 'A beauti-ful door ! ' But Monsieur R., in a plaintive voice, asked him point-blank :

'Why the devil did your friend decide to send us his white elephant? Try and put yourself in our place. If we accept it we shall have the entire Institute after us. If we refuse we shall have all the people in the new movement down on us. Please do not misunderstand me, Monsieur Renoir. I am not against modern painting. I believe in progress. I am even a Socialist, and you know what that means. . . .'

Renoir asked him politely to drop theories and to get down to facts by taking a look at the pictures. With the exception of two or three, Monsieur R. had to acknowledge that the Manets and Degas seemed acceptable. And he consented to take the 'Moulin de la Galette' because it represented the working class. 'I like the working class,' he said. But as soon as he came to the Cézannes he began to wring his hands. 'Don't try to tell me that Cézanne is a painter!' he protested. 'He has money, his father was a banker: and he took up painting as a pastime. I should not be surprised if he did his painting just to make game of us.'

Everyone knows the sequel. At least two-thirds of this unique collection, one of the greatest in the world, was turned down. The remaining third did not get past the doors of the Louvre but was stored away in the Luxembourg Museum. On the death of Charlotte Caillebotte, those works which had been rejected went to various heirs, who got rid of them as quickly as possible. Scorned by France, they were well received in foreign countries. A good many were bought in the United States. I tell this story to any French friend who accuses Americans of having emptied France of its masterpieces by means of the almighty dollar.

One day in 1889, passing through the Rue Houdon, Dr Gachet took it into his head to stop and see the Renoirs. My father was down in Aix at the time, visiting Cézanne and painting a 'Mont Sainte Victoire' of his own. Dr Gachet found little Pierre looking a trifle pale, and attributed this to the city air. He invited my mother to bring the child to Auvers, where he always enjoyed himself, but she declined because of the river there. 'If Renoir knew his son was near the Oise and wasn't there to keep an eye on him, he wouldn't sleep a wink.' Gachet left, but told her his invitation still held, should she decide to change her mind.

The next day my mother went to see Mme Camille's daughter, who had married the owner of the shoe-store in the Rue Lepic, just off the Place du Tertre. Her friends had spoken to her recently of a

little vacant house in a part of Montmartre which was still almost 'like the country'. When Renoir was informed of it he returned to Paris, and decided that it was an excellent idea. And so it happened that my family moved to the ' Château des Brouillards ' at number 13 Rue Girardon.

# 20

It is no great distance from the Rue Houdon to the Rue Girardon. You go through the Place des Abbesses, turn to the right, climb the stone steps of the Rue Ravignan, go down the Rue Norvins until you come to the Moulin de la Galette, then turn to the right again. At the far end of the Rue Girardon, just before reaching the stairs, you come to the Château des Brouillards.

This part of the Butte slopes gently for some distance and then drops sharply. There were no stairs there when I was small. A path went down as far as the Place de la Fontaine du But, and on rainy days you ran the risk of descending it on your behind. Grown people went round by the Rue des Saules, at the foot of which, just below the place where the Lapin Agile now stands, there were moderately easy steps. The Place de la Fontaine du But is now known as the Place Constantin Pecqueur. 'An odd idea' would be my father's comment.

The Château des Brouillards was at the end of the Rue Girardon, poised uneasily on the soft loamy soil of the plateau. On the north side, at the base of the bluff, the Caulaincourt section began. Not yet having been taken over by artists and bistrots, it was the exclusive domain of working-people from the Saint-Ouen district. But building companies already had their eye on it, and were just waiting for a chance to obtain possession.

A hedge surrounded the property, which was composed of several buildings and a fine garden. Once you entered the wrought-iron gate you found yourself in a lane too narrow for a carriage to pass. To the left were some out-buildings—all that remained of an eighteenth-century mansion, a 'Folly', as they called it then. One side of these low dwellings was occupied by Mme Brébant, an old lady who looked like a character out of one of Perrault's fairy-tales. Her son, who lived with her, had built a partition in the middle of

the house to get away from her tyranny. As the wing they in-
habited had only one door, which Mme Brébant had reserved for
herself, he went in and out by a window. The owners of the place,
M. and Mme Guérard, lived in the other wing, but had an entrance
in the Rue Girardon. The group of buildings was surrounded by
fine trees growing in what had once been a private park. The
Folly itself had been destroyed during the Revolution. Its site was
overgrown with rank vegetation, and its stones had probably been
taken to build the mean dwellings in the neighbourhood. Near the
entrance were the concierge's quarters, and just outside, the old
pump where we used to get our water. On the right of the pathway
there was a long rectangular building divided into several dwellings.
It looked out over the whole Caulaincourt section. Just why this
odd conglomeration, perched high above the Paris mist, was called
the Château des Brouillards, no one seems to know. There are many
possible explanations, but the most convincing is simply that the title
is meant to be ironic, since the 'castle' has nothing castellated about
it. Whatever the explanation, the inhabitants, enclosed within the
high hedge and enjoying a certain privacy behind the fences of their
own small gardens, dwelt in a world apart, concealing endless fantasy
under a provincial exterior. This Folly, of which not a scrap of wall
was left, excited their imagination. Some people liked to think that
the ghosts of the old rakes, in white wigs, and their mistresses
wearing heavy satin dresses, still haunted the woody grove which
had once been the scene of their gallantries. Such notions gave these
middle-class bohemians of the nineteenth century a vague feeling of
differing socially in their manners and morals from other Parisians.
How could one expect people who lived in a place which evoked
Watteau's 'Embarkation for the Island of Cythera' to lead the
same life as the dairyman on the corner of the Rue Lepic!

All along our fence there were rose-bushes which had reverted
to their wild state. Just beyond was an orchard belonging to old
Griès, one of the last market-gardeners on the heights of Mont-
martre. I can still taste his pears—small round ones, very hard and
tangy in flavour, not like those sold on the fruit-stands. They had
the effect of an astringent on the tongue. I remember my mother
and Gabrielle saying that the pear tree must have been grafted
on to a quince.

Our house, the last in the rectangular block, had an attic
window on the west side, and from it you could see Mont Valérien,

the hills of Meudon, Argenteuil and Saint-Cloud, and the plain of Gennevilliers. The plain of Saint-Denis was visible from the window on the north, as well as the woods at Montmorency. On clear days you could even make out the basilica of Saint-Denis in the distance. You felt you were right up in the sky. On the south side, not far from the houses of the owners, the Brébants and the concierge, was a rose-garden belonging to a mysterious character whom we could glimpse vaguely through the foliage, digging away, and fertilizing and pruning his trees. There was also a field where cows were grazing. Gabrielle would take me to buy milk in the little house on the edge of it. I was very much afraid of those cows. Farther on, the wooden sails of the Moulin de la Galette stood out stiffly against the sky.

For most Parisians this little paradise of lilacs and roses seemed like the end of the world. Cab-drivers refused to drive up the hill, stopping their cabs either at the Place de la Fontaine du But, where you had to climb the slope to reach the house, or else at the Rue des Abbesses, on the other side of the Butte where it crosses the Rue Lepic, a spot still jammed with swarms of street hawkers crying their wares and blocking the way with their carts. For this last approach you had to take a short-cut via the Rue Tholozé, which climbs steeply in a series of steps coming out on the upper part of the Rue Lepic, just near the entrance of the Moulin de la Galette. The difficulty in getting to the place was largely compensated for by the low rents, the fresh air, the cows, the lilacs and the roses.

Our attic had a partition, which Renoir got permission to remove so that he could turn the space into a studio. For his large compositions, like ' The Bathers ', which he did for Dr Blanche, he rented a studio in the Rue Tourlaque which had been recommended to him by the Italian painter Zandomeneghi, whose acquaintance he had first made back in the Nouvelle Athènes days. My father was very fond of this thick-set musketeer, who was slightly deformed. He was the best company in the world so long as his national pride was not hurt. At the slightest provocation he would stand on the tips of his tiny toes and pronounce with his rolling r's, ' We want control of the Mediter-r-r-ranean ! ' My father would conciliate him by replying, ' I am perfectly willing to give it to you.' In return for this sincere and not too costly concession Zandomeneghi again became the most amiable and obliging of neighbours.

Renoir's two studios were heated by coal-burning stoves, and

the rooms in the apartment by fireplaces. To avoid dying of cold, we had to keep the fires going all winter. One day when Guérard, the young son of the owner of the place, paid him a visit, my father thought he would amuse him by imitating with his cane the gestures of a swordsman. He lunged at the wall, and to the astonishment of them both, the cane went through right up to the knob. They looked outside and discovered that it was projecting beyond the wall like a bar to hang a sign on. ' Humph ! ' said the young man philosophically, ' we can fix that up with several layers of wall-paper.'

It would be wrong to suppose that after his marriage Renoir confined himself entirely to family life. The difference was that instead of being at home everywhere and nowhere he now had a place he was attached to, and that place was wherever my mother happened to be. From now on he was going to leave this haven only for temporary absences : just as birds leave the nest in quest of insects, only to return to its comfort as quickly as possible. The thought of holding his wife in his arms, of breathing in the scent of her young body, and of making love with her, brought him back home. It may be said that towards the end of his life he had reached a point where he discovered the whole world within the radius of his immediate surroundings. Before I was born his field of activities still covered a vast territory. Its capital was the Château des Brouillards, but it took in all of Fragonard's Provence and the Nice region, the Burgundy of Essoyes, the little ports of Brittany, the Normandy of the mussel-gatherers, and the Saintonge. Renoir hurried to paint the port of La Rochelle because Corot had painted it —not to imitate Corot, but to share in the secret which the fortified towers there had disclosed to the old master. He would jump from Cézanne's ' Jas de Bouffan ' in Provence to Mézy with Berthe Morisot, travel about Spain with Gallimard, spend the winter in Beaulieu, in the Midi, and the summer in Pont-Aven, in Brittany. My mother would travel with him if she felt it would not tire little Pierre too much. She refused flatly to accompany him to Spain. His visit there was, in fact, rather short, because ' when you have seen Velasquez, you lose all desire to paint. You realize that everything has already been said.'

As my mother disliked staying in hotels, she usually rented a little house, which was immediately transformed into a ' Renoir domain '. My parents had the gift of making a home for themselves wherever they went, by adopting the oddest kind of lodgings—

'provided they are peasants' houses.' The mere sight of rosewood furniture and bourgeois bric-à-brac would have kept Renoir from painting. The friends who visited them in Brittany, in Provence, or at the farm in Normandy which Oscar Wilde occupied in the winter, had the feeling that the Renoirs had always lived in those places. It derived from a few simple items here and there, such as a vase my mother had picked up for two sous at the market, a bit of bright-coloured calico fastened to the window, and especially the pictures, which very soon were piling up everywhere in the house— without frames, of course, as Renoir would tolerate only old frames carved in hard wood, ' which showed the hand of the craftsman '. Renoir's taste in frames, as indeed in everything, surprised people who prided themselves on having ' good taste '. That expression annoyed him, and by way of defiance he would proclaim that he had ' bad taste '. Bright colours are accepted nowadays in women's clothes, thanks in part perhaps to Renoir, but in his day it was only country people who wore them—genteel people dressed in sober colours. The same attitude applied to picture-frames and antique furniture—they were admired for their quality, but their colour, and the golds especially, had to be faded. My father pointed out that the frames had been new originally, and that they were therefore meant to shine ' like gold '. Several times he treated himself to having a favourite frame re-gilded with gold leaf. For instance, the frame for the portrait he did of me as a hunter : re-gilded fifty years ago, it still shocks people of ' good taste '. It is an Italian frame of the late seventeenth century. Renoir chose it himself in an antique shop in Nice. He felt that a massive frame was necessary to set off the picture properly, ' especially in a drawing-room in the Midi, where there is so much else to tempt the eye.'

I have mentioned Oscar Wilde. Later on, when I was at secondary school, my father told me I had slept during the summer in the same bed that Wilde had slept in during the winter. ' It's just as well it wasn't in the same season ! ' I didn't understand the remark, and asked him what he meant—and that is how I learned about homosexuality. He mentioned a number of famous examples—Henri III, the last of the Valois and certainly a remarkable man, Socrates, Julius Caesar, Verlaine, Rimbaud. ' They are supposed to have either amazingly good taste or an incredibly debased character. The truth is that they are often very unhappy, and the hostility of the world can drive them to achieving great things in literature or

politics.' He could not imagine a painter being a pederast. ' In painting there is an element of workmanship that doesn't go with pederasty, which is really more of a bourgeois pastime.' Lestringuez told him about a police raid near the Place de la Bastille, in which a group of young workmen perverts had been nabbed. Renoir was astonished, but he soon found an explanation. ' It's all Pasteur's fault. With his vaccine, and all the children who have been saved by it, this planet is getting dangerously over-populated. Perhaps God has sent us pederasty to keep things in balance.'

To go back to his travels, I should like to relate another little story. Renoir was painting at Beaulieu under the olive trees. The weather was fine. He and his wife had had an excellent lunch in an inn, and they were feeling very relaxed, ' filled with happiness ', as my mother, always good-humoured after a meal, expressed it. My father had made headway with the landscape he was painting. He felt that he had succeeded in transferring to his canvas a little of the living light that enveloped them. All at once a troop of Parisians came romping in from the near-by railway station, and that put an end to everything. Their ridiculous straw-hats, their showy blouses, their cackling and chatter, the young men's silly jokes, broke the spell. ' Modern man is vulgar. So were men in former times, but it was confined mostly to the nobility, and the middle classes who imitated them : the rest didn't have the means.' I often wondered if that sort of remark didn't indicate something of a misanthrope in Renoir, but any such idea was contradicted by his general behaviour, and particularly by his painting. In fact I am now convinced that the opposite was the case. He was in no doubt about the value of the human species, but equally he was certain that what is called progress degraded human beings by liberating them from material tasks more necessary to the mind than to the body.

The group gathered around Renoir mistook him for some local painter, and asked him why he did not go and study in Paris. My father and mother were accustomed to that sort of thing. As they did not answer, the young upstarts soon got tired of giving advice. Then one of the girls caught sight of a field of artichokes not far away. ' Oh ! Wild artichokes ! ' she exclaimed to the others, pointing to the field, carefully cultivated by a painstaking peasant. The whole crowd made a mad rush for it. The plants they did not up-root they trampled under foot. Their vandalism infuriated my

father, and it made my mother's good peasant blood boil. They tried to stop the barbarous onslaught, but were only bombarded with artichokes for their pains and obliged to take flight.

I was born in the Château des Brouillards on 15th September 1894, shortly after midnight. When the midwife held me up, my mother exclaimed: 'Heavens, how ugly! Take it away!' My father said: 'What a mouth; it's a regular oven! He'll be a glutton.' Alas, his prediction was to come true. My father's friend, the cartoonist Abel Faivre, who had come to spend the night at our house, said I would make a wonderful model for him. He had developed a cult for my father, and apart from his caricatures he tried to paint with the same clear tones. His fellow-cartoonist, Forain, referred to him as ' The Renoir[1] and the Grapes '.

Another witness of my advent into the world was my cousin Eugène, the son of Uncle Victor, and a sergeant in the Colonial Army. Dr Bouffe de Saint Blaise said that my mother had come through the ordeal splendidly, and he prophesied that I would have an iron constitution. He swallowed a little glass of brandy from Essoyes and went home.

Gabrielle had been watching the proceedings, but she had not been allowed to assist in any way. She said, ' Well, *I* think he's beautiful.' Everyone laughed. She was only fifteen at the time. She was a cousin of my mother's, and had come from Essoyes a few months before to help with the preparations for my birth. Years afterwards, when she and I played the little game of taking a trip back into the past, she told me again, as she had told me a hundred times before, that I had been a magnificent baby, and added, ' Too bad you changed.' And to rub it in, she continued: ' You could be heard all over the place. As far as that goes, you're still the same.' Then she turned to my wife. ' You got a husband with a well-oiled tongue.'

To most French people, the very thought of a woman going to a lying-in hospital to have her child seemed barbaric. A baby should come into the world amidst homely surroundings. From the moment of its birth its mind should be exposed to the customs, even the faults and superstitions, of its family. A child making its first contact with the world amidst the cold realities of a hospital might become a sort of anonymous being, and not inherit mamma's head-

---

[1] An allusion to La Fontaine's fable. The name Renoir is derived from ' *renard* ' meaning fox. (Trans.)

aches or papa's taste for travel. My father favoured having the baby at home because he thought hospitals so ugly. ' How unfortunate to open your eyes on Ripolin-painted walls ! '

Apart from my comeliness, which was apparent only to her, Gabrielle's chief recollection of the day I was born was that my mother asked Mme Mathieu, our cook and laundress, to prepare some baked tomatoes according to a recipe she had been given by Cézanne. ' Just be a little less stingy with the olive oil,' she recommended. Faivre had never tasted the dish before. He was so pleased with it that he ate it all, and Mme Mathieu had to prepare another serving. My father was not hungry. He was terribly worried—not about his child, but about his wife. After Pierre was born, and before she had me, she had had a miscarriage. In front of Faivre and Gabrielle he accused himself of selfishness. ' To think of putting Aline in that condition just for a few minutes' pleasure.' Faivre replied, his mouth full of food, ' Don't you worry, boss, you'll do it again.' My cousin Eugène gave a little shrug, for he was averse to any physical effort, and finished his tomatoes, which he ate with careful moderation. After rinsing out his mouth with half a glass of wine mixed with water, he stretched out his legs, leaned back in his chair, and closed his eyes. He was a handsome man, on the tall side, with regular features set off by a moustache trimmed in military style, and a little tuft of hair under-lining his lower lip.

I was baptized in the church of Saint-Pierre-de-Montmartre. Georges Durand-Ruel, one of the sons of Paul Durand-Ruel, was my godfather, and my godmother was Jeanne Baudot. She was only sixteen at the time. She was the daughter of the head doctor of the Western Railway Company, and to the great astonishment of her parents, who felt like the hen that hatched a duck, she took up painting, and admired Renoir.

Our house at the Château des Brouillards was number 6 in the row of dwellings at 13 Rue Girardon. It had two upper floors, plus the attic which had been transformed into a studio. The garden, about fifty feet by seventy-five feet, had rose-bushes in it and one fruit tree. The central path led to the entrance of the house, which consisted of four or five stone steps. The iron ramp was painted black. The front hall, which ended in a staircase, opened on the left into the drawing-room and on the right into the dining-room. At the back was the kitchen and also a butler's pantry. The staircase was circular, as in a tower, giving the kitchen, which was behind it,

a peculiar shape. The steps were comfortably wide but became narrower as you went down to the cellar. My father had the walls of the rooms painted white, and the doors a Trianon grey, just as he did wherever he lived. He had an obsession about the preparation of the Trianon grey, insisting that it should contain the best quality of linseed oil and that the white should be mixed with 'animal black' and not 'peach black'. He wanted a pure grey obtained from a pure white and the best ivory black. The chief fault he had to find with 'peach black' was that it made the grey look 'sentimental' by giving it a bluish tone.

The largest rooms were about twelve feet by fifteen. In the dining-room Renoir had painted mythological subjects on some of the window-panes in translucent colours. I have no idea what became of those panes. The two upper floors were divided on the same plan as the ground floor. My mother slept upstairs over the dining-room; my brother Pierre, when he came home from school on Saturdays, over the drawing-room; Gabrielle above the kitchen. There was a primitive sort of bathroom over the pantry. It was an ordinary room provided with drains for emptying the dirty water. We washed our faces in basins placed on marble-top tables. Regular baths were taken in round zinc tubs about a foot deep. We washed our bodies with enormous sponges. As I have already said, we had to fetch our water from the pump at the entrance to the main pathway. Renoir slept on the second floor next to a guest room; and at the back, over Gabrielle's room, was still another for a servant whenever extra help was needed.

Some of our neighbours stand out clearly in my memory; of certain others I can only recall the sound of a voice, or some gesture. My most vivid recollections of the Château des Brouillards are connected with the visits we made there after we had left the place and I had grown old enough to take things in. I remember how bored I was by the noisy welcome given me by our former neighbours. 'He's a big boy now. I'm sure he doesn't wet his bed any more!' I tried to get away from these adult courtesies, and retired to the nook where we children played. I always felt that the house was still ours, and that in going away to the Rue La Rochefoucauld we had only gone on a visit. I recall bursting into tears when I saw a strange man arrive and take a key out of his pocket and enter the house as if it were his home. To comfort me, Mme Brébant gave me a little plate with a design printed on it. It was a present which touched me

deeply because I knew vaguely that my father had once painted plates. The article in question was very ugly, but I am afraid that children, even those who grew up in the midst of Renoir's canvases, are not easily shocked by ugliness. I remember very well when Mme Brébant gave me the dish. She must have been a little over sixty at the time, yet she seemed to me supernaturally old. She dressed in the fashion of the early Second Empire, before crinolines came in. I can still see her swathed in masses of black ' ruching ', coming slowly towards me in her garden, holding the plate in one hand and a parasol with a folding handle in the other. Bounding along in front of her were two miniature greyhound bitches, Finette and Falla, which yapped noisily. When my father heard the piercing sound they made, he said he approved of the Chinese custom of eating dogs. Mme Brébant's son Maurice loitered some distance behind, but he waved his hand at me and I understood that he would come and talk to me as soon as his mother had gone. He was forty years old by then, fat, bald and very pleasant. On catching sight of her son Mme Brébant motioned to him to join us—which he did, reluctantly. ' You should give your little Jean an enema every day,' Mme Brébant advised my mother. ' Children have a tendency to constipation. That's the way my little Maurice is.' Her ' little Maurice ' made a grimace and walked away to the end of the garden.

A daughter of a neighbouring family, the Varis, happened to pass by. He approached her and, to show how independent he was, whispered something which made her laugh. The Vari girls lived with their parents in one of the little houses at the foot of the slope in the Place de la Fontaine du But. They were pretty, and so numerous one gave up trying to count them. One of them who was my age used to come and play with me. The Varis, both parents and daughters, were all models. My father had several of them pose for him. Mme Brébant smiled with a knowing air. ' Maurice does exactly as he likes,' she said. ' There he is talking to one of those girls. As if that would impress me ! ' In after years I often wondered how Maurice had been brave enough to build the brick partition separating his rooms from those of Mme Brébant. It was my mother's opinion that he must have pretended to build it out of filial affection because he made a terrible noise when he snored and everyone knew that Mme Brébant was a light sleeper.

Besides the two dogs, she kept pet birds. One day she came to

the house and, taking Gabrielle aside, whispered to her : 'Fifi has just died, but don't tell Madame Renoir. It might give her a dreadful shock.' Fifi was one of the canaries.

Mme Brébant was very rich. She owned all the property around the Rue Saint-Vincent. The land on the other side of the Château des Brouillards belonged to old Griès. Mme Brébant was to lose everything through stupid law-suits. Her domineering nature kept her in hot water ; but she did not mind, as she rather enjoyed legal complications. In other respects she had what is known as a heart of gold, and she was one of the last specimens of a bourgeois class that had once been great.

The concierge was called the Marquise de Paillepré. Her husband was descended from a noble family. One of his ancestors had been ruined, along with M. de Beaumarchais, author of *The Marriage of Figaro*, in an affair involving the supply of arms to the American colonists at the time of their revolution. The same gentleman had later been compromised not only by his ultra-revolutionary ideas but also by his friendship with Robespierre and Marat. It was said that he had been partly responsible for several of his fellow-aristocrats losing their heads under the knife. He himself had been guillotined after the fall of the ' Montagne '. On his return to power in 1815, His Majesty Louis XVIII decided that this noble-man's behaviour was a good and sufficient reason for not aiding his widow and children, who had managed to hold on to their estates under Napoleon but were obliged to sell them off bit by bit in order to assure their living. The last of the Pailleprés was a charming man and my father was very fond of him. He was a delivery-man for Dufayel's and was perfectly satisfied with his lot in life. After he had finished the day's work he liked to smoke his pipe in the garden and watch Renoir paint. He never referred to the picture but he did talk willingly about his daily round, describing the customers to whom he had delivered a Henri II buffet, or one of those imitation wrought-iron lanterns with coloured glass which the playwright Courteline fancied so much. This kind of running monologue never bothered Renoir, for he felt quite at ease painting among people who minded their own business and did not try to poke their noses into his. The whole period of my father's stay at the Château des Brouillards was prolific. Renoir told me this himself, so if one remembers his usual enormous output one can imagine the prodigious amount of paint-ing he did at this period. The place inspired him.

M. de Paillepré found his title something of a nuisance. He always shrugged when anyone mentioned it to him. ' Let's not talk about that.' His wife the concierge, on the other hand, was rather defiant about it. Coming from a more ordinary background, she was inclined to assert herself. After she had emptied the rubbish she would put on a long trailing gown, very much in fashion at the time, and walk slowly down the path, fanning herself casually. Running into her one day Mme Brébant remarked reproachfully, ' Madame la Marquise, you are sweeping up my dog's mess with that long skirt you are wearing.' And Mme de Paillepré, forgetting her role, burst into shrieks of laughter.

The poet and journalist Paul Alexis lived next door to us. ' He was full of life, generous, and always gay and enthusiastic.' He was a great friend of Zola, who during this period used to come and see my father quite often. Renoir had not forgotten the novelist's attitude towards Cézanne, but he did his best to hide what he felt about it. He was afraid of hurting Alexis : for to him Zola was a veritable god. Some of Alexis's enemies spread the rumour that he had got his wife out of a bawdy-house. Renoir did not believe a word of it. He had great respect for Mme Alexis, ' a woman of rare distinction ', and he would always reply to malicious tongues by saying, if the rumour were true, all the more honour to her husband. The Alexis couple had a very pretty little daughter who often posed for my father.

The daughters of M. Lefèvre, a neighbour who was flautist at the Opéra, are to be seen in the painting entitled ' Little Girls Playing Croquet '. Another neighbour, a young girl, whom Renoir liked to paint, was Marie Isembart. Her father was a teacher in one of the Paris high-schools.

Farther up the Rue Girardon there was a family we saw very often : the Clovis Hugues. ' Perfect southerners '. The husband was a writer and also a deputy representing Montmartre. My father thought him ' a remarkable man, and very eloquent ', and said if he had been less of a bohemian he would have been President of the Republic. ' But there you are : in politics you have to be a hypocrite, have no character, and speak in solemn tones. It's only the mediocre who don't frighten people.' A dozen or so years earlier the Hugues had been implicated in a notorious scandal. Mme Clovis Hugues had fired several revolver shots at a man who had been blackmailing her. She had been tried and, after a good deal of un-

pleasant publicity, acquitted. But the affair was soon forgotten, and no one ever spoke of it at the Château des Brouillards.

Clovis Hugues used to give Renoir all the gossip of the neighbourhood. The anti-clericals were making a row over the church of Sacré Cœur which was just being built. As a gesture of protest they proposed naming the street leading to the basilica after the Chevalier de la Barre, who had been tortured and put to death at Abbeville twenty-five years before the French Revolution because he had not saluted a religious procession and had sung an obscene song about Mary Magdalen. Clovis thought far too much importance had been given ' the good young man '. ' The name of a weakling in front of their gingerbread church ! The street should be called after a conqueror. Why not Robespierre ? He at least drove Christ out of Notre Dame and replaced Him with a beautiful young girl dressed as the Goddess Reason. Robespierre's name still makes priests tremble.'

The part of Clovis Hugues's story that amused my father most was the way the name Robespierre sounded as it issued from the throat of this native of the Mediterranean. ' It sounded like the roll of drums, as if there were ten r's instead of two.' Mme Hugues was an amateur sculptor and dyed her hair red. Mireille Hugues, aged twelve, is in the ' Little Girls Playing Croquet ' picture, along with the Lefèvre children. One day she came to see my mother with one side of her head a bright red, the other its natural brown. She had wanted to try out her mother's hair-dye, but there was not enough of it left. Although she had been brought up in Paris she had kept her Midi accent. She was full of life and she would play like mad, fall down, and get up covered with bruises. One day as she was watching a funeral go by she leaned out of the second-floor window so far that she lost her balance and fell to the ground. She picked herself up with a laugh, rather the worse for her mishap but too proud to admit it. ' She's a regular tom-cat,' my mother said. ' A tib-cat would be more appropriate for a girl, wouldn't it ? ' said Renoir. During the First World War, Mireille acquitted herself so heroically that she was awarded the Croix de Guerre. We saw less of Marianne, another of the Hugues girls. She was almost grown up and used to visit us when the mood took her. The idlers on the street would look askance at her sky-blue velvet dress, which made a queer contrast with the holes in her stockings. The third daughter, Blanchette

was interested only in music. It was rumoured that she was in love with a tenor at the Opéra Comique. The fourth sister was called Marguerite. The 'artistic' airs the Hugues girls gave themselves provoked a good deal of criticism in the quarter, but Renoir approved of them, and even years afterwards a wistful smile would come over his face whenever he spoke of those charming neighbours. 'They liked having fun and going to dance at the Moulin de la Galette, but they were good little girls all the same.' Remembering my father's affection for that family, I was extremely moved to meet Marianne a quarter of a century later when she was running a restaurant in the Boulevard de Clichy.

One morning there was a great drama at the Hugues'. As he was getting dressed to go to the Chamber of Deputies, Clovis could find only one of his patent-leather shoes. He rushed out of the house in his stocking-feet, and ran all around the neighbourhood waving the one shoe and shouting for the other. It turned out that his daughters had been quarrelling and had begun throwing things, including the shoe, which had been flung out of the window. It was finally discovered in a heap of dead leaves in front of Mme Brébant's door.

Another of the inhabitants of the Rue Girardon was the Egyptologist, Feuardent. He would come to get a breath of fresh air under the trees of the Château des Brouillards. He was said to be a well-mannered and kindly man, but he had a way of patting my cheek with a friendly gesture that made me furious.

Among the other familiar figures was the woman who sold newspapers. She had a feeble-minded sister of forty called Blanchette who used to play blind-man's buff with all the little girls. There was also M. Lebœuf the upholsterer, who, much to our amusement, married a certain Mlle Leveau. The laundryman was perpetually drunk. He was in great favour with my mother and Gabrielle, because his Nièvre accent was similar to that of Essoyes. But when one day he let the laundry fall into the gutter, my mother decided it was time they parted company. It was his dismissal that brought the Mathieu family into the house.

On the Butte, people never invited one another to lunch or dinner. But they would sometimes say, 'I'm having a veal blanquette today. Would that tempt you?' If the answer was 'yes', one would simply set an extra place. Nowadays preparations are made well in advance. People telephone and invite friends who are likely

to get along with one another, and so avoid awkward situations. It amounts almost to a diplomatic manœuvre.

The ladies at the Château des Brouillards never went in for social gatherings. But on occasion one of them would bounce into her neighbour's kitchen and ask for a sprig of chervil, or else bring a present of some wine her husband had just bottled. The community was totally free of the monotonous tyranny which prevails in most social groups. Gentlemen tipping their hats to the ladies and the curtsies little girls made to grown-ups were the Parisians' way of saying as Mowgli did, ' We be of one blood, thou and I.'

# 21

Let us go back now to the period when my mother was pregnant, shortly before I was born. She suddenly got the idea of having a cousin from Essoyes come to Paris and help her with the housework. Gabrielle Renard was fifteen at the time. She had never been out of her native village. The nuns had given her a good education. She knew how to sew and iron. She owed her religious education to her father, because he wanted to annoy the local lay school-teacher, who in his opinion was too pretentious.

The instruction the nuns had given her was amply supplemented by the lessons the young Gabrielle learned at home. At ten she could tell the year of any wine, catch trout with her hands without getting caught by the game warden, tend the cows, help to bleed the pig, gather greens for the rabbits, and collect the manure dropped by the horses as they came in from the fields. The manure was a treasure which everyone coveted. Hardly had it fallen on the white road in steaming lumps than a horde of competitors rushed out, shovel and pail in hand, to gather it up. Every youngster in Essoyes was proud of the family's manure-heap which dominated the courtyard, and was eager to bring in a fresh supply. Their rivalry resulted in epic battles, from which Gabrielle generally emerged victorious but with her clothes in rags. Her mother, being insensitive to the aesthetic qualities of the booty, would end the incident by boxing her ears. Parents' hands were always ready for action in Essoyes. The young fry were often sent away howling, but they were none the less healthy for it. Gabrielle never wore shoes except in the morning, when she went to the nuns' school, and she took them off as soon as she left in the afternoon. When the nuns met her on the street they would tell her that little girls who went barefoot would never grow up to be like Mlle Lemercier, the pride of the village, who wore a veil over her face,

had received her diploma and was going to marry a Colonial official. Gabrielle would retort that she hadn't the slightest desire to be like Mlle Lemercier. As a rule the nuns were fairly successful in giving their pupils a veneer of gentility : with Gabrielle they failed completely.

Gabrielle's father was a great hunter. In winter they often had wild boar to eat at the Renards' house. The children would quarrel over who should have the snout, considered the choicest part. To settle the dispute M. Renard would finally decide to keep it for himself. One day he brought home a young live boar, and before long it became Gabrielle's favourite companion. As it grew bigger she took to riding around on its back. The creature would gallop down the street past the church and finally throw its rider, who fell into the mud, ruining her dress. She got a good cuffing, of course, when she returned home. But punishment never bothered Gabrielle. The children in Essoyes had a trick they used whenever they were chastised in this way. It consisted in jerking your head back just at the right moment so that the force of the blow was weakened, at the same time letting out a screech like a scalded cat. The mother, satisfied, would then go back to more pleasant occupations such as recounting to the neighbours stories of accidents and illnesses, with gruesome details of childbirth, of vineyard-workers crushed under the wheels of heavy carts, of children drowned in the black waters of a mill-race, and so on. The more horrible the tale, the greater the success of the narrator. Gabrielle's little pet eventually grew up into an enormous wild boar, and only just in time was it prevented from disembowelling a cow it had taken a dislike to. It was therefore necessary to kill it and convert it into ham and sausages.

On Sunday, Gabrielle went with her mother to Mass, where, ill at ease in her starched dress, she was called upon to distribute the pieces of blessed bread. But that did not keep her from joining the other youngsters when they followed the priest down the street and mocked him by imitating the cawing of a crow. Essoyes was proud of its ancient tradition of anti-clericalism. The women went to church, but the men rarely set foot in it. In fact Essoyes was one of the few villages left in which the men still performed the ritual of gathering on the parvis in front of the church on Good Friday and eating slices of sausage, to show that they had got beyond the superstitions of the Middle Ages.

Gabrielle arrived in Paris one summer evening in 1894, and

mother met her at the Gare de l'Est. Gabrielle already knew my father, whom she had often seen in Essoyes. For the moment, he was away visiting Gallimard in Normandy. When she saw the Château des Brouillards she exclaimed, ' A fine garden you have ! There's no manure heap ! ' The next morning, as she did not appear for breakfast, my mother knocked at her door. There was no response. Gabrielle was already out in the street, playing with the children she had found there. My mother decided it was a good omen, for all she intended asking her young cousin to do was to play with me after I came into the world. She would trust no one but herself to look after her children and prepare their meals.

Several months later, at the beginning of 1895, I was taken ill with pneumonia. It was freezing hard and the walls of the Château des Brouillards gave little protection against the winter's blasts. For an entire week Gabrielle and my mother did not sleep at all. While one was busy bringing up wood, the other was making swaddling clothes to keep me warm. I had to be carried about constantly in their arms, for if I was laid flat on the bed I began to suffocate. They finally decided to telegraph my father. He was painting down at La Couronne, near Marseilles, along with my godmother Jeanne Baudot and her parents. He left his canvas and brushes, hurried to the station without even taking his suitcase, and jumped into the first train for Paris. He arrived home just in time to relieve the two exhausted women. Thanks to the love of those three devoted people, I was pulled through a crisis which might otherwise have been fatal. Yet once the danger was past, no one made further mention of it. If it had not been for Gabrielle, I should never have known anything about it.

One of the most striking characteristics of my father and his household was their reserve. They all had an instinctive aversion to any conspicuous display of personal emotions. Renoir would have given his life for his children without hesitation. But he was extremely reticent about revealing his private feelings to anyone— even to himself, perhaps.

When seated at his easel it was a different story. There he no longer felt any restraint. With sharp but tender touches of his brush he would joyfully caress the dimples in the cheek or the little creases in the wrist of his children, and shout his love to the universe.

The fear he had of letting other people see his feelings amounted almost to panic, and it was not limited to what he felt about his

children. Everything that touched him deeply he kept within himself. When the poet and politician Déroulède brought back to France a handful of the soil of Alsace, Renoir said : 'I don't like that kind of thing. If our patriotism has to go in for publicity, then things are in a bad way.'

As the result of my many talks with Gabrielle about the Château des Brouillards, where I lived until the age of three, I hardly know which are my recollections and which are hers. She felt sure that I could not have forgotten those early incidents. 'I remember Auguste Philippe's marriage to Virginia Manger in Essoyes perfectly well, and I was only two and a half at the time. You mustn't be stupid. Some people, of course, are like sheep, and can't see further than the rump of the one in front.' 'But,' I replied, 'I had that bronchitis when I was only six months old. Don't you think I was a little young ? ' 'You may have forgotten your bronchitis, but surely not the Château des Brouillards. Don't you remember the kitchen ? It was round, like a kind of tower. And how naughty you were when I carried you around ? And the little girl next door who lisped and called you "pitty little Dan " ? And how you smiled at her, and held out your arms . . . ? '

She was referring to the little Itier girl, who was three at the time. Her parents, who lived in the Rue Girardon, were from the north. M. Itier worked in one of the Government ministries. It was in the days when there was a great vogue for the bicycle. The French public had just discovered ' the little queen ', as it was called in the gay 'nineties, and everyone was rushing out to go pedalling down the dusty roads. M. and Mme Itier shared the national passion. Whenever they had time for it they would mount their tandem and race away in search of new horizons, he dressed in knickerbockers and knee stockings in the English style, she wearing bloomers made especially for cyclists, which were all the rage then with sporting women. Their little daughter was taken along in a small wicker basket-seat fastened above the handlebars. My father, who spent his life worrying over children, shuddered at the thought. Then one day the Itiers' tandem skidded and sent its three riders rolling down the whole length of a steep embankment. When the parents finally managed to get to their feet they found they were covered with bruises. The little girl, however, had had her head split open and had been killed outright. Gabrielle was still moved by the tragedy when recalling it sixty years later. 'She was so sweet,

the way she would come up to me on tiptoe, for fear of waking you, and whisper, "Please let me look at your pitty little Dan." '

I was very much spoiled as a baby. Although my mother disapproved, Gabrielle would carry me about everywhere. The sight of the two of us in the streets of Montmartre was so familiar that Faivre used us as the subject for many of his drawings in *Le Rire*, of which he was one of the star artists. Gabrielle would show them to me and say, ' That's not really you. You're much prettier than that ! '

After the death of the little Itier girl I began to behave badly towards anyone who came near me. I would tolerate other children somewhat, but the minute a grown-up approached me I would shriek ' Ah too Dan ! ' which meant ' He dares touch Dan ! '

After numerous vain attempts to pronounce Gabrielle's name, I decided, having tried ' Ga-bee-bon ', simply to call her ' Bee-bon '. And this is what we all called her until seven years later, when my baby brother Claude baptized her ' Ga ', which stuck to her for the rest of her life.

Going to and fro between the Château des Brouillards and the Rue Tourlaque, my father used to cross the Maquis four times a day. My mother, Gabrielle and I used to wander through that nondescript wasteland hunting for snails. It was a hazardous pursuit, as the ground was covered with brambles. The shacks of the people who lived there were hedged in by rank vegetation. The Maquis area began just behind père Griès's field and extended down as far as the Rue Caulaincourt. What is now the Avenue Junot was a confused jumble of rose-bushes. These shanties, which had been built by the occupants themselves without regard to the first rules of safety or sanitation, were free of all taxes or other legal controls. They owed their survival to the fact that the soil was too soft and loamy for the construction of apartment-houses. The owners of the property were glad to make at least a little money out of land which could not be used in any other way. The tenants had to have long-term leases for it to be worth their while to run up their dwellings, which were put together with planks salvaged from the waste-material left from buildings under construction near by. The taste of the amateur architects ranged in style from the ' cottage ' type, with sloping roof and windows festooned with Virginia creeper, to ramshackle cabins covered with a length of tarred felt. The whole place teemed with cats, dogs and other animals. An old gentleman, dressed summer as well as winter in a shabby frock-coat with a

decoration from the Ministry of Education on the lapel, had for twenty years or more been working on an 'act' for a street-fair show, in the form of a Roman chariot-race, in which the horses were to be rats and the charioteers mice. In other words it was to be a regular *Ben Hur* before the age of films. But the devil had instilled into him a mania for perfection, and in consequence the number was never ready for production. He was respected, however, because he drew a pension from the Government.

The police deliberately ignored the Maquis, visiting it as rarely as possible and only for very good reasons. Once they were assigned to arrest some counterfeiters who had their headquarters there. The counterfeiters were two quite presentable young men, professional engravers who lived in one of the most stylish houses in the quarter, a sort of Swiss chalet, built of wood, of course. They had sown grass in front of it, planted a fir tree, and made a rock-garden out of cement. Thanks to assiduous watering, this miniature landscape stayed quite green, and it could, by a stretch of the imagination, conjure up a Swiss meadow. My father once told the young men that they ought to have a cow to graze on it, and they said they would think it over. The interior of the house was decorated in Swiss fashion, with beams painted dark brown, fretwork furniture and a cuckoo clock. The owners had had the unusual idea of ornamenting the garden with cow-bells, which were hung everywhere: around the doors, along the fence, even on the branches of the fir tree. All visitors were greeted by a veritable carillon. It was very ingenious. There was also a large dog, which people were advised not to pat. The young men often came to see Renoir, admired his painting, and told him they hoped to inherit some property. The police, having made their way into the garden to the silvery sound of bells, found the house empty. The two men had escaped through a back window opening on a path leading down to the Rue Lepic, below the Moulin de la Galette. The dog would have eaten one of the policemen alive if Joséphine, our fish-woman, had not come and quieted it down. As she was their neighbour, the young men had left it with her a few days before, in preparation for their expected sudden departure. Complete equipment for manufacturing bank-notes was discovered in the house. It was said that the culprits had put more than five hundred thousand francs into circulation, and that they had bought a château in Switzerland. Naturally certain people suspected them of homosexual tendencies,

but the poet Jean Lorrain, who had met them, considered the idea absurd. Their association, he maintained, was purely professional. Their neighbour Joséphine was about fifty years old. Every morning before dawn she set out for the Halles market, from which she returned with two large baskets of fish. She was small and wiry, and quick in her movements. She would hawk her wares in such a strident voice that it pierced the walls of the Château des Brouillards —no great feat, in my father's opinion. She knew him well, for he would occasionally stop and listen to her tittle-tattle on his way home in the evening from his studio in the Rue Tourlaque. In the morning their time-tables rarely coincided : by the time he was ready to go through the Maquis she was out in the streets busily selling her fish.

My mother ordered in advance the fish she thought would please Renoir. Herring was a great treat, but only when it was extremely cheap. That was a proof that the schools of fish which came down from the North Sea for their annual migration were plentiful along the French coasts. When prices went up it was a sign that the herring had been caught farther away and had had to be shipped some distance to the Paris markets. In our home the herring were broiled over a charcoal fire and served with mustard sauce, and I can still taste the flavour of that sauce.

Joséphine lived in the Maquis, in a tumbledown house. The holes in the roof were plugged with pieces of oilcloth. Her little plot of land was more extensive than that of the others. She raised chickens and rabbits as a means of livelihood, in addition to the fish trade. She also had a few goats which, much to our wonder and admiration, fed on the thorny bushes growing on the slope. Gabrielle liked to take me to see her because the beautiful heap of manure in the front yard reminded her of Essoyes. Whenever possible, Joséphine would finish her work before lunch. In the afternoon she would take her ease, playing the great lady, entertaining her friends and airing her political opinions. She held forth next to the manure-heap, seated in a large gilded armchair which one of her daughters had given her. She was at no pains to conceal her contempt for the Republic and for its ministers, who came ' from who knows where ! ' She hoped that the King would return some day, surrounded by his courtiers in full regalia, white wigs and all. 'Those fellows knew how to talk to women !' She sighed as she murmured the names of Diane de Poitiers, Mme de Pompadour, and

du Barry. 'Nowadays statesmen's wives do their own shopping, and haggle over the price of whiting.'

Joséphine's house was chock-a-block with material proofs of her 'little ones'' affection. Engraved silver boxes and work-baskets lined with satin competed with rickety chairs and contrasted strangely with the rough boards of the wall partitions. One of the young girls was a dancer at the Opéra. She had a well-known surgeon for a lover, affected a discreet sort of elegance, and liked to give her mother useful presents such as thick wool sweaters, the newest type of stove, an ice-cream freezer, and so on. The other daughter had gone completely to the bad. She would arrive at her mother's house in a victoria drawn by two horses and driven by a liveried coachman. She was the one responsible for the gold chair, and the enormous ring which never left Joséphine's finger. The two sisters avoided each other, but sometimes they chanced to meet when they went to see their mother. Their conversation would take on a bitter-sweet tone. The one who owned the carriage would insist that the other's surgeon friend had left his spectacles by mistake in the abdomen of one of the patients he had operated on. The dancer would retort by alluding to certain mattresses which all of Paris came to roll on. Just as the insults were about to reach the hair-pulling stage, Joséphine would call her daughters to order with the aid of a green switch. Weapon in hand, she would chase them both through the house, out to the courtyard, and into the chicken run, producing a wild cacophony from all the frightened fowls and animals. The whole neighbourhood would be aroused by the uproar, and the coachman would stand by and pretend to be adjusting the harness of his horses. The affair would usually come to an end amidst tears and embraces, the hetaera would offer to take the ballerina home in her carriage, and the coachman would ceremoniously hold the door of the victoria open for the two ladies.

It was especially towards the end of her life, after she had gone to live in California, that Gabrielle liked to hark back to the days of the Château des Brouillards. 'Do you remember when Joséphine's daughter stepped in a dog's mess, and how disgusted the coachman was ? " The carpet, madame ! " And the daughter answered him haughtily, " If you don't like *merde*, my friend, you'll have to look for another place." And,' went on Gabrielle, 'you surely remember the expression on the handsome flunkey's face ?' 'No,' I would have to reply, 'I swear I don't.' Now that Gabrielle has gone there

is no longer anyone to reminisce about Joséphine and her daughters, or to open a window on to a past which seems to me much as the Garden of Eden must have seemed to Adam after he tasted the fruit of the Tree of Knowledge.

In those early days when Gabrielle was opening my eyes to a world still relatively innocent, my mother would be busy with her knitting, sewing or mending. My father had by now begun to earn enough money to enable us to live comfortably, nevertheless my mother felt none too secure. The picture-dealers kept plaguing Renoir to return to his first manner, which was coming into fashion. Such pleas made him very angry, and his wife was alarmed that the need of money might turn him away from his quest for a goal which she herself could not define, which perhaps she could not even imagine, but which she believed in with all her soul.

She used to sew in the garden. There she would be joined by Mme Lefèvre, always very well-dressed, who would tell her about the latest melodrama at the Montmartre Theatre, where she shared a box with the Clovis Hugues. Every Friday, for some reason, she would bring out all her lace. Mme Brébant, wearing a dress with a train, and Mme Isembart, were also members of the group. Finette and Falla would lie at the feet of their mistress ready to bark at any new face. Mme Alexis would read travel-stories aloud. The sound of M. Lefèvre's flute would add an appropriate note to the pastoral scene. On Sundays, when my brother Pierre was home from the Sainte-Croix school, he would put on amateur theatricals with the little Clovis Hugues girls. They would wrap themselves up in old curtains and give imitations of the actors the grown-ups had seen at the Montmartre Theatre. 'Pierre will be an actor some day,' my mother said, little knowing how prophetic her words were.

In another part of the Maquis where Gabrielle used to take me there was a very fat painter, whose name she had forgotten. His wife was equally fat. They munched nougat incessantly. He always painted the same picture : knights in armour resting with their horses under an oak tree. He explained to Bee-bon that, having got the subject just the way he wanted it, and eliminated all mistakes, he was in a position to offer his customers an article which specialization had made perfect. 'If I did another subject,' he said, 'I would have to start all over again.' For instance, the cross on the shield of the knight in the middle of the group was black. He had painted it white for a long time, until he found out that this was an anachron-

ism. Every Saturday he would set out on foot, his picture under his arm, and submit it to different art-dealers. If he had no success he would try his luck with interior-decorators, café proprietors, whore-houses, or even itinerant theatrical troupes. He was a good salesman, and he succeeded in placing one of these pictures nearly every week, whereupon he would do another copy of it the next morning in a few hours.

Another denizen of the Maquis whom Gabrielle remembered vividly was Bibi la Purée, a starving poet. He would come and recite his verses to my mother, and she would reward him with a slice of cold meat garnished with pickles. He never failed to empty the pickle-jar as well as the bottle of wine which went with the snack. My father was always in his studio when Bibi called, but one day he ran into him in the Maquis.

'Good day, Monsieur Renoir. I am Bibi, the poet. Your good lady knows me well.'

'Oh—so you are the one who empties my pickle-jar.'

'Yes. And I'd like to ask you a favour. Would you tell Madame Renoir that the pickles are too salty? I'm afraid to, myself. Creative people can be rather touchy.'

'Thank you,' replied my father. 'I'll be sure to give her your message.'

Gabrielle often spoke of that severe winter when I was so ill with pneumonia that my father had to come back in a hurry from the Midi.

'The pump near the concierge's door was frozen solid. I had to use the one at the corner of the Rue Lepic and the Rue Tholozé. It reminded me of Essoyes when I used to go to the well in the Place de l'Eglise.'

That's how she had spoken to Toulouse-Lautrec for the first time.

'I knew him well by sight. He had come to see the boss several times, and I knew he often stopped to have a drink at the *bougnat*'s[1] on the corner.'

That day Lautrec's friends, Koudoudja and Alida, the pseudo-Oriental tarts from the Boulevard de Clichy, were huddled in a corner, trying to get warm with a few mugs of hot wine. They had no desire to go back to their rooms in the Rue Constance, where the

[1] Slang name for a small coal-dealer. In Paris the *bougnats* often have a small bar in their places. (Trans.)

water had turned to ice in the pitchers. Toulouse-Lautrec was feeling very much at ease. He came out and called to Gabrielle and she went in to the *bougnat*'s with her jug of water. He offered her some hot wine and started to talk about his father, 'even more of a bohemian than himself'. The old gentleman had come all the way to Paris from his crumbling castle four hundred miles away, riding on his mare and without a penny to his name. He slept on straw at night alongside his mare, and drank her milk when she had any. When Gabrielle told me this tale she explained, ' People had a great deal of time in those days. . . . Not the boss, though ; he painted all the time.' She added : ' Toulouse-Lautrec was always polite. He always took off his hat to the *bougnat*'s wife. He was very clean, and he wore a white starched shirt, sometimes without a cravat. When he did put on a cravat, it was always a black one. He was very neat, gay and agreeable. People made fun of him at first because of his size and called him " short-arse ". He didn't give a damn. Then people got used to it. You get used to everything. As the boss would say, " You don't see yourself." '

An account of Renoir's entourage at the time of my birth would not be complete without some reference to the Mathieu family. They are not easy to classify. I might describe them as being aristocrats of the Paris proletariat. M. Mathieu was by profession a ditch-digger ; his wife was a laundress, but she also did all sorts of housework for families in the neighbourhood. He was a well-set-up man of about fifty, tall and rather stout, and his face was adorned with a magnificent moustache. He looked well in his professional clothes, which included baggy corduroy trousers held in place by a red-flannel waist-band. Mme Mathieu, or Yvonne as she was familiarly called, was also robust. I still see her shrewd expression, emphasized by her pointed nose and her sharp black eyes peering out from under the bang of brown hair on her forehead. The couple had several daughters and one son. I remember their daughter Odette at the time of her marriage. She was very pretty, but my father never asked her to pose, because she was given to arguing. ' After two sittings she would have started trying to give me painting-lessons.' Vollard hired her to come and clean house for him, ' but never touch the pictures.' I also recall another daughter, Raymonde, as she was part of our household. We saw very little of the other sister, Yvonne, who worked in a store ; or the boy, Fernand, who was in the Navy at Toulon and rarely came home on

leave. I did not like his uniform : the sailor's cap he wore and the open-neck collar seemed in my eyes to make all sailors look like little boys. Nevertheless, I conceived a great respect for Fernand later on, when his sister Odette told me of his acrobatic feats. Before coming to the Rue Girardon the family had lived under the roof of one of the new six-storey buildings in the Rue Ravignan. On the side of the slope the building was ten storeys high. Fernand would swing himself from one window to another, holding on to the gutters, and then hang by his feet, frightening everyone in the street below, until a policeman arrived.

'What's the idea ? '

' Just practising. I want to be an acrobat.'

M. Mathieu did not often work. He could never come to terms with either the employers or the unions. Before accepting a job he would pick up a handful of earth, look it over, feel it and sniff at it ; then conclude, ' Sorry, monsieur, I'm not working in that kind of soil.' When by chance he did accept a contract, his wife Yvonne received the news as if it were a catastrophe. You should have seen her then, at his lunch-hour, her back bent under the weight of a huge basket filled with pâtés, cold meats, bottles of wine, including a flask of brandy to aid his digestion. M. Mathieu always maintained that the first duty of a working-man is to keep fit.

His solemn naivety delighted Renoir, who, though not appearing to, liked to overhear the conversations that went on in the kitchen. By leaving the dining-room door open while he was painting, he could catch every word.

Old Mathieu excelled at giving indignant descriptions of orgies in which the nuns of a certain convent indulged in company with the monks from a near-by monastery who would visit the Sisters through an underground passage. He spoke slowly, in a pompous tone which gave his stories an unintentionally comic flavour. He had an answer for everything. When his wife took him to task for having bored a hole through the wall between their apartment and the Varis' and hidden it with a dish, which he would remove so that he could see the Vari girls undressing, he replied majestically, ' Madame, I am doing research.' And when his daughter Odette took piano lessons and began learning to play Wagner, his advice to her was, ' You'd better stick to Gounod, my girl.' The younger child, Raymonde, a real little Parisian with a gracious and lively appearance, had inherited her father's solemnity. She was later to follow us to

many of the other places we lived in. Her way of uttering pointed but perfectly banal remarks, enunciating each word carefully, would send my parents into gales of laughter, but their merriment was lost on her, for she considered herself the soul of wisdom. When one day a young man offered her an expensive cigarette with the comment that he never smoked anything but Abdullahs, she said, ' You'd do better to wash your feet.' And in talking with a pretentious house-maid from Nice who boasted about her dieting, she remarked, ' You may eat like a bird, but you s—t like a camel.' She repelled the advances of a bald-headed man by saying, ' I don't play billiards.' She insisted that her father was ' a great artist, a violinist of the first rank, but unfortunately he has never been able to hold a bow because he has a finger missing.'

The loss of his finger gave M. Mathieu a definite feeling of importance. ' It was only when Voltaire became impotent that he was truly great,' he declared, and he waited confidently for his hand to become completely paralysed so that he might rival Voltaire. He was both anti-militarist and anti-German, and he warned my father, ' That Wagner of yours will play you a dirty trick.' He said the Germans were all homosexuals. 'If my daughters should want to go to Germany they would have their parents' consent—but my son Fernand, *never !* ' His explanation of German perversion was that King Frederick II had imposed pederasty on all the Prussians. In the event of war M. Mathieu suggested a way of halting the ' Teuton hordes ' at the frontier : ' We shall oppose them with the dignity of our manhood.' No doubt my father liked the Mathieu family because they represented the common people of Paris, who were so adept at hiding the material poverty of their lives behind a rich vocabulary. It was Renoir's conviction that ' their pride is not put on. If they were willing to bow the knee, they might perhaps be richer.'

At the beginning of 1895, Renoir went down to paint in the Midi with Cézanne and while he was there he learned of the death of Berthe Morisot. The news was a great blow to him. For, of all his friends and companions who had been with him in their struggle for recognition, she was the one with whom he had kept most closely in touch. One wonders what moments were essential in the lives of great creators. One such moment for Renoir was the loss of this friend. ' We were all one group when we first started out. We stood shoulder to shoulder and we encouraged each other. Then

one fine day there was nobody left. The others had gone. It staggers you.' It was in fact not only death which scattered the band of Impressionists. Little by little their diverse tastes had made their meetings less frequent. The Mediterranean attracted Renoir more and more. Monet had settled permanently in Normandy. Pissarro went frequently to Eragny, in the Oise, where he did engravings with his son Lucien. When he came to Paris he was always too busy with his exhibitions to climb up to the Château des Brouillards. He did come once, before I was born, and spent part of the day with my mother. He was having a very difficult time just then, but did not talk about it. ' He was truly a gentleman,' said my mother. He talked to her at great length about his technical researches and about Seurat and the stippling method. Sisley remained faithful to the forest where they had all painted so often in their younger days, and stayed in Moret, eight miles from Fontainebleau. He was now in very poor health. Degas was sulky towards Renoir for his jocular references to his anti-Semitism. As for Cézanne, he had never really been one of the ' Intransigents '. His great friendship with Renoir was founded on other factors which I shall mention later.

When Renoir received my mother's telegram about Berthe Morisot's death, he and Cézanne were out in the country working on the same motif. He folded up his easel at once and hurried to the station without even stopping at the Jas de Bouffan. ' I had a feeling of being all alone in a desert. Once I had got on the train, I recovered my composure by thinking of your mother and Pierre and you. On such occasions you realize what a good thing it is to have a wife and children.' Before she died, Berthe Morisot had asked my father to look after her daughter Julie, then aged seventeen, and her nieces Jeanie and Paule Gobillard. Being a trifle older than the other two girls, Paule took charge of 'the Manet house', as my parents called the mansion at number 41 Rue de Villejust. Jeanie was to marry the poet Paul Valéry, for whom the street was later to be renamed. Paule became so wrapped up in playing the part of big sister that she never married. Julie, a painter herself, was to marry the artist Rouart. In Berthe Morisot's day the Manet circle had been one of the most authentic centres of civilized Parisian life. Although my father, as he grew older, avoided artistic and literary sets like the plague, he loved spending an hour or two at the house in Rue de Villejust. It was not intellectuals one met at Berthe Morisot's, but

simply good company. Mallarmé was a frequent visitor. Berthe
Morisot acted like a special kind of magnet on people, attracting
only the genuine. She had a gift for smoothing rough edges. ' Even
Degas became more civil with her.' ' The little Manet girls ', as they
were called, carried on the family tradition. And when Rouart and
Valéry married into the family, it was further enriched. Whenever
I have an opportunity to go and see my old friends, I feel as if I
were breathing a more subtle air than elsewhere, a remnant of the
breeze which stirred gently through the Manet drawing-room : a
breath of the Parnassian wind which made the Agora so stimulating.

My mother had the idea of bringing together the little Manet
girls and Jeanne Baudot. So began an eternal friendship. In view
of their belief in the hereafter, the word is surely not misplaced.
Paule Gobillard is no more; and my godmother, Jeanne Baudot, died
not long ago in the house in Louveciennes that my father had per-
suaded her parents to buy. Right up to the last she had her eyes
fixed on pictures my father had painted of me when I was six years
old. Every one of the paintings she did herself is a tender tribute to
Renoir, who was to remain the only love of her life. My father's
relations with my godmother were on a purely spiritual basis, as they
had been, equally, with Berthe Morisot. As he grew older, this gift
for friendship with women developed more and more. He would
set out on a trip with Jeanne Baudot ; they would stay in village
inns, take refuge in some farmhouse when it rained, laugh and paint,
eat plain country food. Whenever my mother could spare the time
—for I was a fretful, demanding baby—she would join them. She
took the Manet girls down to Essoyes after Berthe Morisot died.
When I was two, we all went out to Tréboul, near Douarnenez, in
Brittany, and there my mother rented an old Breton house which
had a small pond in the middle of the kitchen ' for the ducks in
winter '. There was a hole in the side of the wall to allow the ducks
to go out or in as they liked. We all had to wash at the well in the
courtyard, and the cooking was done on the hearth of the big open
fireplace next to the pond.

Gabrielle told me how one stormy morning everyone was
awakened by a terrific noise. The women of Tréboul were gathered
on the path overlooking the wind-lashed sea. Their voices were
louder than the roar of the waves. They were shrieking wildly in a
mysterious language which must have stemmed back to the time of
the Druids. All their menfolk had embarked the day before for

Newfoundland, dead drunk and hardly able to drag themselves aboard their fishing-boats. Another of Gabrielle's tales ran as follows : ' The Breton girls would go and pray to a statue of Saint Peter holding up a large key in his hand, and beg him to give them husbands. If he failed to answer their prayers they would come back and hit him with their own keys. The statue was badly mutilated.'

Julie Rouart and Jeanie Valéry often talk to me about my father. They always tell me of his gaiety, and how infectious it was. They speak of the absolute passion he had for painting, and how free it was of any complexes or ' soul states '—detectable ones, at any rate. It had been the same with Bazille, Monet, Berthe Morisot, Pissarro, Sisley and his first companions. One of them would get excited over some motif and set up his easel, and the others would instantly follow his example. Passers-by would stop in astonishment to see these bearded young men, their eyes concentrated on their work, their minds miles away from material preoccupations, carefully applying little patches of colour to their canvases. And to make the sight more unusual, a woman in a light summer dress, Berthe Morisot, was often to be seen with the group. My godmother, Jeanne Baudot, took me not so very long ago to see a clearing in the Forest of Marly, where she and Renoir had painted. ' He would stop, as if by chance, then, if he began humming to himself, I knew he was pleased with the motif in front of him. He would unfold his easel, and I would do the same, and in a few minutes we would both be painting away furiously.'

Another feature of Renoir's relations with his friends was that they were always willing to share their homes with one another. If Renoir felt an urge to go and paint in the country, he thought it perfectly natural to turn up, unannounced, at Gallimard's place in Normandy, or at Berthe Morisot's in Mézy, or at Cézanne's at the Jas de Bouffan, and start work immediately. He would always allow Jeanne Baudot to use his studio whenever we were all away on a trip. And he was constantly letting his friends have the use of his apartment.

Berthe Morisot left a posthumous gift to my father in the person of Ambroise Vollard. She had the perspicacity to see that that strange creature was a genius, in his way : and she had told Renoir about him. It all happened in 1895, just before Renoir's departure for Aix. Owing to Berthe Morisot's death, Vollard did not come to

see Renoir until that autumn. In his biography, *Renoir: An Intimate Record*, he described his visit in the following terms :

> I wanted to know who had posed for a Manet in my possession. It was a canvas representing a man seated on a camp-stool in a path in the Bois de Boulogne. . . . I had been told that Renoir would know who it was, so I set out to look for him. I found that he was living in an old house in Montmartre called the Château des Brouillards. In the garden I found a maid who looked like a gipsy ; and, without telling me to wait, she pointed to the hallway of the house, where a young woman appeared, as buxom and amiable as one of those pastels by Perronneau, or some good lady of the time of Louis XV. It was Madame Renoir.

And here is the same account as given by Gabrielle. I need hardly explain that she was the ' gipsy '.

' I was out in the garden with you—you were playing at pulling my hair. A tall, lanky fellow, with a little beard, called to me over the fence. He said he wanted to talk to the boss. His clothes were rather shabby. His swarthy skin and the way the whites of his eyes showed made him look like a gipsy, or at any rate a savage. I thought he was some rug-seller ; so I told him we didn't need anything in that line. Just then your mother came out and asked him in. He said that he came from Berthe Morisot. He looked so pathetic that your mother gave him some grape tart and a cup of tea. The boss came downstairs just after that. He was working on a picture of one of the little Lefèvre girls in the studio up in the attic.'

My father was very favourably impressed by a certain indolence in the visitor's manner. ' He had the weary look of a Carthaginian general.' And Renoir was even more impressed by the newcomer's attitude in front of a few canvases. ' People argue, make comparisons, trot out the whole history of art, before uttering an opinion. With paintings this young man was as stealthy as a hunting-dog on the scent for game.' My father would willingly have let him have a few canvases, even after Vollard, with his pretended air of innocence, which was going to become famous, had confessed that he could not pay for them. But Renoir was afraid that Durand-Ruel would resent having a competitor.

Vollard gave the impression that he was dozing most of the time ; in reality his eyes were taking in everything behind those

half-closed lids. Sometimes he did actually go to sleep in the middle of a performance at the theatre, or at a dinner-party, or during a conversation on social or æsthetic subjects. By some mystery which was never explained he inevitably opened his eyes wide and cocked an ear the minute anything really interesting was in the wind. He had a talent for putting his adversary off the scent by asking idiotic questions, half naive, half specially fabricated. Sometimes his dodge did not work, as, for instance, when he asked my father, ' Tell me, Monsieur Renoir : what are bloomers for ? ' He was alluding to a new article of clothing for women which was a favourite topic of conversation among models just then. ' For horses,' answered Renoir impatiently. And Vollard remained silent for at least ten minutes. He began every sentence with a ' Tell me.' He always sat in the same chair, averting his eyes from the picture he coveted. This was a favourite tactic of all picture-dealers. ' Tell me, Monsieur Renoir : why is the Eiffel Tower built of iron, and not of stone like the Tower of Pisa ? ' To this Renoir would make no reply. Vollard would doze off again, but wake up presently and put another question : ' Tell me, Monsieur Renoir : why don't they have bull-fights in Switzerland ? With all those cows, you know...'

Speaking of that first interview they had, my father conceived the brilliant idea of putting Vollard on to Cézanne, who, having become disgusted with Paris, not to mention exhibitions and critics, now rarely left his native Aix. ' I have enough to eat,' Cézanne proclaimed, ' *je les emmerde !* ' Renoir was intuitive enough to perceive that this Othello would hasten the inevitable triumph of that great artist by twenty years. Vollard was, of course, well acquainted with Cézanne's painting. But it is very possible that Renoir was instrumental in convincing him of its value, ' which has not been equalled since the end of Romanesque art '. When engaged in conversation of this kind, he totally forgot that he too was a great painter.

On Saturdays my brother Pierre would come home from boarding-school, wearing his Sainte-Croix uniform, which so far had not impressed me very much. After greeting everyone in a hurry, he went off to see the Alexis girls, or the Clovis Hugues, the Lefèvres, or the Isembarts.

We often went out to Louveciennes on Sundays. After my grandfather died, my grandmother was living with her daughter

Lisa and her son-in-law, Leray, in her house on the road to Saint-Germain. We would all wander along the street while my father stopped to look at each shop window, muse over the trash for sale, or gaze at the various products advertised in the windows of the hair-dressers. The numerous displays made a shameless appeal to the stupidity of the public : tooth-pastes guaranteed to turn teeth into pearls, hair-dyes to restore the youthful beauty of hair, all set him gently chuckling. He would then catch up with us and tell my mother what he had seen. She and Bee-bon would take advantage of the chance to put me down, with the admonishment, ' You've got legs ; you'd better use them.' But I would whine, hang back, be dragged along until one or other of them would have to carry me again. Pierre, ignoring these family trivialities, would saunter ahead of us, reciting lines from Racine to the daughter of one of the neighbours, whom my mother might have asked to come with us. Although only twelve, my brother had begun to make an impression on young girls by the gravity of his manner, which was perhaps to be the basis of his talent as an actor in later years.

When going out to Louveciennes, to reach the Gare Saint-Lazare we usually crossed the Maquis, went down the Rue Caulain-court to the Rue d'Amsterdam. We always took a cheese from Granger's with us, a pâté from Bourbonneux's, or some smoked eel from Chatriot's.

As soon as we arrived at Aunt Lisa's I would ask her to take me to see the rabbits. Renoir would go upstairs and spend hours talking to his mother. He would tell her all about his travels. She was sorry never to have had a chance to visit Italy, Spain, Algeria and other southern countries. England held no attraction for her. ' Too much coal.' When she felt she had waited enough, she would call attention to the lunch-hour by rapping on the floor with her cane. I can still hear those rhythmic knocks, which I was later to identify with the three thumps made in the French theatre to an-nounce the raising of the curtain ; and they also bring to mind the deep-blue eyes of my grandmother Marguerite Merlet.

In the evening we returned laden with vegetables and fruit from Lisa's garden, of which she was very proud. For the return trip we took the train from Marly because my mother got out of breath very easily and the road went downhill. The first part of the return journey went well enough. But once in Paris, climbing the Rue d'Amsterdam was less agreeable. During the last hundred yards up

the steep slope of Montmartre, my mother and Gabrielle and Pierre were almost ready to throw Lisa's gifts into the gutter. Renoir would often take me from Gabrielle and, propping me against his shoulder, hurry on ahead. Arriving home, the rest of the family would find me already playing in the garden with one of the neighbours. My father would have disappeared into his studio, and be comparing an old sketch of Louveciennes with the impressions of the day.

One mild spring day, Lisa came to break the news of my grandmother's death. My parents were both away. The news meant nothing to me. I laughed because I was so glad to see my aunt. Turning to Gabrielle she said, ' He is too little to understand.' She found my gaiety heartbreaking. She even uttered the word ' orphan '. Gabrielle calmed her down and reminded her that I was just the grandchild, after all. Then she offered her a piece of the strawberry tart which Yvonne Mathieu had just taken out of the oven. The three of them ate it with great relish ; and to wash it down, Gabrielle fetched a bottle of Essoyes wine from the cellar. Lisa had brought her brother a little flowered shawl that Marguerite Merlet had worn. Renoir was at Bayreuth at the time, biting his nails out of irritation over the *Niebelungen*. As he said afterwards, ' No one has the right to bore people to that extent. I felt like shouting, " Enough of genius ! " '

My mother had gone to Essoyes to see about buying a house next to the one we owned. The acquisition would enable her to turn the two rooms on the ground floor into a studio : for she hoped in this way to persuade her husband to stay in Essoyes during the summer months. It was not because of any sentimental attachment to her birthplace but just because hotel food did not agree any more with Renoir. It may be, also, that she sensed that his travelling-days were numbered. The serene calm that began to come out more and more in his pictures was an indication to her that, from now on, his life should be free from too much physical effort or agitation of any kind.

The only thing Renoir feared at Essoyes was the presence of his mother-in-law. ' A pest.' He entirely approved of his father-in-law, whose story can be told briefly enough. It happened in the year 1865. M. Charigot was a wine-grower, and he owned one of the best vineyards in the locality. He had no trouble selling his wine ; he owned a fine house ; he worked hard, and was happy with his young

wife. She was pretty and a good cook. She was very neat about her house, which was a solid construction trimmed with free stone. The polished oak floors shone like mirrors. Indeed, those floors were Mme Charigot's special pride. They were also to be her undoing. She spent countless hours waxing them. When her husband came home in the evening he would leave bits of mud on their spotless surface, and that made her heart jump. One night she mentioned this to him, though in a most tactful way. He scraped his shoes on the flagstones at the front door, and went to get his slippers. The next day she spoke about it again, and the following day as well. This went on for some time. He was very patient in front of little Aline, who was still a baby, and smiled up at him, uncomprehending, of course. One day he came home, his shoes muddier than usual, but instead of waiting to be nagged at, he pretended he had forgotten to buy some tobacco in the village, turned round and went off. And he didn't stop going until he had put the Atlantic Ocean between himself and his wife. My American cousins are his great-grandchildren.

M. Charigot cleared some land and turned it into one of the first farms in the Red River Valley in North Dakota. Except for himself and a Jesuit priest, the only other inhabitants in those parts were Indians. He returned to France to fight the Prussians in 1870, was wounded, and went back to the country of which he could justly claim to be a pioneer. My grandmother Charigot sold her big house at Essoyes and moved to Paris with her child. My grandfather married again, this time a young Canadian girl.

Once when my cousin Eugène was spending the summer at Essoyes, in a fit of gallantry he offered to make a neat pile of the firewood which a wood-cutter had just delivered to my grandmother Mélie. And an astonishing sight it was to see this man who had never deigned to carry even so much as a small parcel set about piling up logs under the old lady's critical eye. He had got well on with his chore, when she remarked: 'You are not doing it the right way. You should not put the little logs in with the big ones.' 'You are quite right,' answered Eugène quietly, and, dropping the armful he was carrying, he went home and took a nap.

Because Renoir rather admired his nephew's unruffled calm, I think I ought to give some further details about Eugène.

It may be remembered that Uncle Victor, who was five years older than my father, had become a tailor. A Russian grand duke was so pleased with the jackets he had made for him that he took my

uncle back to Russia with him, where he married and had a son called Eugène, who my father maintained was more Russian than the Russians. Victor became a fashionable tailor in Saint Petersburg, made money, bought himself a two-horse victoria for the summer, a sleigh for the winter, and a country house. He covered his wife with jewels. She was the soul of indolence, for she rarely got up from her chaise-longue, and fed entirely on liqueur chocolates. Young Eugène spent most of his time with the servants and a tutor, who made him learn all the novels of Eugène Sue by heart. To give some idea of the free-and-easy atmosphere in which he was brought up, here is a story told him by the coachman when he was a boy.

A certain prince who was a friend of the Czar once hired a French cook called Bertrand, who was nicknamed ' the-sauce-is-choking-me ' because the sauces he concocted were so good that all who tasted them ate until they choked. The noble prince lived in a large country house near Saint Petersburg. One night his daughter, a ravishing blonde of eighteen, was terrified to see the cook come into her room. She tried to call for help, but he covered her head with a pillow. Then he got into bed and raped her. While it was going on, she managed to push the pillow off her face and scream, ' The sauce is choking me ! The sauce is choking me !' Her father heard her from his room, which was in another wing of the house, and being half-asleep, he called back, ' You shouldn't have eaten so much of it ! '

My uncle's undoing came about through the vogue for women's tailor-made suits, for it brought him innumerable female customers whose charms he was unable to resist. The more unfaithful he was to his wife, the more she reclined on her chaise-longue and ate nothing but chocolates, and finally she died from the effects of it all. Victor squandered his fortune on his lovely customers and had to sell his house and return to France with Eugène. By that time he was in poor health himself. Caviar and vodka had done for him what the March sleet and the autumn rains were later to do for his younger brothers. My mother settled him with some peasants in Essoyes, where he lived quite happily for several years. He so much loved staying in bed that eventually he never left it.

I remember him well : his resemblance to my father, and the huge red eiderdown stuffed with feathers on his bed. I must admit that I recall the smell of urine in the room. As he did not like to get

out of bed to go to the lavatory, he used a chamber-pot which was kept under his bedside-table. Chamber-pots were in current use in those days, but my father and mother disapproved of them. In their opinion you had to be really ill not to be able to get up in the night. For this they were regarded as eccentrics. As a matter of fact, in looking back to the olfactory associations of my youth I have to confess that that strong, acrid smell was prevalent in all hotel bedrooms, and even in luxurious private houses.

Uncle Victor died without too much suffering, and he was sincerely missed by the good people he had stayed with, for they had grown quite attached to this gentleman who had had his fling.

As for cousin Eugène, my mother took him in hand and set about finding some occupation for him. She got him placed as an apprentice to a dealer in canvas from whom Renoir bought his materials, but at the end of a week he was discharged. He met with the same fate after working in turn for a maker of picture-frames, a tailor, and a grocer. Eugène frankly warned my parents that it would be the same no matter where he was placed. Although still young, he had, after seeing his mother reposing day in and day out on her couch, sworn to follow her example and never lift his hand to do a stroke of work. My mother tried to make him feel ashamed. She pointed out that a boy of eighteen, in good health and with a good education, should earn his living. The appeal to his self-respect failed, however, whereupon she tried to frighten him with the spectre of poverty. But he shook his head, smiled with an expression of gentle stubbornness, and in his drawling, slightly nasal voice, said, ' My dear Aunt, I have sworn never to work, and I don't intend ever to work.' He added that the prospect of becoming a tramp had no terrors for him. When she found that her arguments were of no avail, she had a brilliant idea : put him in the army ! She didn't wait to see what his reaction to this suggestion would be, but marched him off to the Pépinière Barracks and made him sign up for five years. He soon became an N.C.O., but refused to attend an officers' training course because the effort involved was against his principles of professional laziness. He was transferred to the Colonial Army, and after re-enlisting several times he reached an age at which he was allowed to retire, on a pension which was modest but secure. Except for a few skirmishes, minor battles and military landings, which rather amused him, Eugène spent the greater

part of his time in the army improving a network of roads in the jungle. Lying in a hammock, not in the least disturbed by the pick-axes or the shouts of those working under his orders, he languidly encouraged the cohorts of coloured troopers to sweat away for the glory of Western civilization. His subordinates worshipped him because he never raised his voice when giving orders. He never married, as that would naturally have involved a certain amount of expense and to defray it would have meant working. Still, he almost yielded to the temptation once. The object of his passion was a widow. She belonged to a tribe in Central Africa, and was not only coal-black but as beautiful as a piece of ebony. Unfortunately her tribal religion forbade her to remarry until five years after her husband's death. Eugène was sent out on military duty to Indo-China and he gradually forgot his Congolese Venus.

He was very courageous, and paradoxically enough his laziness added to his courage. Once in Indo-China he settled in the wilds, in a hut in which a king cobra had installed itself. Eugène stayed in the lower part of the hut, while the cobra made its home above, just under the palm-leaf roof. ' As a room-mate he was no trouble at all. On the contrary, with him around there wasn't a rat to be seen. I could hear them scuttle when he would come back in the evening. He moved into the beams over my bed. We looked each other in the eye for a minute, and I blew out the lamp. In the morning, when he went out again, the noise of his movements served as an alarm-clock.'

In addition to Russian and French, Eugène spoke Mandarin Chinese fluently, as well as Cantonese, Annamite, and several Indo-Chinese dialects. When he left the army, one of his friends made him the sales representative for the whole of Siberia of a well-known brand of champagne. He loved travelling about in a sleigh. ' If you are well wrapped up in furs you don't get cold and you can sleep.' But he had to sell his product to his customers—and ' that is work,' so he gave up his lucrative job. In 1914, when he was well over fifty, he re-enlisted in the Colonial Army, and fought under General Mangin's command. He took part in several bayonet-charges, and was wounded at Verdun. I still have his Military Medal, the most distinguished of the French decorations—or at any rate the only one that still amounts to something.

Here are two letters from my mother to my father. I had forgotten ' Quiqui ', but they talked to me about him quite often.

## Renoir, My Father

He was, it seems, a mongrel fox-terrier, and a perfect ruffian; certainly not the nice little Pekinese in ' The Boatmen's Luncheon '.

My dear :
Quiqui has just died. He had convulsions. It was all over in half an hour. I am really upset about it. I think I must bring bad luck to animals. I would like to have him stuffed. I am going to ask Lestringuez what he thinks. It will cost thirty-five francs.

<div align="right">All my love,<br>ALINE</div>

<div align="right">Wednesday night</div>

My dear :
The leak in the roof of your studio has not been repaired yet. The men were to come and mend it on Monday, but there was a wedding. Tuesday was a holiday. Today it rained all day, and they say they must wait until it clears up. However, I hope it will be done by the time you come back. I showed Monsieur Charles the drawing for your bed. He will make it as soon as you return. He wants to talk to you about it. You know how stubborn he is. I don't know what he thinks is too high about it. You can discuss the matter together.

I don't know if I will have enough money to last to the end of the month, because we must buy some more material. We haven't enough for the big curtains to hang at the side of the large window where most of the sun comes in. It is on the west side, I think. Monsieur Charles did not understand that we wanted some hung there. Isn't that what you explained to him? The calico curtains next to the beam and the linen ones on the other side.

I shall be able to buy just the number of yards needed. I found a shop where they sell by the piece. But as I have already spent forty francs for you, I am afraid I won't have enough to buy the material. If you are not planning to return before the end of the month, please send me some.

Tell me, my poor dear : Are you cold up there in Dieppe? We are freezing here in Paris.

Are you working hard? Will your portraits be finished

soon? A month seems so long. Our trip this winter seemed much shorter than the past two weeks without you.

Write to me often, and tell me if you are well.

All my love,

ALINE

The ' trip this winter' must have been the one they took to Beaulieu-sur-Mer where the incident of the artichokes occurred.

# 22

Renoir was opposed to all efforts to train young children. He wanted them to make their first contacts with the world around them on their own. If absolutely necessary, he would tolerate applying a little bitter aloes to a baby's thumb, though he thought that might be an abuse of authority. But then he would contradict himself by insisting on a child having just the right kind of colours and objects in its surroundings. His ideas on the subject were not theoretical. He would not have approved of an ' artistic ' environment. His chief desire was to bring us up amidst good plain things, with as few as possible of them made by machines. Nowadays, the price of such hand-made objects would be prohibitive. He liked to think of a baby's eyes gazing at the light-coloured bodices of women, at cheerfully painted walls, at flowers, fruit, a mother's healthy face. He did disapprove, however, of the custom prevalent in the south of hanging bright objects on the side of a cradle, for he thought it was apt to make a child cross-eyed. He objected to extremes such as letting glaring artificial light shine in a child's eyes, or leaving it completely in the dark. As children, we slept with a night-light in the room. He was very sensitive to unusual or loud noises, especially gunfire, asserting that it harmed the child's delicate sense of hearing. But in Renoir's opinion artificial feeding of infants was the greatest crime of all—' not only because mother's milk has been invented, but because a child should bury its nose in its mother's breast, nuzzle it, and knead it with its chubby hand.' In his way of thinking, bottle-fed babies grew up into men ' lacking all the gentler feelings : anti-social beings who would take drugs to calm their nerves—or worse yet, wild animals always fearing they are going to be attacked.' He insisted that babies need animal protection and comfort from the warmth of a living body. ' By depriving them of those advantages, we are paving the way for generations of mentally deranged.' In

his opinion, a mother who did not breast-feed her child deserved the worst kind of punishment. One day he described one of them as being ' no better than a whore'; but he quickly corrected himself, remembering that he had known prostitutes who were intensely maternal and devoted to their children.

A rule that Renoir laid down for older children was that there should be no furniture with sharp edges against which they might bump their heads. The first thing he did when moving into a new place was to hammer the corners off the marble slabs on mantel-pieces. Then he rounded them and smoothed them down with sandpaper. He did it very neatly, too. The corners of the table were given the same treatment, but with a saw. He forbade anyone to wax the floors, and wanted them cleaned with plenty of water. He was especially fearful of glazed porcelain baths. ' It's like stepping on a banana-skin, and you run the risk of splitting your head open.' He would select our toothbrushes himself, preferring those with soft bristles so as not to damage the enamel of our teeth. He felt that any wound or injury reduced the value of the body and also of the mind, and that the physical and the mental were closely bound together. He was very strict about not letting children play with needles or knives, matches or glass, and he saw to it that the panes in the lower part of glass doors were covered with boards. He would not even allow bleaching water in the house. To explain this ruling to Mme Mathieu, who thought it old-fashioned, Gabrielle told her a story which gave me a terrible nightmare. A workman in the saw-mill at Essoyes had come home one night after a drop too much and, wanting more of the same, had drunk from the first bottle that came to hand. The beverage had turned out to be bleaching water, and he had died in horrible agony : ' vomiting his guts out all over the place '.

All cleaning materials and polishes, as well as medicines, had to be kept out of the kitchen. For polishing copper Renoir recom-mended the use of ashes from the fireplace, where only wood was burned. Mme Mathieu and Gabrielle rebelled against this because they said wood ash did not polish well. Nothing was ever to be cooked in enamel utensils. As an example of how dangerous they were, my father told of an incident that had occurred once when he was lunching with Gallimard in an expensive hotel in Nice. He had started to eat the fried eggs he had ordered, when he suddenly bit into something hard. It was a piece of enamel as

large as a coin and thin as a razor-blade. A child, being less careful, might have swallowed it and run the risk of a perforated intestine. He showed the chip to the head waiter, who took it delicately between his fingers, saying : ' This happens all the time, these days. The enamel on our kitchenware is very poor. The last lot must have been defective.'

It was not until I was three years old that I was allowed to see a puppet-show with Gabrielle. He advised against going to the one in the Champs-Elysées, because the puppets wore cheap, over-shiny silk costumes, but sent us instead to the Tuileries ' Guignol ', which had kept to the best tradition of the city of Lyons. I shall never forget the first performance I saw. To start with, I was positively hypnotized by the drop curtain, painted as an imitation of red and gold draperies. What dreadful mysteries lay behind it? The ' orchestra ' consisted of a single accordion, and its harsh sounds made me impatient for the show to begin. When the curtain finally went up on a public square, I got so excited that I wetted my trousers. And I confess that this reaction is useful even now in enabling me to gauge the merit of any new play. I do not mean that I still go quite that far, but a certain desire, fortunately controllable, is like an inner voice warning me, ' Watch out, this is going to be an important First Night.' I once confided my weakness to my father, and to my surprise he replied, ' Me too!' We experienced this delightful sensation when we attended a performance of the ballet *Petrouchka*.

Renoir was fond of the Lyons ' Guignol ' because it had remained faithful to its origins. He was, it is true, little impressed by the sort of tradition taught in schools, because it is tradition in name only. But he appreciated things that had their origin in regional customs. The back-drop in the Lyonnais type of puppet-show represented the quays along the Saône River, with their drab, squat houses, whose monotonous windows looked like mere holes in the walls. The characters were costumed in the dark grey or brownish tones of the skies over Lyons. The whole affair, presided over by Guignol himself with his bicorne and club and Gnaffron in his fur cap, seemed to Renoir an entertainment worthy of any child—an estimate which, coming from him, was no small compliment.

Often friends to whom I have imparted such recollections tell me frankly that an upbringing of that sort is not likely to prepare

a child for the battle of life. They are perfectly right; but my father was not particularly interested in training us to be fighters. Our parents hoped to arm us against adversity by teaching us to do without luxuries and even material comforts. 'The secret is to have few needs.' If my brothers and I had been obliged to live in a shack and eat nothing but cabbage soup, we should have been just as happy. We were forbidden to dislike this or that kind of food. If one of us refused a dish of beans he was sure to get nothing else but beans until he finally decided to eat them. Such severity was motivated not only by the desire to make life easier for us, but also by the fact that in Renoir's scale of values one of the signs of a bad upbringing was for a child to be finicky at table. He might have resigned himself to our becoming beggars : but prigs, never!

We used oil-lamps—the kind a child can knock over without starting a fire. They were very complicated, with a little pump which served to keep the flame going. They gave off a very soft light, a feature Renoir especially favoured since he made a great to-do about protecting his children's eyesight, as well as his own. It was only later on, when I reached the age of reason, that we began to use paraffin lamps. By the time my young brother Claude had reached the mischievous stage, we had electricity. 'With a good shade to protect the eyes from the electric bulb, there's nothing safer.'

I have told how my parents used to dash home from the theatre during the interval to see that my brother Pierre, then a baby, was safe and asleep. After they moved to the Rue La Rochefoucauld they solved the problem by never going out in the evening until I was old enough to go with them.

My mother never used perfume. In the first place she did not care for it, and second she considered that it deadened the sense of smell, like fumes from soft coal or leaking gas. At the first suspicion of a smell everyone would rush to throw open all the windows. Eau de Cologne, on the other hand, she not only tolerated but approved of. In France it is used not as a perfume but as a freshener after bathing. After my morning bath, my mother always rubbed me down with it until my skin was a glowing red. Another article which my father would not have in the house was tallow candles, because they gave a 'vulgar' light. All candles we used had to be of wax.

There were other things Renoir was cautious about. He refused

to use matches that can be struck on any rough surface, because the fumes given off by the sulphur in manufacturing them damage the health of the workmen : he insisted on safety-matches, which are less dangerous to those manufacturing them.

As I noted earlier, any sort of wound or injury to the human body seemed to him a sacrilege. As there is always a danger of cutting oneself with a razor, the use of one frightened him. He would never have allowed my mother to shave her legs. And he did not like my brother Pierre having a clean-shaven chin.

He warned us not to go out in the sun without a hat. He was not so much afraid of sun-stroke as of the effect of the sun's rays on the cerebellum—' especially nowadays, since the idiotic custom of short hair has come in.' It was his belief that the back of the cranium was the centre for sense perception, and for discerning nuances. By exposing that delicate part of the brain to ultra-violet rays, there was a risk of losing not so much the faculty of learning as the more important one of being able to distinguish one grey from another or one sound from another. ' It's all right for people who want to be a Michelet or a Pasteur to go bareheaded, but if you aspire to be a Rubens, it is better to put a hat on.' He would not hear of smoked-glasses, because they distort the value of the colours in Nature. And it infuriated him to think of people looking at pictures through them.

Naturally he forbade slow-burning stoves that stay in all night. He was all the more firm on that point because of two fatal accidents they had caused to people he knew personally—Mme Zola, and my Aunt Mélanie, Edmond Renoir's wife. Gabrielle told how my aunt had been found ' dead in her bed one morning, blue all over'.

Our apartment in the Rue La Rochefoucauld was on the fourth floor, on the corner of the Rue La Bruyère. Whenever I am in Paris I pass there almost every day. I look up and see again the large balcony overlooking the two streets, and I recall the time when it was my special domain.

Fearing that I might climb over it and fall, my father had had chicken-wire put around the top of it. I had a mania for climbing. He had not had time to have the walls painted light grey, and I seem to remember that the woodwork was dark. But up above, the pictures were hung so close that they touched. A visitor would get the impression of entering a brightly-coloured garden filled with plants, faces and figures. To me it was the natural order of things,

and it was only when I went to other people's houses that I had the feeling of being in an unreal world.

Any excursions we made beyond our home limits were always supervised by my mother. My father was constantly in his studio, a short distance from our apartment. As Gabrielle was now a permanent fixture in our life, she had charge of the housework. I continued to call her Bee-bon. She had not yet started posing in the nude and she only went to the studio to accompany me when Renoir wanted me as a model, or when we went in the evening to escort him home. We would return together along the Rue La Rochefoucauld, and I would beg my two companions to stop in front of the gendarmerie. I was very taken with the gendarmes' uniforms, and made up my mind to become a gendarme when I grew up. As soon as we got back to the house, Renoir would see how things were going in the kitchen, which was large and sunny with windows facing south. He would never consent to live in any apartment which did not have a 'cheerful' kitchen. During the day the servants and models stayed in the other rooms. My mother superintended their work, secretly vexed that she could not do it all herself. But she tired very easily. We were eventually to learn the cause of her fatigue. It was diabetes. The remedy for it, insulin, had not yet been discovered. My favourite pastime, when I was not out playing in the Place de la Trinité with Bee-bon looking after me, was getting in everyone's way in the house. Mme Mathieu was still our cook. She never tired of repeating that when her son Fernand was my age he had been going to school for some time. It was an institution run by Brothers, as they were the only ones who would take children too young for the Communal school. When he came home at night his father would always warn him not to believe the lies he might hear from the 'clerics'. 'If they tell you the earth is flat, do as Galileo did : keep quiet, and do your own thinking.'

In spite of Mme Mathieu's pointed remarks on the subject, my father refused to allow me to learn anything at all. ' Not until he is ten,' he said. ' He'll be able to catch up in a few months.' He was to lower the age limit to seven for a very practical reason, namely the birth of my younger brother, Claude. Incidentally he extended his theories about education to include not only individuals but also nations, generations, and even centuries. He attributed the prosperity of America to the fact that Americans were the sons of poor

immigrants who had generations of illiterate ancestors behind them. ' Now that they have opened up virgin country and have schools, the result is astonishing. But their grandchildren, after two generations of educated parents, will be as dull and blunt as we are.'

He did not want me to have my hair cut, when I was a little boy. Certain of Renoir's biographers have maintained that the reason he insisted on keeping my red hair long was that he liked to paint it. That is quite true, but there was another which had equal weight. A thick head of hair affords considerable protection against falls or blows, as well as the danger from the sun's rays. ' If we do not let children have the protection provided by Nature, we then have to tell them to be careful, which is just as bad for their young minds as premature education.'

He rather pitied infant prodigies. ' Poor little monsters.' He would only countenance one, and that was Mozart. ' He had genius, which makes all the difference.' My mother agreed with him entirely on matters of health and the bodily functions, even allowing me to urinate whenever I needed to. And so, even when I was with the most straitlaced sort of people, I would howl: ' Mamma! Bee-bon! Pee-pee!' The society ladies would smile reprovingly, but my mother did not give a rap : and Dr Baudot, my godmother's father, thought she was perfectly right. However, she did not believe in all lack of restraint, as, for example, when Vollard called and I would run to the door exclaiming, ' Mamma : it's the monkey,' or ' It's the Negro, Mamma!' I must have heard Degas refer to him in this manner : for he hated dagoes and had his doubts about Vollard's origins. But my father would say to my mother when she admonished me, ' If you forbid Jean to call Vollard a Negro, he will get the idea that a Negro is an inferior being, and that would be idiotic.' He was always afraid that arbitrary classifications of this kind might induce me to develop a wrong scale of values. My mother's view was that a good spanking would have remedied an attitude that was entirely false, for I was really very fond of Vollard. I remember seeing him again the day I had called him a monkey. He stood in front of my mother, quite abashed, and said, ' Tell me, Madame Renoir, am I as ugly as that ? ' That was Vollard's tragedy : secretly, he longed to be handsome. And he was—but it was apparent only to a Renoir or a Cézanne. For the ordinary run of people he was a strange creature. An Othello in a business suit

would naturally astonish any conventional person. Vollard eventually came to realize that my affection for him was sincere, and that I had had no intention of offending him.

Certain fashions terrified my father. We know his fear of corsets and high heels. His descriptions were so dramatic that for a long time I believed girls perched on high heels could walk only at the price of terrible pain. 'A dropped womb is inevitable,' he told me, forgetting my age. I was six years old and this idea of the womb tumbling down gave me nightmares.

Our sojourns in the South of France grew longer each year, and began to last through the entire winter season. Renoir now knew that he needed the silvery olive trees of Provence just as thirty-five years earlier he had been drawn to the bluish-green groves of the Forest of Fontainebleau. My mother managed to make this change in our existence very smooth. And thus it turned out that, although born in Paris, I was to become a naturalized southerner in my early boyhood. Pierre stayed on at Sainte-Croix, the boarding school at Neuilly; he was perfectly happy, and his teachers encouraged him to go in for theatricals.

From the period when we lived in the Rue La Rochefoucauld onwards, I have my personal recollections of my father to draw on. I can still see him as he looked when he would come to tuck me into bed each night. What strikes me most when I go back to the time when I first began to be really conscious of the world around me is the certainty I have retained of Renoir's unfaltering inner strength. Everything he did seemed to me ineluctable. A child usually thinks of his father as the centre of the universe. I did not. My father was convinced that each being has his particular function on earth, neither more nor less important than that of the next, and he influenced us accordingly. But I had the feeling that what he did in life was what he was destined to do, and that his role was exactly what he had been created for. Instinctively, as a boy, I knew that my father had no doubts on that score. And it was true. 'I didn't know whether what I was doing was good or bad, but I had reached the point where I didn't give a damn.' The cork had found the current which destiny had meant him to follow. Until then he had pretended to accept the advice people gave him, and to have been influenced by it. He soon returned to his own form of expression. I think I have made it clear that his faltering was only apparent, and that beneath the surface of

Claude Renoir (Coco), 1905

Mme Renoir and Claude, 1901

Left to right: Paul Cézanne fils, Renée Rivière (the future Mme Cézanne), Hélène Rivière (the future Mme Edmond Renoir)

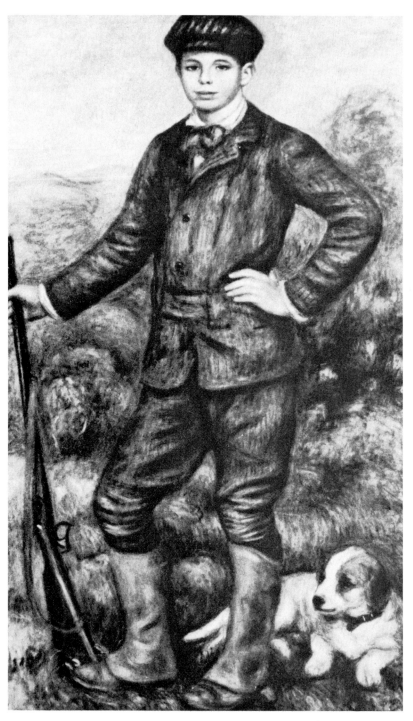

*The Huntsman* (Jean Renoir) by Renoir (1909)

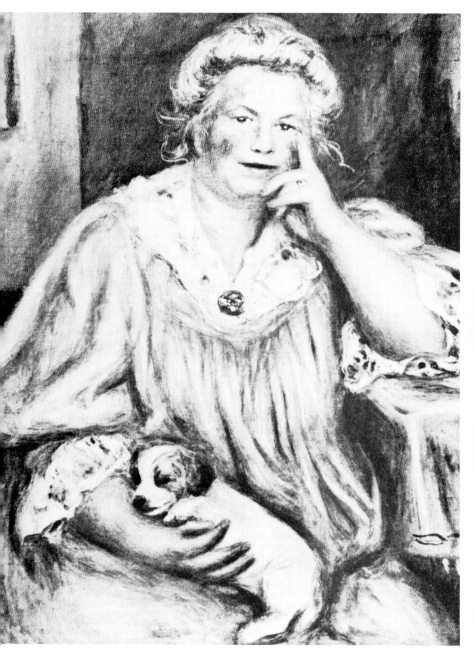

Mme Renoir with Bob by Renoir (1914)

Blanc d'argent.
Jaune de Chrôme
Jaune de Naples,
Ocre Jaune,
Terre de Sienne naturelle
Vermillon
Laque de Garance
Vert Véronèse
Vert Emeraude
Bleu de Cobalt
Bleu Outremer,

couteau à palette
grattoir
épure
a qu'il faut pour peindre

L'ocre Jaune le Jaune de Naples
et la terre de Sienne ne sont
que des tons intermédiaires, dont
on peut se passer puisqu'on peut
pouvez les faire avec les autres coule

Pinceaux de Martre

Brosses, plates en soie

Renoir's palette

Renoir, ca. 1893

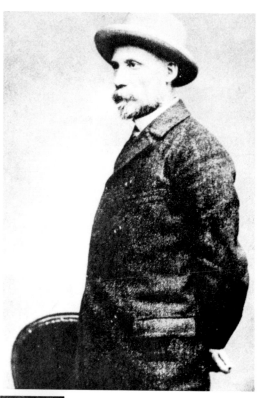

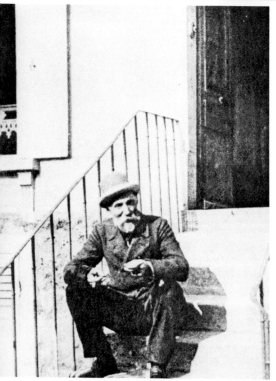

Renoir on the steps of the
Château des Brouillards,
ca. 1895

*Lunch-time* by Renoir (1897). Pierre Renoir reading;
in the background, Jean Renoir and La Boulangère

Gabrielle in Renoir's studio at Cagnes, ca. 1910

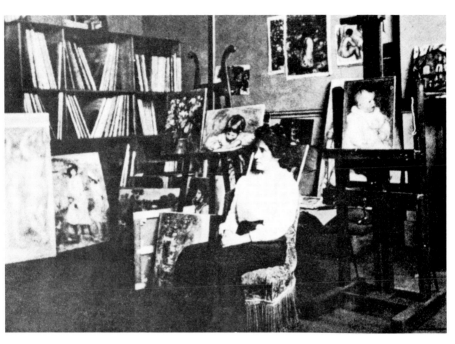

Gabrielle in Renoir's studio in the Rue Caulaincourt, 1902

Renoir and Pierre Renoir in the apartment in the
Rue Caulaincourt, 1908

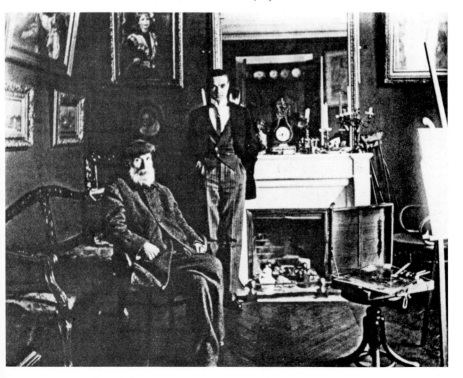

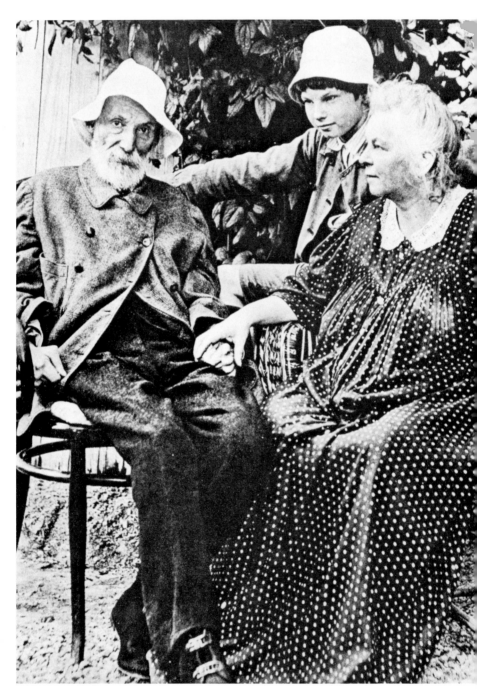

Renoir, Mme Renoir and Coco at Essoyes, 1909

Mme Renoir, 1915

Renoir, ca. 1916

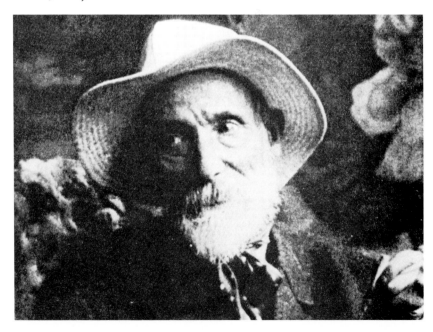

Renoir painting at Cagnes, ca. 1905

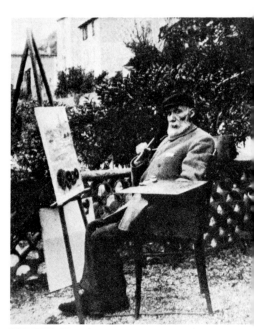

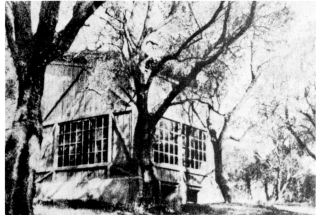

Renoir's studio in
the garden of Les
Collettes

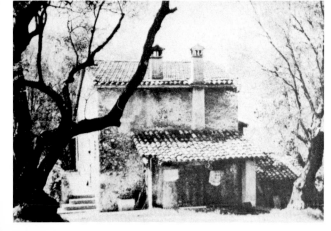

A cottage in the
garden of Les
Collettes

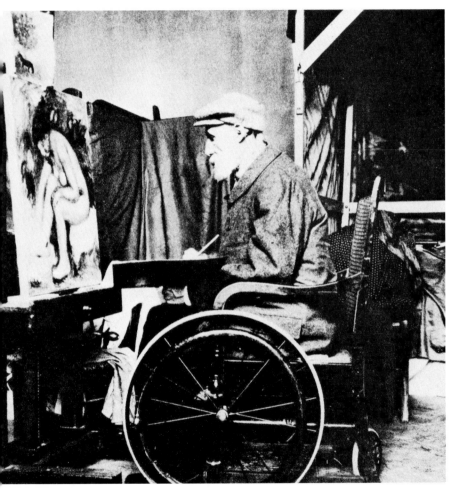

Renoir in his studio at Cagnes, 1914

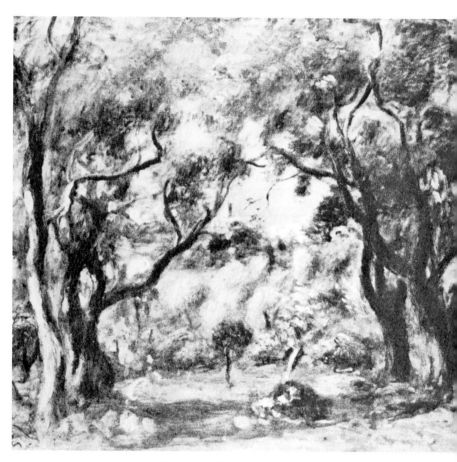

*Les Collettes* by Renoir (1914)

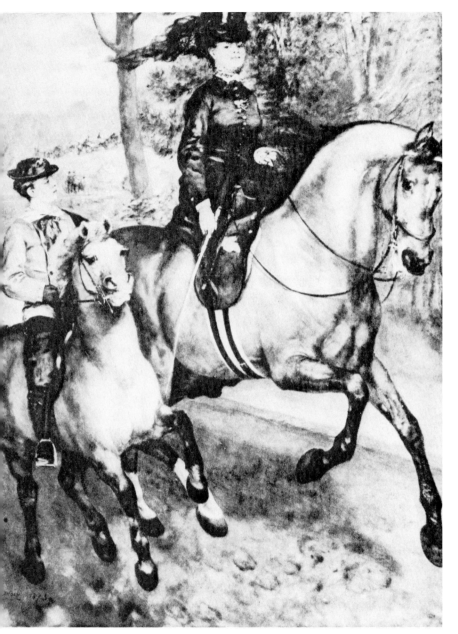

*The Amazon in the Bois de Boulogne* by Renoir (1872)

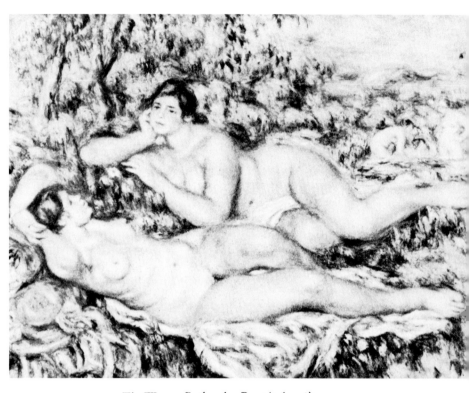

*The Women Bathers* by Renoir (1918)

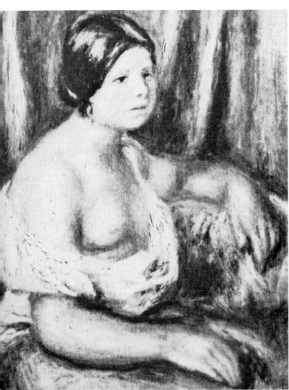

*Woman's Bust* (Madeleine)
by Renoir (1914)

*Nude* (Gabrielle)
by Renoir (ca. 1910)

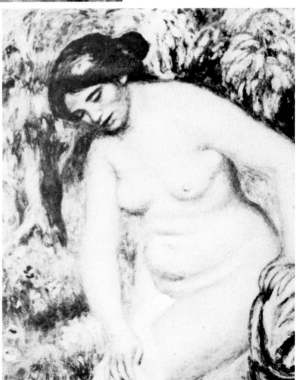

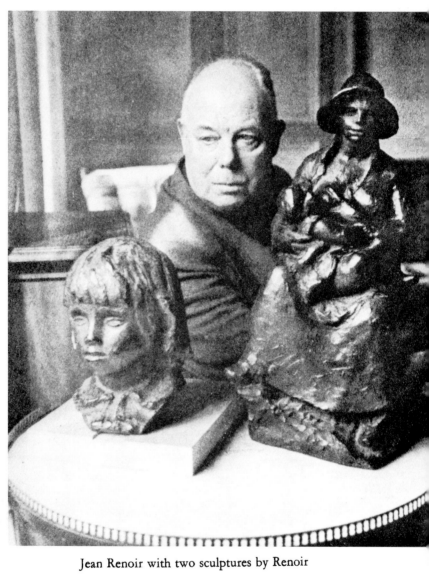

Jean Renoir with two sculptures by Renoir

these hesitations lay a blind unreasoning will. I might even call it a
subconscious will. ' But they made me lose time.'

After the period of the Château des Brouillards, he listened to no
one. He even stopped going to museums. Despite the assertions
and statements he made in his preface to the book on Cennino
Cennini, he no longer looked at the works of the old masters. His
technique took a definite form, uniquely his own. And the older he
grew, the more he cut himself off from all that had been done before
him. If his painting, especially towards the end of his life, attained
the level of the great classic artists, if Renoir joined the company of
Titian, Rubens, Velasquez, it is simply because he belongs to the
same family. Renoir would have hated to hear me say this of him. But
enough time has elapsed since his death to allow me to dispense with
the hypocritical modesty which people affect when speaking of those
near and dear to them.

And so the Renoir for whom I would hurry to open the door the
moment I heard his step on the stairs was a Renoir who had com-
pletely found his way and followed it with confidence. He was in
perfect health, the warmth of the Midi having dispelled the bronch-
itis he was subject to. His mind was more alert than ever. He was
sober in his habits, he went to bed early, he was happy with his wife,
his children and his friends, and he was able to devote an unbeliev-
able amount of time to pursuing the secret that mattered to him most.
By now, much of the mist which had hampered him for so long had
lifted. Many veils had been pulled aside. One discovery led to
another, and he was about to reach the point where he could say to
himself, ' I think I've got it ! ' Among the principal visitors to the
Rue La Rochefoucauld at that time was Paul Durand-Ruel—or ' old
Durand ', as he was affectionately called, though neither Bee-bon
nor I dared to address him in that way. I remember him as a little
man (compared to Faivre, who seemed enormous) ; he was some-
what stout, with a ' Renoir-pink ' skin, well-groomed, with a clean
smell about his person, and impeccably dressed. For a long time,
whenever I read novels about worldly people I would in imagina-
tion see M. Durand-Ruel as the leading character. His little white
moustache was as neat and precise as his gestures. He was always
smiling, and I cannot recall ever hearing him raise his voice. He
intimidated me so much that when I opened the door to him I
refrained from calling out : ' Bee-bon ! Mamma ! It's old Durand !'
Despite my respect, I would confide in him now and then. I would

tell him secrets, such as the one about the butcher's-boy who came to deliver the meat at our house one day and on finding Mme Mathieu's daughter Raymonde alone in the kitchen began to sing the following song, which it seems was obscene:

> ' C'est un p'tit boucher—qui vend d'la bibi—
> qui vend d'la bidoche '

He ended it by starting to take down his breeches, but Raymonde had halted the performance by whacking him with the broomstick. She had asked us not to tell anyone about this incident, as it might give her a bad name. ' A question of honour . . .'

Renoir liked Paul's son, Joseph Durand-Ruel, because of his precision. Paul Durand had transferred the art business from the domain of decoration to that of speculation. Joseph and Georges, my godfather, were, together with several other big dealers, to extend the picture trade to the point where it became a sort of stock-market. If nowadays pictures are quoted like stocks with fluctuations, irrespective of the tastes of the public, the Durand-Ruels are partly responsible. Whether this is a good or an evil is another question. My father was against this kind of speculation even though he had to admit that in the long run it benefited the artist. His distrust of big business did not affect his sincere friendship for the ' Durand boys '. He considered that people of ability should keep abreast of the times. It is their destiny. But though he accepted the methods of modern art-dealers, he could not help regretting that there were no longer any Medicis. ' It's not a picture you hang up on the wall these days, but an investment. Why not frame some Suez Canal shares ? ' Then he added, immediately afterwards, ' When I am travelling, and need an advance from old Durand, I will say it's very convenient.' In conclusion, he said : ' A bank is not a very cheerful institution, but the modern world is arranged in such a way that you can't do without them. It's all of a piece with railways, sewers, gas and appendix operations.'

My mother would have liked to make a match between Jeanne Baudot and Georges Durand-Ruel, and with that in mind she had asked them to be my godparents. Let us go back to the time of my baptism in the church of Saint-Pierre-de-Montmartre. That day my mother had felt rather hopeful of her scheme. The weather was lovely. The gaily-coloured dresses worn by my mother and her friends contrasted sharply with the black of the men's jackets,

# Renoir, My Father

Lace parasols bobbed about among the top-hats, and the tartan waistcoats Faivre and Lestringuez were sporting seemed insignificant compared to the hats the Hugues girls appeared in, huge inverted baskets covered with stuffed birds and silk-petalled flowers. The most admired among the guests was cousin Eugène, in his Colonial Infantry uniform adorned with the medals he had received in far-away lands. Joséphine, our fish-woman, declared it was the finest christening she had ever seen in Montmartre. Jeanne Baudot and Georges Durand-Ruel threw so many of the customary sugared almonds that the children stuffed themselves and had no need to scuffle for more. My father had had a cask of Frontignan wine sent up from the south, and Gabrielle dispensed it to all the guests out in the garden. He had also bought the vol-au-vent at Bourbonneux's himself, and chosen the brioches at Mangin's—'the only decent brioches in Paris'.

Those invited were the usual circle of friends : all the Caillebottes, including the youngest brother, who was a priest; Faivre, Lestringuez, cousin Eugène, various neighbours, and so on. The presence of the Abbé Caillebotte had a tendency to inhibit the company at first. But when he told the story about the woman who had come to his confessional and asked permission to take her bath completely undressed, everyone felt more at ease. Faivre said he would like to change clothes with the priest. My brother Pierre was usually silent, but after drinking a little of our Essoyes wine he recited some verses from the battle scene in *Le Cid* to the young girls from next door. Over dessert, Faivre started to tell a risqué story. My father gave him a kick under the table to remind him that Jeanne Baudot was present. He would not allow anything off-colour to be repeated in front of young girls. True, his favourite authors included La Fontaine, Boccaccio and the Queen of Navarre, but he held that the daughters of his friends would discover these authors themselves in due time. To be precise, he was afraid that the salacious tone some people used in telling broad stories might give young listeners the stupid idea that very natural things are smutty. He had an immense respect for other people's opinions and rules of conduct. And since most parents frowned on this brand of humour, it was not his place to inform children that their parents were mistaken. Some day, human minds would be liberated from prudery and Renoir contributed to the cause by painting nudes of a purity unequalled in the whole history of art. In any event, his

respectful attitude towards women was often described to me by his friends, who defined it as chivalrous. ' Renoir,' said Rivière, ' could have lived in the days of the Courts of Love.'

After the baptism luncheon everyone got up from the table and strolled under the trees at the Château des Brouillards. Some of the guests went to look at the goat M. Griès had just bought. In spite of the hot weather, he was wearing his rabbitskin cap as usual. When my godfather got ready to leave, he kissed my godmother, Jeanne Baudot, goodbye. My mother called my father's attention to it, and he was very pleased. A few days later, Georges Durand-Ruel invited my parents to dinner to meet a lady whom he introduced as his companion. She was an American whom he had met in the United States, where he often went on business—for the Durand-Ruels were to build a place on East 57th Street in New York for their gallery there. My father and mother found Georges's young American friend ' perfect ', and put aside their matrimonial plans for him.

My godfather spoiled me dreadfully. One day when he came to the Rue La Rochefoucauld he brought me a Polichinelle—a puppet as big as myself. As soon as I saw it I yelled with horror. I don't know why I hated this character in his English form as Mr Punch. I only liked the Neapolitan one, dressed in white clothes too big for him. I had a passion for toy ' soldiers of Napoleon ', and I had any number of them. My father liked them too. He was partial to the lead ones made in Nuremberg. When one of his friends told him that my taste for such playthings would make a militarist of me, he retorted, ' In that case, we would have to keep building-blocks away from him because they might make him want to become an architect.' It may be remembered what a poor opinion he had of architects. The same friend protested even more when he saw my brother Pierre playing with a miniature altar equipped with all the necessary accessories for saying Mass. ' What are you going to be when you grow up?' my father asked Pierre. 'An actor,' came the quick reply. Renoir meditated on this for a moment, then said to his friend, ' Perhaps you are right ; an actor and a priest are pretty much the same.'

It was through my godfather Georges that I discovered many interesting things. To his kindness I owed my first gramophone, an early model, with the records made on cylinders. By pressing a button on the machine, the needle could be replaced by a tiny blade,

which recorded sounds spoken into the horn. With this gift came a record which he had made himself, wishing me a Happy New Year. When I heard his voice come out of the machine, I shouted for joy and roused the entire household. Straight away I made a recording of Bee-bon's voice. Cousin Eugène, who happened to be present, shrugged and declared that 'the twanging machine' was still far from perfect. For my father, the gramophone presented another danger to our civilization. 'What with the infernal noise of motor-cars, this machine may play its part in destroying one of our greatest blessings : silence.'

Also thanks to my godfather, who had a country place in the Périgord region, I was to make my first acquaintance with truffles served whole, like potatoes, and not in the form of miserable little slices in pâté de foie gras. In addition to all these wonders, it was from my godfather that I first heard about America. I made him describe the Pullman cars to me time and time again. I was fairly bursting with pride, therefore, whenever he came to the house, and I would exclaim to all and sundry, 'Bee-bon ! Mamma ! Papa ! It's my godfather ! '

Dr Baudot remains one of the persons most closely connected with my memories of Renoir. He wore a frock-coat, and kept to his high-hat, known as a 'stove-pipe', for many years, only giving it up in favour of a homburg, which was then a sort of compromise between the top hat and the bowler. This last seemed too frivolous for him. He had a mottled complexion, and iron-grey side-whiskers. His lower lip protruded a little and was purplish. His eyeglasses hung on a black ribbon, and he was continually lifting them to scrutinize everyone he met. He was a first-rate diagnostician, and he always inquired politely after everyone's health. As soon as I entered his house he would hoist me on to a great wooden chest, which served as a bench in the hall, where the light from the window was excellent. He would inspect my eyes, take my pulse, and make me stick out my tongue. His conclusion was always the same : 'Twenty grammes of sulphate of magnesia.' For adults he would prescribe as much as thirty grammes. Such an innocent remedy caused endless arguments between him and the employees of the Western Railway Company, whose health he watched over with a paternal eye. They implored him to prescribe expensive medicines, with showy labels and magical names. Sulphate of magnesia only cost two sous. How could any-one have the slightest faith in a cure as cheap as that ? But Dr

Baudot was adamant. As he explained to my father : ' They are not ill. French people as a rule are fairly healthy. All that's wrong with them is that they eat too much. Good food, an apéritif before meals, and a little glass of brandy after, to help the stomach : I approve of that. So why deprive yourself when you can get rid of bodily poisons with a harmless dose of magnesia ? ' His office was huge, with large windows looking out on the glassed-over platforms of the Gare Saint-Lazare—the one Monet had painted thirty years before. Gentlemen with gold buttons and braided caps would come in every few minutes and talk respectfully to Dr Baudot. But I sat in my corner and never let out a peep.

At Christmas-time when I had eaten too many marrons glacés I would be made to take a dose of our friend's favourite medicine in a glass of tepid water. It was awful. Next I would be given a glass of lemonade, equally warm, in order to get rid of the magnesia. I would imagine that I was very ill, and swear to myself never to touch marrons glacés again. And I would keep my resolution for several weeks.

Dr Baudot was an excellent doctor, and a psychologist as well. My father was opposed to this theory of ' stuffing oneself and then taking a purge '. He was for moderation without sulphate of mag-nesia. However, in order not to hurt the good doctor's feelings, he pretended to purge himself once a month.

One person whose arrival always put Renoir into a good humour was his friend Gallimard. ' A real eighteenth-century Frenchman.' I think I am right in saying that his wealth came from property his family owned in Neuilly. One of his grandfathers was a nurseryman, a fact which conjured up in my father's mind dreary stretches of fields marked off at intervals by glass frames, ' with the sun re-flected from them glaring in your eyes '. He had nothing against the idea of this hateful landscape being transformed into a series of ' miniature Trianons ' for kept women, though with one reserva-tion : ' You see nothing but walls. Something interesting may be going on on the other side of them ; but the streets look sinister.' He liked streets where there were shops and people ' busy with their own little affairs '. He said, further, of Neuilly, ' A very pretty cemetery, but I prefer Père Lachaise.'[1]

Gallimard had deserted Neuilly for the Grand Boulevards. He

[1] The well-known cemetery on the east side of Paris where many famous people are buried. (Trans.)

always brought in with him the magic atmosphere of 'Parisian life'. He reflected the glory of the brilliant performances which took place in his theatre, the Variétés. My father often used to repeat passages from *Orpheus in the Underworld* to us, asking Abel Faivre to sit at the piano and play him some of the Offenbach airs that he especially liked. Consequently I developed the greatest admiration for this visitor who was on such intimate terms with Jupiter, Cupid and La Belle Hélène. The latter character was impersonated by the actress Diéterle. Even off-stage she kept all the glamour of Offenbach's goddesses. She was a striking blonde and she had 'a milk-white skin and freckles'. She was only too pleased to pose and Renoir did several portraits of her of which one was at her villa in Chatou. Her father was a retired army captain, very meticulous and a great stickler for etiquette. He was simply delighted when Gabrielle would stand at attention in front of him and address him as 'Mon Capitaine'.

Another familiar face at our house was a man named Murer, owner of a famous pastry-shop, and an amateur painter. He was a great friend of Dr Gachet and often went to visit him at Auvers. Gachet's name is associated in my mind with Margot, a little girl I never saw. Her family was called Legrand, I think. My father spoke of her to me several times. Margot was very ill. He asked Dr Gachet to treat her. The doctor did the best he could for her, but to no avail. Margot's suffering brought the two men together, and they spent hours at her bedside. She must have been very beautiful, very touching and very courageous ; and she would keep smiling in spite of the frightful pain that racked her. Paul Gachet, the doctor's son, published the letters his father and mine exchanged on the subject. In them Renoir speaks of small-pox pustules. When Gachet was suddenly confined to his bed with lumbago, Renoir had to watch over Margot by himself ; and in his distress he hoped that death would soon release her. He called in his old friend Dr de Bellio, who saw at once that the child was lost. Nevertheless, at my father's request he prescribed some medicine in order to make her believe she could be cured. But on 25th February 1879 Renoir had to notify Gachet that Margot had died.

This mysterious little dead girl touches me deeply. Who was she? Why did she interest Renoir so much? Who were her parents? Where were they during her illness ? These were enigmas also to Paul Gachet, who wrote to me about her. So I can only envisage

the blonde head lying on the pillow, the pustules, and her distracted smile as she gazed up at her devoted friend leaning anxiously over her.

The painter Deconchy, with his spade beard, mischievous eyes and round felt hat, played an important role in the life of my family. He it was, indeed, who first advised Renoir to go and paint at Cagnes. For he, being in delicate health, used to go there every winter in the days before it was discovered by tourists. A few quiet English people in search of warmth would go and stay at the Hôtel Savournin, in the Lower Town, through which the main road passed at that time. Deconchy fell in love with Mlle Savournin, the hotel-owner's daughter, married her and brought her to see my parents in the Rue La Rochefoucauld. She and my mother took to each other at once, and their friendship was instrumental in helping my parents to decide to go to Cagnes. It was a decision which was to have far-reaching consequences. For the little town and the surrounding country were to take possession of Renoir and his family just as they had done of Deconchy.

# 23

My mother was well aware how important it was that the material side of Renoir's life should be as genuine as his painting. It is to her that my brothers and I owe the good fortune of growing up in a simple environment in which nothing trashy was tolerated. We had unpainted wood furniture which was very much in accord with Renoir's taste. He could not abide fancy modern furniture that had no 'hand-made' look about it. He even had an aversion to certain antiques. I recall how scornful he was, for instance, about the earthenware of Bernard Palissy : ' He burned his authentic Renaissance furniture in the kiln to make his china fruits that look as if they were made of soap.' I have already spoken of his contempt for the products of Meissen and Sèvres. And Gobelin tapestries annoyed him intensely. He approved only of those woven with low warp, as ' high warp makes it possible to copy slavishly pictures unsuitable for tapestries—or worse yet, to imitate Nature ! ' He put celluloid combs at the very bottom of the scale, as well as oilcloth table covers and butter served in small pats or shell shapes. As for margarine, he insisted that either you should do without butter or have real butter, served in one great lump on the table.

In contrast with these small refinements, Renoir found displays of glass and tableware pretentious. ' A clutter of knives, forks and glasses of all shapes and sizes just to eat a boiled egg and drink a drop of cheap wine.' I should add that our meals consisted of one main dish, and as a rule we had only one kind of wine in our cellar. The wine was shipped to us in casks by the wine-grower. While we were at the Château des Brouillards, the bougnat in the Rue Lepic would come to the house and bottle it for us. We would have thought we were falling pretty low if we had gone to buy it at the grocer's. Renoir was suspicious of old wines : ' they are too

heavy and you can't drink them, you have to sip them slowly. It turns into a sort of ceremony, until you almost think you are attending Mass.' He made fun of the 'connoisseurs' who when tasting wine run it over their gums as if using a mouth-wash, and then lift their eyes to heaven in ecstasy. 'They don't know a jot more about it than I do.'

My mother continued to keep open house every Saturday night, and she carried on the tradition of the pot-au-feu. That does not mean, naturally, that if a friend turned up any other day he would not be sure of sitting down to a good meal. Gabrielle would run to the butcher's for a steak while Raymonde prepared the salad. My mother had a number of servants in the house, because as models 'their skin took the light', and also because, owing to her shortness of breath, she had long since given up cooking. But Heaven had endowed her with a gift for directing others, and the meals we enjoyed were well and truly hers. She had collected recipes here and there, including those given her by Marie Corot, but she had adapted them to her own uses—or rather, to suit her husband's taste.

When we did not have guests in for a meal, we usually ate grilled meats or boiled dishes. We avoided as much as possible anything fried or stewed. Bouillabaisse was served only on special occasions, as well as chicken sauté, which my mother considered one of her greatest triumphs. To prepare it she cut the chicken up in pieces, which she browned in a heavy casserole with a little olive oil. As soon as the pieces were ready, she put them aside on a warm plate. The oil was then thrown away, and the chicken put back in the casserole with just a dab of butter. Next she added finely-chopped onions, two peeled medium-size tomatoes, some sprigs of parsley and thyme, a bay leaf, a clove of garlic, salt and pepper, and a very little hot water. The mixture was stirred from time to time to avoid burning and allowed to simmer over a slow fire. A few mushrooms were thrown in half an hour before serving ; Greek, Italian, or Provençal black olives ; and the chicken-liver. At the last moment a little glass of brandy was added, and the lid of the casserole left off to let the fumes evaporate. When serving, she sprinkled chopped parsley and garlic over the dish.

Our favourite treat was potatoes baked in the ashes ; and in winter, chestnuts done the same way. My mother's cooking was, like herself, quick, uncomplicated, definite and orderly. No smell of burnt meat and no scraps left about, the oil and butter used were

fresh each time, and the cooking-utensils were thoroughly scrubbed afterwards. She fitted in well with Renoir's rule of making plenty out of little. Use only the best, but frugally. He rather mistrusted people who did not drink wine. 'They are secret drinkers,' he declared : and he said of those who did not smoke, 'They must have a secret vice.' My mother had the keen appetite ' of a cat '. Renoir remarked that it was her way of paying tribute to Ceres and Bacchus. He refused to believe that the Greek gods had entirely given up the game.

In the Rue La Rochefoucauld days we used to go down some-times on foot to the Grand Boulevards, because my father liked the life and movement there. One warm day as we were walking along my mother said she would like a glass of beer in one of the cafés. When we sat down at a table on the terrace, my father discovered that he was out of cigarettes. My mother suggested sending me to buy some for him.

'What ! Let him go by himself on this crowded boulevard ? '

'Why not ? ' my mother answered. ' He'll have to get accus-tomed to it some time.'

I knew the tobacco shop well enough, as it was at the beginning of the Rue Laffitte, next door to Vollard's gallery. I was so pleased at the idea of being allowed to go on the errand by myself, ' like my brother Pierre ', that Renoir gave his consent. I started off, then, repeating to myself the message I was to give the tobacco woman.

Owing to my long sojourns in my mother's native village, I had acquired a resounding Burgundian accent. I could roll my r's as well as Colette Willy herself. Much to my annoyance, it made people laugh. As I went along, I worked out a sentence for myself which did not contain the treacherous letter : ' Would you please give me a packet of "*jaunes* ", madame,' thus avoiding the words ' Maryland cigarettes '.

All at once I became aware that I had gone far beyond the tobacco shop and had reached the church of Notre Dame de Lorette. Dis-mayed at the thought that my parents might be uneasy about me, I turned round and ran back as fast as I could, only to find my father looking pale and sick with alarm.

' I thought you'd got run over.' And then, by way of reaction, he suddenly became angry. ' Did you ever see such a muddle-head ! You'll never be any good.'

I burst into tears, and could not eat the ice-cream that had been ordered for me.

My father sulked for an hour or so. But he forgot all about it as soon as we got back to the house, and started painting some eels, despite the protests of my mother, who wanted to cook them with wine and onions. When I heard him begin humming to himself, I forgot my own wounded feelings and got out my lead soldiers to play with.

'You know,' he said, ' it's not only that the traffic might run you over. There are kidnappers who might steal you. Or the Salvation Army might get you and make you sing with an English accent.'

# 24

The accident which was to turn my father's life into a martyrdom was a fall from a bicycle in 1897, at Essoyes.

Essoyes, where my mother and Gabrielle were born, has remained more or less unspoiled. There is no other place like it in the whole wide world. There I spent the best years of my childhood. My enchantment used to begin as soon as I got within ten miles of the village, when the train from Paris had passed the flat plain of Champagne and entered the hilly region covered with vineyards near the hamlet of Bourguignons. One can still see the big stone post set up by the kings to indicate the boundary-line between Champagne and Burgundy. And the countryside has the same aspect as all regions that produce good wine : a river at the bottom of a valley. In this case it is the Seine. Down below there are meadows with cows, while along the slopes are woods or vineyards. At the top, the land flattens out into long plateaus, more or less arid. In Essoyes we call them waste-lands ; they are covered with flat stones, a regular paradise for vipers. These flat stones are used for constructing huts with thick walls and stone roofs, which keep them so cool in summer that the vineyard-workers used to tell us to put on our coats when we went inside to rest.

The Seine tributary which flows through the village is known as the Ource. Its banks are shaded by fine trees. Long, waving weeds cover its bed. The Ource follows an irregular course. That is doubtless one of the reasons Renoir liked to paint it. Farther along, the stream becomes sluggish, and the water turns a greenish hue, covering what seemed to us unfathomable depths. The natives of Essoyes call such places ' holes '. There was, for instance, the ' Hole of the Poplars ' ; and the ' Cow hole ', because a cow had drowned there. Parents forbade their children to go near these ' holes ', warning them that if they fell in they would be as helpless

as a fly in a funnel when wine is being poured into a jug. The places Renoir liked better were those where the Ource is shallow and runs over pebbles. 'It's like molten silver,' he said. And those silvery reflections are to be seen in many of his pictures. My father felt well whenever he was at Essoyes, and as he covered his canvases with colour would enjoy having us around as well as the villagers. Essoyes is far enough away to the east to escape the effects of the weather in the Paris region. Its weather is what might be called 'Continental', and the air sweeping over the waste-uplands is as sharp as it is in Lorraine. The people's accent matches their weather. Unfortunately the influence of wireless now tends to make all Frenchmen speak much alike. I am sure that only the old people in Essoyes understand the local dialect I knew when I was a boy.

Gabrielle had not forgotten the first time 'the boss' appeared in Essoyes. My mother had gone there ahead of him and rented a house in the outskirts on the Route de Loches. It was just opposite the house of Paul Simon, who owned the wheat-fields and was therefore held in contempt by the wine-growers. And next to us lived Royer, the stone-cutter, who carved tombstones. The back door faced the Petit Clamart path: a clump of large trees surrounded by a high wall, situated in the middle of the plains extending from the river to the slope of the Terre-à-Pot. At Essoyes a slope really means a hill. 'Clamart' is an old word for cemetery. It was said that a Jacobin of 1792 was buried in the Petit Clamart. He had caused so many priests to be guillotined that when he died the one at Essoyes, feeling more secure with Napoleon in power, had refused to give him Christian burial. Hence this private burial-ground.

Gabrielle, who was eight years old, used to play with her three little cousins in the courtyard of the house. In Essoyes every house had a courtyard, giving access to the barns. And in those vast stone, windowless constructions with huge doors stood the vats in which the grapes were left to ferment after the vintage-season : enormous wooden cylinders which made me think of the towers of a Merovingian fortress. And how cool those barns were, in spite of the Burgundian sun, which I remember beat down pitilessly in summer. Our voices would echo from the limestone walls and the wooden vats, adding to the atmosphere of mystery which filled the place.

At that time my mother was thirty-one years old. 'She was already well filled out but not fat—and very active.' That was

Gabrielle's description. ' She would give us nice fresh bread and a big bar of chocolate. Pierre was a little boy of two, dark and with beautiful curls. Then your father appeared, carrying his paint-box and easel. My cousins and I thought he was very thin, poor man.' Gabrielle came to the house often to see Pierre, and also because of the chocolate. 'We didn't see much of the boss. He would go off by himself to paint in the fields. People said he tried to sell his work in Paris. And they said he was not at all like other people.' When he returned from the fields he liked to stand in front of the large open fireplace and warm himself with his back to the fire. In those days people living out in the French country did almost everything in or around the fireplace, except baking the bread, which was done in the big oven in the oven room. ' Funny idea to like a wood fire when in Paris you have a fine cast-iron stove with nickel trimmings ! ' Gabrielle had a memory like an elephant, and it enabled her, some seventy-five years later, to re-tell me, word for word, what her fellow-townspeople had said about the strange visitor from the city. ' It wasn't exactly that he frightened people. They saw that he was not like the others. It's only that they thought he was puny. As a rule they only liked fat people. Although your mother was well filled out, she was' considered delicate. Your grandmother Mélie was handsome, because she was built like a wardrobe. The queer part is that your father was not really thin. Your mother said so, and I saw it for myself, because I was never off your doorstep. But there you are : his face didn't seem to do him credit. He didn't drink, and that made people think he was ill. He never talked politics. He wore old-fashioned cravats. But everyone liked him in spite of it. Even Mother Bataillé, who wasn't a bit sociable, let him paint her kids. Nobody but he would have dreamed of seeing poor people like the Bataillés, and finding something good about them, and saying that he liked their place. One of their little girls he liked to paint became the grandmother of Félix Suriot, the man who married your cousin, Bellalahem-hem. Bellala's real name is Madeleine Mugnier. The other name came from her pronunciation as a baby, and it stuck to her.'

' They respected his silence.' Gabrielle's phrase moved me greatly. On one side of the fireplace the stew was simmering ; on the other, the daughter of the house heated her flat-irons ; in the centre above the flame the soup cooked in the big cast-iron pot hung on an iron hook. It was nearly always ' red pea ' soup, with bacon

fat. The word for ' bean ' is unknown in Essoyes, and these ' peas ' were of the red, or 'kidney', variety, which grow among the grape-vines. Our cousins would never have eaten field beans. They were fit only for farmers and pigs. Potatoes were looked upon with the same contempt—' Only good for piglets '—and the same applied to the big red plums called ' pig-plums '. Renoir also liked to see the dough kneaded in the big carved oak kneading-trough, which ex-tended across the whole side of the main room. Then he would watch the oven being heated with faggots of small wood ; but never with logs. When the stones inside were red-hot, the embers were pushed back into a corner with a kind of toothless rake. Then any-thing and everything that can be baked was put in : loaves of brown bread as big as the backside of a pretty woman ; back bacon from a freshly-killed pig ; huge round trays of tarts made with whatever fruit was in season—cherries, plums, greengages, black-currants, grapes, and later on, apples. Renoir much preferred the fruit from those twisted trees, which were as stunted as the vine-stalks around them, to the magnificent displays in the expensive Paris fruit-shops. Although not much of a drinker, he liked the wine of Essoyes better than any other—a wine without a trace of sugar in it, as sharp as the east wind that sweeps over the sloping vineyards, the product of soil composed mostly of stones with very little earth. After heavy rains the wine-growers had to carry back, in large wicker baskets, the earth which had been washed away. The yield from this poor soil was a good illustration of Renoir's philosophy : ' Try to create much out of little.' Renoir liked the wine of Essoyes because it was never diluted or mixed. In Essoyes no wine-grower would have thought of improving wine by strengthening it with another wine made from better-exposed grapes. By sampling the wine in a silver wine-taster any citizen of Essoyes could tell where it came from : ' This is from Colas Coute's place, over on the Côte-aux-Biques ' ; or, ' This is a pinot from Larpin's vines.' Larpin's vineyard, planted entirely with pinot vines, well exposed on the middle of the Mallet slopes, was regarded as the best in the region. Respect for the origin of the wine is still prevalent in France, at least when it is a question of famous vine-yards, every cask of which has been wrested from a few hundred square yards of land. A certain soil gives the wine a taste of the flint which abounds in those parts, another soil which may be more clayey gives more body, and still another soil, more bouquet.

## Renoir, My Father

Renoir said that the influx of bounders was responsible for starting the modern vogue for wines 'improved' by blending. 'One is just like another : and that makes life boring.' His taste in wine was the same as his taste in art, and the blending done by the big wine-distributors in Paris seemed to him as depressing as the manufacture of mass-produced furniture. Within a particular wine he sought to discover the wine-grower and his vineyard, just as within a land-scape painting he sought to discern the hand of the painter and the scene which had inspired it.

'I liked being with the wine-growers, because they are so generous.' They are often improvident, too. They don't have the peasant's mania for saving. They work hard the year round. In summer they are already out working in their vineyards by day-break, and they often live quite far away. The Terre-à-Pot is at least three miles from the village. The Côte-aux-Biques starts just behind the police station, but it extends as far as Fontette, on the plateau, the village noted for its good cheese, and for the famous Countess de la Motte, the chief figure in the notorious Necklace Affair just before the French Revolution. Her château is still there. There is also ' en Sarment ' with the Sarment fountain, a spring which never dries up ; and ' en Charmeronde ', from where you have a pano-ramic view of the Seine valley, with the large statue of the Virgin which protects the harvest of the people of Gyé. When the vine-yard-workers return home in the evening they enjoy a good dinner in their fine houses. When money begins to come in, they spend it lavishly. They buy clothes made of the very best material, and order a magnificent tombstone from Royer. Although absolute un-believers, they have put up an impressive freestone church, which incidentally is rather ugly. Renoir liked the little church of Verpillières, three miles away, much better. It is huddled together under its roof, which undulates like an animal's hide. Its Roman-esque windows and its bare walls have a great dignity. A huge elm once stood in front of the door. It had been planted when Joan of Arc passed through the place on her way from Lorraine to Bourges to see the King in the hope of persuading him to drive the English out of France. She had slept in a convent at Val-des-Dames. The elm had been cut down, and the memory of the convent was lost in the night of time. But the ' fountain ' still flows. The water wells up out of the earth inside a sort of vaulted cave, and it is so pure, so clear, you can hardly see it. Strangers who stop there and wish to

quench their thirst suddenly find the water washing over their feet. In my father's day there were three wooden statues on guard, one of the Virgin Mary, one of Saint Joseph, and one of Saint Genès. The older inhabitants like to tell a tale of how the three saints sometimes quarrelled, which led to conversations such as this :

' I hear wind, I hear wind,' said the Virgin.

' Who did it ? Who did it ? ' demanded Saint Joseph.

' One of us three. One of us three,' replied Saint Genès.

Gabrielle also told this about my father : ' He[1] went to see my great-grandmother, your mother's cousin Cendrine. He made the others talk, while he listened and had a good time. There were some who said he didn't talk because he had nothing to say.'

I have never been able to find out if Cendrine was a nickname, of the order of Cendrillon (Cinderella), given her because she spent so much time around the fireplace ; whether it was because she used a great deal of ashes when doing the laundry ; or whether it was perhaps a diminutive of Alexandrine. For her supper every night she soaked pieces of toast in a bowl of hot wine and sugar. One day while everyone was listening to cousin Lexandre, Cendrine's son, my brother Pierre sneaked off with the saucepan in which the mixture was being heated, and drank it all up. Cendrine was terribly upset at having lost her supper—but my mother was afraid that Pierre would die from the effects. In Essoyes, where wine is given even to new-born babies, no one could understand why she was so alarmed. Everyone thought she was mad, and that living in Paris gives one queer ideas.

Lexandre amused Renoir. He had the reputation, deservedly or not, of being a satyr, and he was proud of it. When he happened to go out to the vineyards, the young girls filling their kegs with water at the fountain would take to their heels. 'But not the old ones,' as some gay dog remarked. To avoid losing the good opinion of his fellow-citizens, Lexandre would occasionally go for the tough old birds. When anyone made fun of him about it he would declare : ' I don't give a damn ! I throw their skirts up over their mugs, and then I don't see a thing.'

In spite of his lack of conversation, the villagers adopted my father wholeheartedly. Cousin Lexandre told him confidentially, ' We had a Negro here. He married the Ginelot girl. He was a good

[1] Whenever I talked with Gabrielle, she never said to me, ' your father ' or ' Renoir ', but always spoke of him as 'he' or 'the master'.

worker in the vineyards.' When little girls came across Renoir in the
fields they would whisper to each other, ' There he is, daubing,'
so as not to disturb him. He would call to them, and they would
approach slowly, lowering their heads and twisting the corner of
their pinafores. ' He could kiss a goat between the horns,' they
thought when they looked at his thin face.

Like people everywhere, the natives were fond of using clichés.
On meeting anyone in the street they would say, ' Oh, so you're
awake ', or, ' So you're up ? ' even though it might be the middle
of the afternoon. Obviously, each knew that the other was awake or
out of bed ; but by exchanging these little familiar greetings, they
felt less lonely in this vast world. Renoir said ' Good-day,' and noth-
ing more. And the inhabitants would remark knowingly, ' He
has nothing to say,' thus implying that his thoughts were too
profound to be put into words. My father and mother did not go
back to Essoyes for several years after that. If Gabrielle had not
emigrated to our home in Paris at the time I was born, she would
have gone to live with her relatives at Verpillières and would never
have seen my father again. ' But I would not have forgotten that
funny man who daubed.'

I come now to the accident.

Our cousin, Paul Parisot, had his shop near the Porte des Ternes
in Paris, where he sold, repaired and even manufactured bicycles.
Whenever he came to see us we were lost in admiration of his
beautiful bicycle, a shiny model and absolutely noiseless. He would
lift it with one hand to show how light it was, and with the other,
turn the pedals and make the back wheel spin till it glittered like
fireworks. My father would hold me close to him, out of range, for
fear I would try to touch that magic circle. ' It could cut off your
finger.'

Almost all the young painters who came to see Renoir when
he was at Essoyes rode bicycles. Among the Paris friends were
Albert André and his wife Maleck, d'Espagnat,[1] Matisse and
Roussel. Abel Faivre was a keen cyclist. M. and Mme Valtat rode
a tandem. I recall a picture, certainly painted at Essoyes, which
shows Valtat in knickerbockers seated on the grass near a young
woman, who might be Georgette Pigeot, a Paris dressmaker who
often posed for Renoir. The boys in Essoyes all went out bicycling,
too. They went to and from the vineyards on their bicycles. When

[1] A French painter who was influenced by Renoir.

they started work in the morning, they fastened their tools to the frame and pushed the machine along. The village lies in a bowl of hills, and the roads are steep up to the top where the vines are.

My father finally decided to do as everyone else did, and he had cousin Parisot send him a bicycle. Abel Faivre taught him how to ride it. He never used it when he went out to paint, as his equipment was too cumbersome, but he found it convenient when he was searching for subjects, which he noted down with a few quick pencil-strokes on his sketch-pad.

By 1897 my mother had installed us in a part of our own house at Essoyes. The studio which I mentioned some pages back was not built until a little later, after we had acquired the house next to ours. It was not until 1905 that she planned another studio, which Renoir thought ideal, at the far end of the garden near the saw-mill belonging to M. Decesse. It was there that he tried out a bit of sculpture—'a notion I had running around in my head'—with the sculptor Morel, a native of Essoyes, who was then quite young. The garden contained a vineyard and fruit trees, which made it very pleasant. Before his first studio was built, Renoir had practically no room where he could work. Yet he could make do with little. On the south side of the house a beautiful chestnut tree, which he would never allow to be cut down, cast reflections that interfered with his work. On the opposite side the north light, which most painters prefer, annoyed him. It was only a help to him in Paris, where trees are an unimportant factor. The lack of a studio was always a problem in all the country places where we lived. On rainy days he made drawings. But in 1897 our house in Essoyes had not yet been enlarged, and there was no room to accommodate models. Gabrielle had not yet begun to pose for my father.

On that particular day Renoir, to the surprise of the entire household, was doing nothing. The rain had stopped. The heavy carts were coming back from the fields. My father took it into his head to go out on his bicycle as far as Servigny to see ' what the tops of the poplars look like under a stormy sky '. Servigny was one of several places which enchanted him. I use the word ' enchant ' in its literal sense of casting a spell. At Servigny he muttered the name of Watteau to himself, and hummed one of Mozart's airs. The place had once been the property of some nobleman. The château had been razed during the Revolution. The few bits of wall which had

survived were buried in a mass of vegetation. Renoir meditated with some emotion on the spectacle of a human achievement reverting to Nature. He saw in it a subtle marriage, a blending of Nature and art somewhat akin to what he himself was so passionately searching for in his painting. I often heard him express his regret that he had never been able to visit Angkor, to see the statues of the gods amidst the tangle of jungle growth. The Ource River runs through the Servigny estate, which begins at the Loches bridge. The water under the bridge flows rapidly over a shallow bed of stones, and gives off countless sparkling reflections, which fascinated my father. The stream becomes calm and smooth again as it threads its way along a meadow-land lined with majestic poplars. Renoir would ask us to play ball in the grass, which was more pinkish than green. The spots of colour of our clothing completed the harmony of the landscape.

Servigny owed its rich vegetation to the numerous springs in the locality. They have now been taken over by the town of Troyes for the benefit of the inhabitants, and unfortunately some irresponsible official, thinking he was forwarding the good work, had the magnificent poplars cut down.

As Renoir was riding along on his bicycle on that rainy day in 1897 he skidded in a puddle of water and fell on a heap of stones. When he got up, he realized that he had broken his right arm. He left his bicycle in the ditch and returned home on foot, only thankful that he was ambidextrous. The vineyard-workers he met on the road greeted him with ' Good evening, Monsieur Renoir, is everything going well?' and he answered, 'Quite well,' as he felt that his injured arm was of no interest to anyone. But in fact he was far from feeling well, and he was much worse than he supposed.

Dr Bordes, a native of the South of France practising at Essoyes, was accustomed to fractures. He put Renoir's arm in a plaster cast and advised him not to do any more bicycling. My father had therefore to paint with his left hand, and he was obliged to ask my mother to prepare his palette and to wipe off with a piece of cloth dipped in turpentine those parts of the picture that did not satisfy him. It was the first time he had ever asked anyone to help him with his work. He went back to Paris at the end of the summer with his arm still in plaster. At the end of the customary six weeks Dr Journiac, our Montmartre doctor, came to the house and removed the cast. He announced that the bones had completely knitted. Renoir then

began painting with either hand as it suited him, believing the incident to be closed.

On Christmas Eve that year he felt a slight pain in his right shoulder. However, he went with us to the ' Manets ' in the Rue de Villejust, as Paule Gobillard was giving a Christmas party. Degas was present, and he told Renoir quite cheerfully of all sorts of cases of frightful muscular rheumatism resulting from fractures. Everyone seemed to think it exceedingly funny, Renoir above all. Even so, he consulted Journiac, and was informed to his dismay that medical science had not been able to solve the mystery of arthritis. All that was known about it was that it could become extremely serious. He prescribed antipyrin. Dr Baudot was even less re-assuring, and recommended frequent purges. Renoir followed the orders of the two men, and on his own initiative started taking physical exercise. He had no great faith in the benefit of walking, which brings into play only certain muscles. He believed in ball games. He had always liked juggling as an amusement, so he began practising every morning for ten minutes before going off to his studio. 'The clumsier you are, the more good it does you. When you miss, you have to stoop to pick up the ball, and make any number of movements to get it if it rolls under the furniture.' He would juggle with three little leather balls, about two and a half inches in diameter, of the kind used by children in the old days for such games as ball-and-tambourine, ball-and-shield, ball-and-hunter, and so on. Whenever he had the chance, he would play battledore and shuttle-cock. Tennis seemed too complicated for him : 'You have to go to a special place to play, and at a set time. I prefer my three in-expensive balls, which I can take when I feel like it.' He liked billiards, because it makes you adopt all sorts of awkward postures. With the addition to our house in Essoyes, my mother had a billiard-table installed, and she herself grew quite expert at the game. In spite of her corpulence she beat my father at it regularly. She even challenged some of the local players and became something of a champion.

Towards the end of May my father took us to visit the Bérards at Berneval. We rented the house which Oscar Wilde occupied in the winter. We had already stayed in it during the spring before the bicycle accident. Then when the warm months came we went to Essoyes, taking long walks along the river and hunting for hazel-nuts in September. We returned to the Rue La Rochefoucauld in

time for Pierre's autumn term at Sainte-Croix. In December Renoir suffered a new attack, really terrible this time. He could not move his right arm and he was unable to touch a brush for several days.

His story from then on is the story of his fight against illness. For him the important thing was not to find a cure—he was not a bit interested in his own health—but to continue painting. In certain regions hunters set out huge nets in the path of migrating birds. Illness was the trap fate had set in Renoir's path. He had no choice : he must either get free from the net and continue his way in spite of his affliction, or else close his eyes and die. There was also the practical side of the dilemma. He confided to my mother his fear of not being able to assure the material needs of his family. His output by now was enormous, but he sold immediately almost everything he produced. The money he made sufficed amply for our carefree life, but no more. My mother, however, did not worry in the least. She liked fine houses, a good table and devoted friends, but she would have been just as happy in a thatched cottage, so long as her husband and children were with her.

Renoir's malady grew worse at irregular intervals. I should say that his condition changed radically after my brother Claude was born in 1902. The partial atrophy of a nerve in his left eye became more apparent. It had been caused by a bad cold caught some years before while he was out painting a landscape. His rheumatism made this semi-paralysis worse. Within a few months his face took on the fixed expression which so startled people who met him for the first time. All of us in the family, however, soon got used to his changed appearance, and except for the attacks of pain, which grew steadily worse, we completely forgot he was so ill.

Each year his face became more emaciated, his hands more twisted. One morning he decided to give up juggling the three balls, at which he had been so expert. He was no longer able to pick them up. He threw them as far away as he could, saying in an irritated tone, ' The devil take it, I'm going gaga ! ' He had to fall back on the game of *bilboquet*, played with a ball and peg, ' just like the one Henri III used in Alexandre Dumas!' He also tried juggling with a small log. He asked our coal and wood dealer to cut one for him very evenly, about eight inches long and two inches thick. He scraped it with a knife himself and sandpapered it till it was perfectly smooth. He would toss it into the air, making it turn round

and round, and catch it adroitly, being careful to change hands from time to time. ' One paints with one's hands,' he would say. And in this way his fight to save his hands went on.

He now began to have difficulty in walking. I was still young when he decided to try using a cane. As he had to lean on it more and more, the cane would sometimes slip, and he had to have a rubber tip put on it, ' just like an invalid '. He became more sensitive to temperatures, and would catch cold easily when working out of doors.

We returned to Essoyes every summer. Our house there had been finished by then. My mother would invite friends in continually so as to provide Renoir with the social life he was so fond of and could no longer seek away from home.

For fifteen years we went regularly to Essoyes at the beginning of July. Coco the horse, Fluteau, our cousin Clément and his son Louis would meet us at the station. In winter Coco was hitched to the brake in which Clément went to the wild-boar hunt, but in summer he was used for the less arduous work of taking my father about. The driver was Fluteau, the inn-keeper, whose son now makes a champagne of that name. (In Burgundy all horses are called Coco. It was also the nickname given my brother Claude as a diminutive of his proper name, but that was pure coincidence.)

At lunch-time when he was unhitched and allowed to wander loose in the cobbled court in front of the house, Coco liked to tear down the lowest branches of the chestnut tree. My brother Pierre would cry out indignantly, and Coco would poke his head in the window as if to ask what all the fuss was about. Renoir would laugh at his air of false innocence, and tell Gabrielle to give him a drink. She would fill a ladle with wine and sugar, and Coco would suck it up with relish. Sometimes he would reel a bit afterwards. He finally became incurably rheumatic. My father insisted on letting him die in comfort, so for a long time he stayed in his stall and did nothing— he really suffered too much when he walked. One winter his rheumatism got so bad it was decided that he should be put out of his misery. Marchand, the butcher, said he would see to the matter, and promised that Coco would feel no pain.

When we were not there, our cousin Clément Mugnier and his wife Mélina took care of the house. When I go to Essoyes now, it is their great-grandchildren who are there to welcome me. Clément was a very congenial fellow, and he played the same role in Renoir's

life as the financier Edwards did in Paris, Ferdinand Isnard did in
Cagnes, and, during his earlier years, Baron Barbier had done at the
Grenouillère. These friends had three things in common : they
were corpulent, successful in their respective professions, and totally
ignorant of painting. All three were gay, sensual, lovers of good
food, and devoted to Renoir.

After dinner at night we would often sit on a bench outside the
dining-room window and watch the people as they came down the
road from working in the fields. Seeing the robust Célestine go by,
bent under the heavy basket she was carrying, Clément would de-
clare philosophically : ' D'you see that one ? I could have had her
if I'd wanted to.'

My mother, who did not like such talk, would retort : 'That's a
clever remark. Can't you think of anything else to say ? '

And Clément would retort, in turn : ' Well, you're clever your-
self. You're from here, aren't you ? '

Though this rejoinder made little sense, Renoir rocked with
laughter. He called such esoteric language ' rustic Mallarmé '. We
knew what he meant. We all remembered how the poet Mallarmé
had addressed several letters to Renoir in the form of a cryptogram.
For example :

> A celui qui de couleur vit,
> Au 35 de la rue du vainqueur
> Du dragon, porte ce pli, facteur.

The post-office duly sent the letter to the person it was intended for
at number 35 Rue Saint-Georges.

In 1897, after an interval of some twenty years, Georges Rivière
came back into my father's life. He now had an important post in
the Ministry of Finance, and lived in a little house at Montreuil-
sous-Bois. He had buried himself in that suburb near the Bois de
Vincennes for the sake of his wife's health. She was a ravishing
Polish beauty, who in spite of all her husband's efforts to save her,
died of tuberculosis. Rivière brought his two daughters, Hélène and
Renée, to see us, and they captivated us immediately. All three got
into the way of visiting us at Essoyes every summer. The two girls
and my mother became close friends—to such an extent that she
practically adopted them.

The young men and girls in the village often came to our house.
We would all go out together, along the banks of the river or

through the woods. Sometimes the brake would be brought out, or the victoria, and my father would drive along with us. My mother would come with him, and M. Rivière, and perhaps some special guest, such as Vollard or my godfather, Georges Durand-Ruel, or the sculptor, Maillol, and the young people would follow on their bicycles.

One day we all went in a procession to the Ricey villages, on the Laigne River. They are a good twenty-five miles from Essoyes. You first go up the Courteron hill through the woods. At the top you pass through the vineyards of ' en Charmeronde ', and then you descend to the Seine, which you cross at Gyé. After climbing a chain of hills you reach Upper Ricey, which overlooks Lower Ricey, and then another Ricey, built in terraces along the road to Chablis. The rosé wine of the Ricey district has always been the favourite drink of the citizens of Troyes. The prosperity of the place dates back to the Middle Ages, a fact borne out by the old houses, the churches, and the château dreaming away by the river. The inn is exceedingly old; its rooms have heavy beams overhead, and the kitchen is paved with flagstones and has a big open fire-place.

It was very hot that day. Renoir was hungry. The splendidly carved capital on a house near by had put him in a good mood. He feasted on chicken cocotte and fat green peas cooked with bacon. He drank more than a bottle of pinot rosé wine. On the way back everyone began to sing. The song we liked best was ' Gastibelza, the Man with the Carabine ', words and music by Victor Hugo. ' It's the best thing that destructive poet ever did,' said Renoir. Its theme is of a romantic Spaniard who is betrayed by his beloved. She had not hesitated to give her ' dove-like beauty '

> Pour l'anneau d'or du Comte de Cerdagne
> Pour un bijou.
> Le vent qui souffle à travers la montagne
> Me rendra fou.

I punctured the tyre of my bicycle by running against the wheel of the brake, and came back home balanced on the step of the vehicle. One of the young men with us fell asleep in a hazel-bush, and was not seen again that day. We all waited uneasily to see what effect our outing would have on Renoir. But his walking was neither better nor worse, and he did not seem to have any more or

any less pain than usual. He was therefore all the more sceptical about the benefit to be got from dieting.

The year 1902 was perhaps typical of our time at Essoyes. My brother Claude was just one year old then, and by the time school reopened I myself would be eight.

At six in the morning I would be wakened by the sound of Gabrielle moving about, for she would slip a petticoat over her nightgown and go downstairs to open the door for Marie Corot or some local woman who came in to help. While my brother Pierre was still at school I would sleep in his room on the second floor, next to the one Gabrielle shared with a model brought from Paris. Georgette Pigeot, Adrienne, another of Renoir's models, and La Boulangère also occupied that room in turn. The rest of the floor was an attic. The heavy beams and joists, rough-hewn by the village carpenter, were left exposed in that part of the house, and I was fascinated by them. Through the skylight I could see the road, a strip of dazzling white the minute the sun rose. Beyond was the garden where Clément grew vegetables for us. When he was not working at his grape-vines, Clément amused himself by hoeing the peas or sowing radishes before the hot weather set in. Behind our property there were fields, and farther on, woods. Beyond the woods were vineyards. By leaning over a little, I could just make out those on the slopes dominating Servigny.

As the day wore on, the whole countryside hummed in the summer heat. When you left the coolness of the house you felt as if you had stepped into an oven. And what swarms of insects there were : insufferable gnats, wasps, butterflies ! And along the river the dragon-flies rose like a mist from the clear water. Those early-morning sensations, which preceded the heavy sweat of the day, filled me with a sense of physical well-being which I can still feel when I shut my eyes.

I would slip on my trousers and shirt, and go down to the next floor and say good-morning to my father. He never allowed anybody to come in unless he was fully dressed. He had to change his ways when his legs began to fail him, and allow my mother or Gabrielle or Grand' Louise to help him with his toilet. The nudity of women seemed natural to him, whereas he was embarrassed by the naked male body. When he undertook to paint his ' Judgment of Paris ' he first had the actor Pierre Daltour pose for the young shepherd. But in spite of Daltour's fine athletic body, he finished

the picture by using Gabrielle, La Boulangère and Pigeot in turn as models for the shepherd, saying that he felt more at ease with them.

He always kept his windows wide open. I would kiss him good-morning and hurry down the rest of the stairs to the kitchen, where Marie Corot would give me my breakfast. My mother would get up later. My brother Claude, whom we already called Coco, slept in her room, which meant that she had to get up in the night to tend him, and for this reason she stayed in bed a little longer in the morning. Renoir ate his breakfast in the dining-room. He usually took a cup of coffee with hot milk in it, toast, and butter. He liked to butter the toast himself and then dip it in his coffee.

One of the customs of the Renoir household was that guests were never pressed to eat what was set before them or passed by the maid. My mother had no use for such polite phrases as ' You didn't take enough ', or ' Do have a bit more—just to please me '. She tried to make her guests feel at ease, and let them help themselves as they chose. ' If I kept on insisting, I would have seemed to remind them they were not one of us.' Renoir used to make fun of the expression ' just to please me '. ' I can't see what pleasure a hostess could get from giving me indigestion.' When my mother came down in the morning, my father would greet her rather ceremoniously. And while I was still young I understood that my parents' intimate life was strictly their own affair. I never saw my father kiss his wife in public, or even in front of us children, though I except the conventional goodbye kiss in railway stations. A married couple or a pair of lovers showing their feelings too openly in public made Renoir uncomfortable. ' It won't last long,' he would say, ' they're waving it about too much.'

In spite of his reserve about expressing feelings, ' which are only deep when they're hidden ', he did use the intimate ' *tu* ' when addressing his wife or children, and they replied in the same way; and he also used it with Georges Rivière and his daughters, Claude Monet and the friends of his youth who were still alive. But he said ' *vous* ' to his mother-in-law, and to Gabrielle, and his models, and all children other than his own. He intensely disliked ' *tu* ' when spoken condescendingly. When, for instance, a ' gentleman ' would say familiarly to a workman or a servant, ' Dis donc, mon brave,' my father took a poor view of him. In such a phrase he saw the evil

influence of Romanticism and the survival of the sort of speech that was characteristic of melodrama.

As far back as I can remember, my parents always slept apart. They nearly always had separate, but adjoining, rooms. ' You have to be very young to be able to live in close contact continually without getting on each other's nerves.' On the other hand, Renoir was very much against long separations. I am almost certain that he never deceived his wife. ' In the first place it's pointless. In general, the second woman is like the first, without being accustomed to your whims.' He maintained that, apart from certain queer fish afflicted with a peculiar make-up, like his friend Lhote, who sometimes had to go to the nearest brothel to satisfy a desire as urgent as thirst, most men pursue their one ideal of a woman, which doesn't change. Their different adventures are only a reflection of that ideal. Hence the resemblance between legitimate wives and mistresses. In his youth he once made a dreadful mistake. One of his friends had a mistress whom he often took to the Moulin de la Galette. He had introduced her to Renoir. One day my father met the same woman on the street—or so he thought—and complimented her on the graceful way she danced. But it was his friend's wife !

During Gabrielle's last years, when she was already ill with the disease that was to carry her off, she and I got into the way of discussing everything quite openly. Sometimes we talked about the sexual relations between my father and mother. We both thought that their love life had been very active and affectionate and that their physical relations had ended only after illness had riveted Renoir to his invalid's chair once and for all. I hope my parents will forgive me for not respecting the intimacy which meant so much to them, but I think it is of sufficient importance to justify my taking this liberty, if only to stress how normal Renoir was in everything, including sex.

My father would be enjoying his brown bread, toasted in the fireplace, spreading creamy butter on it—' in Paris they put saffron in it because they think yellow butter is more chic '. Suddenly Primiaud, a young painter who was spending the summer with us, would start beating a drum outside in the garden, having waited for my mother to come down so that he could usher in the new day in this theatrical manner. He was quite tall and heavily bearded, and had large soulful eyes. The wine-growers all wore moustaches, and the

beards affected by the men in the Renoir house amused them as much as our accents did. ' Big-mouth Parisians,' they would say, and try to imitate Raymonde Mathieu's throaty way of speaking. The spectacle of the giant, good-natured Primiaud marking time in the Essoyes streets and rolling out a drum-call like a town-crier caused a great commotion. Our presence was a diversion which the good citizens of Loches, Fontette or Grancey could not boast. At Bar-sur-Seine, which is the sub-Prefecture, they had the glass-works, where youngsters became tubercular from blowing in the long tubes, but Essoyes had a bearded painter, together with a band of ' vagabonds ' still more heavily bearded, who were continually thinking up ways to make people laugh. Primiaud pranced through the streets, treating the young girls to a light, playful roll and the older ones to a more solemn rhythm, gazing at them with his ' spaniel ' eyes as if to say, ' Isn't it beautiful ? ' My grandmother Mélie went to the *mairie* to complain of this military tattoo, for while it did not disturb her rest, as she was up at dawn, she thought the performance unseemly. There was no municipal regulation against beating the drum, and there was no way of putting a stop to it unless so many complaints came in that the village policeman would have to do something about it. But the inhabitants of Essoyes did not complain. On the contrary, they enjoyed the excitement. So when Primiaud went past Mélie's house he would give her a seductive smile and tap on his drum caressingly. He made a madrigal of it, and it sent my grandmother into a frenzy.

Before Renoir had had time to finish his first cigarette, the guests had gathered around him at the breakfast table. Vollard, still half asleep, would ask for an orange. My father would remind him that oranges did not grow at Essoyes.

'You're thinking of the Midi. You'd better have some plums.'

' Tell me, Monsieur Renoir: why don't oranges grow at Essoyes ? '

' Because there are no orange trees.'

Renée Rivière would come down the stairs amidst a chorus of greetings and shouts, kiss Gabrielle and Georgette, and say a friendly good-morning to Marie Corot, who was quite unmoved by the clamour these Parisians made. Marie Corot had the dignity appropriate to one who had baked gougères and other delicacies for one great painter and shown the wife of another great painter how to thicken a sauce without flour. She was a small, plump woman,

well over sixty, dressed in a grey bodice drawn tightly over her bosom, with a narrow lace collar, and a skirt of the same colour. Gabrielle told us that she wore at least three petticoats under her skirt. She never put on an apron—and was always spotless.

Renée Rivière was a brunette with a clear complexion, and was 'nicely built', according to Clément, who prided himself on being a connoisseur. She would have made a magnificent model for Renoir—my mother pointed out what a perfect bosom she had — but my father was reluctant to confine such superb vitality indoors in his studio. 'I don't imagine she has much fun in the winter at Montreuil,' he said. 'While she's at Essoyes, let her make the most of it.' In any case, her father would not have allowed her to pose in the nude. Renoir had to be content with doing several portraits of her, and getting her to sing. She had an exquisite voice. Her contralto was ideal for Cherubino in *The Marriage of Figaro*, and for Cupid in *Orpheus in the Underworld*. Every evening one or other of our guests would sit down at the piano and we would have a first-class concert. Renée was all right for Mozart, but she was too in-genuous to interpret Offenbach's naughtiness well. She was surprisingly naive. 'You're too much of an innocent,' Renoir told her. And he explained to her father, who as he grew older had acquired certain prejudices, 'If your daughter only had a little of the whore about her, she would be an extraordinary singer.' But Rivière didn't want his daughter to be a professional singer. 'A pity,' said Renoir. 'Acting is not a good profession for a man, but it's perfect for a woman. To act a part is the essence of femininity.' Renée's voice was so beautiful that the men—even those who ate sausage on Good Friday—would go to church when she sang there on Sundays.

We were continually playing tricks on her, and she endured them with unfailing good humour. We would make her an apple-pie bed and try to terrify her with sepulchral voices, pretending we were ghosts. She was a great friend of our neighbour Louise Munier, whose parents owned a large herd of cows. One of our games was to blindfold Renée, and, making her believe that we were playing blind-man's buff, leave her alone in the midst of the cattle. One day she was confronted with a little calf, which began to lick her affectionately. 'Stop, Jean!' she cried out. 'You're disgusting!' She tore the bandage off her eyes, and was so frightened at the sight

of the calf that she turned to run, and fell down and skinned her knee. My mother treated it with sublimate and bound it up. Then she took down my trousers and gave me a good beating with a branch from our big hazel-bush—the one that produced the long filbert nuts.

Hélène, Renée's elder sister, was reserved and sensible. She was studying to be a teacher. Their mother, before she fell ill, had been exactly like Renée, but her suffering had made her withdraw into herself. Rivière could see in his two daughters the two different aspects of the woman he had loved so dearly.

None of us could conceive of a holiday at Essoyes without the young Rivière sisters. Shortly after their arrival other guests followed : my first cousin Edmond Renoir, Uncle Edmond's son ; Paul Cézanne, the son of the artist. Edmond was eventually to marry Hélène ; and Paul, Renée. My mother was no match-maker —she was afraid of making mistakes : and to Renoir the very idea of trying to influence other people's destiny seemed indecent. Nevertheless, the idea of two such marriages seemed so appropriate that my parents did all they could to throw the interested parties together. They took a special interest in promoting the match between Paul and Renée. Renée was full of the joy of living. ' She even makes mistakes in spelling,' said Renoir, ' and in my opinion that's essential to a woman.' And in Paul, Cézanne's son, my parents could see his father's traits—even in his silences, and most of all in his reserve. Cézanne and Renoir had a great affection for each other, yet they never showed any outward sign of it. They hardly bothered to shake hands when they met. They used the formal ' *vous* ' when speaking to each other. They would remain together for hours without exchanging a word, perfectly relaxed and at ease in each other's company. I think I can understand their feelings because of the similar friendship I myself had with Cézanne's son. Generally speaking, human beings are drawn to one another for specific reasons. You are happy in the company of such and such a person because he is witty and amusing, with another because he is rich and treats you handsomely, or generous and willing to do you a favour. Paul had all those qualities, yet it was not because of them that I sought his company. I liked to be with Paul simply for the mental and physical pleasure of being with him, just as a dog likes the company of another dog. And I know he felt the same way

about me. In India you find this silent appreciation of one another's presence, something that is difficult to explain in this age of the machine.

To persuade Rivière of the advantages of a marriage between Paul and Renée, my father pointed out that the suitor was 'a good, intelligent man, and near-sighted; believe me, you can't find that combination every day'. The young man was, moreover, well over thirty, had a tendency to stoutness, and was losing his hair. Nothing of human interest escaped his heavy-lidded eyes. His upper lip was adorned with a thick moustache, twirled up at the ends, making him look somewhat like an English army-officer in India who had been converted to Hinduism. He did absolutely nothing in life. Renoir thought, from the letters Paul wrote, that he could have been a great writer. But he had to admit that this son of a genius was handicapped by a paralysing modesty. When I say that Paul did nothing, I mean that he did not practise any known profession. Actually, he had an occupation of a kind superior to that of an artist, a lawyer or a manufacturer: he lived! He had a keen appreciation of life, such as certain aristocrats in a less commercial age must have had. Renoir admired the wholehearted way in which he gave himself to the business of living. My mother hoped that he would settle down and give up spending his nights in cafés, standing his friends drinks and discussing the fine points of boxing, for which he had a weakness.

Paul perhaps imagined that he was too old, too bald and too short-sighted to be worthy of Renée. At times he tried to shun her. He and I would go on long expeditions on the river, explaining that we wanted to set out eel-pots. The skiff we used was a flat-bottomed boat, which we pushed along with poles. There is nothing so mysterious as a river. Away from other human beings, lost in the overhanging foliage, fearful of breaking in on the sound of the water gliding over the weeds, we felt as if we were characters in a tale by Fenimore Cooper, whose writings Paul had just introduced me to. We lay on our stomachs in the skiff, silent and motionless, our faces near the surface of the water, watching the movements of a large fish, which in turn was watching its prey.

My mother preferred fishing with a line. She would put young Claude in Renée's lap and go off with her fishing-tackle, and would often bring back a basket full of little fish, which Marie Corot fried in oil made from the seeds of a yellow flower that grew wild in the

fields. I was very fond of the tart flavour of that oil, as I was of everything connected with Essoyes.

Edmond would read aloud to Hélène. He was just discovering the pleasures of study, which were to become the great passion of his life. He had passed his examinations with the highest honours and had thought of becoming a monk. He had taught in a school in England, and was completing his first survey of modern English writers. He was never to cease studying, and he spent the rest of his life steeping himself in the beauties of the world's great literatures, going without difficulty from Arabic to Russian, from Italian to Scandinavian, and learning in the process many disparate languages. Edmond and Hélène were the intellectuals of our little group.

When Renoir was working indoors we would all go out and amuse ourselves with our friends in the village. Unless we were called to pose for him we never went into the studio. My mother would often go and spend an hour or two there, but only after Coco had been bathed, rubbed down and fed—at the breast, of course. I have the feeling that she was completely happy.

One of the severest whippings I ever received as a child I owed to my brother Coco. It was administered by my mother with the complete approval of my father. Some workmen who were repairing our roof had left their ladder up against the house. I took it into my head to carry up my young brother, aged two, and perch him on the top rung so that he could admire the view. Then, as he refused to come down, I left him there. When my mother caught sight of him in that precarious position thirty-five feet above the ground she was absolutely terrified. On being brought down, Coco cheerfully explained that his big brother had wanted to show him the view. And did I catch it! I can feel the sting of it to this day!

The sculptor Maillol came to spend several weeks with us. He had left his wife behind at Marly to look after the house, because it had no lock on it. The locksmith had tried to sell him a new-fangled lock, but he would have none of it. He wanted a good old-fashioned lock, with a key that felt heavy in the pocket. Otherwise how could you know if you had lost the key? As he was unable to find such a museum-piece he left his door unlatched, and his wife Clotilde to guard the house. Clotilde filled Maillol's whole life. Once some years later when someone from the town hall in Aix-en-Provence came to consult him about a project for a monument to Zola, Maillol suggested doing a statue of Clotilde in the nude for it,

adding that it would be very much to Zola's honour, as his body was so much less beautiful than Clotilde's.

Maillol was slender, wore a beard, and had a strong Midi accent. He made us think of Henri IV. He was finishing a bust of my father. He worked on it in the studio while my father painted. He never asked Renoir to pose. He was so imbued with his subject that the likeness seemed to grow more and more apparent with every touch he put on his material. It was even better than a physical resemblance : what he got into those few handfuls of clay was the very essence of Renoir's character. I was too young to understand then, but years later my father often talked to me about this master-piece.

Before Maillol started this work, my father had sent me to a hardware shop to get some heavy wire for the armature. But the sculptor refused it, saying it was an unnecessary extravagance. He had rummaged about in our barn and found a piece of old wire which had once served to prop the trellis of our grape-vine. One morning we were all awakened by a frightful outcry. Maillol was tearing around the garden like a lunatic. He kept repeating at the top of his voice : ' Renoir's fallen down ! Renoir's fallen down ! ' The rusty old wire had given way; the bust he was working on had fallen, and a shapeless little mass of clay lay on the studio floor. After a few days Maillol summoned up enough courage to start the piece all over again, but judging from what Renoir and Vollard said, I gather he did not succeed in recapturing his first inspiration.

When melons were in season, Marie Corot sent me to buy a good ripe one. The only person who raised melons at Essoyes was Aubert, the gardener. He was not a wine-grower, and he had a garden on the edge of the river in the lower part of Essoyes. The village was divided into ' upper ' and ' lower ' sections, two very different groups of houses. Wine-growers rarely lived in the lower part. We ourselves lived on the higher ground. In his garden Aubert grew fruit and vegetables found nowhere else in Essoyes, such as string beans, fine peas and melons. He sold his produce to the well-to-do citizens of the town, among them the chemist, Decesse, and the other Decesse, who owned the saw-mill, Marchand the butcher, Dr Bordes, and the notary, Mathieu. Aubert had been a gardener at the Château de Compiègne in the time of Napoleon III. Every noon, so he said, he would take a melon to His Majesty. One

day on entering the kitchen, whom should he see but the Emperor himself, taking from his bag a hare he had killed out hunting.

' Oh, so it's you, Aubert, who grows these wonderful melons ? '

' Yes, Sire,' replied Aubert, his face flushing.

Napoleon III turned to his wife, who was busy at the stove, and said : ' Eugénie, rinse out a glass for me. I want to have a drink with our good Aubert for growing such fine melons.'

Renoir said he believed this story was true and he shared the Emperor's taste for Aubert's melons.

I have already mentioned how condescending the wine-growers of Essoyes were towards the ' small farmers '. They had the utmost scorn for the poor wretches who lived in isolated hamlets in the uplands, miles away from the vineyards. Fontette was regarded as being in that category, and also Petit Mallet and Grand Mallet, whose farms, with their thatched-roof buildings, lay close together around the Mallet stream. Noé-les-Mallets was the last word in peasant backwardness. When my mother taunted Clément over the inability of the Essoyens to choose a decent mayor, he replied in a huff, ' I'll go out and get one at Noé ! ' A shepherd at Noé had a godfather living in Essoyes, a retired lawyer, who spent his declining years cultivating snapdragons. The godson brought the old man a clock for his birthday, which he himself had carved out of the trunk of an oak-tree. It was a massive affair, made in the form of a large central ball, surrounded by smaller balls, and painted blue, white and red, the shepherd being deeply patriotic. He had inserted an alarm-clock inside, which fitted so well that one would have thought it had been made expressly for the purpose. The former lawyer had a daughter of fifteen : very pretty and already very popular. I used to go and see her quite often, along with the Rivière girls and several of the local boys. We all laughed hilariously over the shepherd's clock. The young girl thought it might amuse my father to see it, and the boys all abetted her. None of them had ever shown any interest in Renoir's painting, but the fact that he ' sold in Paris ' placed him, in their minds, high above this illiterate bumpkin. They thought he would certainly laugh at the poor shepherd whose simple-mindedness showed in every inch of this crude time-piece. So I picked it up and set out with it under my arm on my bicycle. I was in such a hurry, and laughing so hard, thinking how my father would laugh, that I fell and broke off one of the little decorative balls. To my great surprise, Renoir thought the

clock very handsome, and made me carefully glue back the broken bit. He said that no object made lovingly by hand could be ugly, and that in any case one could see the shepherd's personality expressed in it, whereas all one saw in the gilded bronzes on the mantelpieces of the 'better classes' was a pretentious piece of manufactured goods.

When Baudry came to the door to beg for bread, Renoir stopped his work and asked to see him. Baudry was an old curmudgeon who had broken for good with civilization and the law. He slept in a deserted shack in the woods somewhere near Pic Véron. During the winter he made matches, which he went around selling, thereby competing with a Government monopoly. The police closed their eyes to his activities, and would only arrest him when the weather got very cold : in this way he had the advantage of the little cast-iron stove in the local prison. My mother would give him some money and insist : ' Get yourself a drink. I know that's what you want.' She was contemptuous of the hypocritical attitude of people who insist that charity be given only for practical or moral purposes. Baudry would reply, ' You are more beautiful than Madame des Etangs ' (The Lady of the Ponds). We never learned who the lady with the poetic name was. The old boy also said to my mother, who was perhaps a little stout but so young and attractive, ' Madame, I regard you as my own mother.'

Some of my cousins asked my parents to allow me to be godfather to their little girl, who was just going to be christened although already two and a half years old. Everyone sat down to a great feast set out on trestles in the barn. There were at least a hundred guests. A glass of wine was poured out for the tiny, newly-made Christian. My father ordered water to be put in the glass of wine served to her. Her mother yielded to this strange whim, but did not let the little girl know. When my goddaughter tasted the diluted wine she made a face, and said, ' I don't like wata ! '

Among my memories of Essoyes, I recall the vaulted cellars hewn out of the rock, where we used to go and get pitchers of wine ; the wells, which were so deep that when I leant over the edge the circle of icy water below looked like a little moon ; the sound of the heavy wooden clogs on the stony roads ; the quiet pleasure of being with Renoir as he painted in the meadow on the side of the river near the old paper-mill ; my mother's red dressing-gown as she sat in the tall grass ; the children's voices as they ran after one

another around the willow trees ; the games the young men and the models played as they splashed about in the water-fall of the old mill-race . . . and Paul Cézanne diving in to search for his spectacles and the village girls running up in amazement to see the big man ' as quick as a fish in the water ' who stretched his arms out to them and cried ' Oh, mother, why did you make me so handsome ! ' . . . Then would come the season for burning the dried vine-stalks in the fireplace : the September evenings, as the days grew shorter and the time approached for us to return to Paris.

The day of our departure was always a sad one. Coco the horse would take us the ten miles to Polisot to get to the railway, which runs from Is-sur-Tille to Troyes and links Burgundy with Champagne. After Coco's demise we had to use the diligence. In order to keep a bit of Essoyes with us as long as possible we would take along a good supply of food : a great loaf of brown bread, ham that had been smoked in the big fireplace, and some bottles of strong grape brandy. One year I was given a cheese to carry. In the train, the other people in our compartment began to sniff the air and fan themselves with a newspaper ; finally, not being able to restrain themselves any longer, they said, ' Don't you think your little girl has done something in her drawers ? ' I was the one they mistook for a little girl because of my long red hair. I was indignant at the double insult and I immediately took down my drawers to prove my innocence as well as my sex. The smell persisted just the same, and when we came to the next stop our fellow-passengers could stand it no longer and fled to another compartment. My mother wanted to throw the offending parcel out of the window. My father was highly amused. Gabrielle and I begged to be allowed to keep the cheese, which reached Paris safely, much to the delight of Lestringuez, Faivre and Frank Lamy. For many years I kept a photograph taken after a meal in the dining-room in the Rue La Rochefoucauld, showing us all gathered around Renoir, convulsed with laughter. It may easily have been a memento of the day we ate the famous cheese. (Frank Lamy, however, was little given to laughing at that time. He had a mistress, a young model, who was dying of tuberculosis and who was so frail and delicate that my father, in telling me about her, described her as ' diaphanous '.)

We often played guessing-games around that dining-room table. Renoir liked plays on words, *provided they were bad*. ' My first is a precious metal, my second is a fine material, the whole is something

to keep both in.' The answer is : ' *or* ' (gold), and ' *moire* ' (watered silk), making ' *or-moire* ', or ' *armoire* ' (wardrobe). ' My first has teeth, my second also, my third also, and the whole, as well.' Explanation : ' *chat* ' (cat), ' *loup* ' (wolf), ' *scie* ' (saw), making ' *ja-lou-sie* ' (jealousy), as pronounced, say, by a German, and meaning that jealousy has teeth which rend the heart.

# 25

The climb up the four flights of stairs in our Rue La Rochefoucauld apartment became too painful for my father, whose legs grew steadily worse, and we therefore moved to number 43 Rue Caulaincourt. The new apartment was on the first floor, but, as the building was on the side of the hill, the back rooms were four floors up. We looked out over the roofs in the Rue Damrémont, and had almost the same view as we had had at the Château des Brouillards. To my great delight, I found myself face to face with an old acquaintance : the Maquis, which ended opposite the entrance to our building. My father rented a studio at number 73 in the same street. It was a big room on a level with a little garden, and thanks to the slope of the Montmartre hill, one still had a clear view of the Saint-Denis plain. The cartoonist Steinlen and the painter Fauché lived, respectively, in the basement and on the first floor of the building, with its half-timbering in Old English style. As Renoir detested lifts, he was glad to have found what seemed the ideal combination : while not having to tire himself climbing stairs, he would nevertheless be obliged to walk a little every day. The studio was only a short distance from the apartment. The two places are still in existence. But on the site of the little garden in front of number 73 now stands a seven-storey apartment-building.

The concierge of the studio had a daughter whose beauty was celebrated throughout the district. Her name was Mireille. The butcher-boys delivering meat never failed to stop in front of the iron fence and sing a verse or two of one of the popular songs of the day :

> Elle a doux nom Mireille
> Sa beauté m'ensoleille !

The son of Mme Brunelet, the concierge at number 43, played

the mandolin remarkably well. The tinkling sound of his instrument as he strummed a Neapolitan air still rings in my ears. My father enjoyed it much less than I did, and said, ' It was enough to make you dislike Gorgonzola for ever ! ' Gabrielle took me to visit our old haunts in the Maquis. Daléchamps, the furniture-remover and poet, released his pigeons in honour of our return. His birds were trained to fly in formation in the sky over Montmartre. There were a dozen of them : four painted blue and four red, while the remaining four were left white. Daléchamps was an ardent patriot. He wrote poems in praise of Joan of Arc, and he refused to remove furniture for any-one he suspected of being anti-militarist. The Mother Superior at the school run by the nuns had let him have a piece of land, on which he had built a cabin for himself. My father said that he looked like Rodin, but with ' more of a beard '—a rather difficult feat !

One person who stands out most vividly in my memories of the Rue Caulaincourt is La Boulangère. After Gabrielle, she was the model whom Renoir used more frequently, perhaps, than any other. Heaven had blessed her with two outstanding gifts : the ability to pose divinely, and to fry potatoes divinely. She was of medium height, and had a fair complexion, somewhat pale, with a few freckles ; a turned-up nose, full lips, little feet and a soft, round body, agreeably filled out. She was a nice girl, ready to believe anyone ; she had an overwhelming admiration for men ; and she was incredibly humble. You could say anything to her without offending her. If it had not been for my father's presence, the hands of certain visitors would have strayed sometimes. Her knowing smile rather invited such attentions. She had a mop of mahogany-coloured hair, always in disorder. She was the type who spends her time putting up loose strands and adjusting her combs.

Her real name was Marie Dupuis. She entered our household shortly after Gabrielle's arrival. Renoir had met her on the Boule-vard de Clichy one day in 1899. She had not yet married Dupuis, and was living with M. Berthomier, known as Tai-Tai, a baker's assistant, who worked in a bakery in the Rue Chaussée-d'Antin, where my father used to go to buy rye-bread. That was how Marie acquired the name ' La Boulangère ', which stuck to her for the rest of her life. Tai-Tai died of consumption. La Boulangère's first occupation was making artificial flowers, which ruins the eyesight. For this reason she accepted Renoir's suggestion to pose for him. It was less tiring than making flowers, and paid better. She went to the Hôtel-Dieu

every day to have drops put in her eyes. Dupuis, whom she married
in 1900, was a house-painter. He was an affable fellow, lively and
funny. It was evidently his sense of humour that had won La
Boulangère. He had a moustache, and wore a little tuft of hair on
his chin. As he grew older he became pot-bellied and rheumatic.
He had to give up working on the house-painter's scaffold, because
it tired him to climb to such dizzy heights. Luckily for him, his wife
earned enough for them both. He used to come to see us, and he
taught me the following song :

> Pour vingt-cinq francs, pour vingt-cinq francs,
>     pour vingt-cinq francs, cinquante
> On a un pardessus
> Avec du poil dessus.

La Boulangère was also to suffer from rheumatism towards the
end of her life, quite a while after my father's death. It would seem
that a great many French people were subject to this mysterious
malady at the beginning of the century. And the same may be said
for tuberculosis.

Only once did I see La Boulangère really angry. It was at the
end of the War of 1914. My father was in the South of France. My
brother Pierre and I were living in the Boulevard Rochechouart
apartment. La Boulangère was keeping house for us. Every
morning she would come and ask us what we wanted for lunch.
And being absent-minded, we would say off-hand, ' Oh, steak and
fried potatoes.' After two months of this diet, she had a fit of
nerves, opened the window and threw the food, dish and all, out
into the street.

La Boulangère went with us several times to the South of
France, and once to Essoyes. But neither of those places meant a
thing to her. She got bored whenever she was away from Paris.
And yet she had come to live in Paris only recently : in fact, just a
short time before Renoir had encountered her on the boulevard.
Her sisters were married and living in the capital : Tentense to a
police officer, Jeanne to an adjutant in the army—the glory of the
family. Tentense was a concierge in the Rue Croix-Nivert, and she
had written to her young sister, who was ' getting stale ' in Dijon,
telling her to come and join her in the city. La Boulangère had no
trouble in finding work and a ' friend '. She rented an apartment in
the Rue des Trois Frères, where she was to remain almost to the end

of her life. She was on the friendliest terms with the concierge there, and took her place from time to time. She died in the suburb of Villejuif in 1948. I was in America just then ; I had seen her for the last time in 1937.

I should also like to say a word about Georgette Pigeot, who is still living. She posed a great deal for Renoir. She was a dressmaker and, being highly skilful, she earned a good living. I think she posed for him because she liked being with him. To my father's great delight, she sang all the time, and kept him up-to-date on all the latest songs in the café-concerts. She was a lovely-looking blonde, with a fair skin and a very ' Parisian ' look about her. I ran into her only last year. She is as vivacious as ever, and still tells very amusing stories. I recall one of her songs, which she herself must have forgotten :

> C'est un rat, c'est un rat,
> Vilaine bête,
> Cache ta tête !

And for fear that Renoir had not understood the allusion, she remarked, ' If a person isn't too stupid, he'll know what that means.'

Adrienne, a blonde Venus who walked like a goddess, figures in a great many of my father's pictures. The model, Renée Jolivet, who was born in Essoyes, became an actress, travelled a good deal, and lived in Egypt for many years, was also a superb creature. It would have astonished me if anyone had said that these lovely girls were not part of our family. I did not try to define a kinship which I never doubted. They had absolute trust in my parents. It took me quite a while to realize that they were paid to stay with us. But I am sure that they did not consider the money they received as a salary. As a matter of fact, when they needed anything, they never hesitated to ask for it outright, either from my father or my mother. Often, when they were not posing, they would ask my mother if they could help in some way in the house. They would step down from being Venus on Olympus to pressing my trousers or mending socks. However, except when they were all travelling together, my father never took his meals with them. At lunch-time he liked to meditate, and we rarely sat down to dinner without guests. He knew, too, that among themselves the little geese would feel more free ; that La Boulangère would have no scruples about emptying a whole box

of chocolates; and that Adrienne would ask for several helpings of cabbage soup.

There was a great deal of rough good-humour in the tone of the conversations between Renoir and his models. He called them nit-wits, fat-heads, geese, and would pretend to threaten them with his cane. They would shriek with laughter, take refuge on the sofa, run about as if playing puss-in-the-corner, and dare to make references to the crippled state of his legs : ' We're not afraid of you,' ' You can't catch us,' and so on. Sometimes one of them would come up to him and say : ' Here I am. But you mustn't give me more than one whack.' And he would give her a symbolic blow, to the delight of the others. They liked to imitate the manners of the servant girls in Molière's plays, which they had read because they knew it would please Renoir. ' Instead of making yourselves more stupid by reading silly novelettes, try a little Molière.' He admired the great playwright because he was not ' intellectual '. But one day he had a real quarrel with a model because she was reading a weighty novel by Henri Bordeaux.

At times Gabrielle and La Boulangère would whisper ' Let's play a joke on the master,' and one of them would suddenly ask him, ' You haven't got twenty francs, have you ? ' He would go on with his painting, and reply, ' Look in my inside pocket.' He always carried a certain sum of money with him ' just in case '. Exactly what ' case ' he did not know exactly. I suppose he vaguely distrusted banks, and felt that it might be safer to have some ready cash in case of an emergency. For what, after all, was to prevent the Director of the Bank of France or of the Chase Manhattan Bank from skipping out of the country with the cash-box under his arm ? To continue with Gabrielle's little game: after a few minutes she would hold out the louis she had taken from Renoir's pocket, and say, ' Here's your money.' ' What money ? ' he would ask, astonished. And she concluded, ' You know, I could have taken it all, and he wouldn't have known.'

This reserve of money was also useful when people came to the house appealing for help. I have already related the incident concerning Oullevé. ' Paris,' Renoir said, ' is full of poverty. Now that I am able to sell my paintings I've no right to be selfish.' Gabrielle could tell ' simply by the way the bell was rung '. She would slip on a dressing-gown and go to the door. Sometimes it was a woman in mourning ; or a young girl ; or a mother with

young children. Gabrielle would then go into the little kitchen off
the studio and wait for the boss to call her. He would indicate which
pocket to look in with a movement of the chin. She would take out
one bank-note, or two, or three, understanding from Renoir's ex-
pression when to stop. The visitor could not get over her surprise,
and would go away weeping.

But it was not his charities that cost Renoir most money. On
several occasions unscrupulous friends fleeced him of his pictures.

I was little more than seven when I was an embarrassed witness
at the conclusion of an 'error' of this kind. My father would not
have wanted to use the word 'theft' for fear of giving the culprit
the idea that he was being classed for the rest of his life as an out-
right thief. 'We must assume that it was an accident. After all, that
can happen to anybody. Everything depends on the circumstances.'
It was not the moral issue involved that made Renoir want to keep
his friend from crossing the line which supposedly separates honest
people from thieves. Renoir had the greatest contempt for amateurs
in any field; and 'not everyone can be a thief just because he wants
to.' The friend in question lived a few doors away from the
studio. Before departing for the Midi, my father left him the key,
asking him to look in once in a while to see that 'no tap was
dripping or gas leaking'. When we returned from the Midi, the
friend and his wife left Paris abruptly, without coming to see
us. They asked Steinlen to hand the key to my father, who never
gave the matter a second thought. Next to the kitchen there
was a little store-room full of canvases, some of them still un-
finished. There Gabrielle would hang the clothes she used for
whatever picture she happened to be posing for at the time. The
rest of her costumes were packed in a large peasant chest of drawers,
Louis XV style, which I now have in my house. As she was un-
dressing in the store-room, Gabrielle suddenly noticed that some
fifty canvases were missing. What worried Renoir most was that
the unfinished pictures might be completed by some forger. He
wrote a note to the friend; and the latter, fearing he might have to
face an investigation, turned up immediately. I was posing with
Gabrielle when he called. My father sent us back to the apartment
and remained alone with the gentleman. I knew him well but I
didn't dare even to say hello to him. I was so impressed by his face,
wet with tears and contorted with emotion. He was unable to
utter a single word. Gabrielle told the whole story to my mother,

who looked much upset. There had been talk in the house of this friend's mistress, who may have influenced him to act foolishly. After waiting an hour, my mother sent us back to the studio. She did not go herself, for fear of complicating the situation. The scene, which had begun inside the studio, was now going on in the street. The visitor was down on his knees, kissing Renoir's hands. My father hardly knew which way to look. The most surprising thing was that the passers-by paid no attention, and hurried along intent on their own business. It made me think of a remark my father had made only a few days before: 'In Paris you are absolutely alone. You could be murdered in the street and nobody would take the slightest notice.' The gentleman finally went off at a run, and we all went home to a lunch of lamb chops and mashed potatoes. In telling my mother of the incident, Renoir explained : ' I kept telling him, " It's done, now ; the canvases are sold ; and you haven't the money to buy them back, nor have I. So let's forget about it. But for God's sake, don't make a scene ! " I had the scene, all the same. Tears, protestations, and all the rest.' He was more disturbed by this exhibition of emotion than by the loss of his pictures. Then my mother said : ' We mustn't tell anyone. If his father-in-law ever heard, it would be awful.' His father-in-law was a provincial magistrate. Before returning to the studio, Renoir asked my mother to go to the bank for him. He had given the thief all the money he had with him. ' I'm sure he didn't have enough even to pay his butcher.'

Sometimes, while he was working in the morning, Renoir would stop and say to Gabrielle, as she was preparing to light the fire in the cast-iron stove, ' What are you doing with that newspaper ? '

' I'm starting the fire.'

' But I haven't read it yet.'

' You never read the paper.'

' Wait. Open that portfolio.' It was full of water-colours. ' It's silly to keep all that stuff. A dealer might try to sell them.'

' I think they're pretty,' protested Gabrielle. But she had to obey him, and the entire contents would go into the stove, except for one or two pictures which she would manage to hide behind a piece of furniture. ' But he didn't trust me. He was clever, and he'd turn round all of a sudden to see what I was doing.'

This wholesale sacrifice was in no way prompted by despair. There was no *mea culpa* or Dostoievskian ' soul-searching ' in such

destruction. It was just the conviction that the researches of a painter are his own business. ' It's as if you put on a play in the theatre before you'd finished rehearsing it. And then, you need a lot of paper to light a fire.'

I still have some of the water-colours Gabrielle saved from the fire. She also saved a great many of his little ' notes ' in oil on canvas. Nowadays, many lovers of Renoir's art consider these bits and pieces as having an important place in the corpus of his work. They represent the direct expression of his preoccupations, his researches and his personality. Oddly enough, this was how Renoir also felt when it came to the work of the artists he admired. Once when he was out working in the countryside at Aix with Cézanne, his friend was seized with an urgent need to relieve himself. He went behind a rock with a water-colour he had just finished in his hand. Renoir rushed over and snatched it from him, refusing to give it back unless he promised not to destroy it. Cézanne acquiesced but then said : ' I won't show it to Vollard. He would try to find a buyer for it.'

My father's weakness—that is, his inability to say no to any-one—was well known. Certain swindlers knew that if they could approach him, even in some round-about way, they had a good chance of obtaining a picture from him. They had only to go down the Rue Laffitte to sell it for four times the price they had given. The only difficulty was how to get to him. My mother instructed the models to act as guards. While he was at work, no one dared to disturb him. In the evening only intimates and art-dealers who were trusted friends, such as the Durand-Ruels, Vollard, and the Bernheims, were allowed to see him. My father thought it only fair for the dealers to have a sort of monopoly of the artists' work. ' A dealer has to earn money. That's what he is in business for. And his profits help to support painters the public takes no interest in. The connoisseur who makes a business out of buying pictures is a dishonest man. His competing with the dealers is unfair as he doesn't pay a licence and has no overheads.'

The most favourable time to catch Renoir was when he was going from the apartment to his studio. The model, who went with him, parried the attack by running ahead so that by the time he reached the door she had undressed and was ready to pose. In those circumstances it was not possible to admit any unknown person, and that was that. If, however, the ' enemy ' kept insisting, as

happened occasionally, the model would protest in a loud voice, and threaten to put on her clothes. And Renoir, made courageous by fear of losing his sitting, would turn his back while the nude model walked over and shut the door in the face of the unwelcome visitor. The more scheming individuals would think up some pretext or other. Once, a stranger appeared saying that he was the adoptive father of Sisley's natural daughter. The illegitimate child was of course a pure invention, nevertheless the impostor departed triumphantly with a picture. One of the most persistent interlopers was a former municipal councillor of a little town near Fontainebleau. The fellow pretended that he had been delegated by the municipality to organize a museum for the works of the painters who had made the locality famous. He had told Monet that Renoir had already given a picture ; and he told Renoir that Monet had done the same. He insisted on paying for the paintings, and on having a receipt, duly signed. The transaction was perfectly legal. My father subsequently learned through Joseph Durand-Ruel that this art-enthusiast was only a stooge for a dealer at the far end of the Rue Laffitte, notorious for the forgeries he did not scruple to display in his front window, along with a few genuine pictures to give his shop an air of authenticity.

There was also the retired officer who turned up with a forged Renoir and a disarming smile.

' Monsieur Renoir,'—he had been warned that addressing my father as ' Master ' always put him in a bad humour—' I have just bought one of your pictures. I used all my savings for it, and even got a loan on my pension and mortgaged my little house in Etampes. The only trouble is that it is not signed.' The picture was a shockingly obvious forgery. But Renoir said to him, ' Leave it with me, and I'll touch it up a bit.' He repainted it completely and signed it, and it was a wonder that he did not buy a frame for the crook, who marched off with a small fortune.

Another impostor, an orphaned girl, claimed that she had been swindled by a dishonest lawyer. All that she had been able to save from the inheritance left her by her highly respectable father—some doctor or other who had devoted his life to the deaf and dumb— was a ' Renoir '. And again, there was the distressed mother frantically trying to keep her son from being sent to prison for his gambling debts : a question of honour, and so on. Fortunately, before her husband died, he had bought this ' Renoir ' . . . And each

time, Renoir would fall into the trap. When it was explained to him afterwards how he had been fooled, he pretended to have known all along.

'I saw through their little game from the start. It was as plain as day.'

'Then why did you repaint the picture?'

And he gave the real reason:

'It's less tiring to touch it up with a brush than to have to protect yourself,' he said. Then, after a minute's reflection, he added, 'As for the poor orphan girl, we have no way of knowing whether she had been swindled by her lawyer or not.'

In contrast to his incredible generosity, I recall Renoir's curious thrift, a trait which some people mistook for avarice.

When he was sitting alone by the fire, he would call Gabrielle to take off one or two of the logs. And it was the same with the coal in the very stove where he had burned his water-colours. Yet when he had a model posing for him he would fill the stove to the top—not from kind-heartedness, but for fear that the model would catch cold and be kept from posing in the nude.

As long as he was able to walk, he would never spend money on a cab. He was more or less shocked by the tips given in the smart restaurants. In his eyes this was a sign of timidity: a fear of the head waiter's scorn. I have already told how he refused the comfort of a sleeping-car until his health became so bad that he was in constant pain when sitting up. He thought it idiotic to pay as much for spending the night in a 'travelling-box' as you would for a week in a hotel room.

Side by side with that went a loathing for 'cheap' things. He considered, for instance, that a watch should be made of gold or silver. Nickel set his teeth on edge. He approved only of linen for household use. He never allowed my mother to buy cotton dish-towels because they left white specks on the glass. On the other hand he disdained crystal-ware, vulgar because it was 'faultless'; but he liked to look at bottles manufactured at Bar-sur-Seine because they were irregular, not made from moulds, and the glass had greenish lights in it, 'rich as the waves in Brittany'. The word 'rich' often figured in his conversation, and, of course, its opposite, 'poor', though he preferred the word '*toc*' (trashy). However, riches and poverty did not mean for Renoir what they mean for most people. In his opinion, a fine house in the Monceau

plain, the pride of some millionaire, was merely ' *toc* ' ; while a tumbledown hut glorified by the Mediterranean sun was riches. One day, in discussing with a friend the merits of the painter Rafaelli, then at the height of his fame, he indicated plainly that he had his reservations about that artist's work. ' But you ought to like him,' his friend said, ' he painted the poor.' ' That is precisely why I have my doubts about him,' replied Renoir. ' In painting there are no poor.'

Here are a few of the things that to him were tainted with poverty : English lawns that are a crude green, and too smooth ; white bread ; waxed floors ; things made of rubber ; statues and buildings in Carrara marble—' only fit for cemeteries ' ; meat cooked in frying-pans ; sauces or gravies thickened with flour ; artificial colouring used in cooking ; fireplaces which are never used and polished with black lead ; bread cut in slices—he thought bread should be broken ; fruit peeled with a steel blade instead of a silver knife ; bouillon without the fat skimmed off ; ordinary wine put in a bottle with a grand name on the label ; servants who wait at table wearing white gloves to conceal their dirty hands ; dust-covers on furniture and—even worse—on chandeliers ; a tray and brush for removing crumbs ; books giving a condensed version of a novel or a scientific work, or the history of art in a few chapters ; and magazines and periodicals. To these could be added cement buildings and asphalt pavements ; various cast-iron items ; printed linen ; and, in principle, any object made smooth and regular by too perfect a tool ; central heating, otherwise known as ' even heat ', in which class he also placed wines given a uniform taste by blending them. His attitude was the same towards anything mass-produced ; ready-made clothes ; mouldings on ceilings ; metal trellises or lattices ; animals standardized by scientific feeding ; and human beings standardized by studies and education. A visitor once remarked to him : ' What I like about the X brand of brandy is that the quality is always the same. There's never any unpleasant surprise.' ' What a good definition of nothingness,' answered Renoir.

I think by now the reader will have an adequate idea of my father's likes and dislikes, but I add a few of the things he esteemed as ' rich ' : Parian marble, ' which is pink and never chalky ' ; ivory black ; Burgundian or Romanesque roof tiles covered with moss ; the skin of a healthy woman or child ; brown

bread ; meat grilled over wood or charcoal fires ; fresh sardines ; flagstone pavements or streets paved in sandstone of a slightly bluish colour ; ashes left in a fireplace ; working-men's blue jeans after they have been washed and mended a number of times ; and so on.

He himself wore the same suits of clothes for ten years. If, when his working session was over, a little oil was still left in his paint-saucer, he saved it carefully. He used to scrape his Camembert or Brie cheese, but he never cut off the rind for fear of losing too much of the good part. Before his hands got so deformed, he would peel a pear by holding it in his left hand on the end of a fork and, with the knife in his right hand, remove the skin in slivers as thin as cigarette-paper. He was irritated by people who wasted part of the fruit when peeling it.

Except when we failed in respect for people and things, he would tolerate almost anything my brothers and I did, whether it was getting poor marks in the classroom, playing truant from school, making a noise while he was working, dirtying the floors, overturning a full dish, singing improper songs or tearing our clothes. I know now that he begged my mother to shut her eyes to certain pranks, such as when I made Gabrielle believe that goat-droppings were olives. Just as she started to put some in her mouth, my mother, who was easily disgusted, cried out, and so saved Bee-bon from an unpleasant experience. Then from her pocket she took a little knife, which she always carried, and began cutting a switch off a bush. My father had all he could do to persuade her not to use it on me. On the other hand, he scolded me one day when I helped myself to some Brie cheese by cutting off the soft point at the end of the piece, thereby depriving the rest of the family of the centre, which is the most delicate part because farthest from the rind. He called me a cad, which, coming from him, was as derogatory as possible. In the Renoir household caddishness ranked even below bad manners. Not being frank, beating around the bush, or being affected or ill-mannered, irritated my father. He thought being over-polite was impolite, and it made him want to be rude. To him it was only a caricature of the courtesy of former days, a sign of the conceit of the middle classes, who imagine that they can raise themselves to the level of aristocrats by discarding simplicity.

The cad was one of the characters most often caricatured in Renoir's day. The cad is the newly-rich man who talks and thinks

in an insolent way : ' What difference does it make if I walk on the flowers ? I paid for them, didn't I ? ' He is the poor man who steals the toilet paper in railway trains and says, ' The next comer will have to get out of his mess as best he can.' The cad eats his grapes by picking them directly off the large bunch in the fruit-dish. I have seen my father get up and leave the table in front of a person who was helping himself in this way. The cad makes a noise when others are trying to sleep ; he smokes though it makes others cough ; he spits into a well, and seduces women although he knows he has a venereal disease. The theatre-director who degrades the public with pornography and incites it to murder with plays about crime, is a cad. In my father's estimation, the speculator who cut down an orchard on the banks of the Seine in order to put up a block of flats of reinforced concrete was as caddish as an imbecile who deflowers an innocent young girl. Here is another example of what shocked my father : In the old days a waiter in the big cafés would place a bottle of apéritif on a customer's table and feel sure that the latter would help himself within reason. The crowds at the World's Fair in 1900 were not composed exclusively of aristocrats, and ill-bred visitors took advantage of such confidence by pouring themselves big bumpers simply because it cost no more. As a consequence, the waiter nowadays serves you stingily and takes the bottle off with him, which amounts almost to an insult. One piece of caddishness leads to another, and so it spreads like an epidemic !

The kingdom of cads covers an immense territory, and encompasses the gravest as well as the most trifling faults. Renoir asked only one thing of his sons, and that was to stay outside its frontiers. Even as children we knew enough to give up our seats to an older person in a public conveyance. We also knew that, fundamentally, all men are equal ; and that one should be just as polite to a vagabond like Baudry as to M. Germain, president of the Crédit Lyonnais. We were not required, however, to take off our hats whenever anyone greeted us. A hat is intended to protect the head. A queer idea some people have of exposing children's heads to an icy wind or to the risk of sunstroke under the guise of good manners! To Renoir, caddishness meant destruction. Had he been a Hindu, he would not have followed Shiva and the principle of creation born of destruction. He would undoubtedly have adopted the doctrine of Vishnu, the god of preservation. It sickened him to see a tree

cut down. And his reaction was the same to amputating a limb ; breaking any object ; wearing down precious metal by cleaning it too drastically ; hammering a block of beautiful stone in order to make an ugly statue ; debasing the mind of a child ; hunting as a sport ; squandering natural resources, such as wood, coal, oil, as well as such human assets as talent, devotion and love. A description of his palette will reveal far more than any explanation I can give.

But first of all, I must describe how a painter usually arranges his palette. The paints are squeezed out in mounds like miniature mountains, lapping over and mixing with each other. The thickness is such that the wood surface underneath is entirely hidden. Out of this amalgam it is impossible to pick out a single pure colour ; furthermore, the artist is constantly adding more, so that after he has dipped his brush in it again the new supply of colour is absorbed into the general mass. He has at his disposal an array of brushes, from which he chooses according to need ; for after several applications each one becomes clotted with a multicoloured impasto. When this 'harlequinade' becomes too much for him he scrapes his palette clean and squeezes out a fresh supply of paint. He keeps a drawer full of new tubes, which he takes out as he wants them. The foregoing description is not intended as a critique. Many great painters follow this method, and they sometimes go so far as to squeeze the paint directly on to the canvas.

Renoir's palette was as clean as a new coin. It was square, and fitted neatly into the cover of his paint-box. Into one of his double paint-saucers he poured linseed oil, and into the other a mixture of linseed oil and turpentine in equal proportions. On a low table at the side of his easel there was a glass full of turpentine, in which he almost invariably cleaned his brush after applying a colour. He always had several extra brushes ready in his paint-box, and on the table beside him. He did not use more than two or three at a time. As soon as they began to wear out, or drip, or for some reason made absolute precision of touch impossible, he threw them away. It was his rule to destroy old brushes so that he would not pick one up and use it by mistake. On the little table there were also a number of clean rags for drying his brush occasionally. His paint-box and the table were always in perfect order. He would roll up the tubes from the end so as to squeeze out just the amount of paint he wanted. At the start of a working-session he saw to it that his palette, which had been cleaned after the previous session, was immaculate.

When cleaning it, he first scraped it thoroughly, and wiped the scraper on a piece of paper, which he threw at once into the fire. Then he rubbed the palette with a rag moistened with turpentine until all trace of paint had disappeared from the wood. He also threw the rag into the fire. The brushes were washed with soap in cold water. He thought it a good thing to rub the bristles gently over the palm of the hand. I was sometimes given this task and I was very proud of it.

Renoir himself described the composition of his palette in the following note which evidentlv dates from his Impressionist period :

> Silver white, chrome yellow, Naples yellow, ochre, raw sienna, vermilion, madder red, Veronese green, viridian, cobalt blue, ultramarine blue. Palette-knife, scraper, oil, turpentine—everything necessary for painting.
>
> The yellow ochre, Naples yellow and sienna earth are intermediate tones only, and can be omitted since their equivalents can be made with other colours. Brushes made of marten hair ; flat silk brushes.

It is to be noted that black, ' the queen of colours ', as he was to proclaim after his trip to Italy, is missing.

Towards the end of his life he simplified his palette still further. Here, as nearly as I can remember, is the way he arranged the paints on his palette when he painted ' Les Grandes Baigneuses ', now in the Louvre, in his studio at Les Collettes in Cagnes :

Starting on the lower side, next to the hole for his thumb : silver white in a thick ' sausage-roll ' ; Naples yellow in a small dot ; and the same for the following colours : yellow ochre, sienna earth, red ochre ; madder red, green earth, Veronese green, cobalt blue, ivory black. His choice of colours was not inflexible. On rare occasions I saw Renoir use Chinese vermilion, which he placed between the madder red and the green earth. In his final years he simplified his colour range still more, and for certain pictures omitted either red ochre or green earth. Neither Gabrielle nor I ever saw him use chrome yellow. His economy of means was very impressive. The isolated blobs of colour seemed almost lost on the surface of his palette. Renoir used them frugally, and with respect. He would have felt that he was insulting Mullard, his paint-dealer, who had ground the pigments so carefully for him, if he had over-

loaded his palette or if he had not used the paint down to the last particle.

He always mixed his colours on the canvas. He was very careful to keep an impression of transparency in his picture throughout the different phases of the work. I have already described how he worked on the whole surface of his canvas, and how the motif gradually emerged from the seeming confusion, with each brush-stroke, as though on a photographic plate. I also mentioned the coat of silver white which he applied to the canvas before starting to add colour. He would ask the model posing for him, or whichever of his sons had been given the task, to increase the proportion of linseed oil. As a result, the white took several days to dry ; but it gave Renoir a smoother surface to work on. He did not like fine-grained canvases which were softer to paint on, for he thought them less resistant. In addition to this practical reason there was per-haps another one, which was unconscious : his admiration for Veronese, Titian, and Velasquez, who, it appears, painted on rather coarse-grained canvas. These reasons were complementary: for my father was sure that the great masters wanted to produce work that would be lasting. His concern with durability had nothing to do with the pride of believing his work worthy of eternity. But he knew that his painting would take a good fifty years to ' *se caser* ', or find its place : that was the expression he used for letting the colours find their balance. He often said, 'I would like to keep my canvases for a long time, and ask my children to do the same before letting the public have them.' He had had occasion to note the danger of ' painting for the present ', for certain of his earliest canvases were already turning black. Art-lovers of our day can now verify, forty years after his death, how perfectly his 'long-term method' has succeeded.

Almost all Renoir's works, painted with this thought in mind, have gained with time. I don't mean to say that they themselves have changed in appearance. It is perhaps that we now look at them with different eyes. Renoir was too modest to admit that he was ahead of his time. All great artists are ahead of their time ever since their public outstripped the limited circle of the 'Medicis, François I, and other professional and hereditary Maecenases'. It is the ransom to be paid for the privilege of dealing with the crowd, which is slow by nature. It is natural that the taste of millions of individuals should evolve more slowly than that of a

small group brought up to discuss aesthetics as a matter of course, or that of a few hundred Athenians conversing in the Agora. Elites of that kind had a training which protected them from being shocked by anything new. The critic's profession arose from the need to explain the unaccustomed to the untrained masses. But, by a mysterious combination of circumstances, it so happens that since the rise of criticism, and especially its development in the nineteenth century, the prophecies of these critical soothsayers have more often proved false than true, and have rarely been endorsed by posterity. Delacroix was dragged in the mud, the Impressionists were scorned, and the Cubists vilified as nothing but jokers. Even Diderot delivered himself of some idiocies; and some of Alfred de Musset's pronouncements make one shudder. It would seem that the critical sense has never gone with great creative ability. Ultimately it is the public which, after a long period of assimilation, renders the final verdict. Out of the masses, authentic art-lovers like Choquet emerge occasionally, and they eventually succeed in awakening the others. This tardiness in making people accept the evolution of art, literature, music and even thought, frightened Renoir. He saw in it the death of Western civilization. This evolution is slowed down by mass media, for example by the press, which must provide its readers with material which does not startle them. The artist is obliged, in consequence, to take refuge in an ivory tower among a little band of admirers. Renoir frankly disapproved. ' It quickly degenerates into a mutual-admiration society, and you're done for.'

My father hoped that his works would last long enough to be judged by the public at the propitious moment. His hopes have certainly been fulfilled.

I have mentioned the colours he used, and the dealer in the Rue Pigalle who prepared them for him. Renoir had no great faith in new chemical products which had not yet been proved reliable. The chief fault he found with them was that they gave too ' glossy ' an effect, and he wanted to gain his effects of brilliance by means of the contrasts he had worked out. Mullard's paints were still ground by hand. I can still see his glassed-in workshop, opening on a courtyard, and the half-dozen young women he employed, working away in their white smocks with mortar and pestle.

Towards the end of his life my father seldom made use of canvas fastened to stretchers of fixed size. One of the advantages which his success brought him, and which he appreciated, was being able

to paint what he wanted in whatever size suited his fancy. He would buy large rolls of canvas, generally a yard in width, cut out a piece with his tailor's scissors, and fasten it to a board with drawing-pins. He also had rolls much wider for his 'big jobs'. For portraits, however, he sometimes used canvas already mounted on stretchers of a set size. I think he had in mind antique picture-frames which he admired so much, as they usually correspond in size to the standard stretchers. When his old friend Durand-Ruel reproved him for having done the portrait of a certain lady for a price that lowered its value, Renoir replied, ' She promised to put it in a genuine Louis XV frame that I saw at Grosvalet's.'

Since the days when I went to the studio and posed almost as often as the other models, I have only rarely seen the method of tracings used. My father used a tracing when he was satisfied with the position of a body or of a group but did not like the way it balanced with the background. In my father's phrase, when ' it was not coming together.' To avoid having to make sure once again that the model was ' squarely seated on her backside ', he would make a tracing, put it aside, and go on with other work. He did not take it out of the drawer and start using it on a new canvas until long afterwards, sometimes even months or years. As we know, he would paint the same motif several times. Some of them he reworked with great persistence. But in his eyes, each version was a different picture. The question of the actual ' subject ' did not concern him at all. He told me one day that he regretted not having painted the same picture—he meant the same subject—all his life. In that way, he would have been able to devote himself entirely to what constituted ' creation ' in painting : the relations between form and colour, which have infinite variation in a single motif, and which can better be grasped when there is no further need to concentrate on the motif. I pointed out to him that that was what he had done with his ' Judgment of Paris '. He paused and then asked himself : ' Perhaps I have painted the same three or four pictures all my life. But one thing is certain : ever since my trip to Italy I have been concentrating on the same problems.' He made this remark to me in Cagnes only a short time before his death.

It was while we were living in the Rue Caulaincourt that my father had me pose for him most often. A few years later my brother Claude, who was seven years younger than I, was to take my place in the studio. Coco certainly proved one of the most prolific

inspirations my father ever had. I think only Gabrielle could beat his record in this respect, and she far outstripped him as regards the size of the pictures. I have in mind particularly the large nudes which I saw being born and elaborated.

Renoir could not deal with two ideas simultaneously, but he could go from one motif to another and forget the preceding one. All the problems in a picture on which he was working were perfectly clear to him, and the rest of the world disappeared as completely as if it had never existed. When he did not feel for a picture, he never forced it. Those around him knew at once. He would cease humming to himself and rub the left side of his nose violently with the index finger of the left hand. And he would finally say to the society-woman whose portrait he was doing, or to the model who had stopped his tune : ' We're marking time. I think it would be better if we put it off till tomorrow.' The lady or the model would look crestfallen. He would smoke a cigarette, play a little with his game of bilboquet, and then make up his mind. 'Gabrielle, go and get Jean and his foulard scarf.' Sometimes he would go out for five or ten minutes and walk as far as Manière's to get a packet of Maryland cigarettes. ' You have to stop work and take a stroll once in a while.'

When I was still very young—say at the age of three, four or five—instead of deciding on the pose I was to take, he would wait until I found something to occupy me and keep me quiet. That is how ' Jean Eating Soup ', ' Jean Playing with Toy Soldiers ', ' Jean with Building Blocks ' and ' Jean Looking at a Picture-Book ' came to be painted. I remember quite clearly all the preparations for the picture now in the Art Institute in Chicago, showing me sewing. It was executed at Magagnosc, near Grasse, where my parents had rented a pretty villa on the side of the mountain. I must have been about five at the time. We had a pet rabbit, named Jeannot, which we used to take with us when we went for a walk in the wild land on the other side of the road. My father, mother, Gabrielle, La Boulangère and I would form a circle around Jeannot to keep him from running away up into the mountain. There was a little stream near by, and plenty of long grass, and it did our hearts good to see the little creature, which had been born in a hutch, playing about under the illusion that he was living a wild, free life. ' Just the way Parisians go mountain-climbing in the Alps,' my mother said. ' Like the Douanier Rousseau,' said my father.

# Renoir, My Father

It was in that house that Gabrielle posed in the nude for the first time. La Boulangère had a cold, and Renoir had tried in vain to get a model from Grasse. It was the rose-gathering season for the perfume industry, and all the young people in the vicinity were employed. At the same time, it is possible that the prospect of appearing naked in front of a gentleman frightened many of the girls. My father had a moment's hope with a very pretty girl whose reputation was sufficiently tarnished for her to have nothing left to fear. But she retorted that sleeping with men was no reason for undressing in front of them, and she boasted that she did that sort of thing out in the fields, with all her clothes on. Renoir was not too disappointed, for, after interviewing the girl, he had grave doubts about her personal cleanliness.

My mother finally had the idea of getting Gabrielle as a substitute. She had just turned twenty and she was in the flower of youth. She was so accustomed to seeing her friends pose in the nude that she took the suggestion as a matter of course. She had already appeared in countless pictures, but always fully clothed and always with me. I was the ' star ', and she had the secondary role. She is not in the picture showing me sewing, but it was she who had the idea that kept me quiet in front of the easel instead of running out to play with Jeannot the rabbit. M. Reynaud, the owner of the villa, had brought me a little painted tin camel, which I loved. Gabrielle persuaded me that I ought to make a coat for ' my camel ' out of a piece of satinette she had. It proved such a fascinating task that it kept me almost motionless the whole time. Renoir consented to my being so quiet only because he thought it suited my mood of the moment. He did not like his models to hold their pose stiffly out of sheer will-power—' a body that doesn't move while the mind is galloping off '. As a rule, he would simply ask me, as he did all his models, to stay more or less in the place he had chosen, in front of several pieces of different-coloured cotton cloth fastened to the wall with drawing-pins. He was not particular about the position of the head or limbs. Occasionally, in order to make sure of some detail, he would say, ' Would you mind holding still for a minute ? ' And in fact it would be only for a minute. He liked talking to his models and he liked having them talk to him. But he wanted conversation to be banal. That is why he appreciated Georgette Pigeot's songs. He wanted the subject to lapse into a state of mindlessness, to sink into the void. He wished his models to be relaxed in mind as well as

body. Their gift of serenity was probably another reason why he took so much pleasure in painting women and children. ' Men are too tense : they think too much.' Profound, dramatic or passionate concerns, he thought, set the seal of the transient on face and body whereas, according to him, art is concerned only with the eternal. The hero portrayed at the moment when he is defying the enemy, or a woman shown in the hardest pains of labour, is not a suitable subject for great painting, though men or women who have passed through such ordeals and been ennobled by them become great subjects when later on the artist can portray them in repose. It is not the transitory character of an individual which should be fixed in marble, but his whole general character, the culmination of his entire life, heroic or cowardly, commonplace or fascinating. In short, the artist's task is not to stress this or that instant in a human being's existence, but to make comprehensible the man in his entirety. The ' Seated Scribe ' is not writing a frenzied letter at some historic moment. He is writing all the letters of all the scribes of Egypt, and he is doing so with the sum-total of his experiences in life, as well as with his heredity, with the climate of the Nile, with his conception of divinity, and many other elements, which interact in every living being. This desire to escape from the temporary explains the contempt of great artists for the fashions of the day. It also explains the importance of the nude. For what is more eternal than the human body ? By portraying it unclothed, the artist avoids an element that is based on titillation : I mean the pornographic. The body excites the senses only when its nakedness is revealed bit by bit after having first been seen fully clothed. Renoir often spoke of that ' state of grace which comes from contemplating God's most beautiful creation, the human body '. He added, '—and for my personal taste, the female body.'

I hope I may be forgiven if I return for a moment to a subject already broached in my account of the ' Moulin de la Galette ' painting. I do so only because I am nearing the end of the Renoir story. We begin to sense the impassioned serenity of the final period. It will be easier to understand if I mention something which indicated his progress towards a ' state of calm '. My father disclosed it to me in the course of our conversations.

' When you are young, you think everything is going to slip through your fingers. You run, and you miss the train. As you grow older, you learn that you have time, and that you can catch

the next train. That doesn't mean that you should go to sleep. It is simply a question of being alert and not getting nervous.'

The pursuing ' hunter ' which was one side of his nature did not slacken, indeed was destined never to disappear. Until the day of his death Renoir remained ' on the watch for the motif '. But now the game allowed him to approach with less fear, having discovered that the hunter's buckshot was love continually renewed. I know what I am talking about, having been the ' game ' myself and caught in the trap on more than a hundred canvases.

It may be remembered how my father insisted on my hair being kept long as a protection against blows or falls, and in addition, there was the increasing pleasure he took in painting it. As a consequence, I was still, at the age of seven, going about with my curly red locks. The arrival of my young brother changed the situation. My parents now decided to send me to the Sainte-Croix school, and for that my hair would have to be cut. The entire household was present at the solemn occasion. My father deplored the necessity for it, thinking of all the pictures he might still have painted of my ' thatch '. My mother, precise as well as practical, instructed the barber. Gabrielle and La Boulangère wept. I myself was exultant. My hair had given rise to diverse emotions. For though it had earned me many a compliment at home and in the studio—' real gold,' everyone said, repeating my father's words—in the street the children called me either ' girl ' or ' wolf's head '. The latter insult riled me particularly, because of my father's distaste for the ceiling-mop known familiarly by that name : a large brush fastened on the end of a long pole, for cleaning spider-webs out of corners of the ceilings. Renoir liked spiders. ' They destroy the flies, and sometimes can be very faithful friends.' The servants used to hide the mop in the cellar behind a heap of coal, and only used it when my father was not about.

Whenever some detail in a picture required that I should stay still, Gabrielle would read Andersen's *Fairy Tales* aloud ; and she and my father enjoyed them as much as I did. Our favourite was ' Soup from a Sausage Skewer ', which we all knew by heart. When the mouse tells of the royal banquet and says ' I was the twentieth on the left of our old king, and that was an honourable place, I think,' Gabrielle would lapse into her Burgundian accent : and we would all imagine the feast being held in the style of a wedding in Burgundy. At the end, when the mouse has explained that the

recipe requires the king to dip his tail three times into the boiling soup and he has avoided the ordeal by marrying her, Renoir would give a wink and his face would crinkle with malicious joy. He would put down his brush and ask for a cigarette. We all felt comfortably at ease, and it was very pleasant. Then we would resume the posing-session, and Gabrielle would start ' The Steadfast Tin Soldier '.

Renoir had kept up his custom of receiving visitors in his studio after his day's work. One evening when the summer afterglow was lingering satisfactorily, a friend came in before the sitting was over and heard the conclusion of ' The Ugly Duckling '.

' What l ' he said to Renoir, ' you allow your son to listen to fairy-tales, to downright lies ? First thing you know he'll be getting the idea that animals talk l '

' But they do l ' replied my father.

When Andersen's *Fairy Tales* no longer served to keep me quiet, he would send me off, and begin working on a flower-piece, or a still-life with fruit, or La Boulangère's shoulder, or a profile of Gabrielle.

I was never punished when I behaved badly while posing. And Lord knows I misbehaved often enough. ' It would make him hate the studio. Don't say a word to him l ' Whenever I had been fairly good, and Renoir as a result had been able to get on with his picture, he never wished me to be rewarded for it. He disliked the idea of a child's life being turned into a competition to gain a reward for virtue. He would consent to spankings, ' which are as good for the parents as they are for the children ', although he was never willing to administer them himself. He forbade slapping a child's face : ' That's what backsides were made for.' He did not want us children to be given money for doing a task. To do anyone a favour in the hope of receiving pay for it seemed to him ignoble. ' They'll learn about money soon enough.' He was anxious to in-culcate into us the idea that such things as helping one's fellows, friendship and love were not for sale.

Later on, when I was at school, fired by the example of the bigger boys, who ' did business ', I sold a pencil to one of them. I was quite pleased with the transaction because I felt that was how things worked in this world, and I boasted about it when I got home. To my great surprise, I nearly got a whipping for it. I was made to return the money to the boy with whom I had done the deal, and

even give him a toy pistol my godfather Georges had brought me. Our parents' fear of seeing us become ' mercenary traders ', as well as our knowledge of our father's generosities and frugalities, combined to instil into my brothers and me a clear conception that values based on money are only relative. I can imagine the face my father would have made if he had seen children of rich families in America earning a few pennies by selling soft drinks on roadside stands or delivering newspapers. When these young conformists show their profits to their parents, mamma and papa fairly burst with pride and praise their offspring for their enterprise. Renoir would have regarded such activities as part of a cult which is about to replace Christianity : the cult of the Golden Calf.

Forty years after having posed for one of my last portraits, painted while my hair was still long, I happened to see it again at the Durand-Ruel gallery in New York. It was for sale, and my wife and I were tempted to buy it. I am shown wearing a very nice costume of fine blue velvet, set off by a handsome lace collar. This kind of fancy-dress was to become very popular under the name of ' Little Lord Fauntleroy '. I have a hoop in my hand, and am painted full face and staring out of the canvas with a rather surly expression. Why my father wanted to portray me in this get-up, which I loathed, I do not know. Perhaps it was a feeling of affection for Van Dyck ; or else a desire to see how successful he could be in bringing out the flesh tones against the mass of midnight blue. Before coming to a final decision, my wife and I consulted Gabrielle. ' It's not how you usually looked ! ' she exclaimed. ' We had to put the suit on you by force, and you kept kicking me all the time.' But my father had been determined, and I had had to submit. Gabrielle's recollections of the terrible scene I had made put us off buying the picture. I suppose the lace collar added to the shame I felt at being called a girl because of my hair. As a reaction, I liked only rough materials, heavy shoes, and obviously masculine clothes : above all, my brother Pierre's cap. It was the official headgear worn by the pupils at Sainte-Croix, and for me the ultimate symbol of masculine elegance. Like the kingly crown of old, I believed it conferred on its owner not only an aura of importance but an undeniable proof of virility and courage. When my brother came home on Sundays I was convinced that the admiring attention of the whole country was fixed on his cap. After Claude was born I was sent to school at Sainte-Croix in order to give the newcomer the run of the house ; but at the same time,

knowing that I would now have an opportunity to wear a similar cap, it was hoped that I would stop my interminable whining. Gabrielle has told me that I would sometimes lie on the floor and repeat, ' I want Pierre's cap ! ' for hours on end. One day, while I was down at Essoyes, Marie Corot made me a present of a cap bearing the insignia of the local music society. The shape of it was like Pierre's, but it had no embroidered cross in the centre, nor dark blue velvet around it. ' There, you spoilt little brat,' she said, as she handed it to me, ' now you've got Pierre's cap.' Enraged by her demeaning the sacred object, I clenched my fists and rushed at her. Marie was too valuable a cook for my mother not to punish my outburst of anger with a good spanking.

# 26

Renoir's portrait of Vollard proved to be quite an affair. A good many years had elapsed since his first visit to the Château des Brouillards. He had made Cézanne's acquaintance, and that artist had made him his sole agent—' since the other picture-dealers don't give a damn about me. ' He had by then started to amass that well-deserved fortune which was to astonish all Paris. He lived in the cellar under his shop in the Rue Laffitte, and it was in those incongruous quarters that he stored his Cézannes, his fine furniture and rare editions. He entertained everyone of importance in the Paris art world at sumptuous dinners, usually creole style, concocted by some relative from his native island and served by the Mathieu sisters, Odette and Raymonde, who were now in his service. Odette was a handsome girl. Fearing that he might find her too tempting, he sent her home to sleep at her parents' as soon as the dishes were washed, even while his guests were still present. His one great weakness was a certain snobbery which prompted him to confine his adventures to women in society. My father said that his snobbery helped him to understand his customers better.

He was taller, stronger and more swarthy than ever ; my father averred that he was even handsomer. ' He was Othello before ; as he grew older, he became Masinissa, King of Numidia.' He dozed as much as ever, especially when a prospective buyer asked him the price of a Cézanne. I remember his shop clearly, all painted in yellow ochre. In fact, in everything associated with Vollard, I seem to recall that colour in more or less dark shades, from his superb light-brown tweed suits to his dark southern complexion. You fell over canvases the moment you entered his place. They were stacked against the walls. When a prospective buyer would reach out his hand to turn one round, he was halted by the famous warning : ' That picture won't interest you. It's not for you.'

Only when I was older did this extraordinary man become something more to me than a character out of a fairy-tale and take on the lineaments of a human being. What struck my imagination, as a boy, was the atmosphere of his shop; its colour, the half-hidden canvases; his voice saying, 'Tell me, Monsieur Renoir . . .'; and my mother wishing to learn how the rice served at his dinners was always cooked so that the grains were separate and did not form a sticky mess. Vollard explained to her: 'In Réunion the natives have no time-pieces. They just put rice and water into a calabash, heat it over a fire made with sugar-cane cuttings, go to sleep, and when they wake up it's done, and absolutely perfect!' This example of the triumph of instinct over reason delighted my father.

Before resuming the subject of Vollard's portrait, I should like to confess a piece of boyish naivety, which illustrates vividly the admiration I had for him: I actually believed that the American silver dollar, which was worth a good deal in those days, had been named after him. For years I called it a vollard, and was surprised not to find our friend's face stamped on the silver coins. I am still apt to say, in a moment of absent-mindedness, 'The budget for the development of space-missiles is so-and-so billions of vollards.'

My father's greatest problem with the portrait was how the subject should be dressed. Vollard was very natty, and had his clothes made by one of the best tailors. Renoir shook his head dubiously, and remarked, 'You look as if you were wearing fancy dress.' He was to get used to Vollard's dressiness eventually, and paint him in the suit he wore every day. Cézanne was to achieve masterpieces of Vollard in his white shirt, though in the large portrait he did of him he never dared finish the shirt. There was a tiny little spot which was never painted: 'If I fill up that pin-hole,' Cézanne explained, 'I might upset the balance of the whole picture, and then I would have to start all over again.' Vollard, who felt highly insecure on the rickety stand on which Cézanne had placed him, begged the artist to let the pin-hole be. He had fallen once or twice and hurt his knee, even though Cézanne had assured him: 'You're in no danger as long as you keep still as an apple. Does an apple move?'

For this particular portrait my father wanted to dress his model as an exotic potentate. 'If you could only find a satrap's costume!' La Boulangère, who was partial to the Army, proposed hiring a

general's uniform. Gabrielle was all for a lion-tamer's costume.
Her suggestion was better, but it did not seem ' royal ' enough. In
rummaging through a chest of drawers, where he kept all kinds of
odds and ends, Renoir came across a toreador's costume bought in
Spain, during his trip there with Gallimard. ' Vollard doesn't look
much like a toreador, but the colour will suit him.' All our friends
thought it was a joke. But it was nothing of the sort. Renoir had
no intention of making fun of his model, and he painted the picture
that is now so well known. Yet I still come across people who say
to me, ' Did your father want to play a joke on Vollard?' As if one
painted an enduring masterpiece for the sake of a joke !

The portrait he painted of Mme de Galéa fascinated me far more
because this lady corresponded to my notion of what the Empress
Joséphine must have looked like. My passion for the toy soldiers
of the Empire had not worn off. I had a great many, among them a
special group representing Napoleon and the different personages in
his court. There was Joséphine, of course, resplendent in a white-
and-gold robe and surrounded by her ladies-in-waiting. When
Gabrielle told me that the lady who was sitting for the portrait was
also a creole, my admiration knew no bounds. Her beauty and
distinction were obvious, and Renoir was enormously pleased to
paint her. Vollard had introduced her to him, and it was he who
attended to getting the necessary furniture and accessories for the
picture. I was evidently not the only one to see the connection
between Mme de Galéa and Joséphine de Beauharnais, for all the
articles delivered to the studio were of early Napoleonic style, though
very new and very gilded. They came direct from the Faubourg
Saint-Antoine. Gabrielle and I were loud in our praises. My
mother compressed her lips. Renoir's first impulse had been to send
back the hideous stuff, but he was afraid of hurting Vollard, who
after all knew what he was doing. He hoped, no doubt, that this
accumulation of gold, silk and mahogany would induce Renoir to
turn out something very ' rich '. Renoir covered part of the silk on
the couch with a large satinette cushion, put an old rug on the
floor, draped some pieces of cotton cloth here and there, and for the
background created an imaginary tapestry representing a crane.
Among the gowns provided for his model, he chose a long shimmer-
ing one which left the shoulders and bosom exposed. An aigrette,
a few jewels in the hair and a sparkling collar completed the effect,
and succeeded in giving an impression of ' would-be Empire ', which

amused Renoir highly. As a matter of fact, he could not bear the Empire style except when it was ' *toc* ', and Vollard knew it.

Another of his models who stirred my imagination was Missia Godebska. At the time of her portrait she was Missia Edwards. Her husband made even more of an impression on me. I was at boarding-school by that time, but luckily for me, owing to an attack of laryngitis, I was able to stay at home and breathe in the atmosphere of vitality radiating from those two forceful personalities. To say that Missia was beautiful would be an understatement. Albert André knew her well, and he said that when she entered a restaurant, everyone would stop eating. She was the daughter of a noble Polish family who had lost their fortune. She had grown up in a palace where, although the servants were rarely paid, royalty, great artists and millionaires would come to hear her play on one of her thirty pianos. There were at least half a dozen of these instruments in some rooms. A precursor of Giraudoux who contended in his play *Ondine* that each theatre is suited to only one type of play, Missia was convinced that each piano is appropriate for only one piece of music, and therefore it is impossible to play a Bach fugue on an instrument which has proved suitable for a Schubert melody.

She had been so poor that she had slept on benches in public parks ; and so rich that she could not begin to count her wealth. She had been married several times, and was a friend of all the talented people in the world of art and letters at a period when Paris was overflowing with talent. Her friends ranged from Bonnard to Debussy, Mallarmé and Renoir. She had been married to Charcot the explorer, taken part in the chemical researches of Berthelot, and aided Diaghilev, who frankly admitted that, without Missia, Paris would have had no Russian Ballet. And, although she had a past sufficiently eventful to have filled ten eventful lives, she still looked like a young girl. I suppose that at the time she posed for Renoir she was in fact quite young. The troubles the creditors had brought on her parents had opened her eyes to the realities of life at an age when most girls are still playing with dolls. Her knowledge of Bach and Dante, her acquaintance with Proust and Sibelius, had served as a substitute for formal education. She could speak any number of languages. And her slight Slavic roll of the ' r ' added to the charm of her conversation.

Edwards was a businessman of Turkish extraction, and had the powerful build of a Turk. He could tear a pack of cards apart with

his bare hands, and bend out of shape any coin you gave him. His father had long been a well-known figure in Parisian society, and had financed Paul Durand-Ruel after the War of 1870. Edwards himself had a controlling interest in any number of enterprises. I was very much taken with the high-sounding name of one of the organizations he was connected with : ' L'Aménagement du Port de Santander '. He was the owner of a large newspaper—*Le Matin*, if I am not mistaken—and of coal, copper, iron and nickel mines. He had a finger in a bauxite plant in Provence which turned out aluminium, a metal which was new then but had a great future predicted for it. To amuse Missia he had bought her a car factory—the ' Mors ', I think. In order to win such a woman and persuade her to marry him he had resorted to the following procedure. He would invite her friends to dinner every evening. And as she could not do without her friends, she was forced to join the group. Edwards always had her sit on his right, and every night she would find a little jewel-case under her napkin, containing a diamond of great value. As my father said, ' What woman would resist ? ' She was already married to a remarkable man, a writer of talent, who had founded the first serious *avant-garde* review, and believed himself to be a businessman. Edwards bought up his business affairs, which were in a sorry state, and sent him out to the ends of the earth to manage some sort of mines. His name was Thadée Natanson, and he was the moving spirit of the *Revue Blanche*. But Missia was loyal. She resisted Edwards's advances, until the day when Natanson realized the futility of trying to struggle against a hurricane and gave Missia her freedom.

Certain malicious tongues accused Edwards of numerous grave misdeeds. It was even said that he set no great value on human life. Later on, after Missia's reign was over, and she had married the painter Sert, he lost his new wife, a celebrated actress, on a cruise down the Rhine. At the end of a party on board, during which everyone had dined and wined too well, she slipped into the water and was never seen again. The gossips in Paris insinuated that her ' slipping ' had been ' assisted '. But no one could justify the accusation. I mention this piece of scandal only to give an idea of how everything Edwards did excited public interest at the beginning of the century. In any case, my father took an enormous liking to him, and in return was rewarded with a sincere friendship on Edwards's part. It was all the more touching as Edwards detested

painting as much as Renoir loathed business. Whenever Missia succeeded in dragging her husband to an exhibition, he always sneaked off for a drink with his chauffeur in a near-by bistrot. Even so, he never missed a single sitting while Missia's portrait was being painted. While my father was working, Edwards would coax Gabrielle to go into the little kitchen off the studio and play cards with him. The minute Renoir laid down his brush for a brief rest, he would join them ; and the two men, happy in being together, would discuss anything that came into their heads. Except for art and business, they agreed on almost every subject—food, women, climate—and they even shared the same antipathies. For instance, neither of them could stand people who try to be ' witty ' at the wrong time, atoning for some rudeness by their ' wit '. I recall one of Edwards's anecdotes about an ' ultra-Parisian journalist '. Finding himself late for a dinner to which he had been invited, the would-be wit racked his brains, as he climbed the stairs, for something funny to say to amuse the guests and mollify his hostess. Thinking that he had hit upon something unique, he rang the door-bell, confident that he would create a sensation. A man-servant opened the door. From the entrance-hall he could make out a large number of people seated at table, about to start the meat-course. He placed his hat on the head of his cane, which he straddled, and, imitating a rider, went galloping around the dining-room, crying, ' Gid-ap ! Gid-ap ! ' Everyone looked round in bewilderment, while he slowed down, vaguely uneasy. The last ' Gid-ap ! ' stuck in his throat. He had just realized that he had mistaken the floor and come to the wrong apartment.

At the time when he began Missia's portrait, my father had just gone through the most painful attack of rheumatism he had suffered so far. His hands had become a little more deformed. It was then, in fact, that he had to give up his juggling act and switch to his small log of wood. As he walked about, he would toss and twirl the small log. He asked Mme Brunelet, the concierge, who lived just below, to pardon him for all the noise he made. He even gave her a little canvas, by way of thanking her for being so patient. When he was in his studio he took advantage of each interruption to play bilboquet, at which he had become quite adept. He took quantities of antipyrin and other drugs, and ate hardly anything. And in spite of all these precautions, he felt no better. On some days his joints were so stiff that he had to use two canes just to go the few hundred

yards between the house and his studio. His condition so aroused Edwards's sympathy that his friend would bring a new doctor to see him almost every day. Each of them would examine Renoir, shake his head, and declare that science had not yet been able to discover an effective remedy for this form of rheumatism. One of the doctors asked my father if he had ever had syphilis. He told him no. The practitioner insisted, ' You know, a person can very easily have syphilis and never know it.' ' Is that so?' replied Renoir. Unfortunately, the mysterious malady which kept spreading inexorably through his system was more pitiless than the worst of venereal diseases. And even quite recently the best specialists, using cortisone, were unable to save Raoul Dufy, who also suffered from arthritis.

Apropos of syphilis, Renoir disliked the term and preferred calling it, bluntly, the pox. He was amused at the famous rejoinder which Saint-Simon made to the King's minister who came to announce the death of Louis XV from small-pox, ' Monsieur, with kings all things are great.'

'Those people in the eighteenth century still knew how to speak French.'

Paris was dazzled by the Russian Ballet. While he was at work on her portrait Renoir asked Missia to tell him about Stravinsky. Accompanying herself at the piano, she tried to give him an idea of the young composer's music. ' He is in music what you are in painting.' One evening, when the Edwardses stayed on to dinner— Missia just nibbled at her food, whereas her husband gladly gorged himself on my mother's cooking—they were suddenly struck with an idea. ' We will take you all to the ballet ! ' My father was having a bad attack of pain, and could walk only with difficulty. However, he was willing to be persuaded. My mother got dressed in the twinkling of an eye. Gabrielle ran to the studio and put on a Callot gown that Renoir had used for several of his pictures. Jeanne Baudot, a friend of the Callots, had got the dresses for him, as they were ' very useful for certain subjects '. The dress was out of fashion, and made Gabrielle look like a gipsy, much to the delight of the Edwardses. I was in the party and I donned my Sainte-Croix uniform, with its three rows of gold buttons. Edwards and Missia were already in evening dress, as they were to meet Diaghilev at Maxim's for midnight supper. Renoir went in his working-clothes, a jacket with a turned-up collar, a flannel shirt, a blue cravat with white polka-dots,

and his cap, which he kept on for fear the cold would aggravate his neuralgia. My mother and Gabrielle wanted to put him into his dress-suit. But it seemed too much of an effort for him, and he stayed as he was. Edwards was a box-holder, so there was no problem about getting seats. On arriving at the grand staircase of the theatre, Renoir thought he would have to turn back, but Edwards lifted him up in his arms, and, with Missia and my mother on either side, solemnly carried him up, while everyone looked on in amazement. It must be confessed that we made an odd-looking group. The interior of the theatre was magnificent. The audience which had come to applaud or hiss these ballets that were to revolutionize the theatre was decked out in unimaginable splendour. I am not exaggerating when I say that it was more beautiful than any of my childhood dreams of the royal courts described in Andersen's fairy-tales, or those of Perrault. Nor have I ever beheld anything to approach it since. The black evening-clothes of the men, as they stood behind the women, enhanced their brilliance. It was like an enormous bouquet of bare shoulders emerging from pastel-coloured silks. The white fire of diamonds, the barbaric sparkle of rubies, the cold flash of emeralds, the softness of pearls caressing bosoms, all shone against the smooth flesh of these women, con-ferring on them and, indirectly, on the entire assemblage, a sort of nobility, transient perhaps, but undeniable. They were not creatures of flesh and blood, but figures in a picture : people who are never seen walking in the street, who never catch cold, or perspire as they toil up the slopes of Montmartre in summer. All these people had their opera-glasses fixed on my father, who was not even conscious of it. Gabrielle thought they recognized him, and she deplored his appearance : ' With his jacket all spotted with paint, and a cycling-cap, what will they take us for ? ' My mother smiled, touched by this confidence in ' the master's ' celebrity. But Missia put the matter neatly when she observed, ' Hardly half of them even know the name of Renoir ; but if Titian were here, they would not even know who *he* was ! ' Renoir was carried away by the performance, and Edwards was happy to see his friend's enjoyment. The principal piece on the programme was *Petrouchka*. I cannot recall if it was that first evening that we saw *Le Spectre de la Rose*, in which Nijinsky leapt across the stage ' like a bird ', according to Gabrielle : but my father said, ' like a panther '.

# 27

After he had engraved silverware for forty years, my Uncle Henri had reached the retirement age, and was living with his wife Blanche in a little house in the suburb of Poissy. With plenty of leisure, he could renew his acquaintance with his younger brother, whom he had urged to become a painter so long ago. So many people were now talking about this artist : some with admiration, many others disapprovingly. After several visits to the Rue Caulaincourt, Henri and Blanche came to the conclusion that they would never understand Auguste's painting, though they had to admit that it must be beautiful since it sold well enough to enable him to have a huge studio, a comfortable apartment, a house in Essoyes, and to take trips to the South of France.

Renoir was glad to see his brother again, for he regarded Henri's life as a complete success. The house in Poissy delighted him because it symbolized the acme of bourgeois happiness. The parquet floors and the Renaissance furniture from Dufayel's were waxed and polished till they shone like mirrors. It was all fringed curtains, fragile bibelots, and pictures representing scenes from plays. I have already spoken of the pets the couple had : the fox terrier named King ; and the canary, Mayol, enthroned above a collection of music-boxes and souvenirs of the 1900 World's Fair. The faithful servant, Marie, spent her life shining the andirons with Tripoli polish and wiping up visitors' footmarks with a woollen cloth. Salamander stoves, with their shining nickel trimmings, spread an enervating warmth throughout this downy nest. The fireplace had been white-leaded, and the logs replaced with a basket in Louis XV style, filled with artificial flowers. I recall, also, a spinning-wheel adorned with pink ribbons. Marie's cooking was on the complicated side, but delicious : chicken patties, vols-au-vent, crayfish soups,

profiteroles, meringues and so on, washed down with a bottle of old Bordeaux wine, carefully laid in a wine-basket. I have never seen wine served with such deference, and I was tremendously impressed..

The two families had resumed their friendly relations before I started school at Sainte-Croix. My uncle and aunt took a great interest in me. They thought it perfectly natural that I had not yet started school. At Odiot's, where he worked, my uncle had a colleague who hardly knew how to read or write and yet had been a very successful engraver. But they could not understand why my parents, living in Paris, had never taken me to the theatre, especially to a café-concert. They offered to take me with them every Thursday to a matinée in order to make up for this oversight. My father and mother consented gladly, despite the fears of certain friends at the thought of my young ears hearing the coarse language which was then such an essential feature of French songs. Renoir did not believe the ' forbidden fruit ' would harm me. ' If it had not been forbidden, Adam wouldn't even have bothered to look at it.'

A few days later, somewhat excited, I entered the Scala Theatre clinging to the arm of my Aunt Blanche. I heard Polin sing, though without understanding the allusions which sent the audience into fits of laughter. The expression ' café-concert ' still had its literal meaning. Along the back of the theatre seats ran a narrow shelf on which the spectator in the row behind could place his drink. During the entertainment waiters kept coming in and out and serving customers. ' Waiter : an anisette ! ' ' Waiter : a mazagran coffee ! ' ' Boom ! There you are, sir.' Orders were shouted from all directions, drowning the verses sung by the ' village ingénue ' or the ' comic idiot'. Only the star performers could hope to make the audience fall silent. I cannot resist the temptation to give an idea of one of the songs of the period. A gentleman is seated beside a lady in the theatre, behind a column which prevents them from seeing the performance. The lady complains of the column, and he offers to show her a column of another kind.

> ' Si vous voulez la voir
> Venez chez moi ce soir,
> J'veux bien vous la prêter,
> Mais faut pas l'abîmer.'

My Uncle Henri had a beer ; my aunt and I a grenadine. I was so pleased at my outing that my parents decided to add to it by letting

me go to a Sunday performance every week at the Montmartre
Theatre with Gabrielle. It is to their wise decision that I owe my
acquaintance with the delightfully bawdy repertory of the singers at
the beginning of the century, not to mention all the melodramas of
the great period which were still being played at the Montmartre
Theatre.

My Uncle Henri's death in 1903 was as simple as his life had been.
He and Blanche had just had lunch, and were sitting back com-
fortably digesting it, sunk in the velvet-upholstered chairs in their
drawing-room. She had been telling her husband that King had
tried to bite the postman that morning. He made no answer; in
fact, he seemed to be asleep. 'Come, come,' she said to him, 'don't
act as if you were gaga.' He was dead.

We saw my Aunt Lisa less often. We had kept up with her until
the year 1900, when my father spent part of the summer at Louve-
ciennes. That year my mother had found a charming house there,
hidden away among the foliage, and not far from the station. The
large garden sloped gently down to an old wall, over which the
deserted house next door was just visible. I would often climb over
and play in the 'jungle' on the other side. The place was so
fascinating that I frequently forgot about lunch, and Gabrielle would
have to fetch me. My mother had already grown too stout to climb
over the wall. My father shared my enthusiasm for this enclosed
property, and he advised Dr Baudot to buy it. And that is how my
godmother, Jeanne, came to know Louveciennes. She was to die
in that very house where everything reminded her of Renoir. Only
three years ago she went to join the painter who had given so much
meaning to her life. Every single day since as a young girl she had
set up her easel next to his, Renoir had been present in her memory;
every single day she had remained faithful to the cult of that affec-
tionate magician who had revealed to her the wonders of light, colour
and form.

My Aunt Lisa's house was at the other end of the village. Uncle
Leray sometimes came over to see us, and to say, in a tone that
brooked no refusal, 'I want you to come to lunch tomorrow. Roast
veal. Twelve o'clock sharp.' Their home had seemed rather
sumptuous when I was small, but now it looked decrepit. Perhaps in
my grandmother's day the Lerays had not dared let themselves get
too slack. Now, a thick layer of dust had settled for good on
the furniture. Lisa said frankly that she disliked housework.

Besides, she had no time. Her thirst for dedicating herself to some-
one had not lessened over the years, and she spent her life at the
bedside of the sick. She was especially interested in women in child-
birth, and would do for them what she neglected to do at home,
carefully dusting each piece of furniture, emptying the ashes from
the fireplace, wringing out the washing, carefully simmering the
stew. All the fruit, vegetables, chickens and rabbits they raised in
their little garden were given to the needy. For his part, Leray
went about the village looking for someone to talk to, or rather to
listen to him. When he found a willing ear, he would hold forth on
the subject of politics, castigating the government minister Delcassé,
whom he called ' *la pommade* ' (' bletherer '). One of his favourite
victims was Catherine, the Baudots' maid.

When we arrived for lunch we found the house empty. The
Lerays never locked their doors, and we went in. My great dis-
traction was to jump on the sofa, which had once been red, and make
a cloud of dust rise. My mother would exclaim, ' That's enough ! '
in a tone that implied the possibility of a spanking. ' Oh, let him
play,' said Lisa, as she finally made her appearance. ' He's helping
with the housework.' Then she quickly sent ' Charles ' to buy a
roast of veal. Both of them had forgotten they had invited us. My
uncle set off at once. ' I'll be back in five minutes. You can light the
stove.' Unfortunately it was the loveliest time of the year, and all
the windows were open. As he went along, he would see people
sipping their coffee after their meal. Everyone looked relaxed and
comfortable. ' Did you read in the papers— ? ' he called out. And
that opened the flood-gates. We were lucky if he got back with his
roast of veal by four. Sometimes he did not return until nightfall.
In the meantime my father had taken us all to the near-by inn. It was
a great treat for Lisa. ' Now I shan't have to do the dishes.' As if
that ever troubled her ! Habitually, before she and Leray sat down
at table each of them took a plate out of the pile of dirty dishes left
from the previous meal and washed it. ' Oh, I forgot to wash
the dishes again! I'm getting old and absent-minded. ' When Leray
finally came back with his piece of veal, he had the grace to look
sheepish. One day Renoir took them a piece of wood painted
to look like a sausage. It was such a realistic imitation that
Leray broke his knife trying to cut it. He was furious. He was a
good fellow and my father liked to tease him. ' This man Delcassé,
apart from his stiff manner, seems a real statesman.' Leray turned

red with anger, and began pounding the table. To pacify him, Renoir ordered a hogshead of Bordeaux wine to be sent to him. Lisa invited the whole neighbourhood in for a drink, and the cask was soon emptied.

As the summer drew to a close, my mother wanted to collect the canvases Renoir had painted in the district and left with his sister until his return to Paris. Impossible to find one of them! On an impulse, she went up to the attic, and discovered that several paintings had been used to stop up holes in the roof. Growing suspicious, she continued her search and found other canvases, which Leray had used to build hutches for his rabbits at the far end of the garden. She did not mince words when it came to giving him a piece of her mind. Leray was positively dumbfounded. 'What difference does it make to Renoir? He paints that stuff for the fun of it. That isn't real painting. Anyhow, he'll be doing others in a few days.' And he added that, as the canvas and the linseed oil used for such rubbish was of the best quality, his rabbits would not be in danger of getting wet when it rained!

To complete the family picture, I ought to say something about my Uncle Edmond's happy fate. He gradually lost interest in journalism and literature in general because of another passion. He had discovered the joys of fishing. He gave himself up to it entirely, and became a veritable champion of the sport. He even invented a fishing-rod which was named after him. Indeed, the Renoir rod is still a favourite with a great many anglers. He was to end his days in a pleasant little inn on the banks of the Oise, and there he would receive other amateurs of fishing. He persuaded a charming young woman to be his companion through the last stage of a vigorous old age. She was jealous of the young female fishing enthusiasts who sought out the company of her robust patriarch. But this only lent a pleasant complication to the declining years of a lovable philosopher.

One evening while we were still living in the Rue Caulaincourt, we had hardly finished dinner when we heard loud cries in the street. Smoke was rising from the rose-bushes. Flames were soon visible, and seemed to leap from one shanty to another. The Maquis was ablaze. Its inhabitants ran about like madmen in an effort to save their possessions. Tables, chairs, mattresses, mirrors, were piled pell-mell in the street, hampering the firemen. Chickens, rabbits, goats were fleeing in every direction. In no time at all the whole

Maquis was nothing but a blazing furnace. The concierge came and told us to close our iron shutters: firemen's orders. The heat was so intense that the fire seemed likely to spread to the buildings on our side of the street. My father wanted to take us all to the studio for the night. But the street had become so obstructed by this time that the police would not allow anyone out of the house. Through the cracks in the shutters we could distinguish the red glow of the fire and hear the noise of the conflagration intermingled with shouts. Gabrielle wanted to go out and watch, but was unable to get beyond the doorway. My mother tried to send us all to bed, but we were all too nervous to sleep. She sat down to write a few letters. ' You'll ruin your eyes,' Renoir told her, for he highly disapproved of doing anything by artificial light. He played with his bilboquet and finally asked Gabrielle to tell us the story of ' Mother Goat '.

It was an old tale which dates back to the long winter evenings in thatched peasant huts. It is about a wolf who disguises his voice and pretends to be the mother goat. One of the little goats tells the wolf how to open the door : ' Pull the handle and the latch pin will fall.' The wicked wolf comes in and eats up all the little goats. The story frightened me all the more because of the fire raging outside. I began to imagine that the goats' cabin was in the Maquis, and that the little goats were going to be burned to death.

The next day the Maquis and its flowers were nothing but smoking cinders. A few weeks later excavating machines began digging up the charred earth. A new system of reinforced concrete piles had just come into use, and it was therefore possible to put up buildings on soil which until then had been unsafe for heavy construction. The inhabitants of the Maquis had long leases on very low terms. But one clause in the lease concerning destruction could cancel their right to remain there. The invention of the concrete piles had filled the speculators with the wildest dreams. But the denizens of the Maquis refused to leave. They were offered all sorts of compensation : but in vain. They loved their wooden village and rose-bushes. This fire, which was due to chance, happened just at the right time.

We left for the Midi. By the time we returned, apartment houses six storeys high were already built and ready for tenants. The Rue Caulaincourt, like many other streets in Paris, resembled the bottom of a well.

The great drama of Renoir's life continued to unfold. With each

# Renoir, My Father

episode the situation got worse. His paralysis progressed by quick and sudden changes. In the space of a day he had to start using two canes instead of one. Then, as his fingers became more deformed, he had to give up exercising with the bilboquet, and soon after, even the little log. In 1901 he had high hopes of the curative waters of Aix-les-Bains. That was the year my younger brother, Claude, was born. The confinement took place at Essoyes, where I stayed with my mother. Gabrielle was commissioned to go with my father and make sure he followed his treatment. Renoir came back leaning more heavily than ever on his canes, which he was only to discard for a pair of crutches. In 1904 his optimism was revived for a moment when he took the cure at Bourbonne-les-Bains. It was there that I first went bicycling by myself. I was ten at the time. I felt proud as Punch as I pedalled along on my free-wheeling bicycle with its shiny nickel fixtures, and lighted the acetylene lamp on it at night. I was so pleased with my lamp that I could hardly wait for night to come to show it to my father. He pretended to share my enthusiasm, and called it ' that beautiful lantern '. But my mother and Gabrielle complained that the calcium carbide fumes it gave off smelled of garlic. Although Claude was only three, his miniature bicycle—a real one, not a child's toy—was sent down from Paris by train. He was very dexterous on it, and won great applause ' playing circus ' in front of the patients taking the waters, all more or less helpless. He could ride without holding on to the handlebars, stand up on the frame, and pedal backwards, to the great anxiety of our father, who was always fearful of ' accidents that might cripple, or just cause a cut '.

Renoir enjoyed Bourbonne, which was not at all a fashionable spa. It was still nothing more than an overgrown village, with all the characteristics of small centres in the eastern part of France : somewhat like Essoyes, but more of a town. The walls of the houses were of rough-hewn stone, the roofs of Burgundian tiles. Cows wandered about the streets. The bathing establishment was an attractive old building with grounds shaded by magnificent trees. The feature that won Renoir's heart was the baths. They had been cut out of marble, ' a material you can't slip on ', and they dated back to the days of Mme de Sévigné. That good lady had also come to Bourbonne to take a cure for her rheumatism. I have mentioned before Renoir's aversion to enamelled bath-tubs, which are ' responsible for so many heads being split open '. Alas, all these

advantages proved of little benefit. He finished his cure without deriving the slightest improvement from it.

The threat of complete paralysis only spurred him on to renewed activity. Albert André, whom he loved as a son—and who returned his affection—often spoke of how this burst of activity coincided with the progress of his illness. Those who lived with him know that each stage of this victory of mind over matter was accompanied by a physical defeat : by the atrophy of some muscle, by additional pain. Now that he could barely move about, the ' cork ' half-saw the immensity of the ocean waiting for him at the end of the winding stream of a well-filled life. An artisan among a multitude of other artisans, he hoped to finish the task assigned to him in the building of this huge cathedral, eternally under construction, which is the world given us to live in. He would have had the chance ' to add his little capital ' to one of the columns. He must keep afloat to the end ; he must keep on living.

At the first sign of autumn, we all departed for the Midi. I had been taken out of Sainte-Croix, where I was not happy. The glamour associated with the famous school cap had worn off, owing to a drawback to which I could not get accustomed. I had been taught by my parents not to be too difficult about material things. So far as bed and board went, I was perfectly content. My attitude was the exact opposite of that of many of the other students, who thought it smart to grumble about the hard beds and the bad food. When I expressed my surprise to my father, he said the other boys' complaints were probably a reaction against the poor fare they got at home. By turning up their noses at the beans served at Sainte-Croix, they were able to convince themselves that at home they lived on nothing but pâté de foie gras. ' But don't start trying to imitate them, because that would be a bit caddish.' The drawback that cancelled out all the other possible advantages was the filthy state of the lavatories. They were past belief. Yet even the most refined among my schoolmates, those who put pomade on their hair, thought it quite natural. As if the characteristic of such a place was to be filthy ! I could not bear even to go in there. I would hold back as long as possible, and when I could stand it no longer, slip out at night and relieve myself in the bushes. I was so terrified of being found out, I literally became ill. Finally, I told my parents all about it, and they brought me back home. My infatuation for the cap had been killed by my disgust.

# Renoir, My Father

Another barrier between my fellow-students and myself was their attitude towards sex. The very sight of photographs of naked women threw them into a state of excitement incomprehensible to me. They would pass them on to one another on the sly, and lock themselves in the lavatories so as to be able to contemplate them at their leisure. Some of them would masturbate furiously while gazing at these pictures, which represented a paradise that was earthly but still unattainable. The good Brothers added to the interest of the photographs by hunting them down, confiscating them and punishing the owners. I did not know what to make of it all. From my earliest childhood I had seen my father paint nude women, and to me their nudity seemed quite natural. My indifference won for me the reputation of being blasé, which was absolutely undeserved, as any mystery about nakedness did not even exist so far as I was concerned. I had learned early enough that children are not born under cabbages. I was unbelievably ingenuous.

The only person in the school I regretted leaving was my first friend, Jacques Mortier. But I was to meet him again, when I returned to Sainte-Croix later on, at an age when I had become more hardened, and, I may add, at a time when the lavatories had been properly cleaned. Incidentally, my father visited the school to make sure of this point.

The parlour there was a large, dreary-looking place, and so sombre that the portraits of ecclesiastics which decorated its walls seemed to be emerging like ectoplasm from their black cassocks and the backgrounds painted in bitumen. On Sunday the room was animated by the prattle of the boys' mothers discussing the latest fashion in clothes. When my father came to see me, he seemed out of place among the other parents. His working jacket, with its buttoned-up collar, his hair, which was a little long under his soft felt hat, contrasted strangely with the starched collars, dark silk cravats, waxed moustaches and impeccably creased trousers of all the other fathers. Instinctively, they shunned this being from another world. While I was kissing him, I was embarrassed by the astonished looks of my school-mates.

One Monday, after the first class was over and we were having a break, a boy named Roger came up and spoke to me. His father was head of a big grocery establishment in the section near the Opéra, and owned a villa at Trouville. As the last word in 'swank', his mother had had her appendix removed by the great surgeon, Doyen.

In short, they were people really in the swim. The other boys formed a circle around us. Roger took two sous from his pocket and held them out to me. ' Here,' he said. ' Give this to your father, and tell him to get his hair cut.' I should have taken the money and thanked him for it. My parents had taught me there was nothing shameful in accepting charity. But it was the first time I had ever heard my father criticized. I felt the blood rush to my head. For a fraction of a second the trees in the court and the faces around me blurred. Then I hurled myself on the blasphemer so fiercely that he was taken by surprise and did not have time to defend himself. He fell to the ground, but I kept on hitting him. I seized him by the throat, and would probably have choked him to death if two or three of the Brothers had not intervened. I was summoned before the Prefect of Studies to explain my behaviour. But he could make nothing of my story about my father's hair, so he sent me home for a few days to calm down. At least I got that much out of it. When I returned, I was agreeably surprised to find everyone very considerate towards me. Roger came and shook hands with me. ' You should have told me your father was an artist ! ' Renoir burst out laughing when I told him about it the following Sunday. I realize now that that laugh was a renunciation. Life had taught him that his desire, as a young apprentice porcelain-painter, to avoid attracting notice and to go quietly about his work, would never be fulfilled. ' The danger,' as he explained later, ' is that you are apt to get a swelled head. You run the risk of isolating yourself and becoming vain.' As if he had not possessed the best insurance against any such risk : his love of human beings and of the things of this world. The mis-understanding was not due solely to his way of dressing, it derived from the fact that his vision of life was not like that of other people, who vaguely sensed some gulf between him and themselves. What would the parents of the other students at Sainte-Croix have said if they could have seen his painting ? His last works are still not understood except by a very few of our contemporaries. This makes me rejoice, and gives me the feeling that he is still here, young, living ; and, in spite of his desire to remain ' one of the rank and file ', that he has not ceased to ' startle the bourgeoisie '.

His wish to ' do as everybody else did ' had impelled him to send a canvas to the World's Fair of 1900. ' It won't be noticed beside the Eiffel Tower, but I shan't seem to be setting myself apart from the others.' I was six years old at the time, and the only thing I

remember about the Fair was going up that famous tower with my brother Pierre, Gabrielle, and La Boulangère. We went to the very top. It was a beautiful day. Pierre pointed out the different monuments, which in the distance looked as though they were being presented to us in a case of green velvet. There were still a great many trees in Paris. We were lost in admiration and we breathed in the vivifying air. Everything went well until my brother had the unfortunate idea of telling La Boulangère, who was looking at the people far below and comparing them to ants, that we were almost a thousand feet up. She had a giddy spell, and cried out: 'A thousand feet! It's too much. I'm getting dizzy! . . . I'm getting dizzy!' I immediately had the impression that an irresistible force was drawing me towards the abyss. I seized hold of the railing, shut my eyes and refused to move. Pierre and Gabrielle had to take me down by force. To try and restore my courage, my mother took me to see a huge spectacle, called *Vercingétorix*, at the Hippodrome. There were five hundred extras dressed up as Gauls and Romans, cavalry charges, and, after the siege of Alésia, Vercingétorix was captured and led away in chains, defying Caesar to the last. I strutted out of the theatre ready to pick a fight with the first person I saw daring to laugh at my red locks. Renoir was convulsed. Yet he would have been very annoyed if one of his sons had turned out to be a real hero.

That same year, 1900, the French Government decided to award him the Legion of Honour. The distinction caused him considerable embarrassment. For by accepting it he would put himself in the position of seeming to make a compact with the enemy and to recognize academic art, the official Salon, the Beaux-Arts and the Institute. If he refused it, he would be guilty of doing the thing he detested almost more than anything else in the world: making a theatrical gesture. The writer Arsène Alexandre, who was a frequent visitor to the house, pointed out to him that accepting the Legion of Honour would in no way mean that he was 'accepted', nor would the winners of the Prix de Rome take him to their hearts. Renoir was still undecided, remembering the attitude of his friends towards official 'honours'. He had lost his friend Sisley the year before. Cézanne was inclined to be impressed by a decoration 'thought up by Napoleon, who after all was no jackanapes'. Pissarro, whom Renoir ran into by chance in the entrance of the Gare Saint-Lazare, made fun of it and told him that the Legion of Honour was no longer

a sign of distinction because everyone had it. He had yet to learn what Monet's view of the matter was. Monet had been his faithful companion during the lean years; had shared his fare of haricots and lentils ; had kept him from yielding to discouragement on more than one occasion. Finally, my father resolved to accept the decoration, and he wrote the following letter to Monet :

> My dear friend : I have let them give me the Legion of Honour. Please believe that I am not letting you know of it because I think I am either right or wrong, but only because I do not wish this bit of ribbon to jeopardize our long friendship in any way. . . .

Several days later, he sent a few further words :

> I realize today, and even before, that I wrote you a stupid letter. I wonder what difference it can make to you whether I receive a decoration or not. . . .

At the beginning of his life he had believed that things would change the day prizes and medals were awarded by a new generation imbued with a spirit of justice and liberty. He knew now that corruption is inherent in power, and, even worse, stupidity ! As far back as I can remember, my father remained aloof not only from everything official but also from everything connected with an organization. He did not struggle against these things, but preferred to stick his head in the sand, ' like an ostrich, which is a far cleverer bird than you might suppose from its long neck '. He accepted the fact that governments, railway companies, newspapers, and the School of the Beaux-Arts, exist. He also recognized the existence of rain : but he preferred to forget its existence, except when it fell on his head, just as he forgot his rheumatism except when it made him cry out with pain. He knew that the new art associations, like the Indépendants, which owed their inception to Seurat, or the Salon d'Automne, which was created as a tribute to his own talent, would be no more help to young painters than the Beaux-Arts or the Institute had been. He took no further interest in such organizations once the committee was formed and gentlemen in high collars started arguing round a green baize table. ' Even if they took off their high collars and argued in their shirt-sleeves, they would be just as futile.' In his view, the only way to help the art of painting was not to discuss, organize or reward, but to paint. ' And, for those who do

not paint, to buy.' He looked with a more approving eye on the Salon d'Automne because of the large number of his young friends who exhibited there, but he had no more faith in it than in the other associations.

In 1904 a retrospective exhibition of all his works was put on by this organization. It was such a success that he was quite moved by it. And for a few days he was able to forget the failure of his cure at Bourbonne-les-Bains.

On coming back from Essoyes in 1905 he suffered an attack which confined him to his bed for several days. When he got up again, he could hardly drag himself to the studio. He missed the comforting warmth of the South of France. Yet he could not bring himself to forsake Paris entirely. The ranks of the friends of his youth were thinning. Pissarro died in 1903, Cézanne in 1906. But there were the younger men : d'Espagnat, Valtat, Bonnard, Vuillard, and especially Albert André and his wife, Maleck. Those wonderful friends were the joy of Renoir's last years. I think, indeed, that Albert André was the only friend who knew ' the boss ' well, and understood him completely, during the period before and after we went to live in the Boulevard Rochechouart apartment. It was in 1911 that my mother definitely decided to move to this address. As my father had felt a trifle better the previous year, we had all spent the summer near Munich with our friends the Thurneyssens. His improvement had been such that he resumed using two sticks and hoped to be able to discard his crutches for good. Alas, once he returned to the Midi, the ' backlash ' was so violent that he had to give up walking. My mother bought him a wheel-chair. She took me to Nice with her when she ordered it. She was not given to showing emotion. But in the tram that day great tears were rolling down her cheeks. Renoir was never to use his legs again.

The apartment in the Boulevard Rochechouart was on the first floor. The stairs were not too difficult, and it was possible for two people to carry my father up, sitting on a wide leather band. These are the surroundings in which I first described Renoir at the beginning of this book, and as I said then, his studio was on the same floor as the apartment. He only used the stairs the day he arrived and the day he left. But before coming to the years when he was confined to a wheel-chair, I must give a few further details of his respite immediately before the final ordeal.

Our stay in Bavaria was marvellous. We had rented a little house in Wesling, directly on the lake. Renoir's return to the use of his sticks seemed to us the symbol of regained health. He often went with us on our boating excursions and our outings in the forest. My mother had brought along Renée Rivière, who was not yet married ; and she had also invited Paul Cézanne, who could not come because he was detained in Paris by sentimental complications from which he was anxious to get free before proposing to Renée. My brother Pierre was with us. After finishing at Sainte-Croix he had entered the Conservatoire, emerged with a prize, and was now a full-fledged actor, playing at the Odéon Theatre under Antoine. My father had attempted to dissuade him from a career ' where you only create wind ; where nothing remains, and all is temporary '. But his eldest son's vocation was obvious, and he bowed to the inevitable. He had even worn his Legion of Honour—at Gabrielle's suggestion —for a meeting with Antoine, who had himself been decorated and might have construed the absence of the ribbon in his visitor's buttonhole as a criticism.

My brother Claude was nine ; the Thurneyssens' son, Alexandre, twelve ; and I, sixteen. Our group included several young men and girls from Munich, friends of the Thurneyssens. We had a great deal of music. Mühlfeld, the well-known conductor, gave singing-lessons to Renée, and lessons on the trumpet to me. He con-tended that this primitive instrument, provided it was not a valve trumpet, was the best introduction to the great composers. We went to gather blueberries ; we drank beer ; Renée sang ; and I made the Bavarian forest echo with my brassy trumpeting. Renoir painted Mme Thurneyssen, who was ravishing ; Alexandre, hand-some as a Greek shepherd, and, incidentally, portrayed as one ; and M. Thurneyssen, whom my father thought very interesting.

Dreadful quarrels broke out between Mühlfeld and Renée. The conductor was indignant that anyone with such a voice should show so little desire to devote herself to the cult of Mozart and Bach. But Renée preferred our trips on the lake to the severe lessons of the Kapellmeister. Mühlfeld turned scarlet. Renoir predicted that he would explode some day, which seemed all the more likely in view of the countless jugs of dark beer he gulped down in an effort to calm himself. At that time there was no ' *Masskrug* ' holding less than a quart. One day, after she had sung off-key, he tried to beat Renée with the bow of a double-bass. She ran like mad, and fell

into the lake. She did not know how to swim, and her professor had to jump in, fully clothed, and save her.

Before deciding to settle in Cagnes, where the Deconchys had built a house in the Provençal style and were awaiting us, Renoir tried several places in the Midi. I have already spoken of the villa we had on the outskirts of Grasse. We also lived for a while right in the village of Magagnosc, as well as in Le Cannet and even Nice. During my parents' stay in these places I was mostly away at school and my recollections of them are therefore somewhat vague. Not that my school years were not interspersed with frequent visits home. I would get fed up from time to time, and run away. I would arrive home hungry and dirty, as I had come the whole way on foot. My mother would shrug her shoulders. My father concluded that I was destined for manual rather than for intellectual work. And he speculated on what a person with a nature like mine could do to earn a living. He saw me as a blacksmith, a musician—my mother had made me learn to play the piano—a dentist, carpenter, game-warden, nurseryman. He was against my going into commerce, ' for which you have to have a special talent ' ; and also plumbing, because he was afraid the soldering-lamp might explode. Besides, explosions apart, the almost invisible blue flame made him uneasy. ' You're absent-minded ; you'll put your foot in front of it and get burnt.' He dreamed of a world where one could afford to be absent-minded.

My memories of that period are relatively few. My father's illness was a recognized fact. We had now settled down into a state of affairs which I believed unchangeable. But, for my father, this was not to be : after his legs, his arms began to be deformed, and he foresaw with terror the day when he would no longer be able to hold a brush.

I can see in my mind's eye the garden at Le Cannet, the palms and the orange trees ; Théodore de Wyzeva and his daughter Mimi. As in a mist, I can just make out Mme de Wyzeva, who was very ill. Although my father usually fumed against ' the intellectuals ', he had the friendliest feelings for this family, who were genuinely intellectual. Théodore de Wyzeva had been born in Poland. As a penniless young man he had earned a living by giving German lessons. He did not speak the language, but he thought it a good way to learn. He subsequently became secretary to a bishop *in partibus*, an important personage in the diplomatic service of the Vatican. Being very religious, Wyzeva refused to fall in with the

realism of his superior, which was sometimes not altogether Christian. ' But Monsignor, I tell you that God does exist ! ' he said to him one day, when the bishop put forward a proposal whose materialism Wyzeva considered excessive and false. In 1886 he wrote an article on Seurat, warning him against introducing scientific notions into the field of art. Renoir especially admired his translation of *The Golden Legend* by Jacobus de Voragine, and he asserted, ' I don't know anyone who writes French as delightfully as Wyzeva.' Mimi was older than I, and made quite an impression on me. Whenever she appeared, I would run and wash my hands, and sometimes I even went so far as to comb my hair. I was secretly in love with her.

My recollections of Magagnosc are limited chiefly to my great friend Aussel, who owned a tricycle, and to my first cigarette, given me by another friend, which made me vomit. The dialogue which preceded this experience is still quite clear in my mind:

' Do you smoke ? '

' Only chocolate cigarettes.'

' You're a booby. I'll roll a real one for you.'

This hardened smoker was about eight years old.

The most favourable climate for my father was at Menton. The mountains behind the town protect it like a screen. In this natural hot-house he had a feeling of ' roasting his rheumatism in the sun '. But because of this comforting warmth, the place, before the First World War, was crammed with English people suffering from tuberculosis. As we know, Renoir did not like tourists, and he liked sick tourists even less. Except for Bourbonne-les-Bains, a remnant of the seventeenth century, the very idea of a watering-place plunged him into despair. I remember a trial visit to Vichy. While there he did nothing but yawn, and did not open his paint-box once. My mother had to arrange to get us all away in the shortest possible time. We already had a motor-car, so we were able to get to Moulins and spend the night there. ' Anywhere,' said Renoir, ' so long as I don't have to see those band-stands again.' Luckily for Menton, the doctors have since discovered the curative air of the mountains. The pleasant little centre lost its sick, kept its sunshine, and is now one of the more privileged sections of the enormous city which will soon extend from Marseilles to Calabria.

When we first began going regularly to the Midi, no one suspected that that promised land would become the Coney Island of

Europe. In those days the fishing-ports were still intact and their inhabitants could actually live by selling their sardines or anchovies. Renoir foresaw the danger. 'The Parisian is a marvellous being so long as he is behind his shop in the Faubourg Saint-Antoine. Once outside Paris, he spoils everything.' He perceived advance signs of the catastrophe,—for instance, the disappearance of regional cooking in the big hotels. The passion Parisians have for olive oil, bouillabaisse, sea-urchins and a *brandade* of cod is relatively new. When I was a youngster we astonished everyone by eating dishes cooked in the Midi style. I have mentioned how Renoir thought a painting more beautiful in the country where it was painted. His reasoning was the same regarding ways of living, in general, and eating in particular. He approved of the southern custom of closing the blinds in summer, of not exposing oneself to the sun unless well protected by a stout hat or parasol, and of putting garlic in every dish 'to kill the worms'. When in the Midi he did as the natives did, and behaved like a Parisian only when he returned to Montmartre.

'Don't put olive oil on the salad,' the tourists tell the restaurant waiter. Now the little farm-houses with Mediterranean tile roofs have been replaced by apartment buildings of reinforced concrete, and the old mill in the valley has become a night-club.

# 28

In my father's day Cagnes was a thriving village of prosperous peasants. On the hills olive and orange groves rose in tiers. The orange blossoms were sold to the perfumeries in Grasse. Moreover, everyone had his own vegetable garden, his chickens and his rabbits. The Isnards, the Portaniers and the Estables all did well for themselves. Taxes were almost non-existent; living was not yet dear; and with a small inheritance from their parents people managed reasonably well. The natives of Upper Cagnes had not yet had to sell their old houses to 'artists', or their properties on the hillside to the retired rich. They went from one to the other, perched on their little donkeys, unhurried, and never wearing out the animals, the land, or themselves. My father felt at home with them. They showed little or no curiosity about his painting; and he, for his part, was content to congratulate them when they had had a good harvest. The local products were very varied. The wine from certain hillsides had a sharp flavour, but was excellent; and the Neapolitan fishermen at Cros-de-Cagnes brought in their nets filled with little silvery sardines, which my father said were the best in the world. Their wives carried them in flat baskets, which they balanced on their heads, calling out in a raucous voice, 'Au pei! Au pei!' ('Fresh fish! Fresh fish!') to attract customers. Some of them posed for Renoir.

What pleased him particularly at Cagnes was that you did not have your nose 'right up against the mountains'. He was fond of mountains, but at a distance. 'They should remain what God created them for: a background, as in Giorgione.' He often said to me that he knew nothing in the world more beautiful than the valley of the little Cagne River, when you can just make out the Baou mountain at Saint-Jeanet through the reeds which give the river its name. Cagnes seemed to be waiting for Renoir, and he adopted it,

as one gives oneself to a girl of whom one has dreamt all one s life and then discovered on the doorstep after having roamed the world over. The story of Cagnes and Renoir is a love-story, and, like all the stories about Renoir, it is devoid of anything sensational.

Of the different houses we had there, excepting Les Collettes, of course, I remember especially the Post Office. It was a real Post Office, and the approaches to it were enlivened by the comings and goings of people wanting to buy stamps or send telegrams, which gave occasion for saying good-day to my mother or Gabrielle or for dropping a remark about the weather to my father, who would be out painting on the terrace, his cap with its ear-flaps pulled well down over his bald head and a woollen shawl round his shoulders. The Post Office was a large building clinging to the side of the town just where the main street begins to mount steeply and becomes a sort of cobbled stairway. The little mules placed their hooves carefully on the steps, and carried to houses in the town produce gathered from the surrounding hills. As everywhere along the Mediterranean, the fields are outside the town ramparts, and in the evening everyone returns from work to the protection of the walled enclosure. Few traces of the ramparts remained at Cagnes, but the urban spirit of the Latin was still intact there. The people from the north and their cows, udders swollen with milk, live on farms scattered about the countryside. Those of the south and their wiry goats live in houses huddled one against the other. In the evening the men forgather under the plane trees and engage in long discussions. They have kept the Agora. They are civilized beings ! At the Post Office we were within the encircling wall of the old town, and thanks to the useful purpose of the building, we had our own little Agora right at home.

The Post Office was divided into three sections : the Post Office proper, with the apartment of the tax-collector, M. Raybaud ; the apartment belonging to M. Ferdinand Isnard, the owner ; and our quarters. Our part was situated at the far end of the entrance-court, and it looked out on a large grove of orange trees, growing against walled terraces which descended as far as the road to Vence. Beyond, the remains of the ramparts hugged the sides of the village. The houses emerged from little gardens, and the roofs rose one above the other up to the old church, with its bells hanging in their iron cage. The château was not visible from our house. There was a great deal of talk about Mme Carbonel, an eccentric Russian

woman, who had undertaken to restore it. For several hundred years it had served as a stables and had housed the equipment for the fire-brigade.

The Cagnes Post Office has moved, and is now installed in a large modern building more appropriate to the town's new importance. There are no longer any orange groves. On the other hand, you can post your letters with a stamp bearing Renoir's head. He often said to me, ' It is when you have lost your teeth that you can buy the best beefsteak.'

When the weather was sufficiently warm, Baptistin hitched his docile horse to his victoria and took my father into the countryside to paint. When it was cold, a big fire was lit in the drawing-room which had been transformed into a studio. Baptistin, whose real profession was a cab-driver—at that time hackney cabs were victorias ornamented with a white fringed parasol—willingly gave up the tedium of waiting for fares at the station, and became our general house-man. He pushed Renoir about in his wheel-chair, helped him to get in and out of the victoria, cut the wood, and kept an eye on the temperature in the drawing-room. He also did the shopping and mended the broken furniture. He always spoke of himself in the third person, referring to himself as ' that man '. ' " That man " is going to market,' he would say. ' " That man " is going to groom his horse.' ' " That man " is feeling poorly.' In the local idiom the word ' poorly ' is used for any light indisposition. When the case is grave, one is ' tired '. When the sufferer is ' very tired ', he is not expected to live through the night. Baptistin was a good-looking man, short but well proportioned, with a formidable moustache. He made numerous conquests of the ladies, to the great relief of his legitimate wife, who had enough trouble bringing up all her children, and declared, 'Those he begets on others he doesn't beget on me.' However, when threatened with mobilization as a reservist for service in Morocco, he argued his wife into adding another offspring to the family. The new arrival completed the number necessary to exempt ' that man ' from military service, and he was free to continue working for us. Later on, when my mother bought a motor-car, she had him taught to drive, and he became our chauffeur. He picked out a good, warm uniform at the Thierry and Sigrand store in Nice ' to go up to Paris. Up there it's damned cold ! ' He did not leave our service until he began to feel his age and the road from his house to Les Collettes seemed to him

too long. His legs were growing too heavy ' to walk that long distance ', he explained to my father, pointing to the quarter-mile ribbon of road under the tall plane trees. And an eloquent gesture expressed the deep weariness of those who have worked all their lives and begin to realize that it has lasted a little too long.

The memory of our stay at the Post Office is inseparable from that of our landlord, Ferdinand Isnard. We were very fond of Baptistin ; the Raybauds were the best of neighbours ; another neighbour, the Consul, was a very dear friend of ours. He knew how to keep my father company without tiring him, telling him all sorts of stories about Brazil, where he had been stationed for a long time. The Deconchys often came to our apartment at the Post Office ; and Renoir was always delighted to see them. Numerous friends would turn up unexpectedly from Nice or Paris, and so break the monotony of our existence. But Renoir's greatest pleasure, and indeed my mother's and ours too, was when Dinan, as everyone in the village called our proprietor, would come to see us in the morning.

He was tall and stout ; his face was round and full of creases, as if he laughed all the time, and was set off by a long brown moustache. A cook by profession, he had retired after a glorious career, winding up at the Savoy Hotel in London, in company with Escoffier. He had saved his money and had decided to end his days doing nothing. Like all idlers, he had countless things to do. He would go and inspect his olive groves on the hillside, water his kitchen-garden, feed his chickens and rabbits, and clean his apartment himself. His father, who was nicknamed ' Pilon ' (' Peg-leg '), lived with him. The old man was half paralysed, and scarcely left the house. The name Pilon apparently dated back to the War of 1870, and was bestowed upon him because of his fear of being mobilized. He is supposed to have said to his wife : ' They send you out to charge the Prussians. But not being idiots like us, they stay in the woods. And when you are within range, they fire their cannon, and there you are with a leg off and wearing a peg-leg for the rest of your life ! '

When Dinan went out to the fields, he always carried a basket and a gun. My father would say to him every time, ' Well, Dinan : are you going shooting ? ' ' No,' he would answer, ' I'm going to get some grass for my rabbits.' ' But the gun ? ' ' Oh, you never know . . . ! ' From time to time he would buy a rabbit or some

thrushes from a poacher, and come back feeling very proud of him-self. ' Monsieur Renoir, I am going to make you a nice little rabbit stew ' ; or, ' Do you like thrushes with herbs ? ' ' Have you been shooting ? ' my father would ask, putting down his brush for a moment. Dinan would then confess where he had got the game. He would have so liked to be a hunter. But the trouble was that just as he was about to fire, the little creatures aroused his pity. He would hesitate, and miss ! It would have upset Renoir to be interrupted by anyone else ; but he did not mind if it was Dinan. ' With the rest of them, everything goes to pot. With him, everything stays in my head, and even becomes simplified.' He felt secure with him, as he did with Gabrielle and my mother, and with Albert André and per-haps with La Boulangère. Not, however, with his children. Our questions were too unexpected, and put in an anxious tone that troubled him.

Little by little Dinan, instead of looking after his fields and his old father, came to spend most of his time with Renoir. He asked Gabrielle and my mother to find out what would please my father. ' Don't you think the master would like a nice little beef stew ? ' When speaking of him, he called him ' the master ', just as Gabrielle and the painters did. When addressing him directly, he said ' Monsieur Renoir.' My mother, who continued to call her husband ' Renoir ', just as she had done when she had first made his acquain-tance in the *crémerie* in the Rue Saint-Georges, was referred to as the ' *patronne* '. Dinan's stew simmered for two days. ' It should be cooked so that it will melt in your mouth. Otherwise, why make a stew ! ' He never used his recipes of famous chefs. ' They're all right for the guests at the Savoy ! Except for the Prince of Wales. It was different with him. One day I made him a *brandade* of cod-fish ! ' He never deviated from the recipes he had got from his father and mother ; and his cooking was authentically Cagnois. My mother learned a great deal from him, and my wife has saved a few of his recipes. He added to the culinary education of our family by introducing us to the regional dishes of the Midi. One thing that amused Renoir was that this man, who was gentleness itself, became a despot once he was in front of his stove. Everyone was mobilized : Gabrielle peeled the potatoes, the cook cleaned the fish, and I stoked the fire. It was a regular whirlwind. His orders were brief and precise, and produced immediate action. His moustache, instead of drooping as usual, bristled to the skies. When everything

was ready, he became the gentle Dinan again. At table he sat beside Renoir to pick out the choicest morsels for him.

When his father died he invited his relatives and friends to a great feast, in accordance with local custom. The dead man lay in the room next to the dining-room. The women kept watch and prayed by the light of tapers. Dinan, who had been anxious to do the cooking himself for these guests who had kindly come to say a last farewell to his father, was overcome. Great tears ran down his face; his fine moustache drooped lamentably. Every now and then he went and knelt near Pilon, and his whole frame shook with sobs. Then his conscience would rouse him to his duties towards his guests and he would come back into the dining-room. ' You're not eating a thing ! You're not drinking ! ' His friends complimented him on his meal : ' Your chicken chasseur . . . I don't think you've ever done it better ! And is this wine from your vineyard on the Route de La Colle ? ' Happy to see his guests so satisfied, he sat down and began to eat. ' The chicken isn't bad. . . .' A cousin told a ' good one ', and everyone laughed, including Dinan. His laughter was as unrestrained as his tears had been. Suddenly he remembered his father. A groan replaced his laugh, and he ran and knelt down again beside the deceased. Renoir was not present at this wake. His health would not allow it. My mother had been detained in Paris. Gabrielle went to help with the preparations, and was invited to stay for the feast. It was she who described Dinan's grief to my father. Her account only served to increase his esteem and affection for our friend. ' He mourns his father just as an ancient Greek would have done.'

Renoir had gone several times to paint in a property on the hill on the other side of the Cagne River. The place enchanted him because of its beautiful olive trees and the little farm, which seemed to be a part of the landscape. It was called Les Collettes. The farm-house was inhabited by an Italian peasant named Paul Canova, his old mother, Catherine, and a little mule called ' Litchou '. Paul Canova was a bachelor. His mother loved him jealously, and threatened dire revenge on any girls who had designs on him. To console himself he drank wine with his fellow Piedmontese, and joined in their choruses, which are so moving when heard at night sounding like invocations. When the ' damijana ' was empty they would amuse themselves by fighting one another. Then he would stagger home to Les Collettes, where his mother was waiting for him, stick in hand, to give him a good beating. His friends kept within a

respectful distance of the house, as they were afraid of the old lady's stick as well as her curses. Paul was very dark, short, fat, clean in his person ; and he had a moustache. As there was not much water at Les Collettes he would go down and wash in the river. Catherine never washed. She knew all about the healing-power of herbs, and treated septic sores with spider-webs. I was to learn later that these ' fly-traps ' contained penicillin. In those days my mother, who believed in washing with plenty of water, cautioned me against letting old Catherine treat a cut.

One morning Paul Canova came to see my father. An estate agent in Nice was going to buy the place, fell the trees, and install a horticulturist, who specialized in raising carnations, on the farm. Old Catherine had lived there for forty years. She felt that she was in her own home and she hoped to die there. To be driven out of Les Collettes would have been a terrible blow. In any event, she had already declared her intention of barricading herself in and undergoing a siege if necessary. And did not Paul have his large-calibre gun ? He had fought in the Ethiopian war against Menelik. He would kill one or two gendarmes, and then the rest would not dare to touch his mother.

My father had Baptistin drive him to Les Collettes, and as he listened to this tale he gazed at the olive trees there. They are among the most beautiful in the world. They have stood for five centuries; and storms, droughts, frosts, pruning and neglect have all combined to give them the weirdest shapes. The trunks of some of them resemble strange divinities. The branches are twisted and intertwined in patterns which not even the most daring designer could create. Unlike olive trees in the Aix region, which are small and trimmed on top to facilitate gathering the olives, these trees have been left to grow freely, and they lift their crown of foliage proudly towards the sky. They are large trees, cloaked in majesty combined with feathery lightness. Their silvery leaves cast a subtle shadow. There is no violent contrast between light and shade. We owe these olive trees to François I, who had them planted by his troops in order to keep the men occupied during a truce in his wars against the Emperor Charles V. One of our friends, Benigni, who was much interested in local history, even maintained that two or three of our olive trees had been planted before that time and were nearly a thousand years old.

My father got back into Baptistin's victoria. The thought of

seeing those noble trees transformed into napkin-rings with 'Souvenir of Nice' inscribed on them was unbearable. On arriving home, he interrupted my mother and Dinan, who were playing cards, and sent them off at once to see Mme Armand, the owner of Les Collettes. She was a charming woman, unable to contend with the difficulties of modern life. She was very glad to see her land pass into our hands. 'At least one knows who they are!' And so it was that Renoir bought Les Collettes.

He did not find it all that amusing. Finished now were the cheerfulness and animation around the Post Office, the scandal of the gossips, the greetings of those who came to buy stamps, Dinan taking a little stroll in his slippers, all this life of other people which he savoured, and which reminded him that he was part of a world that was alive. Until then he had always laughed when friends boasted to him of how secluded their house was. 'The most wonderful thing about our villa,' they would exclaim joyfully, 'is that we never see anyone. Trees all around us; not a single house.' Renoir would answer: 'Why not live in a cemetery? But even there you'd have callers.' He often repeated Montesquieu's phrase, 'Man is a sociable animal.' Towards the end of his life he asked me several times to reread the complete aphorism to him: 'On that score, it seems to me that a Frenchman is more of a man than any other. He is man *par excellence*, for he seems to be made uniquely for society.'

My mother arranged that Renoir's love of company should not be thwarted by the move to Les Collettes. The house she built opposite the little farm, which she left intact, was large enough to accommodate numerous friends. She started serving the pot-au-feu every Saturday night again, just as at the Château des Brouillards. In fact everything was much as it had been in the past, except that Rivière, Vollard, the Durand-Ruels, new friends like Maurice Gangnat, the children of friends who had died, such as Marie and Pierre Lestringuez, all had to make a fifteen-hour trip by train instead of climbing on foot up the slope of Montmartre. But what helped my mother to surround Renoir with the physical activity so necessary to him was that she had remained a peasant to her fingertips. The olive trees were tended, dug around, watered, and pruned just enough for their good, but not too much, for fear of distressing Renoir by their mutilation. The orange trees were manured. She planted hundreds of tangerine trees, and put in two

vineyards. She made a vegetable garden, built a hen-house and raised poultry. For all these activities it was necessary to employ manual labour. In the orange-blossom season young girls came to harvest it. There were continual comings and goings, racing up and down the paths, laughing and singing. The life and movement around were as great as they had been at the Post Office. Renoir loved it all. In the olive season the same young girls came with long poles and knocked the olives down on to the large tarpaulin spread on the ground. When there was enough for a cart-load, we set off with Paul and Litchou. The mill stood beside the ' Béal ', a tributary of the Cagne. It was a very old water-mill, with immense grindstones cut from stone quarried in the mountains. Poplars, grey as Renoir liked them, shaded it from the sun's rays. It was cool there, and the smell of crushed olives was sharp in my throat. We had a long wait. Before it is edible, olive oil has to be put through several processes. We were finally able to get a full jar. The first pressing of oil is much the best; the local people call it ' the flower '. I remember its straw-colour, and its clarity. I also recall the jar made at the Biot pottery-works, varnished with copper oxide. My father loved paint-ing these jars. We went back to Les Collettes with Litchou trotting briskly along as if he understood how eager we were to get home. My father had a fire lit, and was waiting for us in the dining-room. We quickly toasted a piece of bread, poured some oil on it while it was still warm, added a little salt, and then gave Renoir the pleasure of being the first to taste the first oil of the year. ' A feast for the gods,' he said, while we, in turn, ate our fragrant bread.

It seems that the different places Renoir lived in, ever since his childhood, coincided with the evolution of his genius. Les Collettes was the perfect setting for his final period. He even had the strength, in spite of his health, to do some sculpture there. ' Under this sun you have a desire to see marble or bronze Venuses among the foliage.' First the sculptor Guino, then Gimond, came and col-laborated with him in this work.

# 29

Excerpt from a letter Renoir wrote to Georges Rivière shortly after settling at Les Collettes :

> . . . I have just received your letter, and am happy over Renée's success [in a singing contest] . . . but I am in mourning for Tolstoy. So the old boy is dead at last. How many streets, squares and statues he is going to have! Lucky dog!
>
> Yours,
> RENOIR

My father never put his Christian name to his signature when writing to intimate friends. Among themselves they used their family names. My mother also had kept to this custom.

In contrast to his personal letter, I wish to quote Renoir's famous preface to the Cennino Cennini book. He wrote it at the request of his friend, the painter Mottez, who had undertaken to republish the translation of this work made by his father, also a painter and a pupil of Ingres. I place the exchange of views between Renoir and Mottez about the preface somewhere around 1910.

Cennino Cennini, born in Tuscany in 1360, is the only artist of the Quattrocento whose treatise on painting has come down to us, giving an exact idea not only of the technique but also of the life of the artists of that period. Renoir was very embarrassed, for, while he admired Cennini's methods, he knew only too well that those methods, when applied in our day by artists with a different mentality, could no longer produce good results. He wanted to please Mottez, and at the same time to say nothing that would conflict with his own deepest convictions. I shall cite the most characteristic passages :

# Renoir, My Father

Dear Monsieur Mottez:

Your intention to publish a new edition of your father's translation of the book by Cennino Cennini is naturally inspired by your filial piety, by your desire to give a highly deserved tribute to one of the most upright and talented artists of the last century. That in itself would be enough to make us grateful to you. But the republication of this treatise on painting has a wider significance, and it comes at the right time, which is an essential condition of its success.

So many wonderful discoveries have been made in the last hundred years that the men of today are dazzled, and seem to have forgotten that others have lived before them. It is a good thing, I believe, to remind them sometimes that they had ancestors whom they should not disdain. The publication of the present work contributes to that end.

. . . Certainly there will always be Ingres and Corots, just as there have been Raphaels and Titians, but they are exceptions, for whom it would be presumptuous to write a treatise on painting.

Those young artists who take the trouble to read Cennini's book, in which the author has described the way his contemporaries lived, will note that the latter were not all men of genius, but they were always marvellous craftsmen.

Now, to make good artisans was Cennini's only aim. Your father understood that fully.

. . . I imagine that the artist, who dreamed of restoring the art of fresco-painting to its former place, felt a great joy in translating Cennini's book.

He found in it, indeed, the encouragement to persevere in his efforts to renew the art, regardless of the difficulties it entailed.

Your father, who could have said with the poet that he had come too late into too old a world, was the victim of a splendid illusion. He believed that it was possible to do again what others had achieved several centuries before us.

He was not ignorant of the fact that the great decorative compositions of the Italian masters are the work not of just one man, but of a group of men: of a workshop where the master was the animating spirit. And it was this collaboration

that he hoped to see repeated so as to give birth to new masterpieces.

The milieu in which your father worked kept his dream alive. In effect, he belonged to that phalanx of young artists who worked in the shadow of Ingres, and this fraternal group was like the workshops of the Renaissance in appearance only. For one can live only in one's own time, and ours does not lend itself to reconstituting such coteries.

. . . We can never know this métier entirely, because we are emancipated from its traditions and hence no one can teach it to us. . . .

Now, this métier of the painters of the Italian Renaissance was the same as that of their predecessors in all past ages.

If the Greeks had left a treatise on painting, you can be sure it would be identical with Cennini's.

All painting, from that of Pompeii, done by Greek artists (the boastful and pillaging Romans would probably not have left anything if it had not been for the Greeks, whom they conquered but were unable to imitate), down to that of Corot, by way of Poussin, seems to have come from the same palette. Formerly all pupils learned this way of painting under their master. Their genius, if they had any, did the rest.

. . . The stern apprenticeship imposed on young painters never prevented them from having originality. Raphael was the pupil of Perugino, but he became the divine Raphael nevertheless.

But to explain the general value of the older art, one must remember that over and above the master's teachings so docilely accepted there was something else, which has also disappeared, filling the soul of Cennini's contemporaries, namely the religious feeling, the most fecund source of their inspiration. And that is what gives to all their works a double character of nobility and innocence, and saves them from the ridiculous and from excess.

Among civilized peoples it is the conception of the Divine which has always implied the idea of order, hierarchy and tradition. If we recognize the fact that men have conceived a heavenly society in the image of an earthly one, it is still more true that this divine organization has in turn had a consider-

able influence on people's minds, and conditioned their ideas.

. . . If Christianity had triumphed in its primitive form, we would have had no cathedrals, or sculpture, or painting.

Fortunately, the Egyptian and Greek gods were not all dead ; it is they who saved beauty by insinuating themselves into the new religion.

. . . It must be noted, however, that, along with the religious feeling, other factors helped to confer on the artisan of former times qualities which make him incomparable.

Such, for example, is the rule laying down that an article shall be made, from its inception to its completion, by the same workman.

The workman could then put a great deal of himself into his work, and take an interest in it because he was doing it all himself. The difficulties he had to overcome, the taste he wanted to display, kept his brain alert : and success filled him with joy.

These elements of interest, this mental stimulation which the artisan found in his work, no longer exist.

The machine and the division of labour have transformed the workman simply into a mechanical hack, and have killed the joy of work.

. . . Whatever the secondary causes of the decadence of our métiers, the principal cause, in my opinion, is the absence of an ideal. The most skilled hand is never anything but the servant of the mind. Moreover, the efforts being made to give us artisans like those of the past will, I fear, be fruitless. Even if the professional schools should succeed in producing skilled workers trained in the technique of their craft, nothing could be done with them if they had no ideal.

So we are very far, it seems, from Cennino Cennini and from painting. And yet—no. Painting is a métier like carpentry or ironmongery ; it is subject to the same rules.

Those who carefully read the book so well translated by your father will be convinced of it. Furthermore, they will find in it the reason for his admiration for the old masters, and also an explanation of why they have no successors today.

Believe me, dear Monsieur Mottez,

I am yours, etc.

Needless to say, after this eulogy of work done in common, of plunging into the anonymous mass of artisans, Renoir returned to his studio ' to go about his own business all alone, far away from bores '. There was one point in this letter which he often referred to in conversation. It was the idea that the only reward for work is the work itself. ' One has to be very naive to work for money. There are more neurasthenics among the rich than there are among the poor. Fame ? For that you have to be a simpleton. Satisfaction in work achieved ? When one picture is finished, I long to begin the next.'

Another article of faith expressed in the above preface was that in my father's view it was impossible to do anything good under the system of division of labour. A picture, a chair, a tapestry, interested him only if the different stages of its creation were an expression of one man's personality. He was fond of explaining that if one pays a fortune for a Louis XVI commode, whereas a commode from Dufayel's, once its newness has worn off, is not worth a sou, this was because in the first one recognizes the hand of the artisan in each stroke of the chisel, while in the second one discovers only an anonymous organization. Whatever the abilities of the different specialized workmen who produced it, the result is only the copy of the work of its designer—perhaps a gifted man, but one whose genius has disappeared owing to the fact that he himself did not make what he had designed. The only element in a work of art which seemed unimportant to Renoir was its general conception. ' As with Shakespeare, who borrowed his subject from whatever source suited him.' More recently, Gide has said, ' In Art only the form counts.'

The pictures Renoir painted were scattered throughout the world through the intermediary of the Durand-Ruels, and Vollard, and, later, the Bernheims. ' Old Durand ' had left the management of his affairs to his sons Joseph and Georges, the latter handling sales in America. To Renoir they were never merchants, but friends: almost his own sons. Vollard was completely one of the family. In addition to his bewildering commercial success, he had become a publisher of rare books. He gave talented artisans the means, and above all, the time, to perfect the art of photographic reproduction. I have before me a partly machine-made copy of a Cézanne, done by Clot, which is certainly as near to the original as it is humanly possible to make. He revived the hand-press for printing the works he

brought out, and he recounted his experiences and impressions in the books he wrote, of which the first that Renoir read was his *Cézanne*.

My father admired the hand-press and the revival of classic type in printing. He was opposed to reproductions : ' If they begin selling perfect imitations of Veronese for twelve francs fifty, what will become of the young painters ! ' Of Vollard's books he said : ' They describe admirably a fascinating man : a certain Vollard. As for Cézanne, we have his pictures, which tell us more about him than the very best biographer could ever do.' If he sees me, he can say as much about these lines I am writing. That does not prevent me from going on. I am neither the first nor the last to try to give an account of him. The sum total of our efforts amounts to homage rather than an explanation of his art, and this homage, being sincere, cannot be displeasing to him.

As for the Bernheims, my father liked them for their fundamental honesty—they were the first to inform him of the high prices certain of his pictures had brought ; for their courtesy ; and, quite sincerely, for the grand style in which they lived. We have seen how taken he was with luxury, when displayed by others. He himself preferred a feast of beans and potatoes to caviar. It was as much as anyone could do to get him to change out of his old coat, frayed at the elbows. But the sight of a delicate throat adorned with pink pearls and rising from the softness of sables, filled him with delight. He did not think much of millionaires who travel by tram or bus, as he felt that the first duty of a millionaire is to spend his millions. He was revolted by the example of the King of the Belgians, who was said to live like someone of the lower middle class, carrying an umbrella when it rained and personally going over his cook's expenses. He saw in it the beginning of the end of a society which no longer took any pride even in keeping up its own façade. ' A king,' he said, ' should go out in a coach, with a crown on his head, and surrounded by young and dazzling mistresses.'

The Bernheims had a magnificent château, a charming town-house, half a dozen motor-cars, a dirigible balloon, handsome children and beautiful wives whose skins ' took the light '.

The Bernheims were sincerely distressed when they saw that Renoir's condition was growing worse. During our stay in Paris in 1912 they decided to try and find a specialist who might be able to help him. For this purpose they made inquiries, at considerable

expense, all over Europe, and, after rigorous elimination, they chose a truly great physician, who practised in Vienna. The doctor pleased my father because he was vivacious : he had keen little eyes, and he understood nothing about painting. He promised to restore the use of my father's paralysed legs within a few weeks. Renoir smiled, not because he was incredulous but because he was philosophical. He already knew. But it was such a dream : to be able to wander in the countryside in search of a motif, to walk around his canvas and let movement aid concentration. He promised to follow the doctor's orders faithfully. The doctor began with a strengthening diet, and it did wonders. At the end of a month Renoir felt much livelier. One morning the doctor arrived and told my father that the day had come, and that he was going to make him walk.

Renoir was in his studio, seated at his easel, ready to paint. His clean palette was resting on his knees, and his eye was already following on the canvas the ideal outline of the model before him. Baptistin turned the wheel-chair round so that the doctor could stand in front of the sick man. My mother, ' that man ' and the model watched the scene, as the family of the paralysed man in the Bible must have done when Jesus told him to arise and walk.

The doctor lifted my father out of the chair. Renoir was standing up for the first time for two years. He was again looking at things from the level at which other men view them. And he gazed about him with great pleasure. The doctor released him. Left to rely on his own strength, my father did not fall. My mother, Baptistin, and the model felt their hearts beat faster. Then the doctor told my father to walk. He stood in front of him, his arms stretched out, ready to catch him if he tottered. My father asked the doctor to move back a little and, mustering all the strength in his body, took his first step. My mother and the two others seemed to have forgotten their own mortal flesh : their whole being was concentrated on that foot, as it painfully lifted itself from the ground, which was pulling it back like a magnet. And my father took another step ; then another, seeming to break the threads of destiny. It was like water reaching the desert : like the light from a star in the night. My father walked round his easel, and came back to his invalid's chair. Still standing, he said to the doctor : ' I give up. It takes all my will-power, and I would have none left for painting. And,' he added with a malicious wink, ' if I have to choose between

walking and painting, I'd much rather paint.' He sat down, and he never got up again.

From the moment he made this important decision, it was a display of fireworks to the end. Although his palette became more and more austere, the most dazzling colours, the most daring contrasts, issued from it. It was as if all Renoir's love of the beauty of this life, which he could no longer enjoy physically, had gushed out of his whole tortured being. He was radiant, in the true sense of the word, by which I mean that we felt there were rays emanating from his brush, as it caressed the canvas.

He was freed from all theories, from all fears. During his later years he had seen new groups and schools arise; Kandinsky and his followers had pioneered an original kind of art. Renoir sympathized with the aims of abstract painting. At times he too had been tempted to dispense with a subject and renounce appearances altogether. Only his modesty held him back. He remained quite content to express his deepest feelings under recognizable forms, as a landscape or a bouquet of flowers or a young girl. These were quite adequate to tell what he knew of the world. And Renoir knew a great deal. All the knowledge he had acquired in his search for truth, in his ceaseless effort to break through the disguises raised by men's stupidity, now lay in his hand, like an immense treasure concentrated in a single jewel, in a sort of Aladdin's lamp. So he strode with giant steps towards that summit where mind and matter become one, knowing full well that no man living can attain those heights. Each stroke of his brush bore witness to this intoxicating approach to revelation. His nudes and his roses declared to the men of this century, already deep in their task of destruction, the stability of the eternal balance of Nature.

Certain people were so grateful to him for this assurance that they made a pilgrimage to Les Collettes to tell him so. Sometimes they came from far away, and, being poor, had made the journey under difficult conditions. The barking of Zaza, our big sheep dog, gave us warning of any unusual arrival. Bistolfi, the young Italian chauffeur, would open the door, to find a blond and bearded Scandinavian standing before him, his clothes all rumpled; or a Japanese, meticulously dressed. My mother would ask them into the dining-room, where Grand' Louise would serve food and wine. But that was not the nourishment they most craved. My father, forewarned, would have them come to the studio. They would

remain there for a long time without saying a word, since they spoke a different language. I was present at some of these meetings. They were rich moments. I recall one Japanese. He had come on foot all the way from the Italian frontier. He had in his pocket a little well-marked map which a previous pilgrim had given him. He showed it to us. The paths through the grounds of Les Collettes were indicated, and the little studio, Renoir's room, the oven where the bread was baked, and the stable for the mule. One of these visitors made a long stay in Cagnes and became a very dear friend of ours. He was the painter Umeara.

Among seekers of truth, painters perhaps come closest to discovering the secret of the balance of forces in the universe, and hence of man's fulfilment. That is why they are so important in modern life. I mean real painters : the great ones. They spring up in little groups in periods of high civilization. Scientists, like painters, also strive to probe this secret. The authentic, the really great, pierce through the outward appearances of things. The problem is a very simple one, that of giving back to man his earthly paradise. The difference between these two types of seekers after truth is that painters woo Nature, whereas scientists violate her. Painters know that material needs are relative, and that the satisfactions of the mind are absolute. Scientists try to balance the two pans of the scales, loading one pan with more and more material desires and the other with their fulfilment. It is an endless process, in which the pan weighted with desires is always the heavier. With the painter, on the other hand, results are lasting. The satisfaction derived from the Lascaux *graffiti* is equal to that got from a still-life by Braque. The discovery of Mme Curie is surpassed by the work carried out by Teller :[1] and Teller's work, in turn, will be outdistanced by those who succeed him. Teller knows it quite well. The modesty of true scientists is one with that of true artists. This search for the secrets of Nature justifies all the huge laboratories, the elaborate museums, the costly experiments, and the picture sales at fabulous prices. Most collectors of painting do not know the terrifying possibilities inherent in owning a work of art. A great painting can change a man's whole view of life. Most people, however, are content to follow blindly in the footsteps of the few

[1] Physicist who took part in the first nuclear researches, and worked on the atomic bomb during the Second World War. He is at present Head of the Nuclear Research Department at the University of California.

who do know. Those who possess the master-word[1] are, and always will be, few. Renoir is perhaps one of the few to put this master-word within reach of a great number of people. He loved his fellow-men, and love works miracles.

There are several photographs of Renoir taken at the end of his life : portraits disturbingly true to life, by Albert André ; a bust, made on the day of his death, by Gimond. They give an idea of his physical appearance, of his frightening emaciation. His body became more and more petrified. His hands with the fingers curled inwards could no longer pick up anything. It has been said, and written, that his brush was fastened to his hand. That is not entirely accurate. The truth is that his skin had become so tender that contact with the wooden handle of the brush injured it. To avoid this, he had a little piece of cloth inserted in the hollow of his hand. His twisted fingers gripped rather than held the brush. But until his last breath his arm remained as steady as that of a young man, and his eyesight as keen as ever. I can still see him applying a point of white, no larger than a pin-head, to his canvas to indicate a reflection in the eye of a model. Unhesitatingly the brush started off like the shot of a good marksman, and hit the bull's-eye. He never rested his arm on any support, he never used a ruler to make sure of his proportions. I have seen him paint a miniature, a portrait of my brother Coco. He would hesitate a moment before deciding how fine a brush to use, then set to work just as he would have painted any other picture. We had to use a magnifying-glass to make out the details of the perfect likeness. He sometimes wore glasses for reading, but he did so chiefly to save his eyes. When he was in a hurry, or when he mislaid his glasses, he managed quite well without them. Whenever the weather permitted, we liked to sit on the terrace in the evening and watch the fishermen at Cros-de-Cagnes sailing back to port. My father was always the first to spot a boat.

Life at Les Collettes had been organized around Renoir's infirmities. Grand' Louise, our cook, was ' as strong as a horse '. She was the one who lifted him out of bed and settled him in his wheel-chair. From time to time he was put into the motor-car, now driven by Bistolfi, who had taken Baptistin's place. My mother had grown very stout, and it was difficult for her to move about much. She was seldom out of her red dressing-gown with the white polka-

[1] A reference to Mowgli's ' We be of one blood, thou and I,' which enabled him to communicate with all the creatures in the jungle. (Trans.)

dots. Dr Prat had had her examined. He had informed her that she had diabetes, and that her days were numbered. It did not trouble her greatly. She simply asked Prat not to tell anyone, and Renoir remained in ignorance for a long time. My brother Claude spent the greater part of his time posing. Gabrielle was about to marry the American painter Conrad Slade. She was not at Cagnes when the War of 1914 broke out. Our most faithful visitors were Albert André and Maurice Gangnat. That great bourgeois gentleman was carrying on the tradition of old Choquet. His feeling for painting was astounding. Whenever he entered the studio, his gaze always fell immediately on the canvas Renoir considered his best. ' He has an eye for it ! ' my father declared. Renoir also said that collectors who really know anything about it are rarer than good painters. Matisse sometimes came to see him. Cézanne's son Paul married Renée, and settled next to Les Collettes. I rarely took part in all these activities, as I was busy at my studies. After my course in philosophy I did a year in mathematics, and then enlisted in the cavalry. In August of the following year the war broke out.

Renoir was driven up to Paris by car. My mother had gone on ahead of him, in the hope of seeing my brother Pierre once more before he left for the Front. She missed him, but found Véra Sergine, his companion, with a superb baby, who was none other than my nephew, Claude. My mother packed them both off to Les Collettes, where they remained until Pierre was badly wounded. He was invalided out of the army and Véra hurried to his bedside.

My father succeeded in finding the regiment of dragoons in which I was serving, in a little town in the eastern part of France, where we were waiting to leave for the Front. Colonel Meyer gave a luncheon in his honour, and I was allowed to attend it. The sight of all those boys in battledress eased Renoir's anguish. He said to me : ' We're all caught in it now. It would be dishonest not to stay with the others.' I carried him to his car. Albert André was with him. When they got to the bend in the road, Renoir told Bistolfi to stop. Aided by Albert André, he managed to turn and make a little sign of farewell to me through the glass.

I was not to see him again until after I was wounded, I rejoined him in the Boulevard Rochechouart, and there obtained the bulk of the material for this book.

When my mother learned that I was wounded she arranged to get a pass and came to see me in the hospital at Gérardmer. She was

informed that they were going to amputate my left leg, which gangrene had turned an odd shade of cobalt blue. She opposed the operation so vehemently that the military doctor at the hospital abandoned the idea. He was replaced by Professor Laroyenne, a specialist, who cured the gangrene by using a curious system of circulating distilled water through my leg. He did not conceal from my mother that I would not have survived the amputation. As soon as my mother saw that I was out of danger, she went back to Cagnes and died.

At the beginning of 1916 I was a pilot in a reconnaissance squadron. Our hangars were set up in that part of Champagne called ' pouilleuse ' because of a dry grass named ' pouille ' which grows in that desertlike region. The brisk air there reminded me of Essoyes. I thought of that outing we had taken to the villages of Ricey,when my father had drunk the rosé wine. It was the hour when the post was distributed. I had a letter postmarked Cagnes. The envelope had been addressed by Grand' Louise. Inside there were three words written in a trembling hand : ' To you. Renoir.' With it was a violet, which had been picked near the wash-house at home, under the olive trees.

After the Armistice, when I was able to return to Cagnes and live with my father, I found the house sinister. The orange trees and the vineyards were almost wild. It was as if people, trees, everything, mourned my mother. The car was garaged and covered with a thick layer of dust. Bistolfi had been called up in the Italian army. The poor boy was broken-hearted as he left the house. He kept repeating, ' I don't give a damn about Trento or Trieste ! ' We never saw him again. Our Paris friends had not yet shaken off the apathy of the war years, and they did not stir from their homes. Dinan was very ill, and no longer able to climb the road to Les Collettes. Fortunately some of the local friends came and helped Renoir through the twilight hours at the end of the day. Benigni and Dr Prat were among the most attentive. Benigni, an official in the Civil Service, amusing and also far-sighted, tried to put our affairs into some sort of order, as they had not been looked after since my mother's death. My father said of Dr Prat : ' Just to see his eyes sparkling above his sheep-dog's beard makes me feel better.'

The more intolerable his suffering became, the more Renoir painted. Some friends in Nice had found a young model for him, Andrée, whom I was to marry after his death. She was sixteen years

old, red-haired, plump, and her skin ' took the light ' better than any model that Renoir had ever had in his life. She sang, slightly off-key, the popular songs of the day, told stories about her girl friends, was gay, and cast over my father the revivifying spell of her joyous youth. Along with the roses, which grew almost wild at Les Collettes, and the great olive trees with their silvery reflections, Andrée was one of the vital elements which helped Renoir to interpret on his canvas the tremendous cry of love he uttered at the end of his life.

His nights were frightful. He was so thin that the slightest rubbing of the sheet caused a sore. Prat had got a trained nurse for him. Renoir did not like the word ' nurse ', and he called her, teasingly, ' doctor '. In the evening he would put off as long as possible the moment when he would have to undergo the ' torture of the bed '. His sores would have to be dressed, and talcum powder applied to places easily irritated. With the exception of his brush, it was hard for him to pick things up any more. ' I can't even scratch myself.' He kept a ruler near by and would ask the nurse to rub his back with it gently, the way the Chinese do. His great problem was to find a tolerable sitting-position. ' Why are the bones in the back-side so pointed ? ' We would lift him up, pull down his trousers, and sprinkle him with talcum ; then they would remove the horse-hair cushion and put a kapok-fibre one in its place. But it was no use. ' It's like fire,' he would grumble. ' I'm sitting on blazing coals ! ' He would get irritable, he would fume and fret, and swear : but he never thought of suicide—I am sure of it, for I was with him almost constantly, and he never concealed from me anything that was on his mind. In his worst moments he would make an allusion to death, but always in a joking way. He praised the wisdom of certain Negro tribes who get rid of their old men by asking them to climb up a coconut tree. The tree is shaken violently. If the old men are not able to hang on, they fall, break their necks and die. He suggested that a law should be adopted limiting military service to the aged. ' No more wars then. The politicians, who are all doddering, would be obliged to serve. And if war broke out all the same, what a chance to get rid of a lot of useless mouths ! ' He raged when his nose ran, because he could not wipe it himself ; he fumed because his hernia belt cut into him ; he was infuriated by the bandages which he had all over his body and which made him perspire. ' I am a disgusting object,' he said. It was not true. He was meticulously clean. Every morning and every night Grand'

Louise and I would remove his clothes, turn him over on his bed, which was covered with oilcloth, and then the nurse would rub him from head to foot with alcohol. He had several sets of false teeth, which he changed continually ; those he was not using were kept in an antiseptic solution. He told me how happy he had been when he had lost his last tooth some years before, while I was at boarding-school. ' At last,' he exclaimed, ' the enemy has abandoned the position ! '

In the morning, after his ' detestable night ', he would allow us to wash and dress him, while he was still half-asleep. He insisted, however, on sitting up to table in an armchair for his breakfast. He had always had a horror of breakfast in bed because of the crumbs, which get under the backside. ' When I think that break-fast in bed is a great luxury for most French people ! For me it was always a nuisance.' He still wanted to have the buttered toast and café au lait of his youth. But it was only a pretence. The toast hurt his gums, and he only nibbled a few crumbs. He cared little for soft rolls or cakes. He would have liked a croissant, but ' you can only get that in Paris.'

Next, we would seat him in a ' sedan-chair '—a wicker armchair with two bamboo poles fastened to the sides. When descending the stairs, Grand' Louise would take hold of the front handles, and the nurse the rear ones. Going up, they reversed their positions. They adopted the same procedure for the sloping ground at Les Collettes. According to the weather, the light, and the work he was doing, Renoir would have himself carried to the studio, or be taken around to look for a ' landscape ', or else finish one he had already begun. He had partly given up using the large indoor studio, with its big window on the north side. The ' cold and perfect' light in it annoyed him. He had a sort of glassed-in shed built for himself, about five yards square, with window-frames which could be opened wide. The light came into it from all directions. This shelter was situated among the olive trees and rank grass. It was almost as if he were working out of doors, but with the glass as a protection for his health, and it was possible to control the light by cotton curtains which could be pulled and adjusted. This invention of an outside studio in which the light could be regulated was the perfect answer to the old question of working from Nature as opposed to working indoors in the studio, since it combined the two.

Another invention enabled him, in spite of the difficulty of his

movements, to undertake relatively large subjects. It was a sort of 'caterpillar' arrangement, made of slats nailed on to a long strip of heavy canvas, which was rolled around two horizontal cylinders, a little over a yard wide, one near the ground, the other about seven feet above. He had his canvas fastened on to the slats with drawing-pins. By turning the lower cylinder with a crank, the strip of canvas could be unrolled either way, and so bring any part of the motif that Renoir wanted to work on to the level of his eye and arm. Most of his last pictures were painted in his out-door studio and on this easel equipped with cylinders.

While he was being put into his wheel-chair, the model went outside and took her place on the flower-spangled grass. The foliage of the olive trees sifted the rays of light and made an arabesque on her red blouse. In a voice still weak from his suffering during the night, Renoir had the adjustable windows opened or closed as he wished, and material hung up to provide him with a protection against the intoxication of the Mediterranean morning. While one of us prepared his palette he could not help groaning once or twice. Adjusting his stricken body to the hard seat of the wheel-chair was painful. But he wanted this 'not too soft' seat, which helped him to keep upright and allowed him a certain amount of movement. I would sit down on the slightly raised floor, my head and body inside the studio, my legs stretched out of the door in the oat-grass. My father's suffering devastated all of us. The nurse, Grand' Louise, the model—often it was Madeleine Bruno, a young girl from the village—and I, all felt a lump in our throats. Whenever we would try to talk in a cheerful voice, it sounded false.

One of us would put the protecting piece of linen in Renoir's hand, pass him the brush he had indicated with a wink of the eye. 'That one, there. . . . No, the other one.'

The flies circled in a shaft of sunlight. A phrase of Gabrielle's comes to my mind : 'His beautiful, slender hands.' Now that I am trying to set down my impressions, I cannot resist opening the drawer and feeling Renoir's gloves—pale grey, and so small. I put them back in their tissue-paper and return to the studio in the garden, to my father's twisted hands, and to . . . the flies. 'Oh, these flies ! ' he would exclaim in a rage, as he brushed one off the end of his nose. 'They smell a corpse.' We made no answer. After the fly had ceased to bother him, he sank back into his somnolence, hypnotized by a dancing butterfly, or by the distant sound of a

cicada. The landscape was a microcosm of all the riches in the world. His eyes, nose and ears were assailed by countless contradictory sensations. 'It's intoxicating,' he kept repeating. He stretched out his arm and dipped his brush into the turpentine. But the movement was painful. He waited a few seconds, as if asking himself 'Why not give up? Isn't it too hard?' Then a glance at the subject restored his courage. He traced on the canvas a mark, in madder red, that only he understood. ' Jean, open the yellow curtain a little more.' Another touch of madder. Then, in a stronger voice, 'It's divine!' We watched him. He smiled and winked, as he called us to witness this conspiracy, which had just been arranged between the grass, the olive trees, the model and himself. After a minute or two he would start humming. And a day of happiness would begin for Renoir, a day as wonderful as the one which preceded it and the one which was to follow.

Lunch-time was not an interruption. His mind would continue its explorations into the mysteries of his picture. The process would continue until evening, when the sun was too low and the shadows were no longer luminous. Then his body got the better of him. His pain would grow sharper: at first, only slightly, then resume its work of torture.

It was under these conditions that he painted 'Les Grandes Baigneuses', now in the Louvre. He considered it the culmination of his life's work. He felt that in this picture he had summed up all his researches and prepared a springboard from which he could plunge into further researches.

He had executed the picture in a relatively short time, aided to a great extent by 'the simple and noble ' way in which Andrée posed. ' Rubens would have been satisfied with it!' After his death, my brothers and I decided to give this painting to the Louvre. The museum authorities considered the colours too 'loud ', and refused it. Barnes, the art collector and writer on art, cabled me that he would like to buy the picture and put it in his museum at Merion, Pennsylvania. It would have been in good company. This great theorist of the art of his time had had the good sense to gather together, for the benefit of his students, the most significant works by contemporary masters. 'Les Grandes Baigneuses' would have hung next to Cézanne's ' The Card-players ', and Renoir's ' The Family ', of which I spoke before, apropos of the Château des Brouillards. The Louvre then reversed its decision and accepted our gift. Times

had indeed changed since the day when the Government refused two-thirds of the Caillebotte Collection and thus deprived France of an inestimable treasure. The opposition continued, and, happily, will continue for centuries to come. Renoir means life, and life is profoundly displeasing to corpses. Yet in the face of this hostility, the number of enthusiastic devotees has multiplied, to include the man in the street. Today Renoir no longer belongs to a closed circle of art-lovers. His admirers pour into the museums and crowd in front of his works. Reproductions multiply. With his frail hands he has pierced the hard shell of the crowd and reached their hearts. Better still, he has moulded the crowd in the image of his ideal, just as he moulded his wife, his children and his models. The streets of our cities are now filled with ' Renoirs ' : young girls, children with wide, candid eyes and skin that take the light.

On Renoir's last trip to Paris, Paul Léon, the Director of the Beaux-Arts, invited him to visit the Louvre, ' opened for him alone '. They escorted him slowly through the different rooms in his ' sedan-chair '. He asked to stop in front of Veronese's ' Marriage at Cana ', and he said to Albert André, who was with him, ' At last I have been able to see it hanging *en cimaise* ! '[1] Albert André was later to speak of this solemn visit as a tribute to the ' Pope of Painting '.

Renoir had succeeded in fulfilling the dreams of his whole life : ' to create riches with modest means '. From his palette, simplified to the last degree, and from the minute ' droppings ' of colour lost on its surface, issued a splendour of dazzling golds and purples, the glow of flesh filled with young and healthy blood, the magic of all-conquering light, and, towering above all these material elements, the serenity of a man approaching supreme knowledge. He now dominated Nature, which all his life he had served as a worshipper. In return she had finally taught him to see beyond surface appearances and, like herself, to create a world out of almost nothing. With a little water, a few minerals, and invisible radiations, Nature creates an oak tree, a forest. From a passionate embrace beings are born. Birds multiply, fish force their way upstream, the rays of the sun illumine and quicken all this stirring mass. ' And it costs nothing ! ' If it were not for man, ' this destructive animal ', the equilibrium of a world in ceaseless movement would be assured. Death would

---

[1] A technical expression meaning 'properly hung and shown to advantage at the right height for the person looking at it'. (Trans.)

come into balance with life; costs would not exceed payments; the cycle of destruction and creation would be complete.

This profusion of riches which poured forth from Renoir's austere palette is overwhelming in the last picture he painted, on the morning of his death. An infection which had developed in his lungs kept him to his room. He asked for his paint-box and brushes, and he painted the anemones which Nénette, our kind-hearted maid, had gone out and gathered for him. For several hours he identified himself with these flowers, and forgot his pain. Then he motioned for someone to take his brush, and said, ' I think I am beginning to understand something about it.' That is the phrase Grand' Louise repeated to me. The nurse thought he said, ' Today I learned something.'

I had been obliged to go to Nice. When I returned I found my father in bed, breathing with difficulty. The nurse had sent for Dr Prat, who had arrived shortly afterwards. He told me that it was the end. A ruptured blood vessel transformed his gasping into a sort of delirium. He died in the night.

He had several times expressed his fear of being buried alive. I insisted that Prat should do whatever was necessary. He asked me to leave the room. When I came back, he was able to assure me that Renoir was dead.

# INDEX

# Index

# Index

# Index

# Index

Nature, necessity for the loving observation of, 214ff.; search for the secrets of, 395
Navarre, Queen of, 291
Neuilly, 294
New York, exhibition of Impressionist painting in, 226, 233
Newton, 82
Nicot, Jean, 111
Niepce, Joseph Nicéphore (physicist), 161
Nijinsky, 360
Nini (model), 143
Nouvelle Athènes restaurant, 126, 224, 242
nude, importance of the, 348
nudity, R.'s attitude towards, 315, 348

occult sciences, 163-4
Odiot (goldsmith), 67
Offenbach, Jacques, 92, 170, 171-2, 295, 319
Opera House, Garnier's, 45, 54, 169, 207
*Orvet*, R.'s exact words used in the play, 117
Ottin (painter), 152, 154
Oullevé (painter), 74-5, 94

Paillepré, the Marquise de (concierge), 250-1
painting, remarks made by R. about, 147-8, 168, 207-8, 208-9, 211, 222-3, 272; on the function of a painter, 125
palette, R.'s, 133, 209, 341-3, 403, 404
Palissy, Bernard, the earthenware of, 297
Paris, 19-20, 42, 44-5, 47-8, 60, 93, 187-8, 200; *see also* Montmartre
Parisot, Paul (a cousin of R.'s), 307
Pascal, 40, 131, 210
Passy, R.'s views on, 20
Pasteur, 245
patchouli, 169
peas, boredom of shelling, 28, 39
pederasty, painters and, 245
Perugino, 389
photography, the Impressionists and, 161-2
Picasso, Pablo, 223
pictures as an investment, R.'s comment on, 290
Pigeot, Georgette (model), 307, 316, 331, 347
pipe, *see* tube
Pissarro, Camille: as Impressionist, 73, 100, 126, 141, 142, 152, 155; the theorist of the group, 102, 109, 165; as a person,

102; his friendship with R., 110, 115, 116, 371-2; supports the Commune, 124, 229; and the Dreyfus case, 230; does engravings, 268; death, 373
Pissarro, Lucien, 268
Polin (café-concert singer), 362
politics of R. and his friends, 229-31
Pompeian frescoes, 208-9
porcelain painting, *see under* Renoir, Pierre Auguste
pot-au-feu, the Saturday evening, 74, 298, 385
Poussin, Nicolas, 389
poverty, things considered by R. to be tainted with, 338
Prat, Dr, 397, 398, 404
Primiaud (painter), 317-18
Primitives, Italian, 208
privy, the, as symbol of the march of time, 168-9
proportions, R.'s views on the ideal physical, 195-6
Proust, Marcel, 356

r's, the pronunciation of, 227
Rabelais, 87, 137
Rafaelli, Jean François, 338
Raphael, 104, 150, 174, 199, 229, 389
reading, R.'s tastes in, 87
Redon, Odilon, 234
Regnier, Anne (R.'s paternal grandmother), 15
religion, R.'s attitude towards, 132-4, 218
Rembrandt, 53, 75, 208
Renard, Gabrielle, *see* Gabrielle
Renoir, Aline (*née* Charigot; R.'s wife, the author's mother): a native of Essoyes, 10; meeting and early relationship with R., 193-5, 200; temporary parting, 200-1; their life together, 212-13, 214, 243-4, 316, 317, 382, 387; travels with R., 202-3, 213-14, 245; as wife and as organizer of family affairs, 232-3, 233-5, 238-9, 261, 263, 297, 308, 311, 312, 363, 373, 376, 380, 385-6, 397; her dinners, 234-5, 298; as hostess, 316; helps R. after his accident, 309, 315; letters to R., 278-9; told of the theft of some of R.'s pictures, 333-4; instructs his models to act as guards, 335; suggests Gabrielle as substitute model, 347; discovers use made of canvases left with the Lerays, 365; birth of her children, 214, 246, 247, 255, 367; care of them, 257, 259, 284, 316, 371, 375; says Pierre will be an actor,

# Index

# Index